what

light

can do

ALSO BY ROBERT HASS

POETRY

Field Guide

Praise

Human Wishes

Sun Under Wood

Time and Materials

The Apple Trees at Olema

ESSAYS

Twentieth Century Pleasures

Now and Then

TRANSLATIONS

The Essential Haiku: Versions of
 Basho, Buson, and Issa

what

light

can do

ESSAYS ON ART, IMAGINATION, AND THE NATURAL WORLD

robert

hass

An Imprint of HarperCollins*Publishers*

HarperCollins books may be purchased for educational, business, or sales promotional use. For information please write: Special Markets Department, HarperCollins Publishers, 10 East 53rd Street, New York, NY 10022.

FIRST EDITION

Designed by Mary Austin Speaker

Library of Congress Cataloging-in-Publication Data has been applied for.

ISBN 978-0-06-192392-0

12 13 14 15 16 OV/RRD 10 9 8 7 6 5 4 3 2 1

contents

author's note

ONE OF ROBERT ADAMS'S BOOKS of photographs is called *What We Bought: The New World.* Robert Adams is, or in this book aims to be, a sort of anti–Ansel Adams. What the two artists have in common, besides a name, is a certain technical authority. The source of that authority is mysterious to me. But it is that thing in their images that, when you look at them, compels you to keep looking. I think it's something to do with the formal imagination. I don't know whether photographers find it in the world, or when they look through the viewfinder, or when they work in the darkroom, but the effect is a calling together of all the elements of an image so that the photograph feels like it is both prior to the act of seeing and the act of seeing. Attention, Simone Weil said, is prayer, and form in art is the way attention comes to life. It's there in *What We Bought,* in which Adams seems to have set out to photograph the sheer, raw, thoughtless ugliness of the country at the edges of urban Denver.

Informis was the old Roman term for ugliness: that which has no form. The American landscape is rich in it. Probably most human landscapes are, but in the United States every child learns nationalism from a song that begins, "Oh, beautiful . . . ," so it is bracing, in the way that truthfulness is bracing, to page through the opening images in *What We Bought.* The first image is a scrubby, misshapen tree in a field of bleached, scrubby high mountain grasses. The tree casts a mild leftward blotch of shadow, so it must be near noon, maybe eleven in the morning, and in this image east must be right. It's morning in America and the tree—it's hard to gauge size in such a landscape; it could be merely a shrub gone wild, but tree or shrub, it could only have gotten to be so formless by having been removed from the ecological context in which it made sense. It is given sense by Adams by being placed square in the

center of the rectangle of the picture—center low. There is a horizon just below the middle of the rectangle, and in the distance, perhaps half a mile off, there are telephone poles, which would indicate a road, and just above the hypothetical road, on the left side of the picture where the shadow is, just on the horizon, there is a tiny stretch of black and white that could be a suburb and could be an escarpment of snowy mountains, very far off. The top half of the image, into which the tree or shrub projects, is sky, though "projects" is not exactly the right word, since the top of the tree seems to flatten out. In fact, the tree is almost square, as if the old, fundamental vocabulary of landscape art—earth, horizon, sky, trees marrying them by growing from the earth and reaching toward the light—had been radically altered. And the sky seems to answer to this. It is immense, but it's streaky, a series of horizontal lines, so that you can almost hear the weather report on a car radio telling you that it is 11:13 and partially overcast this morning in Denver, clearing by afternoon.

Adams's images came to mind when I was trying to think of a way to introduce this collection of essays. One of the things I love about the essay as a form—both as a reader and as a writer—is that it is an act of attention. An essay, like a photograph, is an inquiry, a search. It implies attention to and sustained concentration on some subject. It also implies attention to the essay as a form. There are a lot of different ways to write essays, a lot of different ways to say things, so the pleasure and the frustration of writing essays is that you are often discovering the object of inquiry and the shape of the search at the same time, and spend, therefore, a certain amount of time thinking about the shape of a piece of writing or watching its shape emerge. This is a collection of twenty or so years of incidental practice in the form. For me it was work done around the edges of the practice of poetry. It includes writing of various kinds—critical essays written for a literary audience, literary journalism for magazines and newspapers, lectures, catalogue essays for shows of photographs, introductions to reissues of classic books, argumentative essays written to think through a subject that was on my mind, book reviews to speak about some work that excited me or made me curious.

In *What We Bought* Robert Adams's second photograph is of a raw, bare field harrowed for planting; a tiny, distant horizon of bare trees; and a huge cloudy sky. The next is a field of almost white grass, patchy where the grass has not flourished, a trace of a road through the grass, and a huge sky

with a few small, hovering sunlit clouds. The fourth is a muddy drainage ditch, or perhaps the beginning of an underpass, some heavy equipment in a cluttered distance, a telephone pole, a horizon, and a light cloudy sky. It is as if he thought his subject was the earth, when in fact it was the sky. Putting this book together I could see some of my themes—a fascination with how poetry is made and what it does, which is to say, for me, a fascination with how we figure and share with one another what it is to be conscious and to live, to have lived; an interest in understanding the violence of the century I've spent most of my life in; an interest in the writers of my place; an interest in photography, and in landscape, in how we see and how we have imagined and treated the earth. There may be other things as well that I am not noticing. If there is a sky for me in this collection, it is the act of attention itself, trying to see what's there, what light can do.

I need to thank the editors in whose journals, reviews, and newspapers these pieces appeared and in some cases the venues in which I was invited to give a lecture. The journals include *AGNI, American Poetry Review, Believer, California Monthly, Camerawork, Ironwood, Michigan Quarterly Review, New York Review of Books, New York Times Book Review, Pequod, Poetry Flash, San Francisco Chronicle, Threepenny Review,* and *Washington Post Book World.* "Edward Taylor" first appeared in *Green Thoughts, Green Shades: Essays by Contemporary Poets on the Early Modern Lyric,* ed. Jonathan F. S. Post, University of California Press, 2002. "Reflections on the Epistles of John" was published in *Incarnation: Contemporary Writers on the New Testament,* ed. Alfred Corn, Viking Penguin, 1990. I want to thank Eiko Hosoe, Robert Adams, Laura McPhee, and Robert Buelteman for allowing me to reproduce their work here in a form that doesn't do it justice. They would have had good reason to say no, but I needed the images if readers were going to see what I was talking about, and I hope readers will find their way to the books and exhibitions in which their images can be seen on their own terms. I should say that in a couple of the personal stories in these essays, I've changed names to preserve the privacy of people who figure in them. Thanks to Christopher Rhodes for much editorial help. I need particularly to thank Libby Edelson for her gifted editorial eye and for imagining this book into being. It probably wouldn't exist otherwise. And, as always, eternally, thanks to Brenda Hillman for her endlessly interesting company and her patience and to Daniel Halpern for his friendship and support.

what

light

can do

I. A MISCELLANY OF SHORT PIECES TO BEGIN

wallace stevens in the world

My nineteenth birthday was also the birthday of one of my college friends. I went to an early class in logic that morning. I think we were reading Aristotle's *Posterior Analytics*, because when I got back to my room a group of my friends was there with several bottles of champagne and I remember that in the ensuing hilarity there was much speculation about the comic possibilities in the title of that treatise. My friend Tom had been to a class—it was a Catholic men's college, Saint Mary's—that somehow involved the Latin names for various illicit sexual positions, *coitus reservatus, coitus interruptus, coitus inter femores,* and so on, which was also the source of a lot of buffoonery that blended nicely into the subject of posterior analytics, and at some point in the proceedings one of the more advanced of us got out the volume of Wallace Stevens's *Collected Poems* in its handsome soft blue dust jacket and read "The Emperor of Ice-Cream." I had never heard the poem before and it seemed to me supremely delicious. It was March in California, high spring, the hills still green, with grazing cattle in them, plum trees in blossom, the olive trees around the campus whitening whenever a breeze shook them, and after a while a group of us was marching through the field full of mustard flowers and wild radish in the back of the dormitory, banging on pans with spoons and strumming tennis rackets and chanting out the poem, or at least the first stanza of it, which I find now is what I still have in memory:

> Call the roller of big cigars,
> The muscular one, and bid him whip
> In kitchen cups concupiscent curds.
> Let the wenches dawdle in such dress
> As they are used to wear, and let the boys

Bring flowers in last month's newspapers.
Let be be the finale of seem.
The only emperor is the emperor of ice-cream.

It is probably significant that I don't have the second stanza by heart. I don't know if I took in the fact that the poem was a proposition about behavior at a funeral. If I did, it could only have seemed to me that morning and afternoon immensely droll. I was a sophomore. I read it as a sophomore poem. The year before in my freshman year—I make this confession publicly—I had taped above my desk along with other immortal lines a little poem by Edna St. Vincent Millay that went something like this:

My candle burns at both ends;
It will not last the night;
But ah, my foes, and oh, my friends—
It gives a lovely light!

I had by the following year understood that it was deeply uncool to have lines of Millay adorning one's room and replaced them with something appropriately gloomy by Jean-Paul Sartre, but at that time I took Stevens's line in more or less the same spirit as Millay's, as permission to have fun, to live in the spirit of comedy. I see now that they were in fact probably written out of the same anti-Victorian spirit in the 1920s. They may even have been written in the same year, and the poem is more or less permanently associated for me with that bibulous and raucous first experience of it. I don't remember for sure what if anything I knew about Wallace Stevens except that he was a modern poet.

I want to come back to "The Emperor of Ice-Cream," but let me say a word about coming across a couple of other Stevens poems that complicated my understanding of it. In the fall after the spring I have been describing, a group of us, eight, I think, quadruple dating, were on our way to dinner and a movie and couldn't decide where we wanted to go or what we wanted to see, and the driver, in a moment of inspiration, said, "Oh, the hell with it, let's go to Carmel and run on the beach." It was a three-hour drive then from Berkeley to Carmel. We stopped for sandwiches and wine; we had very little money, so there was no question of staying in a motel, which meant sleeping on the beach if

we didn't drive back in the middle of the night; people had people to notify if they were going to stay out all night; one woman had a father whom we all hated, an amazingly unpleasant man who actually made his living by running a lab that tested for venereal disease and who insisted on testing his daughters regularly, and she was quite worried about getting away with a very late night, which made the rest of us feel appealingly reckless. I don't remember exactly who was there. The driver was a year ahead of me in school, famously smart, a philosophy major who at the end of his senior year read a French novel about Dien Bien Phu and, quoting Nietzsche on the true aristocrat, enlisted in a branch of the service I'd never heard of called Special Forces where he claimed he would learn to parachute, ski cross-country, and fight bare-handed in jungles in places like Annam and Cochin China, which was now called Vietnam. His girlfriend was from the Philippines, extremely beautiful, the daughter of some kind of politician, we understood, and a French major. It was she who produced the white Vintage paperback volume of Wallace Stevens at some point in the drive and suggested that we take turns reading the stanzas of "Sea Surface Full of Clouds." I was stunned by the poem. I am still stunned by the poem. After we had read around and gotten over the shock and novelty of the way the adjectives play over and transform the surface of the poem, and after we had read a few others by Stevens, and other books were produced and other poems read, the conversation moved on, but I got my hands on Marie's Stevens and when we arrived in Carmel and got some more wine and watched the sun set over Carmel Bay in a light rain, I suggested we read the poem again, which we did, to humor me, I think, while the last light smoldered on the horizon. Then we tried to build a fire on the beach, but the rain turned into a lashing Pacific storm and we spent the night, quite wet, eight of us crammed into the car in the parking lot, laughing a lot—it was very sexy as I remember—and making jokes about cars and autoeroticism. I will start to feel like Kinbote, the lunatic annotator of other people's poems with incidents from his own life in Nabokov's *Pale Fire,* if I tell you the story of the lives of each of the people in the car. Marie, who returned to the Philippines and who, I know, had two children and whose spine was badly injured when she was struck by a car; Killpack, who did go to Vietnam and then army intelligence toward the end of the war and after that seemed to disappear from sight; another friend

who was a classics major and later managed a café and wrote poems and died of cancer a couple of years ago; but I will resist except to say that the poem stays with me, in the way that songs we fall in love to stay with us, as a figure for that time and those people, and their different lives will always feel to me as if they are playing out in time the way the adjectives of experience play over the adamant nouns in Stevens's poem: rosy chocolate and chophouse chocolate and musky chocolate, perplexed and tense and tranced machine.

And there was the incident of "The Snow Man." It occurred at a wedding at the end of my sophomore year, of a woman we all liked, large, placid, Irish, a drama major, and the daughter of the man who conducted the last big band in the last seedy, once-glamorous dance hall in San Francisco in the 1950s when dancing to Maury Monohan's orchestra was a citywide trope for absurdly retro behavior. She was marrying a classmate we only grudgingly liked; perhaps we were jealous, but we all showed up for the wedding. And at the reception in one of the rooms of a house that sat over a steep hillside cliff, another of my classmates announced that he was going to kill himself. I came onto this drama late and it's still not clear to me how it began, but when I came into the room, there was a small knot of people standing around one of my friends—his name was Zack and he was an acting student—who was standing by an open window. He looked wild-eyed and he was talking to his friend Tony, with whom I knew he had been in the navy. They were inseparable friends and they cultivated a certain cool bleakness that was stylish then, so that someone of our group had called them the Laurel and Hardy of tragedy. At that moment it looked to me distinctly as if Tony was goading Zack. They had apparently been talking about "the void," the term for nothingness we all used, and Zack must have spoken of his despair, because Tony was telling him with pure scorn that he didn't feel despair because he didn't feel anything. He was always acting, always a fake, generating histrionics to make himself feel real, feel anything at all. Look, jump if you want, Tony was saying, who do you think cares? And you know, he said, you might just have to do it because you've talked yourself into it. It was at that point that Zack said, "I feel it." Hitting his stomach. "I feel it. You know the 'nothing that is not there and the nothing that is'? Well, this is the nothing that fucking is, baby." I thought later that there was something like sexual tension between them, and at that moment I thought that Zack really might jump and that Tony was clearly trying to cut off his avenues of escape, but

the truth is I was so besotted with literature at the time that I remember mainly being impressed that someone could quote Wallace Stevens at a moment like that.

As it happened, Zack did not jump. The bride, Agnes, came into the room after Zack had climbed out the window and onto the balcony, and she began talking to him and then suggested we all leave, which we did, and after a while they came downstairs together and danced to her father's orchestra. If I were Nabokov, I could leave them dancing to "Did You Ever See a Dream Walking?" which I have recently read was one of Wallace Stevens's favorite songs and was the kind of song Agnes's father was apt to play, but I'm not and I have some sense of shame. As for the nothing that is, I was soon enough in graduate school, where the discussion of the poem focused on whether or not it was in favor of the pathetic fallacy, which was another matter, and not long after that I had begun to read around in Buddhism and to see that there were other ways of thinking about the void and that what I loved in the cleanness of the writing of that poem might be connected to those other ways. And some time in that period I came to see that "the nothing that is" was connected to the way the adjectives in "Sea Surface Full of Clouds" played over the nouns, the way that it seemed the quality of things, their accidents, as someone might say who had been dipped in Aristotle, but not their essence, could be known. And I suppose I must have connected that floating thought to the comedy of "The Emperor of Ice-Cream," though I don't exactly remember doing so.

When I was an undergraduate, poetry was much more for me a matter of poems than of poets. But in graduate school I began to acquire some sense of Wallace Stevens. I was never very interested in the Keatsian side of his writing, the wedding-cake baroque of "The Comedian as the Letter C." What I loved in him was the clarity. I wasn't against the other so much as I just didn't take it in, and I certainly didn't understand the issues implicit in the two sides of his style. I knew a few poems, and almost as soon as I began to acquire an attitude toward Stevens, various things intervened to qualify my first hypnotic attraction to him. A couple of things that can stand for this change are the civil rights movement and my discovery in my senior year of the essays of James Baldwin, and through him the essays of Albert Camus, which began to awaken a different political and moral sense in me. And also the assassination of John Kennedy in 1963 and the ensuing

escalation of the war in Vietnam. I heard the news of Kennedy's assassination one day in the fall of my first year of graduate study. I was in a lecture course on poetry given by Yvor Winters when I heard the news. By then I had some idea of who Stevens was and I had read Winters's essay that, though it's clear Winters thought Stevens was a great poet, nevertheless indicts him for a kind of trivial hedonism at the core of his thought. I was disposed to argue with every word Winters spoke, and I thought he was wrong about Stevens, but not entirely wrong. For different reasons than Winters, of course. The country we were growing up into, its racism, the violence it was unleashing in Asia, what seemed in those early years the absolute acquiescence of our elders in that violence, changed the tenor of my thinking about literature and made Wallace Stevens seem much less attractive as a model.

Arguments about him raged in my group of friends. We knew by then that Stevens had been an executive of the Hartford Insurance Company, that he was making good money during the Depression and lived well. One of my closest friends among the graduate students was Jiri Wyatt and he was particularly skeptical of Stevens. Jiri had spent his early childhood hidden with his Jewish parents from the Nazis in the attic of a Slovakian farmhouse. He was much more politically sophisticated than the rest of us, and he was very funny and very bright. I remember specifically arguing with him. I was inclined to take Stevens's side. Jiri had gone to school in Boston. He could be scathing on the subject of what he called Harvard aestheticism, a new category to me, and enraged by the idea of a whole generation of English professors and graduate students fawning over the novels of Virginia Woolf and Henry James and the poems of T. S. Eliot as a cover for indulging their fantasies of belonging to a social class that answered to their aesthetic refinement. "They're cripples," he'd say. "Laughable. I mean, my God, look at this century." At Tressider Union under the oak trees in the spring sun. The war was escalating rapidly. We were all listening to Bob Dylan and the Beatles. "But Stevens's subject," I'd argue, "is epistemology." And Jiri, I think it was Jiri, impatiently: "Oh, come on. At some point epistemology is a bourgeois defense against actually knowing anything."

We did know, or had heard, that Stevens had written a letter to a friend who was buying tea for him in Ceylon in which he said that he didn't care what kind of tea his friend sent on as long as it couldn't

be had in the United States, and I took that story to be, classically, an emblem of our relation to South Asia and thought that its attitude was connected to what I had learned from Winters and Jiri to think of as Stevens's Harvard-aesthete 1910 dandyism, not morally repellent especially because it was so unconscious and so much of its time, but unsatisfactory, not useful. I also knew—it was widely quoted among us—Stevens's reaction to Mussolini's invasion of Ethiopia: that if the coons had taken it from the monkeys, the Italians might as well take it from the coons. Which seemed an equally predictable provincial blindness, but less forgivable. I also knew—or sensed; it hadn't quite happened yet—that Stevens was in the process of becoming what I think he was not then thought to be, one of the central modern poets.

It was in this context that I began to replay in my mind the lines from "The Emperor of Ice-Cream." The first thing that struck me was their lordliness, that part of our pleasure in chanting it several years before had been its imperiousness. Call the roller of big cigars—no doubt a Cuban or a Puerto Rican, I thought at the time, though in New York and Connecticut rolling cigars, I've learned since, was mostly a Jewish trade—and set him to work in the kitchen, where in some fantasy out of Henry James or Charles Laughton's Henry VIII "wenches" were employed. In 1964—my students didn't quite believe this—white men of the older generation in the United States still commonly called the black men who worked in airports handling luggage "boy." I listened again to the line that commanded "boys to bring flowers in last month's newspapers." And while I was at it, I noticed that "last month's newspapers" was a metaphor for history, one I feel the sweetness of now. Who cares about history? Let the boys use it to wrap flowers in when they come courting. But at the time—or was it at that age? I was twenty-two, Stevens was forty-three, twice my age, when he wrote the poem—taking history seriously seemed a central task of poetry.

When I tried myself to write poems about history and politics, I had in mind writing a poem about the California landscape and the U.S. seizure of California after the Mexican-American War and about the Dow Chemical plant in the southern part of San Francisco Bay that was manufacturing napalm for the Asian war. And I thought vaguely that I would focus that poem on the person of a woman, the daughter of the first harbormaster of Yerba Buena, as San Francisco was called in the 1840s. Her fiancé had been murdered by Kit Carson in the skirmishes

that occurred when the old Californian families resisted the U.S. expeditionary force. It was a way of writing about the violence in American history and when I sat down to the poem, which is published in my first book, *Field Guide,* and is called "Palo Alto: The Marshes," the first line I wrote was "She dreamed along the beaches of this coast." It was a couple of days before it occurred to me that I had lifted and transposed the first line of "The Idea of Order at Key West," and when I did, I remembered that the name of the fiancé whom Kit Carson killed was Ramon, and it gave me a place for writing the poem. My consciousness of Stevens's poem fell away as I worked, but its starting point is an instance of how polemical my relation to him felt to me in those years. He felt to me like he needed to be resisted, as if he were a luxury, like ice cream, that was not to be indulged in.

Years later though, when I looked at "The Emperor of Ice-Cream" again, I felt much more forgiving of the tone of the poem. I said to myself, this isn't Babbitt fantasying himself a houseful of servants in Hartford, it is Prospero speaking to his daughter, and speaking in the subjunctive at that. But saying this, one also had to say that in Shakespeare and throughout English literature, royalty expressed as power over others is a central figure for the power of imagination. And somewhere in those years it occurred to me finally that the poem is about death, which I thought made it a more wonderful and darker joke than I had understood. And at some still later stage, I think it must have been after reading Helen Vendler on the use of the subjunctive in Stevens, but also after I had had enough experience of failure and disappointment in my own life to get it, I felt the pathos of the wishing in the poem and of the grammar that expresses that pathos, so that by the time I was the age of Stevens when he wrote the poem, the three words "let be be . . ." struck me as a brilliant and sad figure for the fundamental human wish that seems so often impossible for us and that Stevens had taken for one of his central themes.

And on another occasion—I can remember the shower in which the thought occurred to me, aquamarine tile, the house of a lover, thinking about what I then conceived to be the sadness of the poem—I was wondering about its fundamental gaiety and how it was achieved, and I thought about that delicious phrase that transforms itself from assonance into alliteration, "and bid him whip in kitchen cups concupiscent curds."

It lets you know that, at least in language, magic can happen. It struck me suddenly that "bid him whip in kit/chen cups" contained the longest sequence (five in a row) of consecutively assonantal syllables I could think of in a poem. Toweling off, I must have been mumbling the lines to myself. "What are you thinking about?" she asked. She was wearing a pale, sea-green towel. "I was thinking: Bid him whip in kitchen cups concupiscent curds." "Concupiscent what?" she asked. "Curds," I said, looking her in the eye, trying out an imitation of W. C. Fields, "concupiscent curds."

As I was rereading the poem in the last few weeks, thinking about writing about it, I made another discovery. I decided that the crucial thing about it in the end is the rhythm of the first six lines of the second stanza that I had neglected to take in twenty-five years ago when I was not very interested in hearing about death:

Take from the dresser of deal
Lacking the three glass knobs, that sheet
On which she embroidered fantails once
And spread it so as to cover her face.
If her horny feet protrude, they come
To show how cold she is, and dumb.

This is as pitiless as any verse in Stevens, I think. That enjambment at the end of the fifth line and the stutter of a stop in the sixth delivers the last two syllables as baldly as anyone could contrive, and the rhyme—bum, bum—could not be more hollow. It is writing that returns the word *mordant* to its etymological root. And though I still think it is funny, it seems to me now to be, and to be intended to be, point-blank and very dark. And there are other things to notice. I think my disgust with the class-ridden drollery of the first stanza was not altogether misplaced, but it is certainly undercut by that shabby or melancholy or funny, in any case accurate, domestic touch—the glass knobs missing from the deal dresser. Deal is plain pine or fir, a middle-class dresser, spiffed up a bit with glass. And there is a kind of memento mori in the peacock tail that had been—"once," he writes to suggest the pathos of all our efforts at décor—embroidered on the sheet. And there is also something plain-dealing and very like Robert Frost in the diction—"so as to cover"; and if her horny feet protrude,

"they come / to show . . ." Every detail of the writing is meant to make this death as homely and actual as . . . what? Not Guatemala certainly. As any death in Emily Dickinson.

The second-to-last line of the poem—"Let the lamp affix its beam"— was for a while the only line in the poem that I thought was pure padding. He needed a rhyme for "cream" and a final flourish, hence a spotlight, hence "beam" and the otherwise meaningless lamp. But once you sense how dark, mordant, sardonic, pitiless a reading this poem can sustain, the lamp becomes an interesting figure for the focus of consciousness. It would seem that the beam is affixed on the stage where the final, now supremely ambiguous refrain is going to occur: "The only emperor . . ." One paraphrase might be: turn your attention to living, seize the day. If it says that, it also says: by all means turn your attention away from those horny toes. A sort of memento non mori. Or to borrow a phrase from Eliot, humankind cannot bear very much reality. It is also possible to read it to mean the opposite, that one should affix the beam on the horny toes, so that one understands from a clear look at the reality of death that there can be no emperor but ice cream, no real alternative to death but dessert while you can get it. Which is, I suppose, nearer to my first reading of the poem and to what Winters meant by Stevens's hedonism. I think the issue may be undecidable, finally, since both readings are grammatically permissible and both in their way in character.

Perhaps the point lies in the poem's seeming poised on the knife edge between these two attitudes. But however one reads these penultimate lines, they carry their darkness into that last line. Which makes for a very different poem from the one those college boys thought they were chanting thirty years ago as they waded through wet hillside grass in the early spring and brings it nearer to the nothingness of which Zack had spoken, Zack whom I see now and then on late-night TV playing a psychotic killer or a gaunt, hunted drug dealer in reruns of *Hill Street Blues* or *Cagney and Lacey*.

It may not be completely accidental that while I was puzzling over the ending of "The Emperor of Ice-Cream," a photograph appeared in the newspaper of a pair of stolid Dutch workmen removing a statue of Mikhail Gorbachev, who was briefly and quite literally an emperor, from its stand and carrying it from Madame Tussauds wax museum in Amsterdam, rigidly horizontal, immobilized in a gesture of seigneurial self-assurance. It made me think also that the poem, if it has anything to

say about political power, does so by talking about politics and pleasure and death. And it may not be wrong, in its merciless way, about where power usually resides in the world.

I imagine I am not through thinking about this poem or about "Sunday Morning" or "The Snowman" or "Thirteen Ways of Looking at a Blackbird" or "The Idea of Order at Key West" or "Of Mere Being" or "The World as Meditation," which are other poems I have been brooding over and arguing with myself about for much of my adult life. But I heard it early and I've lived with it for some time and thought that it would serve for one image of the way poems happen in a life when they are lived with, rather than systematically studied. Or alternately studied and lived with, and in that way endlessly reconceived—which seems to have been Wallace Stevens's basic notion of the relation of the imagination to the world.

1985

chekhov's anger

In his journals Chekhov notes two reasons why he doesn't like a lawyer of his acquaintance. One is that he is very stupid; the other is that he is a reptile.

I mention this because Chekhov has a reputation for compassion and stabbing pathos in his stories and for wistful poetry in his plays. But he was a much more various writer than that, much funnier and tougher and more derisive. He began his career writing short pieces for the comic newspapers and magazines that flourished in Russia in the 1880s. His grandfather (this part of the story is well known) was a serf who bought his freedom and became the bailiff of a large estate— and a rabid advocate of serfdom. His father, who was a pious man and a bully, ran a grocery store in the Black Sea port town of Taganrog in southern Russia. Chekhov was the third of six children. When his father went bankrupt in 1876—Anton was sixteen—the family moved to Moscow, leaving Anton behind to finish high school. He joined the family in 1879 and began medical studies at the university. To help out the family, he began sending jokes and short pieces to the magazines. Nine of them were accepted in 1880, at about two and a half cents a line, thirteen in 1881, and then more. In 1882 he moved from the Moscow to the Petersburg papers; in 1883 he published a hundred and twenty-nine pieces, stories, sketches, jokes, for various magazines. He wrote them at the kitchen table, after he had finished his studies, and the stories and gags began to support the family. Between 1880 and 1884, when he graduated from medical school, he wrote over three hundred pieces. They were all published under a pseudonym, and he claimed not to have taken them very seriously.

In the summer of 1885, age twenty-five, a doctor of medicine and a successful freelance writer, he could afford to take his family to the

country for the summer, and there he met one of the most important people of his life, the Petersburg publisher Alexi Suvorin, founder and editor of the largest daily of the period, *New Times.* Writing for *New Times* meant, first of all, that there was no length limit on Chekhov's stories for the first time; secondly, that he was paid enough so that he did not have to produce quite so many; and thirdly, that he had the attention of the largest audience in Russia. It was still not literature—it was, as one writer has said, the "backstairs of journalism"—and he still wrote under a pseudonym. But his work—whether it was aimed at the popular audience rather than the intelligentsia or not—was an immense success. By 1886 he could write to his brother Alexander about a trip to Petersburg, "I'm the latest thing."

The Chekhov who appears in those very early stories is not the author of sad, dove-gray fictions. One early story describes sailors who have drawn lots to see who gets a peek through a porthole to watch a pair of passengers, a minister and his young wife, consummate their marriage. A father and son, as it happens, win, which all the sailors seem to feel is a nice familial touch. They are greeted on first peek by the affecting sight of the wife turned away from her husband and seeming to be shaking her head in shy virginal refusal, a gesture all the sailors—who crowd around to hear a report—find piquant. Eventually the virgin seems to relent, and her husband looks relieved and happy, opens the door, takes a large stack of rubles from a banker who is also on the ship, and leaves the room, closing the door behind him. At which point the father pulls the son away from the perch, telling him that there are some things a young man, for the sake of a sound moral upbringing, just shouldn't be exposed to.

In another story, a petty official at a party overhears his wife making an assignation with his best friend. Electrified by this event, wakened from his usual daydreams about promotion and immense feasts of sturgeon to even more delicious fantasies of revenge, he conceives a plot. The wife and friend intend to meet by a large urn in a public park, where his wife will have a servant leave a message if she can't make it. The husband writes an anonymous letter to the town's largest and most ruthless merchant, threatening to expose his business practices if he does not leave five thousand rubles in the urn in the park by three o'clock the next day. He sends another note to his friend telling him to check the urn at that hour for a message from the wife, and then positions him-

self behind a bush to watch the cad, caught with his hand in the urn, be beaten or arrested or both. As it falls out, the rival arrives at three sharp, reaches into the urn, pulls out an envelope, looks inside, finds five thousand rubles, looks around, shrugs, smiles, pockets the money just as the wife arrives for their tryst, and the pair go off together.

I suppose these stories are the equivalent of newspaper cartoons. They call for a quick, cynical laugh. Chekhov got very adept at writing them, and he must have learned a lot about condensing his material, since some of the papers paid more for short effective pieces than for longer ones. Later he was always advising young writers to cross out, even Maxim Gorky, and especially—here is a bit of Chekhov's letter to Gorky—"to cross out as many adjectives and adverbs as you can. You have so many modifiers that the reader has trouble understanding and gets worn out. It is comprehensible when I write: 'The man sat on the grass,' because it is clear and does not detain one's attention. On the other hand, it is difficult to figure out and hard on the brain if I write: 'The tall, narrow-chested man of medium height and with a red beard sat down on the green grass that had already been trampled down by the pedestrians, sat down silently, looking around timidly and fearfully.' The brain can't grasp all of that at once, and art must be grasped at once, instantaneously." His favorite sentence in the Russian language, he said, was one written by a classmate of his in grammar school. It went: "The sea is large."

The cynicism of these early stories is rough and ready; it makes no show of brooding disenchantment with human nature because it seems not to think all that much about human nature in the first place. Nevertheless, what lies behind it is a certain toughness of mind, which is a theme I will return to. What's most interesting about these casual and satirical stories is that they have almost exactly the same structure as the brilliantly quiet and affecting stories that would, especially among non-Russian readers, form the basis of his reputation.

"Vanka," for example, is the story of a nine-year-old boy who has recently left the country and been apprenticed to a shoemaker by whose family he is beaten and abused. It is Christmas Eve and the lad writes a letter to his grandfather that begins: "Dear Grandad Konstantin Makarich, I am writing to you a letter. I send you Christmas greetings and hope God will send you his blessings. I have no father and no Momma and you are all I have left." Chekhov lets us watch the boy write the let-

ter. His master and mistress are at church. The boy remembers the animals, the servant girls at home; he describes his mistreatment—which is heartbreaking—and he implores his grandfather to come and save him. Do you know the story? Then you will recall the end of it: "Vanka folded the sheet of paper in four and put it into the envelope which he had bought that day for a kopek ... Then he paused to think, dipped his pen into the inkpot, wrote: 'GRANDAD,' scratched his head, thought again and wrote: 'KONSTANTIN MAKARICH IN THE VILLAGE,' " after which he slips out and puts the letter in the mail.

Or "Sleepy." In this one a thirteen-year-old girl, Varka, is tending a baby who cries and cries, will not stop crying. Varka is sleepy, fades in and out of dreams, is slapped and scolded by master and mistress, runs errands, tends the child that cries and cries. At the end of the story, to get a little sleep, Varka solves her problem. She reaches into the cradle, strangles the baby, and lies down on the floor, where she is "in a minute sleeping soundly as the dead." Or "Misery," the story of the Moscow cabman who on a snowy night tries to tell one customer after another that he is grieving because his only son died the week before. "He wants to talk of it properly," Chekhov writes, "with deliberation. ... He wants to tell how his son was taken ill, how he suffered, what he said before he died, how he died. . . . He wants to describe the funeral, and how he went to the hospital to get his son's clothes." No one listens. At the end of the story, the old man can't sleep, so he goes outside and tells the story to the horse. "Suppose you had a colt," he says—it is dark, the middle of the night, the horse is quietly eating oats in its stall— "and you were own mother to that little colt . . . and all at once that little colt went and died . . ."

No one would describe these stories as funny, but they have the same structure as the funny stories. They depend on a surprise ending, usually though not always on dramatic reversal, and the surprise is in one way or another wounding. No one would be inclined to laugh at "Vanka"; it is, as the critic Victor Shklovsky has said, "the saddest Christmas story ever written." And yet I almost laugh. That gasp that the story evokes, the little cry of surprise and dismay, comes out not just because the ending surprises, but because it fits. Of course, we think, how is a little peasant boy supposed to know about addresses and the postal system? It's a miracle that he can write at all. The rightness of the surprise (which might be a definition of metaphor) constitutes

wit. And this is what makes the stories remarkable, I think: not that they are full of pathos—the nineteenth century in Russia teemed with pathos, it was knee-deep in pathos. It is the more terrible presence of wit that gives the stories a feeling not merely of pathos but of tragedy.

Metaphor: I am leaving aside the fact that each of these stories is in a way a figure for the situation of the writer. Everyone who mails off a poem or story addresses it more or less as Vanka addresses it, or is telling their grief to a tired horse in the middle of the night. "Sleepy" is a more disturbing metaphor. Killing the baby: it speaks to the writer's relation both to the reader and to herself or himself. Dickens, for example, picks up the baby and rocks it gently back to sleep and then has it die slowly of cholera in a storm of tears. To the crying infant in each of us who demands immediate succor (so to speak) from the story, Chekhov's response is, on the whole, aggressive. And this aspect of his art was something Chekhov recognized quite clearly. When he was writing *Ivanov* in 1886, he described his technique in a letter to his brother: "I finish every act as I do my stories; I keep the action calm and quiet till the end, then I punch the audience in the face."

Where does the violence of this image come from? I think it has two sources. The first is the violence his father visited on him. "My father," he wrote, "began my education, or, to put it more simply, began to beat me, before I reached the age of five." He could be understanding, even wryly comic, about his treatment. "Our grandfather was beaten by his masters and the lowest official could knock him about. Our father was beaten by our grandfather, and we, by our father. What nerves, what blood we have inherited." But he never forgot it. In his late thirties, immensely successful, his father dead, Chekhov remarked to his friend V. I. Nemirovich-Danchenko, the manager of the Moscow Art Theater, "You know, I have never been able to forgive him for whipping me."

The second source is the violence he visits on himself. That emerges, one imagines, from his anger at his father. The most famous formulation of this is in the letter to his friend and editor Suvorin in January 1889:

> The plebeian intellectuals have to purchase with their youth what the aristocratic writers receive gratis from Mother Nature. Why don't you write a story about a young man whose father was a serf, a young man who was in turn salesman, choir-boy, school-boy and student, brought

up to treat rank with respect, to kiss the hands of priests, to worship other men's ideas, to express gratitude for every bit of bread he eats, constantly flogged, going about giving lessons in worn boots, fighting with other boys, torturing animals, fond of dining with rich relatives, acting the hypocrite before God and man for no other reason than consciousness of his own insignificance—describe how this young man squeezed the slave in him out of his system drop by drop, till one fine morning he wakes up and discovers there is no more slavish blood coursing through his veins; it is all real human blood.

Writing stories and getting paid for it—quick, mocking satiric stories full of the period's comic types: bullying officials, bullying policemen, obsequious clerks, hicks—and in the process replacing his father (not only as breadwinner but as the moral center of the family), was one of the ways he squeezed the slave out of himself. "Anton's will became the dominant one," his brother Michael remembered. " 'That's not true,' he would say, 'We must be fair,' 'Don't tell lies,' and so on." It was a large, young, and talented family, and early visitors to it were impressed by the hilarity and warmth of the Chekhov clan, but at the center of it was Anton's furious self-discipline. "To educate oneself," he wrote to his brother Nicholas, "requires ceaseless, unremitting work, night and day. Every hour counts." It is worth noting this flint in his character at least partly because of his (well-deserved) reputation for gentleness, modesty, and almost saintly compassion. There is at the root of his art a good deal of comic malice: malice at his characters, but also malice at his audience. It would be easy to misstate this, or to emphasize it wrongly, but it explains to me things about Chekhov's art that the usual accounts of his tremendous human attractiveness—"Isn't he adorable," the ancient Tolstoy is supposed to have said to Gorky once, when Chekhov had left the table for a moment—simply don't account for. That there is hardly ever a false note in Chekhov, that he almost never sentimentalizes or leans too hard on a character, that he lets no one off the hook, that his refusal to give the audience what it wanted in the way of wish fulfillment was so extreme that it amounted to reinventing the forms of both the tale and the stage drama, required of him immense toughness and moreover a willingness to hurt, both in the raucous manner of comedy and in the more stubborn, disciplined, even inwardly cruel manner of cool refusal.

As a psychological fact this stance of Chekhov's becomes, in his art and in his thinking about politics, increasingly complex, but at the beginning it is pure advantage. Look, for example, at "The Malefactor," an 1885 story about a peasant who has been hauled into court. It begins with a wonderfully Chekhovian sentence: "An exceedingly lean little peasant, in a striped hempen shirt and patched drawers, stands facing the investigating magistrate." Or perhaps I should say, a Constance Garnett sentence. I have vividly in mind Denise Levertov's poem "Chekhov on the West Heath," in which she describes herself as a young girl, best friend to Constance Garnett's daughter, with whom she walked around Hampstead in the early years of World War II discussing the stories and vowing to live a life Chekhov would approve of. But that is another story, as is the story of how Chekhov came to be translated into the prose of the Bloomsbury group, with its echoes of Forster and Woolf, in 1921. This story takes place in 1885, where a skinny little peasant, sullen, barefooted, morose, is in trouble:

> "Denis Grigoryev!" the magistrate begins. "Come nearer, and answer my questions. On the seventh of July the railway watchman, Ivan Semyonovitch Akinfov, going along the line in the morning, found you at the hundred-and-forty-first mile engaged in unscrewing a nut by which the rails are made fast to the sleepers. Here it is, the nut! . . . With the aforesaid nut he detained you. Is that so?"
>
> "Wha-at?"
>
> "Was this all as Akinfov states?"
>
> "To be sure, it was."
>
> "Very good; well, what were you unscrewing the nut for?"
>
> "What-at?"
>
> "Drop that 'wha-at' and answer the question; what were you unscrewing the nut for?"
>
> "If I hadn't wanted it I shouldn't have unscrewed it," croaks Denis, looking at the ceiling.
>
> "What did you want that nut for?"
>
> "The nut? We make weights out of those nuts for our lines."
>
> "Who is 'we'?"
>
> "We, people . . . The Klimovo peasant, that is."

"Listen, my man; don't play the idiot to me, but speak sensibly. It's no use telling lies here about weights!"

Perhaps the first thing you notice about the story is that it is not *Les Misérables*. I don't know anything about the conventions of these comic papers in the 1880s—whether, for example, the comically stupid peasant was a stock type in the popular press at the same time that he was being endowed with a special and deeply Russian wisdom by the highbrow novelists—but the brilliance of this writing is in the evenhandedness of it. It rises to neither bait. Denis Grigoryev is not some Russian version of Stepin Fetchit, nor is he a figure of pathos out of reformist melodrama. Chekhov is careful, as the story unfolds, to underline the dangerousness of his plundering:

"And what do you suppose railway accidents do come from? Unscrew two or three nuts and you have an accident."

Denis grins, and screws up his eye at the magistrate incredulously.

"Why! How many years have we all in the village been unscrewing nuts, and the Lord has been merciful; and you talk of accidents, killing people. If I had carried away a rail or put a log across the line, say, then maybe it might have upset the train, but . . . pouf! a nut!"

And this, it turns out, is hardly the tip of the iceberg:

"I didn't unscrew it; Ignashka, the son of one-eyed Semyon, gave it me. I mean the one which was under the box, but the one which was in the sledge in the yard Mitrofan and I unscrewed together."

"What Mitrofan?"

"Mitrofan Petrov . . . Haven't you heard of him? He makes nets in our village and sells them to the gentry. He needs a lot of those nuts. Reckon a matter of ten for each net."

"Listen. Article 1081 of the Penal Code lays down that every willful damage of the railway line committed when it can expose the traffic on that line to danger, and the guilty party knows that an accident must be caused by it . . . (Do you understand? Knows! And you could not help knowing what this unscrewing would lead to . . .) is liable to penal servitude."

"Of course, you know best . . . We are ignorant people . . . What do we understand?"

One of the things that Chekhov gets here, wonderfully and terribly, is exactly the moment when Denis retreats into his ignorance as a defense against knowing what he doesn't want to know. It is that reflex, "Well, we're ignorant people, what do we know," with its combination of imbecility and cunning, that makes the story so funny (the magistrate and his class have clearly created the monster that is derailing their trains)—and finally so heartbreaking—because Denis's ignorance, however cunning, is well and deeply learned. He really doesn't have a clue, as Chekhov makes clear at the end of the story when he is dragged off to be sent into exile without the faintest idea what has happened to him or why. "Flog if you like, but flog someone who deserves it, flog with conscience," he says as they pack him off. The laugh one laughs—at the peasant's sense of wounded justice, at the depth of his identification with authority (when their father was through whipping the Chekhov boys, he required them to kiss his hand), at the hopelessness of the whole situation—is something between amusement and despair. It reminds one of the story of the execution of the conspirators who attempted the assassination of Czar Alexander II in 1866. It occurred, apparently, on a rainy day, which made the rope so slick that it would not slide down properly and break the necks of the prisoners. The last of the assassins to be executed, after watching his friends being semi-strangulated by earnest hangmen who stood around talking about the problem like teamsters in the yard of an inn conferring on the axle of a broken cart, is said to have burst into tears finally and said, "Poor Russia, she can't even kill us."

"The Malefactor" reminds us of a crucial fact about Chekhov and his art. Nineteenth-century Russia was, to use an anachronism by way of shorthand, a third-world country. And it was, at the time the story was written, only thirty-five years away from a revolution brought about not so much by the organizational or military brilliance of the revolutionaries as by the sheer political and administrative collapse of a government incompetent almost beyond belief. The decade of the 1880s, during the early years in the reign of Alexander III when Chekhov was beginning to write, was a particularly repressive time. Most of the reforms of the 1860s were nullified, the secret police were turned

loose, the Russification of Jews became government policy, censorship was strict, famine not infrequent. The slogans of the new government were "Nationalism," "Orthodoxy," and "Autocracy." Among the intelligentsia, a populist or Narodnik movement—or several of them—was under way, based on the idea that all social reform had to begin with the peasantry (who constituted something like 80 percent of the population); and this movement was also informed in one way or another by the feeling that the life of the peasants, close to the Russian soil, was the repository of a wisdom that would show the way to a better future. And, as you can imagine, many of Chekhov's readers among the intelligentsia were skeptical of him and of stories like "The Malefactor." It seemed not to take a position, and they wanted to know where Chekhov stood.

It did not help matters that when he moved from the Moscow to the Petersburg newspapers, he was associated primarily with Suvorin's *New Times,* which was the most successful and the most rabidly reactionary newspaper of its day. Suvorin, the editor, was very well connected in government circles: he had even wrangled from the government an exclusive contract for the book and newspaper kiosks in railway stations, which no doubt accounted in part at least for the wide circulation of his newspaper. Chekhov and Suvorin became close friends. Like Chekhov, Suvorin was self-taught. He was also very worldly and deeply cynical, and he had a quick, brilliant, contemptuous intelligence. As Chekhov's fame spread, so did rumors about his relationship with Suvorin. He was going to marry his publisher's daughter, one rumor went, as the price of being featured in his paper.

I am paraphrasing Chekhov's biographers—Henri Troyat, Sophie Laffitte, Vladimir Yermilov, Simon Karlinsky. It is hard to read from this distance the nuances of that world. What interests me about it in terms of the development of Chekhov's art is his attraction to another self-made writer and practical businessman, and the fact that his coolly apolitical style (and his distrust, verging on contempt, for the political style of most of the Russian intelligentsia—privileged, self-flattering, lazy, ineffectual, as they appeared in story after story), along with his passion to record things as he saw them, permitted him to make an alliance with the most conservative intellectual force in his era.

Chekhov's situation reminds me in many ways of the work of V. S. Naipaul, who may turn out to be the most interesting political writer of the 1980s in some of the same ways that Chekhov is interesting, other

considerations of his art aside, as a writer about Russia in the 1880s. Naipaul was born into an Indian family, piously Hindu, on Trinidad. A member of the minority culture on a small island where the majority was a minority in the larger world, and where both minorities, Indian and black, suffered all the humiliations of colonialism and provincial isolation, Naipaul passed—brilliantly, one supposes—through the colonial school system; left the Caribbean for Oxford; published his first novel, *The Mystic Masseur*, shortly after his graduation; and since then, as the biographical notes on the back of the books of this self-made man always say, "has pursued no other profession." What Naipaul has in common with Chekhov is his oblique relation to the majority culture, his instinctive and deep contempt for all forms of fanaticism and self-delusion (this derives partly from childhood boredom with Hindu ritual, as Chekhov's derives from his revulsion at his father's bullying piety), and his ironic awareness of how deeply privileged is the desire on the part of the comfortable, more or less honest, more or less responsible middle-class artists and intellectuals of the developed world to be identified with the oppressed and the forces of human liberation.

Czeslaw Milosz has remarked that one of the main characteristics of postwar literature is that, as the manufacturing economy has been exported to the peripheries where labor is cheap and where the problems of imperialism and colonialism are being worked out—that is, in Asia and the Middle East and Central America and Eastern Europe—so the literary peripheries have become the center; hence the importance of poets like Zbigniew Herbert, Pablo Neruda, Seamus Heaney, and Bei Dao, and of fiction writers like John Coetzee and Milan Kundera and Salman Rushdie and Naipaul. The novelists in particular occupy a position at the fringes of the culture that mainly reads them—in something like the way that Chekhov, the serf's son, was a vertical invader of the landlord literature of Gogol and Turgenev and Tolstoy.

I don't mean to pause too long over this comparison, but it is worth noting that Naipaul, in a recent autobiographical sketch in *Finding the Center*, speaks of the fact that his colonial upbringing probably accounts for the anger that he acknowledges as the wellspring of his art. Naipaul's work has the power to make us uncomfortable in ways that Chekhov's readers must have been made uncomfortable by him. I think, for example, of a passage in *A Bend in the River*, whose protagonist and narrator, an African-born Indian from an East African Hindu

merchant family, has come to run a store in the capital of a newly inde-
pendent Central African nation. The novel is full of scenes that look at
all the political posturing of nationhood in postcolonial, preindustrial
societies with a kind of rue and uneasy apprehension of violence that is
brilliantly rendered. Then suddenly, in the middle of the anxiety and
the tropical heat that feels like a metaphor for the anxiety, the narrator
finds himself at a party in the university where a bunch of Western
intellectuals—graduate students, research scholars, economic devel-
opment advisers—are smoking dope, drinking wine, and listening to
something he has not heard before, an American folksinger named
Joan Baez:

> And the mood became sweeter. The music that was being played came
> to an end, and in the wonderfully lit room, blurred circles of light
> thrown onto the ceiling from the lamps on the floor, people stopped
> dancing. What next came on went straight to my heart—sad guitars,
> words, a song, an American girl singing "Barbara Allen."
>
> That voice! It needed no music; it hardly needed words. By itself it
> created the line of the melody; by itself it created a whole world of feel-
> ing. It is what people of our background look for in music and singing:
> feeling. It is what makes us shout "Wa-wa! Bravo!" and throw bank
> notes and gold at the feet of a singer. Listening to that voice, I felt the
> deepest part of myself awakening, the part that knew loss, homesick-
> ness, grief, and longed for love. And in that voice was the promise of a
> flowering for everyone who listened.
>
> I said to Indar, "Who is the singer?"
>
> He said, "Joan Baez. She's very famous in the States."
>
> "And a millionaire," Yvette said . . .
>
> I gave the book back to Indar, looked away from Yvette and
> him, and returned to the voice. Not all the songs were like "Barbara
> Allen." Some were modern, about war and injustice and oppression
> and nuclear destruction. But always in between there were the older,
> sweeter melodies. These were the ones I waited for, but in the end
> the voice linked the two kinds of song, linked the maidens and lovers
> and sad deaths of by-gone times with the people of today who were
> oppressed and about to die.
>
> It was make believe—I never doubted that. You couldn't listen to
> sweet songs about injustice unless you expected justice and received it

much of the time. You couldn't sing songs about the end of the world unless—like the other people in that room, so beautiful with such simple things: African mats on the floor and African hangings on the wall and spears and masks—you felt that the world was going on and you were safe in it. How easy it was, in that room, to make those assumptions!

It is hard to imagine that a white English or American writer could have written this scene, or would have written it in exactly this way, with exactly this mix of—I'm not sure what to call it—this attitude toward feeling: perhaps a hunger for the lyrical canceled by an intellectual distrust that comes from understanding always the view from the underside. It is this, I think, that makes for the resemblance between Naipaul's and Chekhov's art. Undercutting the lyrical is, one way or another, the satirist's technique. And Chekhov learned in his apprenticeship with the comic papers to do it very economically. What could not have been predicted was the way that he learned to intensify feeling and then undercut it. "The Kiss" is probably the best-known of the early examples of this. But it is even true of "Vanya" and "Sleepy." We identify, as readers, with the homesickness of one child and the exhaustion of another. We want rescue, sleep. And at the end they are snatched from us so quickly that it is, as Chekhov clearly saw, like being slapped in the face.

The opposite tactic can create the same effect, I should add. One can keep the surface cool and let the feeling element play underneath it. The power of "The Malefactor," for example, is hidden in the exactness of Denis Grigoryev's knowledge of the local fish. Chekhov himself was a passionate and, indeed, a scientific fisherman. It is the glimpse of the village that makes his being hauled off finally so terrible.

It comes to be, as you read through the stories, a formal principle of Chekhov's art: to divide the reader's wishes from his or her judgment, or to let that conflict develop in the characters themselves. One of my favorite stories—very funny and very sad—from the early period of Chekhov's maturity is "Neighbors." The situation is that a young landowner, a bachelor who lives in the country with his mother and his sister, finds that his sister has gone to live with a married neighbor. His mother has gone to bed because of the scandal, and he is very badly put out—because of the inconvenience, because he's going to miss his sister

terribly (a fact he's not quite ready to admit to himself), and because he had done his share of mouthing off about free love to demonstrate to himself and to the neighborhood that he is a liberal with a university education and not another vegetating Russian landlord buried in the country like a woodpile rotting in a forest. The sister, of course, is going to take the moral high road and declare her right to act from love, not prejudice and superstition; she's even, he reflects, likely to take that position with her own mother. "Female liberalism," our hero reflects sadly, "is intolerant, pitiless, and harsh." What's more, he thinks, his neighbor Vlasich is a jerk.

Hamlet-like squires of liberal tendency trying to gather the energy to act in the face of the immense and profound inertia of the Russian countryside were, if not a stock, a familiar type in Russian fiction, and it's not surprising that Peter Ivanshin, who likes nothing better than a good meal, an afternoon nap, and conversation about political ideals, is spurred to action. "Stormy emotions raged within him," Chekhov tells us. "He felt the urge to do something striking and impetuous, even if it meant regretting it for the rest of his life. Should he call Vlasich a blackguard, slap his face, challenge him to a duel?" Horsewhip him in his sister's presence and simply ride away? With the latter plan vaguely in mind, he sets off on a sultry, overcast afternoon for his neighbor's house.

Of course, he does nothing of the kind. Summary can't catch the bedraggled air of the two daring young sinners, who, three days after their defiance of convention, are already starting to feel that vague loneliness that overcomes people who have just done something that is supposed to solve all their problems. Vlasich's estate itself is antique and falling apart. It had belonged to a French count who, in the good old days when men were men, had had a student whipped to death in the drawing room for falling in love with the count's daughter, and then had his body chucked in the pond. The lovers tell Peter Ivanshin this legend as if it were a feature of the house that would compensate for the collapsed latticework on the porches and the neglected orchards. Peter Ivanshin sees that the pair are in love for the time being, that Vlasich is a decent, incompetent man who will never be able to buy his wife off with the seventy-five thousand rubles she requires, and that the relationship is an irrevocable mistake. He takes one look at the fear in his sister's eyes and promises to do everything he can to help. As he is about to leave, pity moves him and he goes farther. "I'll come and stay the

night with you sometimes," he says. And when he sees that this does not entirely allay what he now understands is her quite accurate and unconscious presentiment of disaster, he goes one step farther—which is, we see, one step too far. He leans toward his sister, touches her shoulder, and says, "You're quite right, Zina, you've done the right thing."

The reader is left to sort out the tragicomedy of the word "right." Over against the conservative morality by which she had done the wrong thing, the sister had indeed—by the liberal persuasion she shared with her brother, who had abandoned it with a sneer when he rode toward them like a character in Pushkin planning to wield a whip or fight a duel—done the right thing. But that right thing was probably, in terms of the sister's happiness, the wrong thing.

The moments of genius in Chekhov, the moments when you catch him in the act of being a great writer, are all in small details (like the moments in "Lady with a Lapdog" when Anna, asked what her husband does, says, "I don't know exactly what he does, but I know he's a flunkey"). One of the great moments in "Neighbors" occurs when Peter parts from Vlasich and Zina. "Riding into darkness, he looked back and saw Vlasich and Zina walking home along the path—he with long strides, she at his side with quick, jerky steps. They were conducting an animated conversation." Peter's loneliness is in that last sentence, and so is the splendid and perfect blindness of the lovers, who will get immense mileage, maybe even years, from conversation about their situation, followed by conversation about how they used to have conversation about their situation, followed by—what? Misery, some happiness, children perhaps, the final collapse of the porch, acrimony, bickering, recrimination, thickened waists, life.

In this mood Peter, at the end of the story, stares into the count's pond, where the student's body had supposedly been thrown. He despises himself for his weakness. "All life," Chekhov says, "now seemed as dark as this pond with its reflection of the night sky and its tangled water weed." And it is at this moment of Peter's depression that the reader sees he is a very decent and intelligent human being. This is not the last story in which the reader will feel admiration for a character who dislikes himself. It is a form of the division between feeling and judgment to which Chekhov's stories so often bring us. Peter Ivanshin isn't exactly depressed that he didn't horsewhip Vlasich; he's depressed that he doesn't live in a world of lyrical clarity and brutality, where

such gestures are possible. Chekhov has seen to it that we recognize that wish and don't for a moment share it. But Peter is also depressed because if such a world were possible, he would not be heroic enough to live in it. He thinks he's a weakling. And that's the moment in which we especially like his kindness and trust his intelligence. He saw what the relationship would probably come to and did the best by his sister that he could. But we also see that sense in which he's right about himself. From softheartedness he told one lie: he told his sister what he didn't believe, that she was doing the right thing. It is a lie that half of us would tell, and the other half would not have told for reasons equally suspect. Thinking about this, about the young man's depression that he didn't whip his sister's boyfriend, which serves as a screen for having told a lie out of kindness, which was probably itself a screen for his love for his sister, is typical of the way that Chekhov's stories draw us so deeply into life, into the details of life that only storytelling can convey between people (in bars, restaurants, on long walks on Sunday, at kitchen tables, wherever lived life is talked, not theorized, about—that kind of life), that we feel hypnotically present at some source, at the way life really is. Victor Shklovsky has said that the form of Chekhov's stories is based not on emotional resolution but on cognition, that the stories end when the elements of the characters' situation have been presented to the reader, not when they have been resolved. This needs, I think, to be qualified. The stories end very often when the reader sees what is not seen by the characters and, partly by not being seen, defines them. It is this that makes us feel at the end ready both to let go and to be drawn further in.

Almost all of Chekhov's readers in the 1880s admired this fact of his art, but half of them, looking up from Peter Ivanshin brooding by the swamp, said, "Great, but where does Chekhov stand?" It was in 1889 in a liberal journal called *Russian Thought* that Chekhov was first attacked as a writer "without principles." His reply, then and later, that he was only interested in telling the truth, is widely known, and I don't need to quote it here. What is interesting about it, in terms of understanding his art, is to realize how overwhelmingly ideological Russian fiction was. Much of the thrust of deconstruction among contemporary critics is simply to demonstrate, as Roland Barthes did with respect to Balzac in *S/Z*, that all fiction is ideological; but to the extent that it was true in general, it was for various reasons—censorship among them—

especially true of Russian literature. A peasant in a story was not a peasant, he was the peasant problem. No character failed to represent a class or type, no situation escaped allegory. This was probably less true of the comic journals where Chekhov began—which, like television or the comics now, represented more-or-less pure and more-or-less unconscious ideology—than of the intellectual journals in which he published after 1888. There, in the tradition that included Gogol, Turgenev, Dostoyevsky, Goncharov, and Tolstoy, Russian fiction was about the problem of Russia and the Meaning of Life.

Not just mediocre work was loaded with this symbolic freight, but the greatest novels of the era; in fact, that symbolic habit of Russian fiction is no small part of its power. That it is Pierre, not Andre, who finally wins Natasha is, we understand, the meaning of *War and Peace*. When Raskolnikov kisses the earth in the hay market, when the children at sunrise call out, "Hurrah, Karamazov," we understand that we are in the presence of powerful symbols of hope—of a hope, in fact, for nothing less than the transformation of reality. And it was exactly that hope that Chekhov distrusted. It was an attitude that he shared with a whole generation of European writers whom we have come to think of as naturalists: realists who were inclined to reject the romantic and symbolic elements in realists like Dickens and Balzac and Dostoyevsky, and stake their claim on a cooler, more scientific notion of realism.

Chekhov was not practicing his craft in a void. His stories constitute a kind of deconstruction of the habits of Russian fiction up to this time. If at the emotive level he was committed to constructing stories that didn't merely gratify a reader's wishes, at another level he was trying to understand how to portray his characters so that they did not turn into types and thus raise expectations that the resolution of the story would be a hint toward some transformed reality he could not bring himself to believe in. This is in some ways the central fact of his art, the problem that amused and fascinated him intensely at the beginning of his career and tormented him at the end of it. In short, the problem that Chekhov faced when he was twenty-eight years old and was invited for the first time to submit a piece of fiction to one of the most important literary magazines of his time, was nothing less than the relationship, artistically and philosophically, between realism and hope. It can be traced, not only as an inner theme of the stories but as the source of their formal invention, from the brilliant early sketches through the

publication of his first masterpiece, "The Steppe," in 1888 to the last pair of completely remarkable stories, "The Bishop" in 1902 and "The Betrothed" in 1903.

We have been taught by the fiction writers of the nineteenth century to read work for its view not just of individual lives but of a whole society. Chekhov managed to do this, not by writing largely and symbolically, but by covering immense amounts of Russian life. Taken as a whole, his work is as impressive a vision of Russian society as Balzac's *Comédie humaine* and Zola's novels were of French society. And we have been taught, mostly by the nineteenth-century poets, that the inner subject of a great work of art is the growth of the artist's mind. I think where I end, then, is with a kind of recommendation: that the collected stories, taken as a whole and read in chronological order, are one of the great works of modern literature, and if no one story equals in breadth of vision the classic novels of the nineteenth century, then the whole body of stories—read the way you would read a modern poem, like Wordsworth's *Prelude* or Pound's *Cantos*—are, taken together, an achievement on the scale of *War and Peace*. Or *Ulysses*. Or *Leaves of Grass*. Or *Remembrance of Things Past*. If Chekhov is not one of the greatest modern novelists, he is one of the greatest poets.

1986

howl at fifty

There aren't a lot of places in San Francisco that deserve the status of literary monuments—perhaps the house in the Tenderloin where Robert Frost was born; or the site of Jack London's birthplace on Third Street; or the alley off Bush Street where the police found the body of Miles Archer, Sam Spade's partner in Dashiell Hammett's *The Maltese Falcon*. Another of them ought to be the apartment house at 1010 Montgomery, just off Broadway, where a twenty-nine-year-old Jewish-American, gay, New Jersey–born, Ivy League–educated former marketing research drone and incipient visionary named Allen Ginsberg labored through the summer of 1955 writing a long poem that was published the following year by an enterprising North Beach bookstore called City Lights, read with interest by a San Francisco captain of police, prosecuted by the city's district attorney, and vindicated in the courts, and that has since altered the face of American poetry, influenced a generation of singer-composers who reshaped popular music, helped to launch a counterculture, made San Francisco a kind of world capital of poetry, sold well over six hundred thousand copies (unthinkable for a book of poems), been translated into twenty-one languages, and is, this year, twenty years older than its author was when he published the poem. Hard to believe. *Howl*, with its incandescent mad laughter and sadness and apocalyptic anger and immensely liberating sanity and power, is fifty years old.

Probably the best way for admirers of the poem to acknowledge this event, if they happened to live in or be visiting San Francisco, would be to put on a pair of walking shoes and make their way to Lawrence Ferlinghetti's bookstore at Columbus and Broadway. Once there, they should descend the narrow stairway in the back of the shop. It used to lead to the poetry section in the basement, where, until recently, they

would have found that small book in its stark black-and-white cover on a rack next to tables at which the young of the city have been poring over new writing for three generations. That would have been the place to sit down at a table and begin to revisit that remarkable poem. Now, however, visitors will find the book in a small room up, rather than down, a set of narrow stairs, to which the poetry section has been moved and set around by an arrangement of books that make a sort of shrine to the Beat generation.

If they don't want to read the poem there, they can take the extreme measure of buying it, so that they can stroll up Grant Avenue to Caffe Trieste, which will smell as pungently of deeply roasted and finely ground coffee beans as it must have done in 1955, when the Co-Existence Bagel Shop was just around the corner and the world had had only ten years to absorb in the deepest neural synapses of the brain the fact that two whole cities of men, women, and children, Japanese as it happened, could be tormented into ash in one shuddering fifteen-second blaze of light and heat dreamed into existence by human science. And there, in the smell of steam and coffee, without nostalgia (though it is permitted to let the ghosts of Senator Joseph McCarthy, John Foster Dulles, James Dean, Charlie Parker, Jean-Paul Sartre, and Julius and Ethel Rosenberg hover just above the counter piled with crisp, palm-shaped, and un-American pastries), they can begin to let the language of one of the most bracing, nervy, and celebrated works of art made by an American in the postwar years begin to work on them.

The opening line of the poem is by now so famous in some circles that it has the quality of a quotation, like "Are you talking to me?" or "To be or not to be—that is the question." It had then, at the time of its publication, the surprise of one long bardic line, written to be read out loud in a single release of breath that the stomach muscles could feel:

I have seen the best minds of my generation destroyed by madness,
 starving hysterical naked

Not actually a particularly promising start. It irritated some people because its author clearly meant the best minds among the intellectual desperados and bohemians he knew on New York's Upper West Side when he attended Columbia University; the writing seemed like East Coast chauvinism. It irritated others because of that battery of

unpunctuated adjectives, which looked, to a certain fastidious taste in a conservative decade, tacky and ragged. It is true that the line is a little hysterical and grandiloquent, but it is also true that it has the desire to be large and outrageous—and that behind the extremity of the language is the first glint of a cosmic sense of humor. "Am I freaking out?" the language seems to say. "All right then, I am freaking out." And there is electricity in it: you can sense the cowed and obedient dogs of the silent generation about to bite through the leash of the conformist 1950s.

The second line of the poem is another long breath:

> dragging themselves through the negro streets at dawn looking for
> an angry fix

This isn't so great either; it has about it a kind of pure, kitschy, period romanticism. Romantic about Harlem, romantic about substance abuse. Remember Negroes? This line was written one year after the Warren Court's decision on desegregation, just months before the Montgomery bus boycott. A daring and recently famous young novelist, Norman Mailer, would soon publish an essay entitled "The White Negro" about how the new generation, sickened by American glut, could only identify with the cool hipsters of the black underclass. That identification of whites with excluded blacks is in Ginsberg's line; it comes from the outlaw chic of jazz, and in a few years it was to issue in the participation of white college students in the Student Nonviolent Coordinating Committee and the Mississippi freedom rides (and the eventual dis-invitation of white student participation by SNCC).

The romanticism about drugs comes partly from the author's meeting with the older writer William Burroughs, who was in the process of writing that remarkable monster of a novel *Naked Lunch*. And the subject was in the air. Nelson Algren had published a novel about musicians and drugs, *The Man with the Golden Arm*—Frank Sinatra starred in the 1955 movie version. Ginsberg's attitude would be corny, or dangerous, if it were not for the word *angry*. It gets a snarling self-punishment into the stab of the needle, and it lets you know that you are in the presence of a writer of some quality, who is just getting warmed up.

The next line has more real fire. It is the one that particularly infuriated the assistant district attorney who led the prosecution of Lawrence Ferlinghetti for publishing and selling *Howl*. It goes:

> angelheaded hipsters burning for the ancient heavenly connection to the starry dynamo in the machinery of night

When the book came to the attention of Captain William Hanrahan of the Juvenile Bureau, he dispatched two officers to City Lights to arrest Ferlinghetti and his clerk, the amiable friend of all North Beach's late-night browsers among books, Shig Murao. The trial of Ferlinghetti, in the court of Judge Clayton Horn, on the charge that he "did willfully and lewdly print, publish and sell obscene and indecent writings," kept the city amused for a couple of weeks. The counsel and former counsel of the American Civil Liberties Union, Albert Bendich and Lawrence Speiser, defended Ferlinghetti, along with Jake Ehrlich, San Francisco's most glamorous criminal lawyer. The expert witnesses were a roll call of the city's literati: the novelist Walter Van Tilburg Clark, author of *The Ox-Bow Incident;* American Conservatory Theater director Herbert Blau; poet Kenneth Rexroth; UC Berkeley professor Mark Schorer; poet Mark Linenthal from San Francisco State; and Luther Nichols, the book editor of the San Francisco *Examiner.*

The assistant district attorney, Ralph McIntosh, an elderly man, cross-examined the suave and impeccable Schorer, one of the country's best-known literary critics. According to contemporary accounts, which can be found in the new annotated edition of *Howl* published by Harper & Row, McIntosh shook the book at Schorer. "I presume you understand the whole thing, is that right?"

Schorer: "I hope so. It's not always easy to know that one understands exactly what a contemporary poet is saying, but I think I do."

McIntosh, who seemed more personally upset by the poem's obscurity than by its alleged obscenity, waved it wildly in the air. "Do you," he demanded, "understand what *angelheaded hipsters burning for the ancient heavenly connection to the starry dynamo in the machinery of night* means?"

One thing it means is that its author was on a roll, and he continues to accelerate through several pages of these long, relentless lines that spin, twist, leap, and twitch with a combination of invention, rage, pathos, and

high comedy that had not been seen in American poetry since T. S. Eliot recovered from a nervous breakdown by writing *The Waste Land*.

> who poverty and tatters and hollow-eyed and high sat up smoking in
> the supernatural darkness of cold-water flats floating across the
> tops of cities contemplating jazz,
> who bared their brains to Heaven under the El and saw
> Mohammedan angels staggering on tenement roofs illuminated,
> who passed through universities with radiant cool eyes hallucinating
> Arkansas and Blake-light tragedy among the scholars of war,
> who were expelled from the academies for crazy & publishing
> obscene odes on the windows of the skull,
> who cowered in unshaven rooms in underwear, burning their money
> in wastebaskets and listening to the Terror through the wall

Much of *Howl* is a kind of exploded, hallucinatory autobiography. Allen Ginsberg grew up in Paterson, New Jersey; his father, Louis, was a schoolteacher and a moderately well-known, quite conservative lyric poet. His mother, Naomi, a Russian-Jewish immigrant who grew up on Manhattan's Lower East Side and became the subject of her son's best poem, "Kaddish," was mad—afflicted, suddenly, in the middle of her life, with paranoid schizophrenia. Her son, in high school, visited her at the Greystone Park Psychiatric Hospital near Morristown, New Jersey, where she was receiving electroshock therapy and insulin treatments. Later, she was hospitalized once again at Pilgrim State Hospital in Brentwood, New York. Her son was writing *Howl* only a few years after having signed papers giving permission for his mother's lobotomy, and she died not long after he finished the poem.

Sexual frankness was what got *Howl* in trouble, as well as the fact that the sexuality it was frank about was not necessarily heterosexual. The poem made it perfectly clear that its cast of saintly, crazy-sane, vision-hungry hipsters loved boys as well as girls. The knowledge of his own sexual preferences must have been dawning on the young Ginsberg at just the time that he was dealing with his mother's madness. It is a powerful combination. His mother as a misfit, himself as a misfit.

Her insulin injections, her shock therapy—set that against the public world of the late forties and early fifties. The Jewish-American leftist Rosenbergs burned in the electric chair for espionage. Whole

cities burned by a new kind of doom that had darkened the air above Japan. The revelation of the Nazi concentration camps. It is not hard to understand the sense of horror that erupts in *Howl*, especially in the middle sections in its vision of Moloch, Canaanite god of fire, terrible spirit of everything punitive, soulless and materialist in modern American life, and the spirit, of course, of Ginsberg's own guilt and self-hatred:

> What sphinx of cement and aluminum bashed open their skulls and
> ate up their brains and imagination?
> Moloch! Solitude! Filth! Ugliness! Ashcans and unobtainable dollars!
> Children screaming under the stairways! Boys sobbing in
> armies! Old men weeping in the parks!

The vision of Moloch came to Ginsberg, oddly enough, when he was living in an apartment on Nob Hill in the fall of 1954 and had a hallucinatory nocturnal glimpse of the illuminated Sutter-Powell façade of the Sir Francis Drake Hotel. It became for him suddenly the grinning face of the great beast itself.

It is not surprising that Ginsberg had a self-consciously bad-boy career at Columbia University—he was suspended in his sophomore year for writing a phrase that was, if taken seriously, and the cleaning woman who noticed it and reported him apparently did, both obscene and anti-Semitic on an unclean dormitory window with his finger, among other derelictions. By the time he was a senior, cultivating the style of an existential outlaw, he got himself into real trouble when a car he was in was discovered to be carrying stolen goods. He was arrested and stayed out of jail by pleading insanity, and thus was committed to New York State Psychiatric Institute, where he met Carl Solomon, the friend to whom *Howl* is dedicated, and where he got a firsthand look at what institutional America did with people like his mother.

It must have been a searing experience, and it is pretty clearly what is behind the furious energy of his poem. Carl Solomon came to stand for a whole generation of idealistic, crypto-mystic lost souls. In the private logic of the poem, all the angelheaded hipsters become Carl Solomon—recommitted to a mental hospital at the time when Ginsberg was writing the poem—and Solomon, in the most aston-

ishing and affecting moment in the poem, blurs into the figure of its secret subject, mad sad Naomi:

> who threw potato salad at CCNY lecturers on Dadaism and
> subsequently presented themselves on the granite steps of the
> madhouse with shaven heads and harlequin speech of suicide,
> demanding instantaneous lobotomy

These were stunts of Carl Solomon's, hyperbolically described; the next lines refer to the period when he and Ginsberg were incarcerated together:

> and who were given instead the concrete void of insulin Metrazol
> electricity hydrotherapy psychotherapy pingpong & amnesia,
> who in humorless protest overturned only one symbolic pingpong
> table resting briefly in catatonia,
> returning years later truly bald except for a wig of blood, and tears
> and fingers, to the visible madman doom of the wards of the
> madtowns of the East,
> Pilgrim State's Rockland's and Greystone's foetid halls, bickering
> with the echoes of the soul, rocking and rolling in the
> midnight solitude-bench dolmen-realms of love, dream of life a
> nightmare, bodies turned to stone as heavy as the moon,
> with mother finally ******, and the last fantastic book flung out
> of the tenement window, and the last door closed at 4 a.m.
> and the last telephone slammed at the wall in reply and the
> last furnished room emptied down to the last piece of mental
> furniture, a yellow paper rose twisted on a wire hanger in the
> closet, and even that imaginary, nothing but a hopeful little bit
> of hallucination—
> Ah, Carl, while you are not safe I am not safe, and now you're really
> in the total animal soup of time—

So, the reader of this poem in the café may reflect, working on a second espresso, it turns out that this wild text of a wild new generation is about a son's acceptance of his mother's madness and of the sadness of her life, like a yellowed paper rose on a coat hanger in an empty room. And about a man's acceptance of his own sexuality and about the shame of the punishing, warmongering, body-hating, and money-grubbing forces in

what is supposed to be a free and generous republic. And about the power of love and the way that suffering teaches us tenderness.

The Honorable Clayton W. J. Horn, who presided at the *Howl* trial, was an unknown quantity. No one on either side knew whether to be encouraged by the fact that he had recently taken the somewhat eccentric step of sentencing five female shoplifters to an afternoon spent viewing Cecil B. DeMille's recently released *The Ten Commandments* (Charlton Heston as Moses) and writing essays on the moral lessons it contained. As it turned out, he wrote a lucid opinion that is still an important part of California law affecting freedom of speech, and it contains an account of the poem that is as good as one might expect from literary criticism: "The first part of *Howl* presents a picture of a nightmare world; the second part is an indictment of those elements in modern society destructive of the best qualities in human nature; such elements are predominantly identified as materialism, conformity and mechanization leading to war. . . . 'Footnote to Howl' seems to be a declamation that everything is holy, including parts of the body by name. It ends in a plea for holy living."

Judge Horn found the poem not obscene and Ferlinghetti not guilty. The result of the trial, of course, was that *Howl* became a national cause célèbre, and San Francisco got the reputation, curiously, of a place especially hospitable to poetry. And it also helped give definition to a new generation. When the verdict was announced, the *San Francisco Chronicle* reported, it drew applause from a courtroom packed with "the most fantastic collection of beards, turtlenecked shirts and Italian hairdos ever to grace the grimy precincts of the Hall of Justice."

But *Howl* transcended its generation. Our Sunday readers, finished with their coffee and the poem, might very well step into the cool early winter afternoon reflecting that things have not changed very much. Though there is plenty of other evidence, the "Strategic Defense Initiative"—the fantasy that it is somehow rational to plant our most terrible weapons pointed back at ourselves among the starry dynamos in the machinery of night—is sufficient indication that Moloch has still got hold of a good chunk of the American soul. So our readers may also reflect that it is absolutely necessary, at least once in every generation, that someone get unhypnotized long enough to let the sense of the absurd crystallize and the grief and rage well up into a howl loud enough for the rest of us to hear.

1986, 2006

the kingdom of reversals: notes on hosoe's mishima

<p>N<i>ote: The subject of this essay is a book of photographs by Eikoh Hosoe of the novelist Yukio Mishima, or, rather, of a dream world to which he enlisted Mishima. One of the attractions of Hosoe's work is that he represents in late-twentieth-century photography the opposite tendency from the documentary one—from the work of Henri Cartier-Bresson and Walker Evans and Robert Frank, the realist tradition through which I first fell in love with photography as an art. Hosoe's work is theatrical and baroque. The first of his books in English, </i>Man and Woman<i> (1960), had made me understand the ways in which a book of photographs could be a constructed thing like a book of poems. And there was something else about that book—the abstract, high-fashion chic of its compositions and the vulnerability of the bodies that were its subject.</i></p>

<i>What I felt looking at it was subliminal and difficult to describe. I grew up in San Francisco, not much more than a mile from the Golden Gate Bridge and blocks from the military base from which the war in the Pacific was being conducted. Among my earliest memories is sitting on my mother's lap in a darkened room, shades down, lightless except for the gold, cathedral-window glow of our 1940s radio, my brother, father, and grandparents gathered around us. We were having a "blackout." I don't know which ones were drills and which were based on some intelligence from radar or ships at sea to suggest that Japanese planes were headed toward the city. The routine was to turn out all lights, pull down the heavy blackout shades, and listen to the radio for further information. Our air force, of course, incinerated several Japanese cities, not only Hiroshima and Nagasaki, but Tokyo as well, where a firebombing</i>

burned a hundred thousand people alive in a single night. The Japanese Imperial Air Force had ruthlessly bombed the civilian populations of Nanjing in 1937 and Canton in 1938 and did considerable damage to the military bases in Honolulu and to towns and cities in the Philippines, Australia, and the Pacific Islands. For whatever reasons, they did not, after Canton, practice the total war against civilian populations that we visited on them. The world is full of small moral contingencies. An American writer looking at a book of photographs of naked Japanese bodies is, in that way, contingent, or so I thought paging through Hosoe's Man and Woman. *So when I was invited by the magazine* Camerawork *to write something about Hosoe's second book, it seemed to me an interesting proposition. I was three, four, and five years old at the time of the blackouts, sitting on my mother's lap in my grandfather's house. Yukio Mishima, having been a schoolboy who spent his days making detailed and heroic drawings of airplanes and battleships, was excused from military duty because of respiratory problems and was beginning to write stories.*

Looking at Yukio Mishima's body in the first of the images of him that make up Eikoh Hosoe's *Barakei, Ordeal by Roses*, it is impossible not to think about the novelist's public suicide. "I will never admit the decay of the flesh," Mishima had written. But the body in the photographs does not express the flesh, it expresses the will. The articulation of the arms and shoulders, impenetrably sad, does not make you think of eternal summer, it makes you think of exercise equipment, of a man methodically doing his reps in a gym, and it is the immense void in which that effort has been expended that seems to darken the figure's eyes. "Body-building," the American sport that Mishima helped to popularize in Japan, begins, in these images, to seem like a kind of male anorexia—a war against the flesh, a triumph of the will.

Still, it is a body; it looks curiously frail. In an interview with for-
eign journalists in 1966, Mishima, according to his biographer Henry
Scott Stokes, was asked about the Japanese practice of seppuku—
Japanese do not use the expression *hara-kiri*—and this was his reply:
"I cannot believe in Western sincerity because it is invisible, but in
medieval times we believed that sincerity resided in our entrails, and
if we needed to show our sincerity, we had to cut our bellies and take

out our *visible* sincerity. And it was also a symbol of the will of the soldier, the samurai." Witnesses said that Mishima's own hand shook badly four years later when he was making a five-inch horizontal cut in his lower abdomen. Apparently the body tries to expel the knife and one has to push hard against the musculature. The hands of Masakatsu Morita, who was the not-very-bright leader of Mishima's private army of right-wing students and probably his lover, were also shaking. He was to perform the ritual decapitation. In his panic, he missed three times, or perhaps he could not get a footing. The rug was already very slick. Another of the student fascists, trained in swordsmanship, had to intervene. By then Mishima's body, hacked about the shoulders and the head, had slumped over, his intestines had begun to slither from his wound, and he was groaning. The student circled the slippery body, found an angle of approach, and then he severed the head.

In Hosoe's image Mishima's head looks as if it had been severed from the body and then replaced at a slightly peculiar angle. This is a familiar technique in surrealist photomontage, but in this case it is a trompe l'oeil. Mishima is wearing a wing collar, despite the fact that his torso is naked—an absurdity that is also a familiar surrealist technique—and the white space of the collar, along with that small tilt of dejection or abjection in the head, provide the illusion that the head has been separated from the body and then replaced. And this is interesting because, usually, in the imagery of disjunction between head and body, the head is the villain of the piece. It carries the symbolism of law and inhibition, the body is all blossom and powerlessness. But in Hosoe's image of Mishima, it is the head that both carries the weight of an actual human sadness and seems capable of floating away. Lonely as that body is, overprepared for some nameless event, it does not express freedom but servitude. As if the point needed to be underlined—whether, really, it needed underlining or not—it has been underlined by the body in loose chains that stands parallel to the phallic pillar by the winding staircase. That body does not express what an actual enchained body might express in a South African jail or in an interrogation room in Guatemala. There is nothing in it of the weight of metal or the smell of human terror. It belongs, in fact, to the imagery of a dreamy erotic submission, of an inverted freedom. Very little in this photograph is what it seems, though it is all familiar enough. This is the kingdom of reversals.

Or it would be if Mishima's death were not written across it so entirely.

Mishima killed himself in 1970. The photographs in *Barakei* were made, mostly, in the spring and summer of 1962. Hosoe met Mishima in September of 1961 because Mishima had suggested to his publisher using him for a book jacket portrait. Hosoe was in his early twenties and had done some work with a Tokyo dance company that had caught Mishima's eye. The novelist was ten years the photographer's senior and the most famous younger writer in Japan. The portrait session grew, at Hosoe's suggestion, into a series of sittings, increasingly elaborate. *Barakei* was published in 1963, seven years before Mishima's death and four years or so before his sudden and surprising plunge into politics.

This is worth noticing because the jacket copy on the Aperture edition of the book calls it "the fierce and lyrical testament of the legendary Japanese writer Yukio Mishima," and says that "its morbid climax is a prophecy of the writer's shocking ritual suicide which stunned the world in 1970—now the subject of Paul Schrader's controversial film produced by Francis Ford Coppola." *Barakei* is not Yukio Mishima's testament. Mishima was a writer. His testament is in his novels, notably *Confessions of a Mask, Forbidden Colors, The Temple of the Golden Pavilion, The Sailor Who Fell from Grace with the Sea*, and the tetralogy he finished at the end of his life, The Sea of Fertility.

Moreover, though *Barakei* is the only book of photographs of Mishima to appear in his lifetime, he was photographed incessantly throughout a very public life, not only as a writer but as an actor in theater and film. The point is that neither the frankly commercial claim of the publisher nor the perhaps emotional claim of the artist—"Here," Hosoe wrote, "is the perfect body of Mishima"—accurately represents what these images are; and more importantly, the images themselves, ambitious, theatrical, derivative, brilliant, and slightly glitzy, have their power, retrospectively, and bear the burden of having to stand up to the weight of meaning inscribed on them either by the farce and horror of Mishima's death or the riddle of its meaning.

Look again at the image of Mishima's body, and consider the experience of his generation of Japanese. Leave aside the niceties of detail—according to Stokes he was raised by a furiously possessive and voluptuously bitter grandmother, he was a sickly boy who found all juxtapositions of beauty and death sexually stimulating, he was drafted toward the end of the war to work in a factory that manufactured kamikaze planes. Leave aside the fact that Westerners are not supposed to be

able to understand "the Japanese mind." This is the body of a man who, at the end of his boyhood, during which he read fairy tales and drew battleships and listened to wartime propaganda about the omnipotence of his race and his emperor, watched his country suffer a humiliating and total military defeat. That is why it is called in Mishima's writing "1945, the year of the defeat." At the surrender on August 15 and shortly afterward, five hundred Japanese military officers committed suicide. It is hard not to think that some upwelling of defeat and powerlessness produced that passion for physical fitness and the celebration of the samurai spirit that had begun to appear in Mishima's work when the photographs were taken. It is hard not to think that his disgust with a demilitarized Japan and his passion for the return of the empire and the wild miscalculation of the "attempted coup" do not also spring from that moment.

If the American disengagement from Vietnam and the taking of hostages in Iran by the political opponents of a tyrant whom our government had installed could have produced the body of Sylvester Stallone, is there anything surprising about the body of Yukio Mishima?

That the war was lost had already been made clear to most Japanese by the resignation of the Tojo cabinet in July 1944. Mishima was a young man writing his first novel as the world he knew was coming to an end. His days, he said, had a strangely leisured air. "I had the feeling of being neither alive nor dead," he wrote. And later: "True pain can only come gradually. It is exactly like tuberculosis in that the disease has already progressed to a critical stage before the patient becomes aware of the symptoms." On August 6, 1945, earth and sky shook, and an entire city was obliterated. There was a pause, such as human beings had never experienced before, and after three days another city was leveled. Everyone expected Tokyo would be next. For a week nothing happened. "If it had gone on any longer," Mishima wrote, "there would have been nothing to do but go mad." The emperor's surrender came on August 15.

Look at Mishima's body again. Is that hardness the vitality of a lived life? The defiance of an opponent? Preparation for the embrace of a lover? Is the terrible history that I think I see there truly there? Is it inscribed that there are things you can't do to human beings without inviting terrible and unpredictable retribution? And is it such a retribution that has begun to emerge in the austerity and scalding melancholy of Mishima's body? What is clear about these photographs is that they are not going to

tell us. If it were simply a question of inviting death as a sexual embrace or of an ideal beauty in Promethean defiance of time, they certainly seem to have something to say. They are in that way what they seem to be: avant-garde art, the fashionably daring, distinctly but obliquely erotic art of disorientation produced by the clever young on the fringes of large cities throughout the twentieth century—actually since the middle of the nineteenth. If we read in Mishima's body that those cities are hostages to annihilation, to things we don't understand and may never understand about human destructiveness, we are likely to feel that Hosoe's lovely and disturbing images are, at this level of discourse, out of their depth.

This is not a criticism of the young Hosoe, who attempted, as he said, "a document of the writer" who had mesmerized his generation with lyrical novels of sensuality and death. That world, the world of Mishima the romantic novelist, Hosoe really does explore. And Mishima was, in 1962, quite enthusiastic about the result. "The world to which I was abducted under the spell of his lens was abnormal, warped, sarcastic, grotesque, savage, and promiscuous . . . yet there was a clear undercurrent of lyricism murmuring gently through the unseen conduits." And again: "I was escorted to a world which was a weird, repellent city—naked, comic, wretched, cruel, and overdecorative into the bargain—yet in its underground channel there flowed, inexhaustibly, a pellucid stream of unsullied feeling."

This overstates the case in the way that a gorgeous writer can, but it suggests the territory of dark, romantic transfiguration in which these images have their interest and authority. The photographs in the book are gathered into four groups that make a sort of allegorical progression. The first, entitled "The Citizen's Daily Round," is the least interesting. Mishima wrapped in a garden hose lying on a marble mosaic of the zodiac, the scene shot from the head, low down, from an overstated *Citizen Kane*–like angle. The next section, "The Laughing Clock and Idle Witness," aims for satirical shock, but as it moves toward the sexual themes of the third section, "Divers Desecrations," something much more powerful begins to happen.

Like other visitors to Mishima's house, Hosoe, when he first met the novelist, was taken aback to find that he had built himself an Italianate villa in a suburb of Tokyo and filled it with reproductions of paintings by Botticelli and Giorgione and Spanish baroque furniture. The architect who built it was so offended by it that he wrote an article denouncing Mishima's taste, an act that, of course, delighted Mishima and that he seconded with great passion in an article of his own. It is not hard to see why Mishima was attracted to the magical world of Italian Neoplatonism with its landscapes of gods and goddesses and its philosophic melancholy. For "Divers Desecrations" and the final group of images, "Retribution of the Rose," Hosoe's theatrical instinct and his decision to immerse Mishima in a world of his own objects served him very well. He commissioned a scenery painter to create a special background based on Giorgione's *Sleeping Venus*. Somewhat less interestingly he had Venus painted without her upper half (it could make you wish he had never heard of Man Ray). But when he places Mishima in this world, which is very like the idyllic world of *The Sound of Waves*, the result is moving.

And here it begins to be possible to think about conventions of beauty and disturbance—even to think about them in relation to magic and to fascism. I have in mind the notion of abjection in Julia Kristeva's *Powers of Horror*, her study of Céline. The territory of abjection, according to Kristeva, is whatever the body sloughs off or expels: shit, piss, menstrual blood, pus, toenail parings, dead skin—anything that comes from us and feels dead to us or despised, if we are going to get on with life. The stages of our relation to these disjecta include narcissistic fascination, repression, mild revulsion, and exile into it (that

is the stage of identification: I feel like shit, I feel like toenail parings, etc.). When mild revulsion becomes repelled fascination, the abject has begun to stir, animate, invade life. Repelled fascination is both a psychological threshold and a level of aesthetic experience that we're all familiar with. It belongs, for example, to our first thumbing through *Barakei* and to the frisson of pleasure and fear at the images in trailers for horror films and to the films themselves, of course, which are, as marketers seem to understand, a source of the suppressed delight with which fourteen-year-olds, whose very bodies are a process of transformation, say, "Gross!"

One of our responses to this sense of powers stirring and moving toward us from the territories of death and denial is to begin to fear that they are more powerful than life. Humans tend to make alliances with power. In black magic, through such an alliance, the abject assumes demonic power. In the more playful *as if* of art, it achieves magical potency.

Abjection exists at, defines a boundary between, self and not-self, good and not-good. The art of this boundary is the art of thresholds, the place of disturbance. And the art of disturbance is to function at that threshold where transmigration seems to be going on between life and death, good and evil, pain and pleasure, male and female, the ugly and the beautiful: the kingdom of reversals. I suppose an ecological account of this would be to say that human beings are comfortable with the carbon cycle, the basic process of birth, growth, death, decay, and birth, as long as it operates in a straightforward and clockwise cycle, so that death always produces new life. Black magic and terror begin with the thought that the process might be reversible: the hand emerging from the coffin, the monster from the swamp, effluent creatures of the sewers from the toilet. They are another flowering, the flowering of un-nature that gave Baudelaire the title of his book of poems.

One of the most powerful images in *Barakei* shows a naked woman, one hand over her labia in the gesture of Venus *pudenda,* one hand transformed into (or being transformed from?) animal horn. Next to her and parallel is, convincingly, the bottom half of Giorgione's *Sleeping Venus.*

Next to her is the male, the Adam-after-the-fall (we know this because he wears a black loincloth, as if he were in mourning for his genitals), with something like an egg or a ball in his hand. Curled above the three in a position at once fetal and defensive is another more childish naked figure. One of the telling things about this image is that we do not for a moment think about the novelist Mishima. This is Hosoe's image, and it situates itself at the threshold of some undeclared form of sexuality. The disturbance in the image lies in the sensation of how powerfully that sexuality desires—and resists the desire—to be born, to declare itself.

It would be easy to multiply examples and refine a sense of Hosoe's subject. In his particular blending of the surreal and the baroque, his exploration of this border is more ecstatic than horrific. But the final images in the book are, I think, supposed to be truly terrible. They are the ones in which the rose of beauty, the phallic and vaginal rose, takes its revenge for our adoration. And they aren't in the end terrible; they are too full, like the baroque itself, of youthful melancholy and grief. In one of them Mishima really does look like eternal summer or a Renaissance shepherd meditating on the tears of things while the shadow of a hanged man behind him prefigures death. It is a beautiful image, and there is a level at which one wants to share that melancholy, and it is at this point that the figure of Mishima intrudes.

Kristeva's contention is that abjection can demystify power, as it could, for example, if you were to write history from the point of view of a toenail paring, or embrace abomination to rob power of its ability to name what is abominable and what it, therefore, has been instituted to protect us from. In his introduction to *Barakei,* Mishima makes a similar claim. In the daylight world everything is clean and orderly, he observes, and beneath our concern for public morality are "foul, filthy sewers," whereas in the foul, dark, disordered world of *Barakei,* there is a clear pure current of feeling. The disturbance at the border is intended to free us from the power of repression and its inevitable and ineluctable contract with horror.

In *Barakei* we encounter these powers and feel the escape from them through Hosoe's dream transfigurations only fitfully, and though one feels that the photographs come occasionally to the ground of mystery for Hosoe, one does not feel that they touch, finally, the mystery of Yukio Mishima, for whom the identification between death and beauty became so powerful that it made all of life abject. He was, after all, one of the most gifted survivors of one of the most appalling acts of violence in the twentieth century and it seems in the end to have taught him contempt for life. It taught him to worship death—not Romantic, Neoplatonist, surrealist, or post-structuralist death, but death itself, made visible. It is itself an appalling thing and not to be romanticized under any circumstance. The appropriate elegiac gesture is from a part of the world that also saw its share of violence—the Eastern European custom of casting poppy seeds on the grave to ensure that the spirits of the dead, except in the kingdom of reversals, never visit us again.

1986

george oppen: his art

*N*ote: *This essay was written as a brief talk to be given on the occasion of George Oppen's seventy-fifth birthday in 1983 at Intersection, an arts space in San Francisco. He died the following year. I hadn't quite understood, none of us did, I think, how far gone he was into Alzheimer's disease, and so I have no idea what George took in of what was said of him and his work. He had been a soldier, wounded in France, in the last year of World War II, and he had a soldierly bearing. What I remember is the silhouette of his upright posture in the back of the room.*

His generation of American poets, the second generation of modernists, lived in the shadow of their great elders. Whether they were read or not, the first generation—Ezra Pound and T. S. Eliot and Robert Frost and Gertrude Stein—were household names among educated Americans. The younger generation, writing in their shadow, did their work in a curious public isolation that one of them described as a kind of internal exile. And in George's case, actual exile, for ten years in Mexico, during the McCarthy era, when he ran a small furniture-manufacturing business.

He was born in New Rochelle, New York, born to some wealth—his father was a diamond merchant—and after George's mother's death when he was four, the father remarried and moved the family to San Francisco, where George grew up. He started college at Oregon State and was expelled within months for staying out all night with his girlfriend, Mary, who became his wife. The young couple took off for New York City, where they met other young poets and started a press (with George's money) and where, at the age of twenty-four, he published his first book of poems, Discrete Series. *It was 1934, the country was in the depths of the Depression, and—this is a story poets know—George and Mary got involved in tenants'-rights strikes in Brooklyn, took up political*

organizing, joined the Communist Party of America, which eventually sent George to work in the auto factories in Detroit. During those years he simply set poetry aside. When the U.S. joined the war in 1941, he was thirty-three years old, working in a critical war industry, and he didn't have to go, but he enlisted, elected to be in the infantry, and fought his way across France until he was wounded in 1944, awarded a Purple Heart, and sent home, to a country that was not hospitable to the young radicals of the 1930s.

*In 1958, when he was fifty years old, still living in Mexico, he began writing again and moved to New York, back to Brooklyn, and then to San Francisco. The books that made him a permanent part of American liter-*ature, The Materials *(1962)*, This in Which *(1965)*, Of Being Numerous *(1968)*, appeared in due order. This young poet of the 1930s did most of his crucial work and came to the attention of other poets in the 1960s.* Of Being Numerous *received the Pulitzer Prize in 1969; his* Collected Poems *from* New Directions, *the publishers of Ezra Pound and William Carlos Williams, who had been his mentors, appeared in 1975. Sometime during those years I first laid eyes on George at one of San Francisco's mammoth group poetry readings. It may have been to honor the memory of Ezra Pound, who died in 1972. Gary Snyder read, I remember, and Allen Ginsberg, and Lawrence Ferlinghetti and Michael McClure. There were a couple of dozen poets, and in those tumultuous years, they all tended to dress florally. Suddenly on the stage appeared a taut, lean, grizzled man in a quiet dark suit, white shirt, and narrow black tie. Hard to convey how unexpected he looked. The person I was with, older than me, with different points of reference, turned to me and said, "Who is that guy? He looks like he's been editing the* Daily Worker *for the last thirty years." And then George read, for three or four minutes, poems that were so exact, concentrated, musical, and resonant that I found myself looking around, a little amazed, to see if other people were hearing what I was hearing.*

Over the next decade George figured out how to deal with fashion issues in the literary world of San Francisco. He wore jeans or slacks, an old tweed jacket in that cool and foggy city. On warm days Mary wore a straw sun hat and flowery dresses and together they walked the neighborhoods holding hands. Occasionally they dropped into the coffeehouses where young poets congregated, and they became for a generation a sort of walking legend. Sightings were reported: that was George Oppen, who had been a young

"objectivist" in New York in the 1930s, who had published the poems of
William Carlos Williams when no one else was publishing them, who had
been to Rapallo and met Ezra Pound, who had been a radical in the thirties,
and fought in the war, and lived in the exile community of the American
left in Mexico in the fifties, and who had written poems that had nothing to
prove except their own astonishment at what he called in one of them "the
mineral fact of the world."

So—this was the man who figures in the following essay, delivered as
a talk among other talks on a crisp November Sunday about a poet poets
had come to love, George shadowy in the back of the room and a year
from his death.

At a panel discussion of George Oppen's work last fall in New York,
a young poet said a very striking thing. He said that the situation of
George Oppen in poetry now is like the situation of Paul Cézanne in
painting in 1900: that is, very interesting work could be done by people
who didn't know Cézanne's paintings, but no really new work could be
done by anyone who hadn't assimilated his achievement. I think the
situations of the two artists were distinctly different, that Cézanne was
a trailblazer in a way that Oppen was not. Oppen, a second-generation
modernist, consolidated and refined elements of the practice of Ezra
Pound and William Carlos Williams. He is one of the most powerful
and moving poets of his generation, and a transformative figure, if he
is going to be one, in a different way than Cézanne and on a different
scale. But there is a purity of intent and aesthetic concentration in the
two artists that made me think I understood why the one artist would
bring the other to mind. I tried to think of ways in which the example
of Cézanne applied to Oppen, and it seemed to me, first of all, that, as
with Cézanne, the force of his example as an artist is moral. There are
many ways in which poets can have moral influence. I remember a
friend coming home from a party in the 1970s and saying, "God, I'm
so relieved. Gary Snyder eats potato chips." That is one kind of influ-
ence; it has to do with the way in which we take accomplished artists,
especially those who seem to embody a moral vision, as examples of
how to function in the world. But there is another kind of force that
occurs at the level of composition, at the level of how you function when
you're writing, and I tried to name for myself three instances of George
Oppen's influence at that level.

One is Oppen's sense of language, particularly of the noun—especially because one associates modernism with the return, through Pound's championing of Ernest Fenollosa's essay on the Chinese ideogram, to the power of the verb in writing. "There are no nouns in the natural world," Fenollosa said, and Pound insisted on the ideogrammatic character of language, as did Charles Olson: that the poem was a verb, a figure for the action of the mind. George Oppen took another view of this matter. In fact, in an interview, he said,

> I'm really concerned with the substantive, with the subject of the sentence, with what we are talking about and not rushing over the subject matter in order to make a comment upon it. It is still a principle with me of more than poetry to notice, to state, to lay down the substantive for its own sake. I realize the possibility of attacking many of the things I'm saying and I say them as a sort of faith. The little words that I like so much, like "tree," "hill," and so on, are, I suppose, just as much a taxonomy as the more elaborate words; they're categories, classes, concepts, things we invent for ourselves. Nevertheless, there are certain ones without which we really are unable to exist, including the concept of humanity.

It seems to me that one can say more about the way that this operates in Oppen's work, and that it's important to do so right now because, in my generation of writers at least, the issue of the noun has become very difficult. The work of the language poets, particularly some of the essays of Ron Silliman, has suggested a profound distrust of the mimetic idea that there is a constituting connection between word and thing; they have suggested, in fact, that the connection between word and thing has become a sort of conspiracy among the writer, the reader, and the merchant to convince themselves that the objects of desire are real. And that the light given off by them is not a property of the mind but a property of their entirely imaginary obtainability and that the practice of mimetic art at all is to repeat the lie of capitalist economics. Which is a profound charge, and a very similar charge is made by Robert Pinsky in his *Situation of Poetry*, which argues that the passion of modernist poetry has turned out to be the passion of Romantic poetry, to possess the particular by using words that are always general, so that language is trying intensely to do what language doesn't do, and

that modernism has failed as a project in the way that Romanticism failed as a project by necessarily producing a body of poetry whose subject is passionate disappointment.

In the middle of this dilemma what happens with the nouns in George Oppen's poetry, it seems to me, is that you can actually watch, as the words are laid down on the page, the process from which the perception of the thing gets born into its numinous quality as a word, an abstraction out of the thing. It is very hard to describe how it happens, but it reminds me of a phrase in Robert Duncan's "Often I Am Permitted to Return to a Meadow," when he says, "as if it were a given property of the mind that certain bounds hold against chaos." It seems to me that over and over again one sees that happening in George's poems. I'll give one example. The noun here is "1875":

The great stone
Above the river
In the pylon of the bridge

'1875'

Frozen in the moonlight
In the frozen air over the footpath, consciousness

Which has nothing to gain, which awaits nothing,
Which loves itself

So the noun is one instance. What happens to the noun as an aspect of perception in George Oppen's poetry is another. That is, if the imagist poem is a picture, then an Oppen poem, like the poems of the other members of the objectivist group, wanted to be an X-ray. The great discovery of the objectivist poets—I think it does make sense to speak of these quite different poets as a movement—was that what was really going on at the level of prosody was not a presentation of the image as a picture but an analysis of the constitutive elements of the image as it is being presented. As soon as they found ways to render this subtle shift in emphasis, it became clear that an image was not a picture of a thing, but a picture of the mind perceiving a thing. And as soon as it became the picture of the mind perceiving the thing, then the moral-

ity of perception came to be an issue. And what's extraordinary about George Oppen's poetry is moment after moment in his work, line by line, syllable by syllable, you have a sense of an enormous ethical pressure brought to bear on the act of perception, and a sense that the ethical pressure of the act of perception is for him the same thing as the writing of the poem. And that is a way in which he is extraordinarily like Cézanne, it seems to me. The way Cézanne made lines, the way he studied color and tint, the way he insisted on seeing made it impossible for people to paint in the same way they had painted before. I'm not prepared to say that Oppen's poems are going to have that kind of force; I think we are going to have to wait and see, but I do know that in this way the sense one gets from the work of these two artists is remarkably alike. George Oppen said about it:

> Let me see what we thought and whether I can generalize about it. I'll just put it in personal terms. What I felt I was doing was beginning from Imagism as a position of honesty. The first question in poetry at that time was simply the question of honesty, sincerity. The point for me, and I think for Louis, too, was the attempt to construct a meaning, to construct a method of thought from the imagist technique of poetry, from the imagist intensity of vision. If no one were going to challenge me, I would say "a test of truth." If I had to back it up I'd say anyway, "a test of sincerity." That there is a moment, in actual time, when you believe something to be true, and you construct a meaning from those moments of conviction.

Examples of this are everywhere in George's work. But it occurs to me to point out that Henry James was, as Hugh Kenner has suggested, the grandfather of this sense of the sentence as an ethical activity of perception and to notice that James makes an appearance in the first poem in George Oppen's first book, *Discrete Series:*

> The knowledge not of sorrow, you were
> saying, but of boredom
> Is—aside from reading speaking
> smoking—
> Of what, Maude Blessingbourne it was,
> wished to know when, having risen,

"approached the window as if to see
 what really was going on";
And saw rain falling, in the distance
 more slowly
The road clear from her past the window-
 glass—
Of the world, weather-swept, with which
 One shares the century.

Finally the third thing. Once you become aware of the sentence as an activity of perception, you become aware of it as an activity of consciousness. In George's poems we experience poetry as the activity of consciousness itself. And the effect is great purity. His work seems pure in the way that bird flight can seem pure, or the running of children or the habit of patient attention to detail in the elderly.

Most poets are afraid of consciousness, perhaps because our art has magical and incantatory roots. And consciousness of consciousness, as the naked ground of all serious speech, has tormented twentieth-century writing. The first condition of honesty in poetry, and in the other arts, has been a certain self-reflexiveness; at the same time a flight from consciousness is probably the root of the passion to possess the world through language. That seems to be the fork in our path: a self-referential and hermetic poetry on one side, and on the other a passionate quest that strains toward and against dissolution.

George Oppen's poems are remarkably free of both these passions. They are also free from many of the subversions of ego that accompany them: the desire to charm, the desire to dazzle, the need to have one's suffering seen and acknowledged. This freedom is the ambience of only a few artists. Cézanne wasn't trying to do anything to Mont Sainte-Victoire; he wasn't trying to give it anything or take anything from it or make anything out of it. The mountain was there and he was there, and the painting—which was both consciousness of the mountain and consciousness of the consciousness of the mountain—was their meeting place and a single-minded act of devotion to that meeting place. For George Oppen that place of our attention is both a religious and a political fact; it is the common place, or the res publica, or the this-in-which. In his art it is much more a quality or an ambience than it is an idea, but I will end with something from a late poem, "Who Shall Doubt," which seems to address it:

consciousness

in itself

of itself carrying

'the principle
of the actual' being
actual
itself ((but this maybe is a love
poem

Mary)) nevertheless

neither

the power
of the self nor the racing
car nor the lily

is sweet but this

1985

ernesto cardenal: a nicaraguan poet's beginnings

ote: This piece is a book review written for the Washington Post Book World *in the latter years of the Reagan administration, which was conducting an illegal war in Nicaragua and financing terror against a revolutionary movement that opposed the military dictatorship in El Salvador. It seemed an auspicious time and place to write a little something about Central American poetry, and a brilliant translation of a book of poems about Americans in Nicaragua in the nineteenth century came to hand.*

Father Ernesto Cardenal is the minister of culture of Nicaragua. A priest and a political revolutionary, he is widely regarded as one of the most important Latin-American poets of his generation, and it is not without interest that, while the Reagan administration is conducting an illegal war against the Sandinista government in which he serves, a volume of translations of his poems has just appeared. *With Walker in Nicaragua* presents Cardenal's earliest published work, poems begun in New York City when he was a student at Columbia University, studying with Lionel Trilling and Mark Van Doren. It is in some ways ironic that he has been so strongly influenced by North American poetry, and it occurs to me to say by way of introduction to his work that if Americans are going to pay taxes to support a war against his country, they ought at least to have the decency to read his books in order to learn something about one of the visions that underlie the resistance to U.S. domination in Central America.

There could hardly be a better introduction to this poet than Jonathan Cohen's beautifully edited and really brilliant translations of his early poems. *With Walker in Nicaragua* is an admirable book in every way.

There are two extraordinary poems in it; all of the poems are interesting; the introductory essay is helpful, clear, and brief; and Cohen's translations are so good you feel that the poems might have been written in English.

Cardenal was born in Granada on the northern shore of Lake Nicaragua in 1925. His early childhood was spent during the last years of the U.S. Marine Corps occupation of his country and he grew up under the regime of the elder Somoza. Then, as under the younger Somoza, Nicaragua was one of the poorest countries in all of Spanish America with an adult illiteracy rate of something like 70 percent and an infant mortality rate that rose, during recurrent periods of epidemic, to 30 or 40 percent. In his youth Cardenal's poems, mostly love poems, were influenced by his countryman Rubén Darío and by the Chilean Pablo Neruda. It was not until he went to New York in the 1940s to study at Columbia that he came under the spell of North American poetry, particularly the work of Walt Whitman and Ezra Pound. Cohen's selections begin at this turning point.

Spanish-language poetry, including Latin-American poetry, has a tendency toward rhetorical lushness. What attracted the young Cardenal to the North Americans was their objectivity, their outwardness, and—in Pound's case—their use of historical and documentary materials. These gave Cardenal a way to reenvision his own country. He began by writing short, mostly descriptive poems based on the journals of early mariners and explorers like Sir Walter Raleigh; when he returned to his homeland, this technique issued in two remarkable long poems, "With Walker in Nicaragua" and "Squier in Nicaragua," both based on that moment in the nineteenth century when the country had become interesting to its northern neighbors as an overland route to reach the Pacific and sail to the California gold fields and as a possible site for an interoceanic canal.

William Walker, the figure in the title poem, was a Tennessean and an adventurer who set out, with a small army of Yankee mercenaries, or "filibusters," to conquer Cuba and Central America, create a slave-owning empire, and attach it to the southern United States. He began this ambitious enterprise by invading Nicaragua. Initially he had the support of Commodore Cornelius Vanderbilt, who ran a steamship line from New York to San Francisco with an overland crossing in Nicaragua. During the Filibuster War of 1855–57, Walker succeeded in making himself president of Nicaragua, legalizing slavery, and mak-

ing English the official language of the country. Or, rather, he suc-
ceeded in passing laws to that effect. Vanderbilt turned on him, made
an alliance with Great Britain and the other Central American states,
and drove him out. He was later arrested and executed in Honduras.

Cardenal handles this story by telling it from the point of view
of one of Walker's comrades-in-arms, an old man in a cabin on the
American frontier reminiscing about his salad days. It is a brilliant and
rather surprising choice, all the more effective for being morally and
politically neutral, and it allows Cardenal to suffuse the poem with the
old man's—and his own—love of the sensuous Nicaraguan landscape:

> And that warm sweet odor of Central America
> The white houses with red-tiled roofs and with warm sunny eaves
> and a tropical courtyard with a fountain and a woman by the fountain.
> And the heat making our beards grow longer.

It is easy enough to see where this tone and these rhythms come
from. Here is Ezra Pound remembering Venice in 1903:

> I sat on the Dogana's steps
> For the gondolas cost too much that year
> And there were not "those girls," there was one face
> And the Buccentoro twenty yards off, howling "Stretti"
> And the lit cross-beams that year, in the Morosini,
> And peacocks in Kore's house, or there might have been

This cross-fertilization makes Cohen's translations eerily beautiful.
Passed back into English, it is as if we have suddenly a limpid Pound,
clear and sensual, without all that nervous and restless static. How
well this technique suits narrative can be seen in Cohen's rendering
of the moment when Corral, the Nicaraguan president whom Walker
deposed, is about to be executed:

> And that day on which he was arrested (tried by court-martial
> and the prisoner threw himself at the mercy of Walker,
> and Walker: that the prisoner would be shot at noon)
> ladies came, with Señora Corral and her three daughters weeping
> the youngest two embracing Walker's knees:

and he, in between officers and surrounded by his Cuban bodyguards.
And we filibusters outside listened in silence.
And that man, who'd had a sweetheart in Nashville,
Helen Martin, a deaf-mute,
who died of yellow fever,
—for whom he learned the language of hands
and together they'd make silent signs in the air—
as if a fleeting compassion like the batting of an eye-lid
had then crossed his eyes of colorless ice
lifting his hand he said:
—that Corral would not be shot
at noon, but at two in the afternoon.
And we saw the town square overshadowed by a cloud,
the still palm trees, the Cathedral, the great stone cross
and at the end of Main Street, like a wall, the leaden lake.

"With Walker in Nicaragua" is a narrative poem; "Squier in Nicaragua," a long lyrical poem rather like a Pound Canto, is both simpler than "With Walker" and more complex. Ephraim Squier was the U.S. chargé d'affaires to the Central American republics, a diplomat with an interest in archeology, who wrote a book about his travels, *Nicaragua, Its People, Scenery, Monuments, and the Proposed Interoceanic Canal*, in 1852. Squier is a very entertaining writer, and if Americans had a taste for their own travel literature, his book would be in print. It is writing from an era of frank imperialism, and Squier's social and political attitudes were probably conventional enough.

Cardenal, in adapting his source, leaves these explicitly political materials alone. His Squier is the travel writer, amazed at the lushness and beauty of the country:

Green afternoons in the jungle; sad
afternoons. A green river
going through green pastures
green marshes.
Afternoons that smell of mud, rain-soaked leaves, of
wet ferns and mushrooms.
The green, moss-colored sloth
little by little climbing . . .

Though there is something of Neruda in this, the rhythmic model seems, once again, to be Pound:

> Autumn moon; hills rise about lakes
> against sunset.
> Evening is like a curtain of cloud,
> a blur above ripples; and through it
> sharp long spikes of the cinnamon,
> a cold tune amid reeds . . .

The rhythms of the verse are hypnotic, like a steady ripple in clear water, and they suggest a traveler both dazed and alert. Cardenal makes no use of Squier's wry social observation, or of the descriptions of the life of the cities, the cockfights, the pre-Columbian ruins. There is a glimpse of political violence in the poem, of cities on fire, but it does not seem different from the green blaze of the jungle. The landscape is above all—and deeply—sexual, and it is full of women:

> A black boat lashed to the shore;
> in the water a woman with bare breasts
> and a purple skirt,
> washing clothes on a white rock,
> and water up to her knees;
> and her long straight hair was falling freely to the water . . .
> Níndirí, beautiful Níndirí:
> oranges, golden bananas, icaco plums,
> gold among the leaves.
> Girls the color of chocolate,
> their breasts bare,
> spinning white cotton among the trees . . .
> the flower of the malinche, the sacuanjoche flower,
> in their curl and braids black as jet.
> Smiles on lips rouged with anato.
> And the girls of Masaya
> with their large red earthen jars and pots
> and their white sleeveless blouses . . .
> The girls of Managua
> toward evening would go singing down to the lakeshore

to fill their watery jars.
Silvery sardines were leaping up in the water.

On the surface of the writing is the sheer beauty of the place seen through a foreigner's eyes. It is only by implication that we understand Squier to be participating, unconsciously, in a rape:

A green cross next to a spring,
decorated with dried wreaths,
and a little boy sitting at the foot of a cross.
And so I asked him why the cross was there:
It commemorated a horrible crime, he said.
And I learned nothing else about the cross,
except that the victim was a woman.

There are two remarkable things about these poems besides their gorgeous imagery. One is that the author grants his Yankee despoilers their point of view; the poems are an authentic act of historical imagination. The other is that, though they foreshadow the tragic political history of Central America, they convey into the present those first travelers' sense of wonder and freshness. It is the erotic current in Cardenal's love of the Central American landscape that does this. The poems describe a land that is resilient and luxuriantly possible.

Cardenal's later poems, indeed his entire remarkable career, are an exploration of this possibility. Jonathan Cohen's volume ends in 1954. In that year the young Cardenal became engaged in a plot against the elder Somoza. It was uncovered, and though he escaped torture and execution, some of his friends did not. In 1956, acting on his decision to become a priest, he entered the Abbey of Gethsemani in Trappist, Kentucky, where his spiritual director was the poet Thomas Merton. Cardenal was ordained in 1965 and founded a spiritual community among the Nicaraguan peasantry in the Solentiname Islands that tried to put into practice a conception of Christian social justice and become an important center for Latin America's developing theology of liberation. In 1970 he visited Cuba and experienced what he described as "a second conversion," which led him to formulate his own philosophy of Christian Marxism. In 1977 the younger Somoza destroyed the community at Solentiname

and Cardenal became the field chaplain for the Sandinista National Liberation Front, and in 1979 he became the Nicaraguan minister of culture. This development can be traced in many volumes of poetry and prose, some of which have been translated into English.

Cardenal's poetry in the 1960s is rich in variety and as fine as the early work. The poems of the 1970s, a very difficult time in his country, are not always so successful, I think. There is a tendency in them to make of the revolution a symbol that answers all questions, as in this poem translated by Donald Walsh:

> That was my Vision, that night in San José de Costa Rica:
> all of creation even on billboards was groaning in pain
> because of man's exploitation of man. All of creation
> was screaming, screaming with great shouts for
> the Revolution.

This makes a static symbol of what one knows is a process. The history of this century has taught us that, however inevitable a revolution may be and however just, what follows in its wake is the settling of scores, the rebuilding of ruined economies, the countermoves of more powerful states, a tug-of-war between revolutionary idealism and human nature that gets decided as often as not in prisons. Reading Cardenal's later poetry, one wants to turn again to the no less adamant but more reflective tones of another poet whose country has suffered from its proximity to powerful and jealous states; the Polish writer Zbigniew Herbert is less tempted by the idea of apocalyptic transformation and it makes his tone seem saner and more focused, in these lines, for example, from a recent book:

> My defenseless country will admit you invader
> and give you a plot of earth under a willow—and peace
> so those who come after us will learn again
> the most difficult art—the forgiveness of sins.

But it's a little tricky for an American writer these days to lecture a Nicaraguan writer on the forgiveness of sins.

1987

II. A LONGER ESSAY ON LITERATURE AND WAR

study war no more: violence, literature, and immanuel kant

1.

In the spring of 2005 I was invited to the Republic of Korea to partici-pate in an international literary conference. The subject they asked me to address was the idea of "perpetual peace" in the literary imagina-tion. If I ever knew that Immanuel Kant had written an essay with that title, it did not leap to mind. My one thought was that it was almost impossible for a citizen of the United States to think about this idea two years after the Bush administration had stampeded the country into the invasion of Iraq, an event that was, for people who understood what was happening, like watching a train wreck one was helpless to prevent. The claims made to justify the invasion by the American gov-ernment were known, by any reasonably well-informed person, to be false; millions of people all over the world demonstrated in the streets against the invasion; popular support for the invasion in the United States was never much more than half of the adult population and far less than half among U.S. allies like England, Poland, Spain, Italy, and Korea, which had been persuaded to give some military support to the United States. The invasion occurred anyway. The television newsreaders dutifully read the government's propaganda on the air, the TV screens were full of images of rippling American flags and roll-ing tanks accompanied by the strains of stirring martial music, and official opposition to the war, even official caution about its prudence,

was limited, for all practical purposes, to a single elderly senator in the opposition party.

The main consequence of the war so far has been the death of a very large number of innocent Iraqi civilians and the flight from their country of two and a half million others who could afford to leave. The country is in such chaos that it's impossible to get an even remotely accurate count of the casualties, but the most conservative estimate is one hundred thousand people, and the count may be as high as half a million. These are civilian casualties. A significant part of that number has been children. That means—inside a head made slightly demented by the violence that is invisible to us here in the United States—that the average length of these dead Iraqi bodies must be no more than four feet, and so, taking the median casualty estimates, that would mean that, if you laid out the dead in a straight line, head to toe, along Interstate 80 on a cold spring afternoon like this one, they would reach from San Francisco to somewhere between Truckee and Reno. If the higher estimates are accurate, possibly to Salt Lake City. Swaddled mostly in black, dusted with new snow.

How did this happen? And why are ordinary Americans not being driven crazy by it? Writers continue to write their poems and stories about their own worlds and their private feelings, professors profess, the merchants open their shops, and almost everyone either sits in cafés on Sunday reading about the war over foamy cappuccinos or goes to church and prays and sings with, in my brief observation, clear hearts and consciences. Some of the Catholics and Baptists even meet after church, so intense is their reverence for life, to plan strategies for persuading young women with unwanted pregnancies to bear children and put them up for adoption rather than destroy the fertilized eggs in their wombs. Given this reverence for life, you would think whole communities would be on their knees rubbing their hair and faces with ash to express their remorse for the suffering of the people of Iraq. But it is not so.

Which returns us to the question of how the war happened. Fear seemed to have driven the American public, fear and anger and an almost complete ignorance of the history, geography, and cultures of the Middle East. For this latter deficiency, they should not necessarily be blamed. There is no reason why a waitress in Iowa or an accountant in San Diego should know what happened in the 1930s when the British

invaded Iraq with the intention of securing its oil and fixing its government. Nor should they be expected to know the difference between a Sunni and a Shiite Muslim. Or why bombing Saddam Hussein because of a terrorist act perpetrated by Saudi Arabian Wahhabi Muslim terrorists would seem to peoples in the Middle East an act of pure aggression against all Islamic cultures by a power that could not distinguish among them. People have bills to pay, children to pick up from school. These complexities are what representative government is for and they are also a principal reason for freedom of the press.

The failure of elected officials and of the press has been in this way quite staggering. According to a recent newspaper article, the second-in-command in the Bush administration's office of public relations, designated to influence public opinion in the Middle East, doesn't know the difference between a Sunni and a Shiite Muslim. At the time of the invasion, according to polls, the majority of Americans believed that Saddam Hussein was responsible for the acts of terrorism against the Pentagon and the World Trade Center, and—notice this—so did the majority of American elected officials in our cities, towns, and states. This testifies to the success of the administration's war propaganda, but it is nevertheless on the part of the press and the elected officials morally culpable ignorance. The moral and intellectual failure of American journalists and of political and policy intellectuals was breathtaking, an almost complete—to borrow Julien Benda's phrase— *trahison des clercs,* a nearly complete sellout by the institutions and people who make their living reporting on government, who seemed mainly either to be seduced by the self-confidence of the Bush administration or intimidated by the threat of the loss of access to power.

As for the press once the war was under way, the U.S. military and its civilian administrators had learned from the experience of the Vietnam War that one key to civilian support for a war was control of the people reporting on it. In the intervening years they had come to understand that the best way to control journalists was to give them what they wanted. And what they wanted was "hot news," not background briefings, not statistics designed to maintain the morale of troops and civilians on the home front, not ideological reiterations of the justifications for the war or the war strategy, and not reminders, when confronted by military setbacks or atrocities or local civilian suffering, of the officially rosy larger picture—these had been the style of

the entirely misleading military press conferences for journalists in the Vietnam War, in which communications officers from the commanding general's staff read fictional numbers of enemy dead to skeptical reporters who then went into the combat zones to report for themselves apparent facts that tended to undermine the official story and also to be visually compelling.

But in the twenty-five or thirty years since Vietnam, American television had also changed. Cable television had created the twenty-four-hour news channels familiar to the world from CNN, and these many channels were engaged in intense competition for the advertising dollars that produced their income. What was required were vivid and exciting images that made viewers feel good about the war and the American young who were fighting it. This was achieved by embedding journalists in military units where they were more or less compelled, by their angle of vision and by the men around them who were protecting their lives, to take the American combat soldiers' view of the experience and to have as little access as possible to the point of view of the enemy or of the helpless civil society of Iraq, which was caught in the crossfire. In return the employers of the reporters got what they needed, television images that made war seem heroic, young Americans brave and heroic. The military, as a matter of policy, released no statistics on Iraqi civilian casualties and forbade any photographing of the care or transportation of the bodies of American dead. So the American public was insulated from the horror of war. It was a stunning and appalling public relations victory for the war party in Washington, and profoundly dismaying to observe for people of my generation who had some memory of the journalists of the Vietnam era, many of whom allowed one to believe in the survival of an occasional respect for facts, even in wartime.

Seeing how easy it was for the administration to persuade the American people to give up some of their sons and daughters to this war and to shut out of their conscious knowledge the suffering they were inflicting, seeing how easy it was for whole classes of journalists, military men, intelligence officers, politicians, diplomats, and academics to be silenced, intimidated, or marginalized so that the fictional reasons for the war could be floated, is one of the reasons why I felt my own imagination shrinking from any idea of "perpetual peace."

. . .

"We have fed our hearts on fantasy," the Irish poet William Butler Yeats once wrote, "and our hearts grew brutal on the fare." It seemed to me, in my dismay, easy to think of perpetual peace as one of those sentimental ideas that bred brutality. The only way to maintain wholly unreal ideals is to make sure that the right hand never knows what the left hand is doing, but the right hand, of course, does know what it has elected not to know, and why, and this knowledge breeds a cynicism about the behavior of others that makes brutality possible by making it seem inevitable. One comes, thinking this way, to very dark conclusions, even before one has even begun to turn to the question of the role literature can play in making sense of, let alone having an effect on, such a world.

What began to make it possible for me to make that turn was a reading of Immanuel Kant's great essay on the subject. It was published in 1795. Its title is *"Zum ewigen Frieden,"* in English, "On Perpetual Peace." Before I got to it, I had wondered whether the originators of this idea for a panel in Korea could have understood the principal connotations of the words in English. They called to my mind two phrases from the Mass for the Dead in my Roman Catholic childhood. One was, of course, *"Requiescant in pacem,"* "May they rest in peace." The other, also from the Mass for the Dead, was *"Lux perpetua luceat eis,"* "May the perpetual light shine upon them." I had sung them both all through my childhood; I thought, somewhat bitterly and ruefully, that these echoes were entirely appropriate, and that the idea of perpetual peace was not only naïve, it was, as an ideal, undesirable. It was undesirable because life is conflict. One might speak of nonviolence as an ideal, or pacifism as a philosophical or even a tactical relation to human violence; one might speak of peacefulness as a social habit or tranquility as a spiritual one, but, I thought, if those ideas are worth valuing, they are worth fighting for, and some lines from William Blake's "Jerusalem" came to my mind:

Bring me my Bow of burning gold:
Bring me my Arrows of desire:
Bring me my Spear: O clouds unfold!
Bring me my Chariot of fire!

I will not cease from Mental Fight,
Nor shall my Sword sleep in my hand,
Till we have built Jerusalem
In England's green & pleasant Land.

Blake believed that the human imagination was born from conflict. Limitation, against which it must always rebel, brought it into being. Which inclines me to think, in fact, that symbolic violence, the transformation of violent impulse into image, may be one of the essential levers that brings imagination into being. So, I had wanted to say, as to the idea of perpetual peace, forget it. The only people who are fully at peace, as the Korean phrase translated into English unconsciously suggested, are the dead. It turns out, of course, that this was exactly Immanuel Kant's joke. Or rather the joke of the Dutch shopkeeper whose sign Kant glimpsed sometime toward the end of the eighteenth century and its interminable small wars. Carved into the sign on a tobacconist's shop was the image of a graveyard and of a man contentedly leaning against a gravestone and smoking a pipe. Underneath him the phrase "To Perpetual Peace" was inscribed. So might a harried shopkeeper nod sardonically toward his final reward. And thus was the phrase translated from Dutch into German, from German into Korean, and from Korean into English, so that I, remembering the Church Latin of my childhood, could misunderstand it. But my misunderstanding was good preparation for the surprise and nobility of Immanuel Kant's essay. Against common sense, against the sound skepticism of Dutch shopkeepers and the cynicism of "heads of state," to quote Kant, "who can never get enough of war," he had taken up reason, philosophy's bow of burning gold, and tried to see what a sane and reflective intelligence could say about the dream of an *ewigen Frieden*.

The example of Kant, his refusal to give in to despair or cynicism, made me think that an essay like this might be possible. Kant proposed six preliminary articles for peace among nations and three definitive articles. Reading them, these few pages with their list of eight or nine ideas seemed to me a remarkable moment in the relatively brief history of human consciousness. Someone had proposed the idea of thinking through in a reasonable way, outside the context of any particular religious or tribal ideal, how one might go about eliminating or at least minimizing warfare among peoples.

His ideas, of course, reflect the historical experience of the European eighteenth century. One of his preliminary propositions addresses war as a habit of mind: "No treaty of peace that tacitly reserves issues for a future war shall be held valid." It is less a legislative proposition—intention is next to impossible to regulate—than a definition. Two of the remaining articles are, in effect, counsels for disarmament: "Standing armies shall be gradually abolished" and "No national debt shall be contracted in connection with the foreign affairs of the nation." The other two define sovereignty: "No independent nation, be it large or small, may be acquired by another nation by inheritance, exchange, gift, or purchase" and "No nation shall forcibly interfere with the constitution and government of another." A final article addresses limiting the means of waging war that make future wars more likely; it is a start on international conventions for the regulation of warfare.

And just as the final preliminary article anticipates the Geneva Conventions, which the U.S. government has felt justified in selectively ignoring in its treatment of prisoners during the wars in Iraq and Afghanistan, Kant's three definitive articles imagine a global structure of governance that would tend toward the establishment of peace. First, he says, the civil constitution of every nation should be republican. Secondly, the rights of nations shall be based on a federation of free states. And finally, there should exist among states a right of what he calls "universal hospitality." This implies the free circulation of peoples and ideas: the right of aliens not to be treated as enemies in another's country and the right of all humans to associate "by virtue," he says, "of their common ownership of the earth's surface." The rest of the essay is a reflection on how, practically, these propositions might be first instituted and secondly guaranteed. I will not attempt to summarize his thought, but only remark that the definitive articles themselves are so far-seeing that we are still trying to establish the ideals he proposes and find the grounds for their guarantee.

I rehearse them here, really, out of wonder. They were produced in the same century that produced *Candide*, that famous cure for innocence. And "On Perpetual Peace" is not exactly innocent. It insists, in fact, that violent war and its expectation are the natural condition of man, and that the state of peace is unnatural and must be struggled toward. Its nobility is its rebellion toward innocence and against the brutality of things-as-they-are. The essay is one of the most admirable

documents of the European Enlightenment. It is an act of imagination that issues from an impatient hope that human beings can eventually be led to what is both prudent and good through the use of reason.

2.

This is peroration, a way of saying that reading Immanuel Kant led me to wonder if his essay embodies what reason brings to the idea of perpetual peace—though two still more violent centuries intercede between the composition of his essay and the present, during which technologies have increased immeasurably the human capacity to destroy not only human lives and cultures but much of the rest of the biological life on earth—what the literary imagination has had to contribute.

But I am not quite done with casting doubt on this enterprise. We do not know, in the first place, how old literature is, in the sense of song-making and storytelling. We get our first glimpse of it at the horizon of literacy, which even in the most precocious cultures occurred only two or three thousand years ago—and the record in all of those cultures is that the storytelling, singing, and mythmaking began with some form of the glorification of a masculine warrior ethos. There are evolutionary reasons for this, no doubt, rooted in hunting cultures and in the allied skills necessary for self-defense in times when the relation of each tribe to every other was, as the earliest records suggest they were, piratical at best. We can see the instinctual mechanisms of it in male competition for dominance across the mammal species. Also, in humans and other animals, territoriality seems deeply instinctual, especially for humans as it exists among children, and in adolescents and young adults as strategies of affiliation through violence in our crowded cities. It is there in the *Iliad* and the *Odyssey;* in the apotheosis of the warrior Arjuna in the Bhagavad Gita; in *Beowulf* and the *Nibelungen* tales; in the psalms of David, which are shot through with tribal self-righteousness and violence; and in the Book of Kings. It is in the countless Chinese and Japanese tales of noble warriors and self-immolating retainers. It finds its smooth and half-ironical summing up in the verses of Horace: *"Dulce et decorum est pro patria mori."* In Korean literature its evocation of unquestioning loyalty to political authority is in the classic *sijo* of Chong Mongju.

Of course, it has been argued that the poems of Homer convey a

tragic sense of war. And so they do: the death of Hector and the grief of Priam and the ruin of Troy, the death of Patroclus and the death of Achilles have been deeply imprinted in the world's imagination. And so also the wanderings and suffering of Odysseus. And it has been argued, though no one is quite sure how Virgil intended to conclude the *Aeneid*, that its concluding image, the moment when Aeneas hesitates and then plunges his sword into the gut of his rival and enemy Turnus, is an emblem of the violence of war as original sin, of the founding act of Roman power—and by extension all earthly power—as an act of violent usurpation. And it has been observed that *Beowulf* is profoundly elegiac, as indeed are all the oral poems in the old Germanic languages. And it has been argued that in all these ancient poems war itself is a kind of metaphor for nature, which takes from us all, eventually, our youth and our strength and our beauty, so that war has the special beauty of taking these things from us while we still have them. And it seems to me that it is for this reason that, even though the evocation of war in the greatest of our early literature is tragic, it makes the meaning conferred by the tragedy of war immensely attractive—so that over and over human beings have made the choice of Achilles. They have preferred the dead lion to the living lamb.

Perhaps the sense of the tragic in these stories, a sense that we might imagine would cause some humans to pause longer at the threshold of violent behaviors, reaches deeper into some minds and hearts than others. It may not be the case that these stories are so attractive and so memorable because they are war stories, but everybody knows, for example, from the history of film that it is practically impossible to make an antiwar film that does not at some level make war seem attractive. It is not just the hugely popular fantasies that celebrate violence and killing and the taking of revenge against a usually faceless (but racially coded) form of evil, the films of Sylvester Stallone, or the comic fantasy violence of the brilliant upstart in the films of Jackie Chan, or the dream of murderous violence as a form of balletic, even supernatural grace in samurai films and Hong Kong thrillers. These are the films that the world's audiences pay billions of dollars a year to see and see again. They seem to be what the human heart craves. But films of more complicated moral intent can make war seem equally attractive. The American writer Anthony Swofford describes in *Jarhead* his experience in a pla-

toon of marine snipers in the first Iraq war. One of the stories he tells
is about the leisure time of the warriors in training. Together they
watched all the antiwar films that had been produced in response
to the Vietnam War, films like *Platoon* and *Full Metal Jacket*. They
watched them, he said, to feed a kind of warrior lust, a sense of exhil-
aration at the root of their training. Even if the heroes of those films
came to a solitary understanding of the horror of war, what made the
films so attractive finally was that the soldiers had to go through the
war to acquire that understanding. The sort of moral orphaning, the
loneliness in the universe that those young men acquired and that
Swofford's recruits in the desert recognized, was a gift that war gave
them. And if antiwar films have this effect, we do well to wonder how
deeply the sheer misery, cruelty, and waste of war ever penetrates
human consciousness.

The truth is that we have no control for testing the proposition that
literature or philosophy, or religion for that matter, has had any miti-
gating effect on the violence of human behavior. This is the only world
we've had and it is an exceedingly violent one, made more violent in the
last hundred years by the enormous inventiveness of human technol-
ogy and the greater ability of nation states to mobilize vast populations
for the purposes of war. We know that the human heart loves images
of superior strength, loves especially the combination of superior physi-
cal strength with superior agility of mind and nobility or gracefulness
of demeanor. It loves vengeance, though there is some hope in the fact
that, through some scruple in our natures, it loves vengeance against
those who have done harm to the innocent and the weak, and it con-
structs plots, just as nation-states construct ideological justifications for
war, that allow for this moral gratification of the love of violence and
vengeance. Would some better and more powerful act of imagination
make the world any better than it has been? Is the world better than
it would have been had there been no songs or stories that rebelled
against the violence in our natures and mirrored it back to us in a way
that might have made us, or some of us, hesitate? There isn't a control
for this experiment. We have no way of knowing.

Except that we know, perhaps, that it is better to speak than not to
speak. One of the twentieth century's instructors in this fact has been
Czeslaw Milosz. Here are some lines that come to my mind in this con-
text from a poem of his called "The Spirit of the Laws." It was written

in Washington, D.C., in 1947, where he found himself in the wake of the destruction of Warsaw:

> From the cry of the children on the floors of stations beyond time,
> From the sadness of the engineer of prison trains . . .
>
> With the silenced memory of dead friends,
> And the silenced memory of towns and rivers,
> I was ready to tear out the heart of the earth with a knife
> And put there a glowing diamond of shouts and complaints,
> I was ready to smear the bottom of the roots with blood
> To invoke the names of their leaves,
> To cover the malachite monuments with the skin of night
> And write down with phosphorus Mene Tekel Upharsin,
> Shining with the traces of melting eyelids.

It is better to speak than not to speak, even if our speech is violent resistance to violence.

3.

Notice that I have begun to speak of literature as resistance—not as a flowering, not as a pulse of the irresistible force of life, but as a restraint upon that force. This past weekend I met my daughter and her family in Chicago. We were going to spend a day in the big city and take my grandchildren to the Art Institute. I was a little surprised that they were so willing, in fact eager, to go to a museum. It turned out that what the boys, aged eight and ten, looked forward to seeing was the museum's large collection of armor and weapons. Both of the boys are at an age when, if I say so myself, they look like Botticellian angels. I regarded their shining eyes and their rosy cheeks and their blond curls for a moment and set out in search of the armor. As it happened, the way there led through the galleries of Asian art, where we faced, as we were passing, seated on a pedestal, a very beautiful eighth-century Cambodian Buddha carved from granite of soft gray-brown, legs folded, eyelids shut, the index finger and thumb of each hand touching to enclose the circuit of contained and overwhelmingly peaceful energy that the figure expressed. The gran-

ite glowed under an artfully placed light, and I said to my grandsons, "Okay, if we are going to go look at the armor, we need to stop here a minute," and I told them the story of Prince Siddhartha, how his father had brought him up in a kingdom in the Himalayan foothills in such a way that he would never see any form of human suffering, how, when he was a young man and curious, he snuck out of the palace compound and visited the local village, how he saw there a sick man and a poor man and a beggar and a corpse, and how, overcome with infinite sorrow at human suffering, he vowed to set out on a path that would lead him to overcome the violence in the human heart. I looked into the face of my eight-year-old grandson, who was looking up at the Buddha. He had an expression on his face of almost perfect patience. I understood that he understood that I was, in effect, telling him to wash his hands before dinner. We walked the rest of the way through the Asian galleries and then we came to dinner. It would suit my purposes if what we first saw was a savage, old, brutally efficient Mycenaean battle helmet with eye slits and a nose guard, but what we came to first was a whole suit of French armor from the thirteenth century, ornamented with patterns of fleurs-de-lis, and covered in chain mail that actually looked fairly delicate. "Cool," my grandson said, and stared at it for a long while, before we moved on to the rest of the helmets, swords, daggers, pikes, lances, maces, gauntlets, battle-axes, and flails. (All of it brilliantly worked in metal. The granite that the Buddha was carved from is rock from the earth's first cooling reheated to burning under intense pressure. Human metalwork is a replication of that process. Looking at the armor, you could almost hear the sound of the smithy's hammer. We were staring into the fire of transformation through which the human species had come to control most of the forms of life on earth.)

4.

So I can think of three ways in which literature has resisted the imagination's love of war. The first, though not the earliest in the history of literature, is by imagining peace. The second is through laughter. The third is through witness. There are probably others.

The first antiwar speech in the European literary tradition is the one delivered by the bandy-legged Thersites in the second book of

the *Iliad*. He is presented as an ugly little man, a cynic, the stomach's response to the heroic ethos, and Odysseus promptly beats him down. But he spoke up, and his voice has echoed through the centuries. He is our first glimpse of the satiric and comic view of war. Homer's contemporary Hesiod wrote the other poem that comes down to us from the oral tradition in Greece. *Works and Days* is something like a farmer's almanac. It recommends to landowners that they begin planting before the Pleiades have sunk into the sea and that they honor the gods, avoid war, and, if they can, avoid lawyers. The poem initiates a long tradition, but set next to the *Iliad,* the great poem of warfare, and the *Odyssey,* the great poem of revenge, one would have to conclude that its sensible advice has not exercised a particularly strong hold on the human imagination.

The next important reframings of the heroism of war that I'm aware of both came from fifth-century Athens. And they take quite different approaches. First, there is Aristophanes's *The Peace,* a comic parable about the search for peace in what might be called the Hesiodic tradition. It was followed, six years later, by *The Trojan Women,* in which Euripides wrote the first searingly angry depiction of the horror and senselessness of war. *Lysistrata* came four years after that. All three plays were probably elicited by the brutal Athenian occupation of the island of Melos during the Peloponnesian War, which we know from Thucydides's great and coolly terrible account of it. The Melians asked to remain neutral during the war with Sparta. The Athenian navy invaded the island, killed all the adult males, raped the women, and sent the women and children into slavery, an event that, according to Thucydides, put an end to Athenian democracy. It is not without meaning that both of these later plays were written by men from the point of view of women. It seems that they needed to step outside the male ethos in order to speak their thoughts. It's instructive to see that all three traditions are here at the outset.

Let's look first at what would seem to be the least promising of them, the imagination of peace. There are ways in which poetry, or at least some poems I love, have embodied an idea of peace so that humans can hold it in mind. The poem that leapt to my mind was a haiku by Basho, because it is one I often say to myself as a sort of mantra, a way of calling myself to calm or to evenness of temper. It is a poem that appears in his *Narrow Road to the Far North,* and it begins with a note, indicating it was written at a hermitage where the travelers had stopped for the

evening and done some work in exchange for their dinner. It reads in English translation:

A cool fall night—
getting dinner, we peeled
eggplants, cucumbers.

It seemed, it still seems, a joke, like Kant's joke at the expense of philosophy, to hold this small poem up to the whole history of human violence, and yet there are powerful reasons for doing so. It is not an accident that the poem takes place at a hermitage or a monastery. It is not an accident that it is almost ridiculously simple, too simple to be a poem at all. Nor is it an accident that it is about paying attention to the most ordinary human experiences, or that the *kigo*, the seasonal reference in the poem, "a cool fall night," is, by its association with the change of seasons signaled by a new sharpness in the night air, a traditional figure for awareness of mortality. This is a poem about the preciousness, the almost silly preciousness of the most ordinary experiences and about the fact that we are all going to die someday. Its aesthetic and its spiritual tradition is specifically Buddhist. The hermitage in which the poem is set implies a withdrawal from worldliness, from the violence of the world.

There are, so far as I know, in the history of the world two figures who have stood powerfully against its history of violence. They are Christ and the Buddha. Christianity, of course, is hardly a pacifist religion. It has, like Islam, a history of zeal for conversion by the sword and for the warrior ethos. But there is explicitly in the teaching of Jesus of Nazareth and occasionally in the history of Christianity a profound resistance to violence against life. I have a less clear sense of the history of Buddhist civilizations, and I am sure that pious Buddhists have also found ways to pick up the sword, but respect for life seems to have been nearer the center of Buddhist practice than of Christian. I could be wrong about this and merely idealizing a tradition I understand less well. Nevertheless, it is from these traditions, I think, that resistance to violence and the embodiment of an idea of peace in literature have principally drawn.

Though perhaps there is, in the European world, the earlier tradition. I am thinking about Hesiod, and also about a phrase of Ezra

Pound's, "Mediterranean sanity." Pound associated the Christianity that he knew with an unhealthy dualism about the body and the soul and an unhealthy devaluing of the body, nature, and the natural world. In his early poems he tried to reimagine, as many other aesthete-poets did at the turn of the twentieth century, the terms for a viable revival of paganism. Part of what I think he had in mind was a sort of realistic pastoralism in the Greek and Roman admiration for abundance and good order, for fields of ripe grain and for grape harvests and for the loveliness of winds whitening an olive orchard. It is from both Buddhist and Christian points of view, I think, a secular and a worldly tradition, though a very rich one. And it has its moments. One of them is this wedding song from one of the plays of Aristophanes, *The Peace*. The play was performed in 421. This song and another in *The Birds* are the oldest surviving processional wedding songs in a European language and they probably survived as models for the wedding poems of Catullus written three hundred years later. In English translation it reads like this:

It's time to say words of good omen
And to bring forth the bridegroom and the bride.
It's time to raise torches and dance and rejoice.
We can take harrow and plow and sharp scythes back to the fields
Once we have danced and poured wine and chased out bad luck,
And after we've prayed to the gods of the earth, sea, and sky
To help us to an ample life, to grant us a good crop of barley
And plenty of wine and the sweet meat of figs,
And that we bring forth children, supple limbed, loud at their play,
And that all the good things we lose by war
Are returned to us when we gather ripe fruit for the wedding feast
And the fiery sword has been put away.

(It is worth observing that Euripides, six years later in *The Trojan Women*, used the meter of this song for Cassandra's frenzied lament at her rape by Agamemnon.)

If this is the worldly tradition of resistance to violence, the other poem that came to my mind, quickly, on the heels of my thought of Basho, was a very famous poem about peace by William Butler Yeats. It is "The Lake Isle of Innisfree":

I will arise and go now, and go to Innisfree,
And a small cabin build there, of clay and wattles made.
Nine bean-rows will I have there, a hive for the honey-bee,
And live alone in the bee-loud glade.

And I shall have some peace there, for peace comes dropping slow,
Dropping from the veils of morning to where the cricket sings;
There midnight's all a glimmer, and noon a purple glow,
And evening full of the linnet's wings.

I will arise and go now, for always night and day
I hear lake water lapping, with low sounds by the shore;
While I stand on the roadway, or on the pavements gray,
I hear it in the deep heart's core.

I think I thought about this poem in connection with Basho's because they are both poems of retreat. Students of Yeats know several things about this poem. One is that Innisfree is a place in the west of Ireland where the Irish language was still spoken and that therefore was considered after centuries of brutal British colonial occupation a purer and truer Ireland and nearer to the ancient essence of the Irish national character. Another is that Yeats was inspired to write this poem by his reading of Henry David Thoreau's *Walden*. So Thoreau's record of his withdrawal to a hermitage at Walden Pond near Concord, Massachusetts, a record from which the American environmental movement may be said to have begun, also sparked the Irish poet to imagine a similar withdrawal. Yeats lived in London. He was sociable, a man of the theater, and in his later life a politician. As beautiful as it is, I have always thought of this poem, therefore, a bit skeptically; it seemed a busy man's daydream, which perhaps it is, and deficient as a work of art for that reason. But I have come to see that there is another way of thinking about the poem. It is deficient perhaps as a description of a realizable place on earth, but it is not deficient as a description of a place held close to the heart.

It is not irrelevant that the Henry David Thoreau who wrote *Walden* is also the man who invented nonviolent civil disobedience when he refused to pay a tax to support the Mexican-American War of 1846 (like the Iraq War, one of America's adventures in invading another country to liberate it from tyranny). Thoreau went to jail for his refusal and

wrote an essay about it. Thoreau's essay was read by the South African lawyer Mohandas Gandhi, who put Thoreau's idea into practice in India on a national scale in order to resist British colonialism; Martin Luther King studied Gandhi's example and forged a Christian form of nonviolent civil disobedience to help African-Americans to resist and overthrow the American version of apartheid. It is a strange mix of cultural traditions: something flinty and individualist in New England Protestantism, and the deep streak of asceticism in the Hindu Gandhi, and the powerful millenarian longings stirred in the African-American Christian churches by the biblical story of the Jewish people freed from Egyptian bondage. There were in each of these traditions, and perhaps a weaker though not less real one in the aestheticism of the Irish poet, sources for resistance to the world and its instinctual violence.

It is also important to notice here that the two times in modern history when the idea of nonviolence became a force for political change occurred not because literature lit a torch in the human imagination but because the ideal of nonviolence allied itself to powerful religious traditions. Gandhi was able to connect the nonviolent ideas of Thoreau and Tolstoy not only to the Indian desire for national self-determination and an end to imperialism but to very powerful, deep, and ancient currents in Hindu asceticism. Martin Luther King married Gandhi's nonviolence to the profound millenarian longings in Southern African-American Christian churches. It is probably the case—at least it has been until now the case—that religion penetrates much more deeply into cultures than literature does. Written literature is one expression of a nation's public culture, one of the places where its values are embodied and transmitted. It is also, in practice, an important part of the way that each society's sense of its ideological commons is transmitted through the education system. And it is, for those not directly engaged in education, a leisure activity of the educated class, as most of the popular arts, movies, TV, music, are the leisure activities of the whole society, whereas religion might be described as a set of communal practices around commonly held symbols of the sacred.

The important thing about this—from the point of view of this discussion—is that the imagination of peace in literature has almost always derived from religious traditions, perhaps because religion, as a set of practices and beliefs, reaches deep into the daily life of peoples and into their private, as well as their public, culture. It affects not only

their sensibilities and evolving ideas about their lives but the way they marry and eat and have sex and practice hygiene and take care of the ill and tend to the poor and educate their children. And it may only be through some force like religion that the power of the imagination of violence can ever, very deeply, be contained. I say this with some wonder, since I inherited in the course of my own education the European Enlightenment's distrust of organized religion.

5.

War and laughter.

The laughter comes in two forms: the satiric and the comedic.

One of the interesting facts about the history of war in Europe and the United States has to do with the ways wars have been commemorated. I have read that the practice of publicly honoring fallen soldiers is a relatively recent innovation and that it was brought into existence by the plebiscite. Before the advent of democratic elections, military victories were honored by statues of generals or the public display of some sort of war loot, e.g., an Egyptian obelisk set down in a square in London or Paris, or by the creation of some ceremonial arch that dignified imperial power. Only when heads of state became accountable to the citizenry for the fates of their sons did nations begin to find ways to memorialize the ordinary soldiers and sailors who had previously, though the historians do not exactly say this, been either mercenaries or a drafted peasantry and hence cannon fodder assumed to be included anonymously in the gesture of national greatness. Thersites would no doubt have his say about this late onset of public piety—from the tombs of the unknown soldiers in France and the United States to the simple and eloquent listing at the Vietnam War Memorial in Washington, D.C., of the names of the fifty-five thousand American dead. (It would have taken more space than a public park could accommodate to name as well the two million Vietnamese dead.)

But Thersites does not have his say in these memorials. The common soldier is remembered there as mute and a hero. And Thersites is neither of these. He is the bottom-up view of the world, the one that sees Agamemnon as a blowhard prince who sends other men to their doom while grabbing the lion's share of the women and the loot. Thersites is

the one who thinks that the male virtues of courage and loyalty are for idiots. In the history of European and American literature, at least, he has his say in comedy and satire. He is, for that reason, dangerous. He often shows up in literature paired with his opposite: Don Quixote and Sancho Panza, Prince Hal and Falstaff. One of the rich sources of all humor is discrepancy, but the distance between the ideal and the real, between war rhetoric and the actuality of war, may be too painful in its consequences to be mined very directly. Perhaps that's why these classic pairings have a way of showing up in the literary imagination. The ways in which Falstaff and Panza subvert the warrior ethos would be too threatening if they appeared on the stage by themselves. They need to be measured against some idea of the nobility and attractiveness of the ideals human beings imagine and then imagine themselves killing and dying for, just as the madness of Quixote and the mix of courage, privilege, and calculation in King Henry V need to be measured against Sancho and Sir John.

There is some hope for an understanding of peace in this dialectic of the imagination. Just as there are heroic and tragic ways of presenting images of war, there are satiric and comic ways of calling warrior virtues into question. Satire in that way opposes romance; it is the enemy of idealization. Whenever it hears ideals of self-sacrifice being evoked, it asks who is doing the sacrificing and—to use a pungent term from the habits of European tables—it asks whose bread is being buttered. Satire is the instrument of Thersites. It was also the instrument of Karl Marx when the spirit of invective moved him. Its power, always, and its threat is to ask, from the bottom up, who pays? Who profits?

Comedy, which is sometimes satiric and sometimes not, has the same contentious relationship to tragedy. I have in mind here the connection in the European tradition between comedy as a genre and fertility ritual and also Northrop Frye's way of thinking about genre in literature. If tragedy is an autumnal rite that emerged from the exhausted end of the agricultural cycle, comedy belongs to rituals of spring and the rebirth of things. Classic comedy like Shakespeare's celebrates the victory of the young over the old, the agile over the rigid, simplicity over cunning. Clowns are an important element in comedy. They represent the normal, the normally silly, the unheroic dailiness of life and its wisdom. Comedies end with marriage: they are about—to paraphrase Aristophanes—the goodness of life once we have put the

flaming sword aside. Eros and Thanatos. Comedy is on the side of Eros
as a subverter so long as it returns life eventually to the norm of social
order. It is against Thanatos in almost every circumstance. I think of
Thanatos not as an instinctual drive toward death in human beings. I
doubt there is such a thing. Thanatos is the imaginative conception of
death as escape from nature, death as glorious transformation. We feel
its presence in the stillness at the end of a tragedy, in our awe at the
power of death and the struggle of life. Martyrs love Thanatos. The
appeal of death in war must certainly lie in part in its escape from the
tedium of a normal life and from age and change. The beauty in youth-
ful death lies there; it lies in the choice made by Achilles to be a dead
hero rather than an ordinary old man with liver-spotted hands. And
comedy has no use for this view of the world.

I grew up in the years immediately after the Second World War. It
was a time in the United States when movies were the central ritual
of American popular culture. So I grew up on a steady diet of heroic
and patriotic movies. And also on a diet of comedies, including what
were called "service comedies," movies in which the protagonists were
in the armed forces. It is one of the interesting facts about the era that
produced John Wayne as an international archetype of the genial, easy-
going, and relentless American warrior that it also produced as a sec-
ond feature comedies whose protagonists were lovable cowards. Often,
usually, they behaved bravely when the moment required it. Often they
did the right thing or triumphed by accident. Usually the forces they
were pitted against were large and stupid. Sometimes they survived by
wit, sometimes by innocence. Almost always they acknowledged fear.
And they would always rather play than fight. In almost all of the films
I can remember, they would eventually back into the warrior ethos, but
their glory was the way that they called it into question.

Commercial film could probably not carry this subversion very
far. It found its way into modern literature and into the landscape of
the mechanized and almost inconceivably destructive thing that war
became in the twentieth century in figures like Hasek's Good Soldier
Svejk and Joseph Heller's Yossarian in *Catch-22*. Yossarian's dilemma
probably captures as well as anything the paradox at the center of the
heroic ethic. Yossarian can be excused from his duties as a bomber
pilot only if he is insane. And the fact that he wants to be excused
is proof of his sanity. It is part of the richness of Heller's book that

our laugh at this impossibility contains the responses evoked by both satire and comedy.

Another way of thinking about war and laughter is to consult thinkers on the psychology of humor—its sources in human life and its uses. One psychoanalyst who writes about this subject has distinguished among three connected forms of pleasure that get expressed through humor and he connects them to stages in human development. The three expressions are the smile of happiness, the belly laugh, and the quick laughter that responds to wit. The smile of happiness has its origins in the smile of the infant who gazes into the full face of the mother. It belongs, for the psychologist, to Freud's oral stage of life where we receive nurture and learn trust. The belly laugh belongs to the toddler phase of development. There is apparently a moment in development when a child, seeing a man in a film slip on a banana peel and fall down, does not cry, but laughs, and laughs richly. This change, they speculate, is connected to self-mastery. The child who can walk, who has begun to have autonomy by mastering his bowels and using the toilet, can laugh from a feeling of confidence and a perception of absurdity. This is the territory of slapstick comedy. The comedy based on verbal wit is associated with the acquisition of language (and, for the psychoanalyst, the Oedipus complex). It is the intellectual equivalent of what the belly laugh is the physical model for, but it is a more aggressive version. It sees through things; it gets the ridiculousness of pretension, of our vanities, blindnesses, benighted idealizations. It may see them sweetly or harshly, but it sees them. And perhaps these three impulses, laughter at the goodness of existence, laughter at its ridiculousness, and laughter at its pretensions, are all in the service of an imagination of life that has some power to hold at bay, or at least mitigate, the power in us of the imaginations of violent triumph and destruction.

6.

War and witness. Human beings seem unable to hold in mind the enormity of their violence or the damage it has done. They seem not, as T. S. Eliot observed, to be able "to bear very much reality." And so the function of witness has been to try to see what's there. It is apparently

the most difficult act of imagination, to see through the acts of imagi-
nation, the pictures of the world, that desire and ideology are always
constructing.

The examples are not difficult to point to. *The Trojan Women* is
probably the earliest effort, and a rare one, to create an entirely tragic
and unredeemed vision of the violence of war, and its achievement was,
as the tragic poetry of Athens sometimes did, to step outside the point
of view of the male warriors. In the twentieth century Erich Maria
Remarque's *All Quiet on the Western Front* is often described as the
great depiction of the horror of war. It was published in 1928 and the
events in Europe that followed are not an argument for the efficacy of
literature. But perhaps Immanuel Kant's essay is a counsel of patience.
Realism, as a literary movement, is two centuries old. It was born, in
part, out of *Don Quixote*, and it staked its claim as antiromance. Perhaps
the battle scenes in *The Charterhouse of Parma* and Tolstoy's *Sebastopol
Sketches* and *War and Peace* a hundred years or so into that project were
first attempts to demythologize warfare, that is to say, neither to exalt
nor attack the warrior ethic, but to describe what war is like from the
perspective of ordinary soldiers, a perspective on which Remarque's
novel and other books of that genre have built.

This struggle of the literary imagination became acute in the twen-
tieth century. "Reality," Czeslaw Milosz asked in his "Six Lectures" of
1985, "what can we do with it? Where is it in words?"

> Just as it flickers, it vanishes. Innumerable lives
> Unremembered. Cities on maps, only.
> Without that face in the window, on the first floor, by the market,
> Without those two in the bushes near the gas plant.

It is one of Milosz's themes that we cannot grasp our most ordi-
nary experience, let alone our most violent and terrible. The value
of the passage that follows is not perhaps that it "witnesses," in the
English-language sense of "bearing witness" to, a life and a death, but
its anguish at the limits of witness:

> While here, I, an instructor in forgetting,
> Teach that pain passes (for it's the pain of others),
> Still in my mind trying to save Miss Jadwiga,

A little hunchback, librarian by profession,
Who perished in the shelter of an apartment house
That was considered safe but toppled down
And no one was able to dig through the slabs of wall,
Though knocking and voices were heard for many days.
So a name is lost for ages, forever,
No one will know about her last hours.
Time carries her in layers of the Pliocene.
The true enemy of man is generalization.
The true enemy of man, so-called History,
Attracts and terrifies with its plural numbers.

Milosz's power as a poet of witness comes from the fact that he despairs of its possibility. A realist by temper, and by philosophical conviction a believer in the uniqueness and singularity of every mortal life, he has a keen sense of the inadequacy of language to its task as well as the necessity of that task. His greatest poems push language to the place where language, the linguistic enterprise, wavers.

Another European poet of witness to the horror of the European wars was Paul Celan, a Romanian Jew and German poet who had to make an account of his experience in the language that had forged the rhetoric that had sentenced his parents to death. Celan was an artist driven to tear apart and reconstruct the language he worked in. That is one form the impossibility of witness takes. It seems to me that Ko Un's remarkable *Ten Thousand Lives* is another form of the impossibility of the realist project and another defiant assault on generalization. In the versions available in English, *Ten Thousand Lives* is, as it were, Euripides's *Trojan Women* fused with Aristophanes's *Lysistrata*—an accounting of the tragedy of war exploded out of the unities of drama into the individual lyrics of countless lives, comic and tragic, terrible and kindly.

Milosz's lecture ends this way:

History is not, as Marx told us, anti-nature,
And if a goddess, it is a goddess of blind fate.
The little skeleton of Miss Jadwiga, the spot
Where her heart was pulsating. This only
I place against necessity, law, theory.

Ko Un in *Ten Thousand Lives* has placed against them the peasant women from a far village whom a boy, almost asleep on a Saturday night, hears returning home from the market town where they spent the day. Dogs bark as they pass. He can hear the murmur, but not the content of their talk, about their day, and their children, and what they have seen and what they bought and sold. Here is a bit of the poem in English translation. In Korean I am told it carries some of the rhythm of a *pansori* performance, of the storytelling style of a village storyteller:

> In darkest night, near midnight, the dogs
> In the middle of Saet'ŏ begin their raucous barking.
> One dog barked, so the next one barks
> Until the dogs at Kalmoe across the fields
> Follow suit and start barking as well.
> Between the barking of dogs
> Scraps of voices echo: *eh ah oh* . . .
> Not unlike the sound that the night's wild geese
> Let drift into the bitter cold air
> As they fly over, high above,
> Not unlike that splendid sound
> Echoing back and forth.
> It's women from Sŏnjei-ri on their way home
> From the old-style market at Kusan
> Where they'd gone with garlic bulbs by the hundreds
> In baskets on their heads,
> There being a shortage of *kim ch'i* cabbage
> From the bean fields.
> Now they're on their way home
> After getting rid of what couldn't be sold
> At the clearing auction at closing time—
> Several miles gone,
> Several miles to go in deepest night!

What the poem does, in fact, is one of the things art has the power to do. It refreshes our sense of ordinary life, and—in this case—our sense that there are lives other than our own and that people with hopes and dreams and desires are going about them as we are going about ours. Boris Eichenbaum, the Russian formalist

critic, has said that "the function of art is to make the grass grass and the stone stone, by freeing us from the automatism of perception." It may be that the small power of the literary arts to make some contribution to resisting the violence of princes, and of the human heart that princes like George Bush symbolize, lies here.

7.

I'd like to end by returning for a moment to Kant's essay. It requires an emendation. As much as Kant foresaw, he did not see the technical advances that would make war so much more lethal than it had ever been. In the twentieth century, terror became the essential tactic of superpower warfare. From the bombing of Hiroshima through the napalming of Vietnam and the "Shock and Awe" campaign in Baghdad, American warfare has been, essentially, terror, so that the low-tech use of our own strategies by fanatics should come as no surprise to us. These same technological advances have made the ecosystems of the earth so fragile that every human war is now, automatically, a war against the earth, and this is something else that Kant did not foresee. So our understanding of war requires at least two more preliminary articles.

7. No nation at war shall employ weapons systems or combat strategies whose most substantial impact is suffered by civilians.
8. Nations at war shall be financially responsible for the environmental consequences of their methods of warfare, the value of which is to be determined by a disinterested international tribunal.

While we are smoking the Dutch shopkeeper's pipe and smiling the German philosopher's rueful smile, we may as well make these two more offerings at the altar of reason and imagination.

2007

III. SOME CALIFORNIA WRITERS

jack london in his time: *martin eden*

When Jack London, aged twenty-one, arrived at Dyea Beach in August of 1897, six steep miles of the Chilkoot Pass stood between him and the trail to the gold fields of the Yukon. The beaches were thick with stampeders, prospectors, would-be prospectors, and the piles of gear that were going to get them to Dawson City and make them rich once they got there. But most of them were not moving, for the very good reason that they could not get over the pass. To prevent mass suicide by greed, the North West Mounted Police required that each man who entered the territory carry a thousand pounds of food and five hundred dollars in cash. Beyond the pass, it was another twenty-one miles to Lake Lindeman, where the long river voyage to the Yukon began. The August sun was powerful, the switchback trail up Chilkoot was littered with dead and exhausted horses, and the Tlingit porters had raised their rates to fifty cents a pound. London's brother-in-law, an unprepossessing Oakland grocer of about sixty, calculated that it would cost them their entire grubstake to get to the lake and a boat. He regarded the milling crowds on the beach and his own prospects and decided to go home.

Jack London then did a characteristic thing. According to his biographer, Richard O'Connor, "he stripped down to his bright red flannels, loaded a hundred and fifty pounds on his back, and charged up the pass." None of the accounts say exactly what the total weight in food and gear was—somewhere between half and three-quarters of a ton. He carried it all to the top of the pass in twenty-four-mile round trips, twelve miles under pack. The vitality of it is impressive, and the methodicalness even more so. It helps to explain how he was able to write fifty books in sixteen years, and how that combination of method and will, exhilarating at first, must have eaten him up. At the end,

three miles from the lake, he made four trips a day. It took him nearly a month; he boasted, years later in *John Barleycorn,* that after a while he could outpack some of the "Siwash" porters and that he liked whooping encouragement to them as he passed them. His account of it is high-spirited, and it has the fine, careless tone of the prose that made him, in a few short years, one of the most famous writers in the world: "I had let career go hang, and was on the adventure-path again in quest of fortune."

Earlier that year, he had, after dropping out of the University of California, worked fourteen-hour days in a steam laundry. At eighteen he had shoveled coal in a power plant, sometimes on eighteen-hour shifts. At fifteen, when his father was injured and couldn't work, he had put in twelve-hour days in a cannery at ten cents an hour. At that moment, in high summer, in the spruce scent of the air on a ridge above a fjordlike Alaskan bay, he must have felt that he had been trans-formed, even with the pack on his back, from a beast of burden into a much more splendid kind of animal. *Martin Eden* is his autobiographi-cal novel, but *Martin Eden* comes later, in 1909. If Jack London had written the story of his life in 1897, that story would have been *The Call of the Wild,* at the end of which Buck, the domesticated Californian dog, has become a wolf and "may be seen running at the head of the pack through the pale moonlight or glimmering borealis, leaping gigantic above his fellows, his great throat a-bellow as he sings a song of the younger world, which is the song of the pack."

London was a romantic; it was his special gift as a writer to make life seem vivid and intense. He had had a dreary childhood and a diffi-cult youth, and they filled him with a sense—which it is another of the gifts of his fiction to convey—that there were great things in the world and great things inside him, and that there was something wrong with a society that beat the sense of grandeur out of other people, or wore it away. To freeze one of those moments on the mountain is to see the immediate appeal of his work: life as a grand struggle, masculine, openhanded, and best attacked head-on. Out of this sensibility, quick, generous, and responsive, and out of his prodigal, half-formed gifts and immense determination he made real art and forged his huge success. It is this that makes the end of his relatively short life, the bad health and heavy drinking, the political contradictions and foolish choices and personal disappointments, and that last stream of mediocre, half-

finished, and self-aggrandizing books, seem tragic. He is, still, the most widely read fiction writer in the world, translated into almost every language and selling briskly in most of them. And there is a reason for this. He wanted life to be large and gallant, and wanted his books to convey it, and they do.

But there is also another side to this image of the young man on the mountain: the suspicion, for example, that the readers of Jack London's time would have seen it as a kind of allegory. Notice that it is Tlingits he is passing on the trail. Here is one of London's contemporaries, the Congregationalist minister Josiah Strong, discoursing on the extermination of Native Americans and the manifest destiny of the Anglo-Saxon race: "It would seem as if these inferior tribes were only precursors of a superior race, voices in the wilderness crying: Prepare ye the way of the Lord." The literary and popular culture of the first decade of the 1900s, which Jack London came to embody and which trapped him in ways that are familiar to us from the careers of Ernest Hemingway and Jack Kerouac, was dominated by imperialism, social Darwinism, and a style of aggressive masculinity. Theodore Roosevelt set the tone. He came to the presidency when McKinley was assassinated in Buffalo in 1901, and he was admired by the public for "the reckless and exultant sweep," the *Encyclopaedia Britannica* said, of his charge up Kettle Hill. The year before his ascension to the presidency, he had published a book called *The Strenuous Life*, and a few years before that, an essay entitled "The Manly Virtues and Practical Politics."

One of the windfalls of the cult of the masculine was wilderness preservation. It was argued that a red-blooded civilization would grow effeminate if it did not have wild spaces. And it was, again, President Roosevelt who gave the movement a boost by accompanying John Muir and a requisite number of reporters on a camping trip to Yosemite Valley. The tone is even in the early poems of Ezra Pound; in the truly awful, though handsomely written, "Ballad of the Goodly Fere," for example, which contains, in Kiplingesque meters, a portrait of Christ as a manly fellow, especially at the Last Supper:

> Oh we drank his "Hale" in the good red wine
> When we last made company,
> No capon priest was the Goodly Fere
> But a man o' men was he.

There is even an echo of it, touchingly, in Henry James's *The Ambassadors*—published, like *The Call of the Wild*, in 1903—that moment in the garden when the elderly Lambert Strether is moved to give one of his young countrymen advice: "Do what you like so long as you don't make my mistake . . . Live! . . . It doesn't matter so much what you do in particular, so long as you have your life. If you haven't had that, what have you had?"

Two political offspring of the cult of masculinity and the grand struggle were the justification of monopoly capital by invoking the laws of social Darwinism, and the justification of imperialism and racism by invoking the heroic responsibility of bearing the white man's burden. Social Darwinism had come to the United States by way of the writings of Herbert Spencer, a civil engineer who became the main philosophical spokesman for English industrialism and Victorian science. Charles Darwin borrowed the phrase "survival of the fittest" from him; Spencer had glimpsed the idea of it in the population studies of Thomas Malthus and erected on it a philosophy of progress that he grounded in mechanical physics and evolutionary biology. Spencer's vogue in America was immense, and Martin Eden, a West Coast provincial, was not the first young American to think that Spencer had put all of life on a sound philosophical basis. American churchmen, of course, disliked his materialism and agnosticism. Part of his attraction was his air of scientific certainty. His definition of evolution, for example: "an integration of matter and concomitant dissipation of motion; during which the matter passes from an indifferent, incoherent homogeneity to a definite, coherent heterogeneity; and during which the retained motion undergoes a parallel transformation." It must have been very satisfying to young men like Martin Eden to think that, having memorized that mouthful, they were in cool possession of the meaning of all life.

Among the less intellectually inclined, as Richard Hofstadter points out in *Social Darwinism in American Thought*, Spencer's ideas took a less complicated form. It was Friedrich Nietzsche who remarked that there hovered over English Darwinism a melancholy sense of many humble people in straitened circumstances. The laboring poor were the indifferent, incoherent homogeneity from which the captains of fate and large businesses emerged. "The fortunes of railroad companies," the financier James Hill said in 1910, "are determined by the law

of the survival of the fittest." He was echoing Andrew Carnegie, who had said much the same thing and who, in his autobiography, remembered his conversion to Spencer and Darwin in rapturous terms: "I remember the light came as in a flood and all was clear. Not only had I got rid of theology and the supernatural, but I had found the truth of evolution. 'All is well since all grows better,' was my motto." John D. Rockefeller was similarly impressed. "The growth of a large business is merely the survival of the fittest," he said in 1900, and, in 1915, more simply: "God gave me my money."

To the suspicion that the images of the young man charging up the hill and the young dog transformed into a wolf carry a large freight of ideology could be added another—that the unleashing of sheer vigor or of predatory power is not in itself either much of an accomplishment or morally very appealing. Nietzsche's idea of the superman also was enjoying a vogue in turn-of-the-century America, and though Nietzsche had understood the economic roots of social Darwinism, his superman seemed to mesh nicely with a swashbuckling version of the survival of the fittest, as if it were a Horatio Alger story with a certain amount of bloodlust thrown in. Simply, the idea that man, at his best, is a wild predator is a dangerous idea, and it is difficult not to feel that that idea, among others, lies buried in *The Call of the Wild*.

Parallel to this culture of warrior manliness, there was a growing movement for the political emancipation of women. In the last twenty-five years of the nineteenth century, the American industrial system was jolted by a series of depressions, the first of which came in the year of Jack London's birth. There was wide unemployment, the market in labor was crowded, wages were low, and the conditions of work for men, women, and children were shameful. During this time drunkenness among the working poor was perceived to be a problem as serious as poverty itself and a particular threat to families. It is hard to remember from our present vantage point that there was serious opposition to woman's suffrage because it threatened to abolish the male camaraderie of the saloon. When Jack London came to write an autobiography—it is one of his best books—he wrote it in the form of a temperance tract. *John Barleycorn* begins with London's announcement of his intention to support what was called female emancipation. His reason for doing so was his decision that the use of alcohol should be outlawed because it was a killer—not a killer of weaklings only, which would be

more or less in the natural order of things, but a killer of strong men. *John Barleycorn* is a complicated, and in some ways a cunning, book, but one of the things it seems to assert is that the way alcohol kills these men is by dissolving their illusions by too-frequent exposure to the fundamental truth of life: that the grand struggle for existence is a dream, a meaningless bubble in the meaningless weirs of the evolution of matter.

But we have come in a circle that brings us to the darkness at the end of *Martin Eden,* and to look at that book, we had better look at Jack London's life, from which it was drawn.

Jack London's life, crowded with events, was eventful even before he was born, in San Francisco on the twelfth of January 1876. It is often said in biographical notes that he was born in the "slums of San Francisco," but that is not true. Nor is it true that he was born into the working class. It is pretty certain that he was, though he did not know it until many years later, the child of his mother's short, violent relationship with a man named W. H. Chaney. She, Flora Wellman, was a spiritual-ist, and he was an astrologer. The youngest daughter and the rebel of a large, comfortable Massillon, Ohio, family, as a child she contracted a nearly fatal case of typhus, which badly stunted her growth—as an adult she was less than five feet tall, partially bald, and she had poor vision. She became interested in spiritualism during adolescence—it was at that time closely connected to the women's movement—and in her early adult years she broke with her family and went west. Chaney was, when they met, a man of fifty-five; he had practiced law and jour-nalism in Maine, where he had left behind a reputation for virulent combativeness, and had drifted to New York and then to San Francisco.

The couple met in 1874 and moved in together. She gave piano les-sons and séances; he lectured on astro-theology and conducted what the biographies call "an astrological practice." When Flora became pregnant, Chaney left her. According to a newspaper report printed in the *San Francisco Chronicle* in June of 1875, she responded by shooting herself in the forehead with a pistol. The publicity briefly made her a cause célèbre in the circle of socialists, spiritualists, phrenologists, and advocates of free love, freethinking, and women's emancipation in which the couple had moved. Flora, big with child, told her story at spiritualists' meetings, and collections were taken up on her behalf.

Chaney wrote and had printed a pamphlet defending himself and claiming that she had not shot herself but only gouged her forehead with a piece of glass to simulate a wound. (His only other known publication was a volume entitled *Primer of Astrology and American Urania*, privately printed in Saint Louis, Missouri, in 1890.) Eight months after Jack's birth, Flora married, and she gave her son her husband's name.

John London was, by all accounts, an exceptionally kind and gentle man. Born in Pennsylvania, he had farmed in Iowa and served in the Union Army. When Flora met him, he was a door-to-door salesman for the Singer Sewing Machine Company. A widower, he was living in a boardinghouse and, unable to take care of them, had placed his two daughters in an orphanage. It appeared to John and Flora that they could be mutually useful to each other, and the pair married. John London did not share his wife's advanced interests, and though she continued to give séances occasionally, she abandoned most of her political and otherwordly pursuits. In the middle of a severe economic depression, they set about trying to make a better life, a task they failed at dismally and often. Jack London, in later life, attributed their failure to his mother, who got her way by having fits of hysteria and whose way was always to push her luck.

The family first tried a grocery store in Oakland; John London was cheated by his partner, and the store failed when Jack was four. His stepfather then tried his hand at farming—growing produce in Alameda for the Oakland markets, ranching on the San Mateo coast, then raising an olive orchard and chickens in the Livermore Valley. In *John Barleycorn*, Jack London speaks of these places as "poor-ranches," as if what they raised were poverty, and he remembers the San Mateo coast as bleak and sad. In any case, the farms also failed, and in 1886, when Jack was ten, the family returned to Oakland, where they rented a pair of cottages and ran a boardinghouse for young women who had been imported from Scotland to work in the cotton mills. Within a year, the couple had decided to buy the cottages, and then lost the mortgages on them. Though the Londons were not working class, they had failed at five businesses, and now they came into it. John London found work as a night watchman on the Oakland wharves and washed down the decks of a yacht club on weekends. Jack was sent to work before and after school as a newspaper boy, an iceman's apprentice, and a pinsetter in a bowling alley. But he loved the life of the city streets, and he discovered the Oakland Public Library, where he was befriended by the

librarian, a poet named Ina Coolbrith, and he began to read books with the hunger of the famished. "I read everything," he wrote later, "but principally history and adventure, and all the old travels and voyages. I read mornings, afternoons, and nights. I read in bed, I read at table, I read as I walked to and from school and I read at recess while the other boys were playing."

Early in *Martin Eden* there is this description of the novel's hero: "He was a harp; all his life that he had known and that was his con- sciousness was the strings; and the flood of music was the wind that poured against those strings and set them vibrating with memories and dreams. He did not merely feel. Sensation invested itself in form and color and radiance, and what his imagination dared, it objecti- fied in some magic and sublimated way." This is Martin in love, but it catches something of Jack London's gift for saturating himself in his experience. He spent less than a year in the Yukon, much of it shut in a winter cabin and some of it sick with scurvy, but among all the writing that the years of the Alaskan gold rush engendered, it is his version (and that of Charlie Chaplin) that survives in the American imagination. The time between his fourteenth and twenty-first birth- days was the seedbed of his imagination; he described it, mythologized it, transformed it, and fashioned from it the persona of his adult years, a projection powerful and attractive enough to become an industry. The Oakland waterfront, with its restaurants and boutiques, is now known as Jack London Square.

Then it was known as the waterfront, and when John London injured himself in a railroad accident, the family—both of John London's daughters had married and left—moved to a shack not far from it. Jack had graduated from grammar school and had gone to work at odd jobs and taught himself to sail a small skiff in the estuary; now he took a job in a cannery, where he put in between ten and sixteen hours a day at ten cents an hour. He quit after a few months; borrowed three hundred dollars from his nurse, a woman named Jenny Prentice, to whom Jack was close all his life; bought a sloop; and got into the profitable business of robbing South Bay oyster farms in the middle of the night. When his sloop was sunk by a rival thief, he worked briefly, on the other side of the law, for the California Fish Patrol.

We are now deep into his self-mythologizing. Much of the account of this period reads like a boy's adventure story, and it was, later, writ-

ten as boys' adventure stories, *The Cruise of the* Dazzler in 1902 and *Tales of the Fish Patrol* in 1905. How did the Londons in their poverty come to employ a nursemaid for their children who was able to save three hundred dollars from her wages? And would she have loaned it— when men made a monthly wage of thirty to fifty dollars—to a fifteen-year-old boy to buy a boat? But I am passing along the story as it is told by the biographers, whose main source was Jack himself.

At any rate, when other children were in high school, he was, in his own phrase, "a man among men," working the waterfront and drinking with the sailors in their taverns. In January of 1893 he signed on to the sealer *Sophia Sutherland* and spent seven months at sea, including stops at Yokohama and the Bonin Islands and seven weeks in the breeding grounds of the Bering Sea, where the crew slaughtered and skinned seals from sunup to sundown and the decks were slick with gore. He came home to a job in a jute mill, again at ten cents an hour, and then, with the idea of apprenticing himself as an electrician, he shoveled coal in a power plant twelve to thirteen hours a day, seven days a week, with one day off a month, at a flat thirty dollars a week. In April of that year, 1894, he had had enough, and he joined the western branch of Coxey's Army and went on the road.

Coxey's Army was conceived as a nationwide march of the unemployed on Washington, D.C., to demand the creation of federal public works projects, and it raised the specter of revolution before the comfortable classes in America. Jack had no politics and went along on a lark. He dropped out of the army in Hannibal, Missouri. Many men had defected by then or were intimidated out of proceeding. Jacob Coxey (who happened to come from Flora Wellman's hometown of Massillon, Ohio) did reach Washington, where he was promptly arrested for treading on federal grass. Jack rode the rails to Chicago and then to New York, and was himself jailed for vagrancy while attempting to view Niagara Falls. He spent thirty days in the Erie County Penitentiary. He tells this story in *The Road.* Though he was apolitical when he left Oakland, he returned a socialist. He also made another decision in that year, which he described in an essay:

> The women of the streets and the men of the gutter drew very close to me. I saw the picture of the Social Pit as vividly as though it were a concrete thing, and at the bottom of the Pit I saw them, myself above

them, not far, and hanging on to the slippery wall by main strength and sweat. And I confess a terror seized me. What when my strength failed? When I should be unable to work shoulder to shoulder with the strong men who were as yet babes unborn? And there and then I swore a great oath. It ran something like this: *All my days I have worked hard with my body, and according to the number of days I have worked, by just that much I am nearer the bottom of the Pit. I shall climb out of the Pit but not by the muscles of my body shall I climb out. I shall do no more hard work and may God strike me dead if I do another hard day's work with my body more than I absolutely have to do.*

The other kind of work is mental. When he returned home, he enrolled in Oakland High School, and it was there, through her brother Ted, that he met Mabel Applegarth, on whom he would pattern Ruth Morse, the refined professor's daughter of *Martin Eden*.

He came to know Ted through the high school's Henry Clay Debating Society, where he was able to try out the ideas in the books on socialism he was beginning to read. Soon he was a regular visitor at the Applegarths'. They were English immigrants; Mr. Applegarth was a mining engineer, and it was probably the first respectable middle-class home Jack London had ever been inside. He was immediately dazzled by Mabel. "It was a great love," he wrote to his friend Anna Strunsky in 1900, "but see! time passed. I grew. I saw immortality fade from her. Saw her only woman. And still I did not dream of judging. She was very small. The positive virtues were hers, and likewise the negative vices. She was pure, honest, true, sincere. But she was small. Her virtues led her nowhere. Works? She had none. Her culture was a surface smear, her deepest depth a singing shallow. Do you understand? Can I explain further? I awoke, and judged, and my puppy love was over."

In fact, it did not happen so quickly. Jack, an oversized high school freshman, courted Mabel through the school year while he tried to teach himself to write by turning out stories and essays for the school paper. A high school course was then three years. He decided to compact two of them into a summer, and he spent it studying furiously for the University of California entrance exam, which he passed. A semester at Berkeley—what he remembered of it was standing on the steps of Wheeler Hall, conscious of his rotting teeth from a poor boy's long

diet of candy—only made him more restless, and he dropped out at midyear, determined to make his own way as a writer. It was then that he took the job in the steam laundry described so brilliantly in *Martin Eden*. He was getting nowhere. By summer he was off to the Yukon.

When he returned, confirmed in his politics, his head full of new experience, deeply absorbed in reading Spencer for philosophy and Kipling for the art of fiction, he was still resolved to marry Mabel as soon as he had made enough money to do so. He lived with his mother, and he wrote night and day, refusing any other work. He had arrived home in July, and he sold his first story in December. "To the Man on Trail" was taken by a San Francisco magazine, *Overland Monthly* (the *Transcontinental Monthly* of *Martin Eden*). The following August *Atlantic Monthly* took a story, and by December he had a contract for a book. During this time, Mabel, dubious about the value of his work, was Jack's only literary confidante. Part of her anxiety may have been that her father had died and Mrs. Applegarth had begun to tighten her hold on her daughter. "Mother was always a selfish woman," one of her brothers once observed, "Mabel spent her life taking care of her." When Mrs. Applegarth moved herself and her daughter to San Jose, Jack bicycled the thirty miles to visit her. Now, with the book contract in hand, he proposed marriage. Mrs. Applegarth gave her consent, on the condition that Jack either move in with them or provide a home for her in Oakland. Jack was not at all certain that he could disentangle himself from his own mother and saw that the situation was impossible. That was January of 1900. Jack and Mabel did not formally end their relationship, but in April of that year he married Bess Maddern, one of his high school classmates. She was a plumber's daughter, tranquilly beautiful and very bright; she had tutored Jack in mathematics while he was preparing for his entrance exams. The marriage lasted only three years, during which Bess gave birth to two daughters. Early in their marriage, in the first flush of his success, Jack had met and fallen in love with Charmian Kittredge. He married her in 1905 and lived with Charmian for the rest of his life.

In that first decade Jack London did his best work, turning out books at the rate of three and sometimes four a year. They included the Klondike stories in several volumes, *The Call of the Wild*, *The People of the Abyss* (an account of life in London's East End slums), *The Sea Wolf* (based on his experience on the *Sophia Sutherland*), *The War of*

the Classes (a book of political essays), *The Road,* and *The Iron Heel.* He was a very well paid and very famous writer when, in Honolulu in 1907, on a much publicized voyage around the world in his own yacht, he began to write a book based on his own struggle to become a writer. *Martin Eden* was his eighth novel and twenty-first book; he would write another twenty-nine before his death in 1916.

"Critics," he wrote in *John Barleycorn,* "have complained about the swift education one of my characters, Martin Eden, achieved. From three years, from a sailor with a common school education, I made a successful writer of him. The critics say this is impossible. Yet I was Martin Eden." This is true and not. Martin Eden was raised in a working-class family; Jack's background was more curious than that. Unlike Martin, he found his way to books early, and unlike Martin, he had the support of his mother. Though she seems not to have given him much affection or attention as a child—he complained to Charmian that she never touched him—she did encourage him in his efforts to educate himself and to write. It is hard, in fact, not to suppose that there is some connection between his large appetites and meteoric rise and Flora Wellman's intensely thwarted life—he seems to come out of it like a cork from a bottle. There must also be a connection between her spiritualism and her son's resolute and dogmatic materialism. Flora's séances were quite spooky to him as a child; the power that the rational laws of Herbert Spencer had for Jack must have been as much relief as discovery. In *Martin Eden,* Jack London does not sketch—perhaps, like most of us, he only barely understood—the familial shapes of love and fear that formed him.

But if he was not Martin Eden, his beginnings were inauspicious enough. He had had one year of high school education and a semester of college. Nor did he have, like Dreiser and Hemingway, an apprenticeship in journalism:

> My difficulty was that I had no one to advise me. I didn't know a soul
> who had written or who had ever tried to write. I didn't even know
> one reporter. Also, to succeed at the writing game, I found I had to
> unlearn about everything the teachers and professors of literature of
> the high school and university had taught me. I was very indignant
> about this at the time; though now I can understand it. They did not

know the trick of successful writing in the years of 1895 and 1896. They knew all about "Snowbound" and "Sartor Resartus"; but the American editors of 1899 did not want such truck. They wanted the 1899 truck, and offered to pay so well for it that the teachers and professors of literature would have quit their jobs could they have supplied it.

There is a certain amount of swagger and irony in this, but it underlines an important fact—Jack London apprenticed himself to the marketplace and to the conventions of popular fiction, which in 1899 was a medium of entertainment.

This explains why, in his later years, he churned out work like a writer for television and lived like a movie star. It also explains, or helps to explain, some of the limitations of his work. Part of his legend is that he was a precocious boy who with the help of Ina Coolbrith was reading *Madame Bovary* and *Anna Karenina* at twelve. But he doesn't write like it. He writes like someone who has read lots and lots of magazine fiction. That is why, even today, reading London has for many readers the flavor of the popular novels of their childhood. It is in small things, like the elaborate characterization of dialogue. " 'Hold on, Arthur, my boy,' " Martin says in the first chapter of the novel, and London adds, "attempting to mask his anxiety with facetious utterance." And again: " 'That's all right,' was the reassuring answer." This seems so old-fashioned because the writers who did study *Madame Bovary*, like Hemingway, embarked on a thorough scouring of the Victorianisms that cluttered American prose fiction. They let readers understand for themselves that Martin was feeling out of place. Also typical is the careless use of whatever metaphor comes to hand. In *The Call of the Wild*, for example, there is a characteristic moment. London is describing the transformation of Buck: "A carnivorous animal, living on a straight meat diet, he was in full flower, at the high tide of life, overspilling with vigor and vitality." There is something funny about a carnivore in full flower, and about a flower that becomes a tide. Even though London's prose has a vigor that sweeps past these moments, it is hard not to be at least half aware of them. That is why George Orwell, who liked Jack London and admired *Martin Eden*, could also say of the novel that "the texture of the writing is poor, the phrasing is obvious and worn, and the dialogue is erratic."

The plot of the popular novel is a daydream; it was part of London's success that he was able to project his own deprived boy's powerful daydreams on the world. In the novels this makes for problems of construction and problems of shading. The whole later development of *Martin Eden,* for example, is coarsely conceived and a little false. Martin's selflessness and moral vindication are too complete. London wants him to be an individualist, but he needs to get him in trouble as a socialist, and that involves some fidgeting with the plot. Martin's noble restraint when women throw themselves at him, the melodramatic circumstances of his last meeting with Ruth, the Dickensian distribution of chicken farms and steam laundries to the folk Martin has met along the way, the judge who sits still while Martin delivers himself of a scathing philosophical lecture—it is all too much. But it is also the usual machinery of high-minded and improbable fiction. It was the set of conventions London had learned to use.

And though his work has these serious weaknesses, the power of *Martin Eden* is undeniable: it has a force that sets it apart from many more gracefully written novels. There is even a way in which the book is served by its flaws. The writing at the outset may be awkward. London, describing a drawing room, is dealing with a more complicated social world than he had ever attempted before, and the prose gets better as the novel proceeds, so that there is an odd way in which it matches the transformation of that young fellow who "awkwardly removed his cap" in the novel's first sentence. In *The Great Gatsby,* for example, it means everything that Nick Carraway's tone and Fitzgerald's style are finer than those of the characters Nick finds himself among, because that is the point of the book. But Martin Eden's style doesn't need to be finer than the Morses'; it simply needs to be more alert and alive, which it is, so that the first chapter of *Martin Eden,* whatever its flaws, is one of the best things in the book.

The struggle to become an artist is an old and powerful theme. And Jack London makes it persuasive partly because he is in his own territory—it is really the Horatio Alger story of his childhood, about the poor boy making good—and partly because he focuses on a writer's work, and London almost always writes brilliantly about work. All the detail is wonderful to read: the hours at the typewriter, the zigzag course from the door to the head of the bed, the Spartan meals of rice and dried fruit, and the incessant trips to the pawnshop. But more

impressive than the account of Martin Eden's work is the story of the growth of his mind, the great theme of romantic poetry. And this is also convincing, not, certainly, in the set-piece speeches, but in the passages about Martin's solitary study.

Martin Eden is also, of course, the story of a love affair. Martin is half in love with the world he has glimpsed in the Morses' house, and so the language of his emotion is full of vague, though deeply felt, intensities. But Ruth is sexually attracted to Martin. And here Jack London was working right at the edge of what was acceptable to the audience he was writing for. This may account for Ruth's slightly peculiar fixation on Martin's neck. But on the whole the writing is very strong, and like the prose of D. H. Lawrence's *Sons and Lovers*, it is in some ways stronger and more subtle because of the sublimation it is forced to deal in. Ruth's attraction is unconscious, and, though she is treated rather roughly in this book, London's rendering of her deepest feelings can be both tender and shrewd.

The romantic plot and the story of Martin's development are linked because it is one of the points of the novel that he grows past his lover; the sense of a person's intellectual growth is one of the rarest and most difficult things to render in fiction, and London deals with it so expressively partly because he manages so well the slow changes in Martin's perception of Ruth. And this growing past her brings us to the center of the book, which is its sense of anger and betrayal, rooted in Martin's discovery that the people who had evoked for him the deepest imagination of the wonder and mystery of life were, finally, little souls, neither good nor bad, for whom culture was good manners and thirty thousand dollars a year was worth almost anything. Because the Morses cannot finally be blamed for the fact that they are the best that Martin's world has to offer, nor for the fact that in growing toward them and past them, he had cut himself off from the narrow but solid and comforting pleasures of his own social world, there is nothing for him to be angry at but existence itself. And because he has not yet understood this quite, Martin goes dead. It is at this moment, once the machinery of the plot has faded, that *Martin Eden* becomes a very remarkable book.

For the final development of the theme of Martin's changing consciousness, the introduction of the character of Brissenden is crucial. He was modeled on a San Francisco poet named George Sterling, who was Jack London's closest friend. The style of late nineteenth-century poets

in the poker game of manly life was to pass. If evolution was a remorseless struggle in which only the most rugged succeeded in transmitting their genes, they were willing to be strange flowers that bloomed only once. The French symbolists were the first to strike this pose, the English and American decadents and aesthetes at the turn of the century followed their lead, and the type became the stock figure for the poet in popular culture. The genius of Charlie Chaplin's conception of the Little Tramp, for example, was to give him a touch of this figure, and how it must have confounded the unconscious script of his audience as it released them into laughter! Not the carnivore in the wilderness on a straight meat diet, but that little poet, the dreamer and flower sniffer, who kowtowed when he had to and scrapped when he had to, and somehow survived. Brissenden, like George Sterling, who actually did commit suicide, is the pure type, and he is very sympathetically drawn. He is there to suggest, by his fineness of spirit and his aristocratic uselessness, that, despite Martin's excitement about Spencer, evolution may not be such a grand thing after all.

He is also there to introduce Martin Eden to socialism and to raise that theme in the novel. Contemporary readers were very aware of it—or, rather, they were aware of what they felt to be the absence of it. London was the best-known American socialist of his time, and though he had run for mayor of Oakland on the Socialist ticket, and contributed financially to the party, and was about to publish a book called *Revolution*, he was coming under attack from his compatriots for his high living. He was particularly sensitive to criticism of *Martin Eden*, and he defended the book to the novelist Upton Sinclair: "Martin Eden is an individualist, I am a socialist. That is why I continue to live, and that is the reason why Martin Eden died." Sinclair, writing about the book, noted that reviewers had not grasped London's point, if that was his point: "It is easy to understand the befuddlement of critics; for he had shown such sympathy with the hard-driving individualist that it would hardly occur to anyone that the character was meant to be a warning and a reproach."

It is true that there is no reproach in the novel; London had got too deep into his subject to be passing out moral judgments. There is, however, a warning, and it comes from Brissenden in the thirty-eighth chapter, when Martin is on the verge of literary success: " 'I'd like to see you a socialist before I'm gone. It will give you a sanction for your

existence. It is the one thing that will save you in the time of disap-
pointment that is coming to you.' "

Brissenden, it turns out, is exactly right. The time of disappoint-
ment comes and Martin can find no sanction for his existence in his
individualism. London is careful to underline this again on shipboard.
Finding he has no use for the other people in first class—he knows
exactly why their shirts look so white and crisp—and finding that he
hardly recognizes the world of the crew, he stumbles onto an intel-
lectually inclined quartermaster who tries to prod him "with socialist
propaganda," but at this point Martin is too far gone.

The writing in these last pages, London's rendering of Martin's
sickness with the bright white light of existence, is brilliant, the
numbness of it truly terrible: "He slept much. After breakfast he
sought out his deck chair with a magazine he never finished. The
printed pages tired him. He puzzled that men found so much to
write about, and, puzzling, dozed in his chair. When the gong
awoke him for luncheon, he was irritated that he must awaken.
There was no satisfaction in being awake." It is like the freezing
numbness of his chilling late story "To Build a Fire." He wrote
about this sickness also in *John Barleycorn:* "I had read too much
positive science"—he means Spencer—"and lived too much posi-
tive science," and he attributed his condition to "the savage inter-
pretation of biological fact."

Nor was he the only one of his contemporaries to feel this. We have
seen Andrew Carnegie's response to the doctrine of evolution. Here is
the response of the young Theodore Dreiser:

> Up to this time there had been in me a blazing and unchecked desire
> to get on and the feeling that in doing so we did get somewhere; now
> in its place was the feeling that spiritually one got nowhere, that
> there was no hereafter, that one lived and had his being because
> one had to, and that it was of no importance. Of one's ideals, strug-
> gles, deprivations, sorrows and joys, it could only be said that they
> were chemic compulsions, something which for some inexplicable
> but unimportant reason responded to and resulted from the hope of
> pleasure and the fear of pain. Man was a mechanism, undevised and
> uncreated, and a badly and carelessly driven one at that . . . I fear
> that I cannot make you feel how those things came upon me in the

course of a few weeks' reading and left me numb, my gravest fears
as to the unsolvable disorder and brutality of life eternally verified.

This is, I think, where we find Martin in the last chapter: his anger
numb, his self-love burned out, and in full possession of the dark idea
that has, throughout the novel, flickered just underneath its confidence
in evolution. But the book takes one more surprising turn. Martin's
gift had been for struggle, and he gathers himself to struggle one more
time. His antagonist is the force that has, all his life, driven him "up
to the surface and into the clear sight of the stars," and his one weapon
is the tension of his will. The final scene in the novel is a little like
something of Dostoevsky, and the writing, which is surely the best in
the book, has unmistakable conviction. One sees what Jack London has
discovered. If the world is merely a matter of personal interest, with-
out transcendent principle, then its one meaning is the instinct to live,
and the man of will must sanction himself in the struggle with that
meaning. The logic of the novel is the love of death, and perhaps it is a
dream-logic of the culture, which may be why *Martin Eden* continues
to haunt the American imagination.

1986

mary austin and *the land of little rain*

M any years after she had written this slight, fierce, remarkable book, which was her first and has proved to be her most enduring, Mary Austin mused that it was composed at a time when "life stood at a breathing pause between the old ways and the new." The same thing could be said of the book itself and that is part of its fascination. *The Land of Little Rain* consists of fourteen sketches—brief essays, vignettes—about the deserts and mountain valleys of the remotest part of southeastern California at the turn of the nineteenth century. It was published about a hundred years ago, in 1903, and has become a small classic of American literature. It is a book writers love and that environmentalists and students of environmental history have been rediscovering. In the year of its publication, the historian Frederick Jackson Turner published his famous essay declaring the end of the American frontier. This may have been the breathing pause that Mary Austin had in mind. She had made a record of one of the last scraps of it, its remnant Ute, Shoshone, and Paiute peoples, its Mexican villages surviving like small islands in the completed Yankee conquest, and its more deeply stranded postboom mining towns, waiting with red-rimmed eyes for the next strike or the next flowering of the religion of luck to take the phantasmal shape of Las Vegas. She had written a book that told the country something about itself, and that was at the same time a last book in the genre of Victorian nature study and one of the first in the emerging genre of twentieth-century environmental literature.

It is, however one locates it, something of an amazement. An argument could be made that *The Land of Little Rain* has survived for a century on the sheer, odd deliciousness of its sentences. It is wonderfully and strangely written, but it has other things to recommend it. It

sits in its lineage as the most important book of American nature writing between John Muir's *The Mountains of California* (1894) and Aldo Leopold's *A Sand County Almanac* (1949). It is a fundamental text in any history of women's writing about the natural world and, in spite—or perhaps because—of the fact that the subject never comes up, of American feminist prose. It is, along with Muir's *Mountains,* one of the books that initiates the literature of California, and, more specifically, of Southern California. Its subject is deserts, that is to say, places where both nature and people are up against it, and this is reason enough to notice that it belongs to a way of thinking and writing that is recognizable kin to the Nathanael West of *The Day of the Locust* or the Raymond Chandler of *The Big Sleep.* Indeed, the theft of water from the Owens Valley, where Mary Austin wrote this book, by the municipality of Los Angeles is the hidden subject of Roman Polanski's *Chinatown.* It makes one see that *The Land of Little Rain* not only foreshadows the noir sensibility, but also that the Los Angeles novel is in many ways an extension of the Western. It is also a book by a Midwesterner, and if it is a Western, it is also an anti-Midwestern. Because it is a series of sketches, originally published in *Atlantic Monthly,* taking its form from the conventions of nineteenth-century American magazines—the nature essay, the local color piece—at a time when most Americans still lived in small towns and villages, and culture was largely what got spoken from pulpits and lecture platforms and what arrived in the mail in the form of magazines, it has a good deal to tell us about the intellectual and spiritual disposition of its turn-of-the-century audience.

These are some of the claims the book makes to our attention, and there are others.

It is a secret book of self-invention. It is a secret history of the condition and yearnings of restless and talented women in the evangelical America of the 1880s and 1890s, all the more about gender and sexuality because it is for the most part mute on those subjects. It has its place in the history of American prose; you will hear in its sentences echoes of the sentences of Herman Melville and swear at certain moments that you are hearing echoes of the later prose style of Cormac McCarthy. It takes a reading of a couple of Mary Austin's other less well-known books, her novel *A Woman of Genius* (1912) and her autobiography *Earth Horizon* (1932), to make these connections clear, because one of the achievements of *The Land of Little Rain* is the mix of authority and effacement in its authorial voice.

It aims to be, first of all, a meditation on place, though the place itself is also effaced a little, and is two places actually, which you can find by consulting a map: the arid country east of Bakersfield, California, where the San Fernando Valley ends in the transverse range of the Tehachapi Mountains, and the long narrow valley east of the Sierra Nevada that runs from Bishop in the north through Big Pine and Independence (note the name: the author of this book lived in these towns—Independence had a population of three hundred—at the age of twenty-six, having left her husband, and taught school to earn a living and tried to raise her retarded two-year-old daughter, without child care, while she worked, and tried to write) and Lone Pine, and south to the Coso Range and the Slate and Quail and Granite Mountains, places you cannot see much of now, since they are home to a U.S. naval weapons center and access is restricted. It is no surprise that the book she wrote is, save for the dreamy idyll of its last chapter, a cool-minded meditation on freedom and necessity, adaptation and survival.

Mary Hunter Austin was born in 1868 in Carlinville, Illinois, in the heart of the Protestant, evangelical Middle West. Her father, an immigrant from Yorkshire, was a captain in the Union Army during the Civil War and an attorney after it. He was a book-reading man, apparently a somewhat ineffectual one, who never quite recovered from a malaria he had contracted during the war, and who was, in her account of him, delighted by his lively and intelligent daughter. He died when she was nine years old. Her mother, of French Huguenot and Scots-Irish stock, was born in Carlinville, was not so fond of her daughter, and lived a life committed to the thin respectabilities of the small-town Methodist church. Mary Austin would write about her relationship with her mother twice, once in fictionalized form in her novel of growing up, *A Woman of Genius*, and again in her autobiography. In both accounts she tries to see her sympathetically. She admired her strength in difficult circumstances and learned firsthand, she wrote with characteristic sharpness, "the strange indignities offered to widowhood by a society which made out of a woman's economic dependence on her husband a kind of sanctity which was violated by his death." But in the novel she is at pains to describe what it was like to be mothered by a woman who regarded her daughter with a distaste she could not overcome, but which she understood it to be her religious duty to repress. It tells us most of what we need to know of Mary

Austin's mother that when she came to visit her daughter in the small town in the eastern Sierra where she was living with her husband, summoned by her daughter's concern that something was wrong with her new baby, and it became clear that the child was retarded, her mother turned to her and said, "I don't know what you've done, daughter, to have such a judgment upon you."

The portrait of the fictional Taylorville in *A Woman of Genius* is likely an accurate reflection of the culture of Carlinville. It's interesting to read now partly because the world of *The Land of Little Rain* is a sort of counter-Carlinville and because she describes with irony a world we are bound to regard with some nostalgia. "Of Taylorville," the narrator says,

> where I grew up and was married, the most distinguishing thing was that there was nothing to distinguish it from a hundred towns in Ohianna. To begin with, it was laid out about a square, and had two streets at right angles, known as Main and Broad. Broad Street, I remember, ran east and west between the high school and the railway station, and Main Street had a Catholic cemetery on the south and a tool and die works on the north to mark—there was no other visible distinction—the points at which it became a country road. There were numerous cross streets east and west, called after the Governors, or perhaps it was the Presidents, and north and south, set forth on official maps as avenues, taking their names from the trees with which they were falsely declared to be planted, though I do not recall they were ever spoken of by those names except by the leading county paper which had its office in one corner of the square over the Co-operative store, was Republican in politics, and stood for Progress.
>
> The square was planted with maples; a hitching rack ran quite around it and was, in the number and character of the vehicles attached to it, a sort of public calendar for the days of the week and the seasons. On court days and elections, I remember, they quite filled the rack and overflowed the tieposts in front of the courthouse, which stood on its own ground a little off from the square, balanced on the opposite side by the Methodist Church. It was a perfect index to the country neighborhoods that spread east and north to the flat, black corn lands, west to the marl and clay of the river district, and south to the tall-weeded, oozy Bottoms. Teams from the Bottoms, I believe,

always had cockleburs in their tails; and spanking dapple grays drove in with shining top-buggies from the stock farms whose flacking windmills on the straight horizon of the north, struck on my childish imagination as some sort of mechanical scarecrow to frighten away the homey charms of the wooded hills. I recall this sort of detail as the only thing in my native town that affected my imagination.

But if Carlinville didn't do much to stimulate her imagination, her mother did see to it that she got an education. There was a small Presbyterian school, Blackburn College, and she entered it at sixteen. Blackburn had two courses of study, English literature and science. In her autobiography she remarks on her reason for taking the science curriculum: "English I can study myself; for science I have to have laboratories and a teacher." She had already acquired a passion for the outdoors, though her mother had cautioned her to "not talk appreciatively about landscapes and flowers and the habits of little animals and birds to boys; they didn't like it." There was in the town a professor of botany of some distinction, a man named Charles Robertson, and Mary Hunter envied him his wanderings in the fields, though the town, she wrote, spoke of him "a little the way they spoke of a man who played the piano for a living." Her interest in natural history had been kindled by a self-education and self-improvement course to which her mother had subscribed. The Chautauqua Association of upstate New York educated a good part of the aspiring middle class in American small towns in the latter part of the nineteenth century. It put John Ruskin's *The Seven Lamps of Architecture* in the hands of Mary Hunter at the age of fourteen. (I own a copy that my grandmother received by mail when she was a girl in a mining town in Montana.) Her mother told her she was too young to read such a book; it would make people think she was conceited. She didn't understand the book, she writes, but her yearning to find someone who could explain to her how to understand it was so intense, it made her nauseous. Chautauqua also put into her hands from its geology course *The Old Red Sandstone,* a book by the Scotch geologist Hugh Miller, which opened for her the great debates of Victorian science. It is rather remarkable that she found her way to it. "The whole theory of Evolution," she wrote, "was still of doubtful admissibility for convinced Methodists." But it gave her a fascination with the living earth. It may also have connected her, this male study her mother both

gave her and cautioned her about, to her dead father. At fifteen she took up the Victorian passion for natural history collections, that inheritance of the grand Linnean enterprise to construct a universal natural history. Her part of it was to collect fossil crinoids, those beautiful ancient sea lilies whose imprints were embedded in the shales formed by what had been the great inland sea of the Middle West.

Mary Austin was very lucky in her education. As Wallace Stegner remarks in his biography of John Wesley Powell, *Beyond the Hundredth Meridian*, the story of the Midwestern frontier in the two generations before her, the stories of John Muir and Powell, of Abraham Lincoln and Mark Twain and Edward Eggleston and Hamlin Garland, had to do with getting one's hands on books. And, in the cases of Powell and Muir, getting to one of those towns with Gothic brick edifices that housed libraries, laboratories, natural history collections, and people who could begin to answer the questions that mute, passionate observation, as an escape from farm chores, had filled them with. Blackburn College was such a place and the writer Mary Austin put what she learned there to good use. One of the things one understands about *The Land of Little Rain* within a few pages is that the reader is in the presence of a first-rate intelligence and an educated eye. It's one of the pleasures of nature writing to be, vicariously, one of those people who seem to be able to read ancient watercourses at a glance and remember the sequence of geological strata and have learned to tell the goldenrods apart. "Science" in a Midwestern American college in the 1880s must have meant principally those disciplines that the Victorians had a passion for: natural history, geology, biology, botany, as well as geography and astronomy, chemistry and physics. Of these latter disciplines Mary Austin remarked that she got no more than an inkling of laboratory technique. But these were the years when Lyell's *Principles of Geology* and Darwin's *On the Origin of Species* had shaken the intellectual foundations of the sciences and of religious thought, and the echoes at least of this great tidal shift reached her at Blackburn. She reports that she was the only person in attendance when Professor Robinson gave a public lecture on mutualism in the relation between insects and plants. The luminous cabinets of eighteenth-century natural science were giving way to the dynamics of evolutionary biology, and the auditor of that lecture, a college girl of twenty, was there to hear about it.

It was in the summer after her graduation that the family, wid-

owed mother, son, and reluctant daughter, set out for California. Mary's brother was drawn to the Tejon country of Southern California, on the promise of growing prosperous by dint of hard work by farming where there was plentiful land and no water. Mary and her mother had gone to San Francisco by train and to Los Angeles by coastal steamer, where they met the brother who had gone ahead to scout the territory. They went by stagecoach to Pasadena, where they hired horses and a covered wagon to take them across the Tehachapi Mountains and into the arid southern end of the San Fernando Valley just east of Bakersfield. Mary Austin made this trip of some one hundred miles on horseback. Writing, not dry-land farming, was already her ambition and she made careful notes that she transformed into her first publication, an account of the journey that was printed in her college literary magazine.

It was another twelve years before she sat down to the first of the sketches that comprise *The Land of Little Rain*. She had already had some short stories and a few poems published by that time. She had married—to escape her family, one suspects. She had moved with her husband to the Owens Valley, the remotest place in California, north of Death Valley, east of the Sierra Nevada, west of the ranges of dry Nevadan mountains with names like Amargosa and Panamint. In the small towns of that valley she had given birth to her damaged child; taught herself the botany of the place, its geology and history; interrogated Mexican sheepherders about plants; listened to whatever stories the Indians who lived on the fringes of the towns, having been pushed out of their ancestral villages, would tell her. She had left her husband, who had often left her to wander mountain mining camps—he was a Stanford graduate in engineering—looking for some sort of business to get into. She had taught school in Lone Pine and Independence, had reconciled with her husband and separated again, gone to Los Angeles and met some literary folk around a local magazine who gave her some encouragement, gone back to the Owens Valley and her husband, and taken up again her teaching job.

It was there in the fall of 1900 that she started to write this book. In 1902 she sent a few of the pieces to *Atlantic Monthly*, then the most prestigious literary and general-interest magazine in the country. Boston must have seemed a long way from Independence, California, in the winter of 1902, and the mail a kind of miracle. In the spring of that year, she heard from Bliss Perry, the *Atlantic* editor. He proposed

to publish six of the stories in the magazine over the coming year at $8 a page, and to publish a group of them as a book soon thereafter, with a $150 advance to be paid at once. (Wallace Stevens in 1900, down from Harvard, was working as a night reporter for the *New York Tribune*, making $18–20 a week. His rent was $20 a month, and a good meal in a restaurant, he noted in his diary, cost about forty cents.) The first sketch to be printed was the one titled, with a faintly biblical flavor, "My Neighbor's Field"; soon after "The Land of Little Rain" appeared, in the same issue of the magazine as Frederick Jackson Turner's "Contributions of the West to American Democracy." To compare the two, Turner's sense of triumph—"the first rough conquest of the wilderness is accomplished"—and his notion of the "steady influence" exerted by the frontier on American democracy, with the vision of Mary Austin's prospectors, her ground's-eye view of the desert rodent's paths to water, is to understand how profoundly her difficult life had prepared her to write this book.

It is there from the first sentence in the force of her prose. Here is the voice of the twenty-one-year-old author of "One Hundred Miles on Horseback," the account of her trip from Pasadena to Bakersfield, which she published in her college literary magazine in January 1889:

> Those whose lives have been spent in the prairie lands of Illinois can have little conception of the pleasures of a journey on horseback through the most picturesque part of California.

If one knows what is to come, this is almost comically the voice of the tenderfoot. Compare it with what came eleven years later, in the now-famous opening lines of *The Land of Little Rain:*

> East away from the Sierras, south from the Panamint and Amargosa, east and south many an uncounted mile, is the Country of Lost Borders.
>
> Ute, Paiute, Mojave, and Shoshone inhabit its frontiers, and as far into the heart of it as a man dare go. Not the law, but the land sets the limit. Desert is the name it wears upon maps, but the Indian's is the better word. Desert is a loose term to indicate land that supports no man; whether the land can be bitted and broken to that purpose is not proven. Void of life it never is, however dry the air and villainous the soil.

This is not a tourist's voice but a mythographer's. The sentences have a biblical cadence that is perhaps faintly, grimly parodic. They were written before Gertrude Stein taught writers of American prose to intensify formal effects through repetition, before Ernest Hemingway sent everyone to the school of radical simplification. And this gives her prose a hundred years later some of its delicious, oddly antiquated tang. You can hear in it the deep knowledge of the King James Bible, the love of Shakespearean eloquence, that raffish play with eloquence that occurs when it collides with the mundane world, which gives the prose of Dickens and Melville their distinctive qualities. In fact, if there is a model for the first of Mary Austin's sketches, it might well be the portrait of the Galápagos Islands in Melville's "The Encantadas." They are both symbolic and moralized landscapes. *Paysage moralisé* is the name art criticism has given to the fact that, when human beings describe a landscape, in words or paint, they are usually, perhaps inescapably, describing a vision of the world. It is interesting that Melville's portrait of those islands is so often compared to Darwin's in *The Voyage of the Beagle* in order to remark the moment in which poetry and science parted company in the middle of the nineteenth century. A case could be made for the emergence of the nature essay that it is the effort to hold together what the development of evolutionary biology and modern geology and geography had torn asunder. In this way Mary Austin's college course in "science" must have been of immense value to her. It meant she got a grounding in just those disciplines, and it's clear enough that they also inform her prose. Much of its authority comes from an informed intensity of observation. Here she is, for example, on desert flora:

> Their whole duty is to flower and fruit and they do it hardly, or with tropical luxuriance, as the rain admits. It is recorded in the report of the Death Valley expedition that after a year of abundant rains, on the Colorado desert was found a specimen of Amaranthus ten feet high. A year later the same species in the same place matured in the drought at four inches. One hopes the land may breed like qualities in her offspring, not tritely to "try," but to do. Seldom does the desert herb attain the full stature of the type. Extreme aridity and extreme altitude have the same dwarfing effect, so that we find in the high Sierras and in Death Valley related species in miniature that reach

a comely growth in mean temperatures. Very fertile are the desert plants in expedients to prevent evaporation, turning their foliage edgewise toward the sun, growing silky hairs, exuding viscid gum. The wind, which has a long sweep, harries and helps them. It rolls up dunes about the stock stems, encompassing and protective, and above the dunes, which may be, as with mesquite, three times as high as a man, the blossoming twigs flourish and bear fruit.

And here, at the end of the essay, on the desert night:

For all the toll the desert takes of a man it gives compensations, deep breaths, deep sleep, and the communion of the stars. It comes upon one with new force in the pauses of the night that the Chaldeans were a desert-bred people. It is hard to escape the sense of mastery as the stars move in the wide heavens to risings and settings unobscured. They look large and near and palpitant; as if they moved on some stately service not needful to declare. Wheeling to their stations in the sky, they make the poor world-fret of no account. Of no account you who lie out there watching, nor the lean coyote that stands off in the scrub from you and howls and howls.

It is partly this mix of a botanist's sense of the shapes given to the world by the struggle for existence—to use her term for it—and the poet's sense of fate and fatedness and the loneliness of being a human on the earth that gives the book its tone and its vision. The book is full of many kinds of fate and they are viewed as matter-of-factly as the instance admits. Here is a troop of coyotes hunting an antelope:

Probably we never fully credit the interdependence of wild creatures and their cognizance of the affairs of their own kind. When the five coyotes that range the Tejon from Pasteria to Tunawai planned a relay race to bring down an antelope strayed from the band, beside myself to watch, an eagle swung down from Mt. Pinos, buzzards material-ized out of invisible ether, and hawks came trooping like small boys to a street fight.

And here is a female bobcat in a sudden hill country storm, when the rain sluices down and trout float belly-up in the shock of it:

What taxed me most in the wreck of one of my favorite cañons by cloud-burst was to see a bobcat mother mouthing her drowned kittens in the ruined lair built in the wash, far above the limit of accustomed waters, but not far enough from the unexpected. After a time you get the point of view of gods about these things to save you from being to pitiful.

And here she is on the aging of Paiute women:

By all counts she would have been about sixty years old when it came her turn to sit in the dust on the sunny side of the wickiup, with little strength left for anything but looking. And in time she paid the toll of the smoky huts and became blind. This is a thing so long expected by the Paiutes that when it comes they find it neither bitter nor sweet, but tolerable because common. There were three other blind women in the campoodie, withered fruit on a bough, but they had memory and speech. By noon of the sun there were never any left in the campoodie but these or some mother of weanlings, and they sat to keep the ashes warm upon the hearth. If it were cold, they burrowed in the blankets of the hut; if it were warm, they followed the shadow of the wickiup around. Stir much out of their places they hardly dare, since one might not help another; but they called, in high, old cracked voices, gossip and reminder across the ash heaps.

And what clear-eyed pathos is in her description of the remains of a miner's boomtown's grim humor:

Jimville does not know a great deal about the crust of the earth, it prefers a "hunch." That is an intimation from the gods that if you go over a brown back of the hills, by a dripping spring, up Coso way, you will find what is worth while. I have never heard that the failure of any particular hunch disproved the principle. Somehow the rawness of the land favors the sense of a personal relation to the supernatural. There is not much interference of crops, cities, clothes, and manners between you and the organizing forces to cut off communication.

This is the funniest and darkest version of the transcendentalist ideal of communion with Nature in the book, and it is the place where it meets wryly with a Darwinian fatalism.

Another thing to notice about the prose is its point of view, which for all its authority tries to be no particular point of view. The narrative location moves freely from the "we" of science who find Amaranthus in the high Sierra, to the "you" who, like all of us, is of no account under the desert stars, to the "I" that makes an observation from time to time that is merely personal. It is a brilliance of the book that it disperses its point of view so thoroughly, because it's not, like "One Hundred Miles on Horseback," about an experience someone has; it's not centered in the meaning somebody derives from an experience. It tries to disperse its voice so that the place itself seems to speak, or the writer seems to speak from no one's mouth in particular. And the form of the apparently casual sequence of sketches works very well for that purpose.

So what makes the book personal in the end is not its point of view but its structure. The organization seems casual, almost random, at first reading, but when one stands back from it several patterns emerge, both from the organization of individual pieces and from the articulated shape of the whole book. As Lawrence Buell has observed in *The Environmental Imagination,* the book is divided into two sections, each ending with the portrait of a community. The first half of the book is, roughly, about the desert world, and it ends with the portrait of Jimville; the second half begins with an Owens Valley meadow and ends with the pastoral idyll of a Mexican California town. Inside each is a mix of botanical sketches, surveys of fauna, and human portraits, the pocket miner and the old Shoshone Winnenap' in the first section, as contrasting examples of Anglo and Native adaptation to the land, and the Paiute woman Seyavi, who stands in implicit contrast to the neighbor Naboth, who has fenced the land "for a few wild-eyed steer" in the second. And the book is structured as a kind of ascent, out of Death Valley, where life is at its not unbeautiful nadir, to the richness of the Mexican town called, after the wetness of the grape, El Pueblo de las Uvas, where the quails cry out one of the book's themes: "*cuidado.*"

And through the book flows water, the central symbol as it is the central fact, the lack of it, its occasional abundance, the trails animals make on their way to it, the strategies plants have for saving it, the sky that it pours or fails to pour out of. It brokers all the relationships in the book as it brokers almost all the politics of the arid inland West. It is, for Mary Austin, in this book, what marriage is in a novel by Jane Austen: the element that explains everything. Indeed, writing about

water, she makes what seems to be a courtly and mocking nod to the first sentence in *Pride and Prejudice*. "It is," the essay "Other Water Borders" begins, "the proper destiny of every considerable stream to become an irrigation ditch." She will say a few sentences later that "it is difficult to come into intimate relations with appropriated waters," and sum up with these two sentences, the first of which represents perfectly the mind-set of the U.S. Bureau of Reclamation, the character of environmental struggles in the West for the next century. This reminds us that it was an irrigation ditch that took her in the first place into the territory that gave her her art. Her husband, the Stanford engineering graduate, brought her into the land of little rain because he'd gotten a job supervising the construction of an irrigation ditch, just as her brother's dream of dry-land farming—based on the widespread nineteenth-century fantasy that water somehow "followed the plow"—had brought her to California in the first place. After a while, reading her book and thinking about her life, the presence of water in it begins to have symbolic resonance:

> There is little water in the Ceriso in the best of times, and that little brackish and smelling vilely, but by a lone Juniper where the rim of the Ceriso breaks away to the lower country, there is a perpetual rill of fresh sweet drink in the midst of lush grass and watercress. In a dry season there is no water else for a man's long journey of a day.

She had dramatized in this book a world not friendly to us and not easy to live in, but one where one might, nevertheless, with attention and knowledge, find one's way to sweet water. Might, the book says, and might not.

The success of *The Land of Little Rain* gave Mary Austin the life she had been so determined to get to. She could make her living as a writer. In a short time her marriage dissolved; she found an institution for her daughter, Ruth; and she moved to Carmel, a beautiful small town on the central California coast that was in the process of becoming an artist's colony. From there she moved to London, and New York, where her play about the native world of California had a successful run, and in her later years to Santa Fe. She wrote many more books, and several of them are still alive. The best of the novels are surely *A Woman of Genius* and *The Ford*, a 1917 book in which she returned to the subject of California

and the Owens Valley water wars. In 1923 she published *The American Rhythm: Studies and Re-expressions of Amerindian Song,* a pioneering and not very successful effort to appropriate Native American oral traditions for the purposes of an American free-verse nature poetry. She died in Santa Fe, a rather grand literary person in her time, though still, her autobiography suggests, in many ways the driven, wounded, unfulfilled young girl of her growing up. In all the years since, *The Land of Little Rain* continues to be read. The issues she cared about, the marginalization of Native Americans, the economic exploitation of Mexicans in the United States, the status of women, the politics of water, the preservation of wild places, are still very much on people's minds, and writers still turn to the odd beauty of her prose. She has, in fact, a kind of progeny among desert writers, in Joseph Krutch's *The Desert Year* (1952) and Edward Abbey's *Desert Solitaire* (1968) and Gary Paul Nabhan's *The Desert Smells Like Rain* (1982) and Terry Tempest Williams's *Refuge* (1991). Desert plants, she had written, are very fertile in expedients. They find ways to flower.

2003

the fury of robinson jeffers

Robinson and Una Jeffers first saw Carmel Bay in the fall of 1914. It must have been in that year as beautiful as any place on earth. A rocky coast, ridges of cypress and pine, ghostly in the fog. On clear days the Carmel River glittered past the ruin of an old Franciscan mission, and the surf was an intense sapphire, foaming to turquoise as it crested. Gulls, cormorants, and pelicans among the rocks, hawks hovering overhead. In the distance the Santa Lucia Mountains rising steeply from the sea and ranging south toward Big Sur. Jeffers was then twenty-seven years old, and a writer, though of no special promise. Una was three years his senior, a very striking woman by all accounts, small and vivid. They had been married a little over a year, and they had arrived by stagecoach. It was almost the last moment of the nineteenth century. Europe had just gone to war; the United States would be entering it soon.

Within a few years that astonishing explosion in American writing that came to be known as modernism would be well under way. Ezra Pound, then in London, had already published *Lustra*, Frost's *North of Boston* would appear the following year, followed by Eliot's *Prufrock and Other Observations* and Williams's *Al Que Quiere!* in 1917, Moore's *Poems* in 1921, and Stevens's *Harmonium* in 1923. Jeffers's contribution to that decisive literary moment was the last to arrive. *Tamar and Other Poems* was published in 1924, *Roan Stallion, Tamar, and Other Poems* in 1925. The poems that gave that book its originality and force had begun to be written about five years earlier, in 1919, just after the end of the war and the Versailles peace, which issued, among the writers of Europe and America, in that curious and intense fusion of energy and despair that produced *The Waste Land* and *Soldiers' Pay* and *The Sun Also Rises*.

Robinson Jeffers was thirty-two when he began to discover what he had to say and the style in which to say it. He had by then published two volumes of apprentice work, *Flagons and Apples* (1912) and *Californians* (1916), which even for a sympathetic and interested reader are fairly hard going: conventional in form, conventional in thought, and not especially well made. Reading them makes the leap to *Roan Stallion* seem even more surprising and unparalleled. It may have taken the poet a while to find his voice, but the voice that he found, with its long line, its suppleness and somber beauty, its sense of power and edge and prophetic risk, is unmistakable. "Natural Music" may not be the first poem in the formed style, but it is one of the earliest and it is fascinating how much of Jeffers's vision is already present in it:

> The old voice of the ocean, the bird-chatter of little rivers,
> (Winter has given them gold for silver
> To stain their water and bladed green for brown to line their banks)
> From different throats intone one language.
> So I believe if we were strong enough to listen without
> Divisions of desire and terror
> To the storm of the sick nations, the rage of the hunger-smitten cities,
> Those voices also would be found
> Clean as a child's; or like some girl's breathing who dances alone
> By the ocean-shore, dreaming of lovers.

It almost seems like malice, the way the last image takes the lush, romantic diction of late nineteenth-century poetry and forces it against the most terrible human circumstances. But that is what this poem does; it suggests that the sound of the river and the sound of cities being bombed—a practice that had yet to be perfected when the poem was written—and the sound of a young girl's first vaguely sexual longing for happiness need to be understood as a single, entirely natural music, that the whole cycle of human desire, which is also the cycle of human history, is in a certain way nothing, a sound on the wind. This idea—it is ultimately a religious idea—would alternately, sometimes simultaneously, torment and console Robinson Jeffers for the rest of his life.

Mostly, at the beginning, it consoled him. Everywhere in the work there is the sense of a man to whom the wholeness and beauty of the world, particularly the world as seen from a rocky bluff above Carmel

Bay, and its reality, its actually being there outside his own circle of human need, is a stunning and sobering gift:

> At night, toward dawn, all the lights of the shore have died,
> And the wind moves. Moves in the dark
> The sleeping power of the ocean, no more beastlike than manlike,
> Not to be compared; itself and itself.

And again:

> Great-enough both accepts and subdues; the great frame takes all
> creatures;
> From the greatness of their element they all take beauty.
> Gulls; and the dingy freightship lurching south in the eye of the
> rain-wind;
> The airplane dipping over the hill; hawks hovering,
> The white grass of the headland; cormorants roosting upon the guano—
> Whitened skerries; pelicans awind; sea-slime
> Shining at night in the wave-stir . . .

All the young moderns were deeply influenced by symbolist verse and were also looking for a way past the cloudiness of its rhetoric, its subjectivity and aestheticism; for Jeffers this feeling of the power and actuality of the physical world was the way, as the poem "Credo" makes clear:

> My friend from Asia has powers and magic, he plucks a blue leaf from
> the young blue-gum
> And gazing upon it, gathering and quieting
> The God in his mind, creates an ocean more real than the ocean, the
> salt, the actual
> Appalling presence, the power of the waters.
> He believes that nothing is real except as we make it. I humbler have
> found in my blood
> Bred west of the Caucasus a harder mysticism.
> Multitude stands in my mind but I think that the ocean in the bone
> vault is only
> The bone vault's ocean: out there is the ocean's . . .

It is not much of a jump from this assertion of the integrity and reality of the natural world to the identification of that world with God. It was in fact the leap that had already been taken by the American transcendentalists. And it is one that he made soon enough; Jeffers's is a more chilling conception than Emerson's, based as it is on the early twentieth century's picture of the physical universe and on the status of human beings as understood by evolutionary biology. For Jeffers the news from the physical sciences meant that the world simply is, and that human consciousness had no very special part in it, and human suffering no special meaning. And freedom consists in understanding this. It is what he would say in poem after poem, down to the final poem of his final book, *The Beginning and the End and Other Poems:*

> The wings and the wild hungers, the wave-worn skerries, the bright
> quick minnows
> Living in terror to die in torment—
> Man's fate and their—and the island rocks and immense ocean
> beyond, and Lobos
> Darkening above the bay: they are beautiful?
> That is their quality: not mercy, not mind, not goodness, but the
> beauty of God.

Does he begin to sound like a preacher? His father was a Presbyterian minister and a Calvinist theologian. It seems to be the fate of American poets to reinvent the religions of their childhoods in their poetry. Jeffers is certainly an instance. And if he needed, in Calvinist fashion, to believe in the perfection of God and the absolute depravity of man, man in the twentieth century seemed to cooperate with that need. He had before him every day the contrast between the grand theater of sundown off Point Lobos and a horror that rapidly escalated from trench warfare through the invention of aerial bombardment to Guernica, Dachau, Hiroshima, and the gulags.

Moreover, he had, like many others in his generation, read Oswald Spengler's *The Decline of the West* and other fashionable theories of culture cycles that suggested, in reaction to the cheerfully Hegelian optimism of a previous generation, that Western civilization was doomed. So it too, rising and falling, terrible as the fall was, could be seen as a phase in the rhythm of the tragic dance. This view gets stated most forcefully in "Rearmament,"

a poem written in about 1934, when he saw accurately that the world had begun to prepare for another war:

These grand and fatal movements toward death: the grandeur of the mass
Makes pity a fool, the tearing pity
For the atoms of the mass, the persons, the victims, makes it seem
 monstrous
To admire the tragic beauty they build.
It is beautiful as a river flowing or a slowly gathering
Glacier on a high mountain rock-face,
Bound to plow down a forest, or as frost in November,
The gold and flaming death-dance for leaves,
Or a girl in the night of her spent maidenhood, bleeding and kissing.
I would burn my right hand in a slow fire
To change the future . . . I should do foolishly. The beauty of modern
Man is not in the persons but in the
Disastrous rhythm, the heavy and mobile masses, the dance of the
Dream-led masses down the dark mountain.

None of these developments was entirely visible to the young couple looking down on Carmel in 1914. The moment has qualities of both beginning and aftermath. "When the stage-coach topped the hill," the poet recalled later, "and we looked down through pines and seafogs on Carmel, it was evident that we had come without knowing it to our inevitable place." Their arrival there had not been simple. Una and Jeffers had met eight years before in Los Angeles. Jeffers was born in Pittsburgh, Pennsylvania, where his father was a professor of theology. He was educated partly in private schools in Pittsburgh and partly abroad—in Zurich, Lausanne, Leipzig, and Geneva, so he was fluent in German and French at the age of twelve, and he also knew Latin and Greek and commented later on the method of instruction: "When I was nine years old, my father began to slap Latin into me, literally, with his hands." It's hard not to believe that there is some connection between this father, whom he loved deeply and unaffectedly, as far as one can tell, and the cruelly beautiful God of the later poems. But the result of his education, after the family had moved west in 1903, was that he graduated from Occidental College in Los Angeles at the precocious age of eighteen.

In the fall of 1906 he began, in a desultory way, to do graduate work

in comparative literature at the University of Southern California, where Una, the wife of a successful lawyer, young herself, bored by golf and hungry for poetry, had been taking courses. They met, appropriately enough, in a class on German Romanticism, and they read *Faust* together. It is difficult, from the published accounts, to make out very clearly the course of their long torturous courtship. Jeffers left that winter for the University of Zurich but returned the following fall to try medical studies at USC. Una meanwhile continued to work on her BA and then on a master's degree. She wrote a thesis entitled "The Enduring Element of Mysticism in Man." In *Robinson Jeffers: Poet of California*, James Karman quotes one particularly interesting passage. "In certain centuries," Una wrote, "the souls of men seem to be stirring and wakening after long sleep, and tentatively trying in a thousand different ways to break through the crust of the material which encompasses them: at such times we see men restless, troubled, striving for they scarcely know what."

This probably catches something of Una Kuster's state of mind in those years and something of the febrile spirit at the beginning of the new century; it must also reflect the state of mind of her intense and drifting poet lover. It certainly demonstrates the way the pair influenced each other. A sudden, Nietzschean pronouncement that leaps out of the early narrative "Roan Stallion" seems to borrow from Una's prose directly:

> Humanity is
> the start of the race; I say
> Humanity is the mold to break away from, the crust to break
> through, the coal to break into fire
> The atom to be split.
> Tragedy that breaks man's face and a white fire flies out;
> vision that fools him
> Out of his limits, desire that fools him out of his limits, unnatural
> crime, inhuman science
> Slit eyes in the mask . . .

In the fall of 1910, apparently in an effort to break off the affair, Jeffers left Los Angeles and enrolled in forestry studies at the University of Washington in Seattle. Part of his motive may have been attraction to

"human science," but he seems mostly to have been floundering toward a profession. Wallace Stevens was at about this time trying to talk his father into letting him try the impractical career of a journalist. William Carlos Williams was about to start medical practice. T. S. Eliot would soon and rather reluctantly try to please his parents by embarking on graduate work in philosophy, and then ditch it for a job in banking. Only Ezra Pound flaunted silk scarves and lived by his wits. Jeffers was then twenty-three; interestingly, his mother and father accompanied him to Seattle, "to make a home," his mother said, "for Robin." By 1911 he was back in California, drinking a lot and at a loss.

Una had gone to Europe at her husband's suggestion to think things over. She was courted there by a man—he sounds as if he were invented by Henry James—called Percy Peacock. What a small world it must have been. The biographies actually quote an interview from the *Los Angeles Times* in which Una's husband Teddy Kuster gives his view of the affair: "She turned to philosophy and the school of modern decadents," he explained to a reporter, "and she talked of things beyond the ken of those who had dwelt upon the lower levels." In the spring of 1912 Jeffers had a volume of his verse, *Flagons and Apples,* privately published. It is very much in the style of modern decadents like Arthur Symons and Ernest Dowson, sensual and world-weary and, in truth, fairly awful; even its young author seems to have thought so.

And then—as in the silent movies, which were beginning to be made in nearby Hollywood—everything unraveled toward a happy ending. Una returned from Europe to find that Teddy had fallen in love (with an eighteen-year-old, Una's age when she met him) and was now willing to file for divorce. Robin had just had a short story—very urbane in manner—accepted by a fashionable magazine, *The Smart Set.* More crucially, he had come into "a modest legacy" of $10,000 on the death of a distant relative. They were married on August 2, 1913.

Ten months later—the Furies did not visit on them the large-scale catastrophes suffered by the characters in Jeffers's poems, but they inflicted a quieter and more common cruelty—they lost their first child, a girl named Maeve, who was born and died on May 5, 1914. And at the end of that year, in December, while Robin and Una were exploring the Big Sur coast for the first time, they received news of the death of Dr. Jeffers.

But whatever grief they nursed through that summer or the follow-

ing winter, they had come to Carmel-by-the-Sea, as it was then called, to start a new life, and they began it with great energy. That the life came to have the quality of myth was not an accident. They were a romantic young couple, and they had acted a great drama together. They wanted to live in an original way, and like many young artists, they set about it consciously. Later, at the height of the fame of Robinson Jeffers (and he became very famous: his face appeared on the cover of *Time* in the early thirties and *Vogue* did a story on the family; he was exactly the magazines' idea of a poet, unlike the studious Eliot or the cranky unintelligible Pound), their story was the one that many people came to know: how these adulterous lovers had broken with convention and gone to a remote spot on the California coast and built themselves a stone cottage by the sea to which they gave the name of Tor House; how Robin, having learned the art of masonry, built Una a tower, called Hawk Tower, beside the house, the tower inspired by his wife's love of the Irish poet Yeats, the stones hauled by hand from the Pacific shore; that they had twin sons, Garth and Donnan; that they lived a life a little apart, idyllic, solitary, pastoral; and that there, in the house by the Pacific, the poet broke through the conventions of nineteenth-century poetry and wrote great, long-lined, turbulent poems, full of the rhythms of the sea and as cold and passionate and morally indifferent as the sea itself.

There are several things wrong with this picture, though there is some truth in it. Carmel was, for one thing, a less remote place than it might have seemed. It already had some reputation as an artist's colony. In fact, the year before the Jefferses arrived, Jack London had published a novel, serialized in *Cosmopolitan,* called *The Valley of the Moon,* which describes and affectionately satirizes life in Carmel and the group of artists who settled there. They were mostly California writers: George Sterling, a San Francisco poet; Mary Austin, who later wrote a small classic about the southern deserts, *The Land of Little Rain;* Upton Sinclair. Other writers came and went; Sinclair Lewis, Lincoln Steffens. Jack London's version of the town is interesting partly because it catches the attitudes of the art crowd circa 1912. His tactic is to let a pair of working-class lovers, she a laundress, he a teamster and ex-prizefighter, wander into town looking for a better life than the one of bitter toil they have known. Among the golden-tongued and privileged inhabitants of Carmel,

who seem to be living in a beautiful place and in exquisite freedom, Saxon, the heroine, is puzzled:

> But what she could not comprehend was the pessimism that so often cropped up. The wild Irish playwright has terrible spells of depression. The poet Shelley, who also wrote vaudeville turns in his concrete cell, was a chronic pessimist. St. John, a young magazine writer, was an anarchist disciple of Nietzsche. Mason, a painter, held to a doctrine of eternal recurrence that was petrifying. And Hall, usually so merry, could outfoot them all when he got started on the cosmic pathos of religion and the gibbering anthropomorphisms of those who loved not to die. Saxon was oppressed by these sad children of art. It was inconceivable that they, of all people, should be so forlorn.

It seems a summary of Jeffers's themes, composed seven or eight years before he came to them.

Una's letters provide another look at Carmel a few years later. James Karman quotes one that suggests a rather lively and tony social scene:

> We went to an amusing dinner party there at Bechdolt's the other night. The Jimmy Hoppers were there and the Lloyd Osbornes. He, you know, is Stevenson's step-son. They live part of the year in an interesting place near Gilroy—the other part in New York, London, and Paris. They were in France and London last winter—Jimmy Hopper has been two years at the front and left here last week on his way to France again for Colliers. Lots of war talk. No end of interesting people here—The other night when we were dressing for dinner Robin said "What to wear" and I said his good-looking riding suit— and I'd wear a dinner gown. People dress so queerly here—one of us would be fixed right—sure enough. Osbourne big and grey and massively English was in golf clothes—she, his young second wife in a black chiffon velvet very low with Paris written all over it.
>
> Some weeks ago we went to (a big) dinner at the Hoppers served in the garden—the Hoppers have George Sterling's house. The piece de resistance was mussels which the Wilson chef prepared right before our eyes over an outdoor fireplace. The Wilsons are the Harry Leon Wilsons—you know his magazine stories. They have a big place down the coast—a chef, gardeners, chauffeurs, outdoor swimming pool and

that kind of thing. Mrs. W. is stunning—to look at—stunning interesting clothes.—His first wife is Rose O-Neil—(the Kewpie creator, you know—). Everyone here has ex-es so I guess I am quite unnoticed about that—anyway no one knows it I guess.

Jeffers can't have liked the social round very much. He had had a rather solitary childhood and was, as an adult, taciturn and—many observers reported—painfully shy. But Carmel was not a wild and desolate refuge, however solitary the poet chose to be. He and Una did have twin sons in 1916; she went south to Pasadena to be near a family physician for the delivery. And in 1918 they bought the Tor House property and began to build the cottage. The site was then two miles from the village; work began in the summer of 1919. Jeffers worked with the mason and his crew he had hired to build the house, writing in the morning—this was the period of his breakthrough to the *Tamar* poems—and doing physical labor in the afternoons; and he planted some two thousand trees on the property, eucalyptus and cypress and pine. Most of these are gone now, but the house, set among other, more modern and more expensive coastal houses, still stands; it is beautifully modest, with windows facing the sea; low ceilings with heavy, polished beams; and an exquisite cottage garden of heather and beach wildflowers, and herbs. The tower, which was built between 1920 and 1924, is a witty, small building, constructed in a spirit of play, with a lookout in the top, and a dungeon, and a secret passageway for the boys to play in.

There are poems that suggest a rich domestic life—"household verses," the poet called them. And forty years after their arrival in Carmel, when he was almost seventy and Una dead of cancer, it was this vision of their life that the old poet both fiercely and sentimentally recalled:

> Una is still alive.
> A few years back we are making love greedy as hawks,
> A boy and a married girl. A few years back
> We are still young, strong shouldered, joyfully laboring
> To make our house. Then she, in the wide sea-window,
> Endlessly enduring but not very patient,
> Teaches our sons to read. She is still there,
> Her beautiful pale face, heavy hair, great eyes
> Bent to the book.

Many poems—like "The Deer Lay Down Their Bones," which is among his best—testify to the depth of his love for his wife and the life they shared. But this would not obscure the fact that in 1915 Jeffers was in many ways a confused and deeply pained and unhappy man, or the fact that he wrote in the end a poetry that feels deeply lonely and tormented.

The reasons for his confusion were clear enough. He felt he had gotten nowhere in his art. *Californians,* published in 1916, was not very well received, and though it is an advance over *Flagons and Apples,* he himself recognized that it was derivative, that he hadn't found his way yet. He writes about this time with charming candor in a 1935 preface to the Modern Library reissue of *Roan Stallion.* He is walking in the woods and falls into "bitter meditation":

It had come to me that I was already older than Keats when he died, and I too had written many verses, but they were all worthless. I had imitated and imitated, and that was all . . .

When I sat down the dog and went back over our bridge for the bundle of firewood my thoughts began to be more practical, not more pleasant. This originality, without which a writer of verses is only a verse-writer, is there any way to attain it? The more advanced contemporary poets were attaining it by going farther and farther along the way that perhaps Mallarme's aging dream had shown them, divorcing poetry from reason and ideas, bringing it nearer to music, finally to astonish the world with what would look like pure nonsense and would be pure poetry. No doubt these lucky writers were imitating each other instead of imitating Shelley and Milton as I had done . . . but no, not all of them, someone must be setting the pace, going farther than anyone had dared to go before. Ezra Pound perhaps? Whoever it was, was original . . .

But now, as I smelled the wild honey midway the trestle and meditated the direction of modern poetry, my discouragement blackened. It seemed to me that Mallarme and his followers, renouncing intelligibility in order to concentrate the music of poetry, had turned off the road into a narrowing lane. Their ancestors could only make further renunciations; idea had gone, now meter had gone, imagery would have to go; then recognizable emotions would have to go; perhaps at last words might have to go or give up their meaning, nothing be left but musical syllables. Every advance required the elimination of some aspect

of reality, and what could it profit me to know the direction of modern literature if I did not like the direction? It was too much like putting out one's eyes to cultivate the sense of hearing, or cutting off the right hand to develop the left. These austerities were not for me . . .

I laid down the bundle of sticks and stood sadly by the bridgehead. The sea-fog was coming up the ravine, fingering through the pines, the air smelled of the sea and pine-resin and yerba buena, my girl and my dog were with me . . . and I was standing there like a God-forsaken man-of-letters, making my final decision not to become a "modern." I did not want to become slight and fantastic, abstract and unintelligible.

I was doomed to go on imitating dead men, unless some impossible wind should blow me emotions or ideas, or a point of view, or even mere rhythms, that had not this to them. There was nothing to do about it . . .

That impossible wind came to Robinson Jeffers three or four years after the moment he describes. The romantic Una spoke of it as "an awakening such as adolescents and religious converts experience" and attributed it partly to a strength her husband absorbed from handling stone. In fact, it is not clear what happened. There is as much evidence to argue for a gradual evolution as there is for a sudden revelation. At least at the level of style, it is possible to watch the long, characteristic, free-verse lines emerge from the metrical experimentation in the early lyrics and narratives. It derives, I think, not from Whitman, as so many critics have assumed, but from the long-lined dactylic and anapestic experiments of the late Victorian poets like Swinburne. Jeffers wrote some songlike lyrics in about 1917 that illustrate the point. One of them begins:

> Was it lovely to lie among violets ablosssom in the valleys
> of love on the breast of the south?
> It was lovely but lovelier now
> To behold the calm head of the dancer we dreaded, his curls
> are as tendrils of the vineyard, O Death.

The lilt of it is almost ludicrously exaggerated: was it lovely to lie among violets ablosssom in the valleys of love on the breast of the south?

But it is not hard to see how the long line of a poem like "Continent's End" derives from it:

> At the equinox when the earth was veiled in a late rain,
>> wreathed with wet poppies, waiting spring,
> The ocean swelled for a far storm and beat its boundary, the
>> ground-swell shook the beds of granite.

It is much more a sobering up of Victorian verse, a suppression of those rocking-horse rhythms that the prepositional phrase invites into the English language, than it is a leap to Whitman's exhilarated and playful long line. And for a writer who loved the prose of Thomas Hardy—there is a stone in Tor House on which the poet paused in his labors to carve the fact of Hardy's death on a day in 1924—that sober and rhythmic line had the virtue of being very well suited to realistic narrative, like the beginning of "Roan Stallion":

> The dog barked; then the woman stood in the doorway, and
>> hearing iron strike stone down the steep road
> Covered her head with a black shawl and entered the light
>> rain; she stood at the turn of the road.

You can hear, particularly in this last line, a varying and doubling of the light, anapestic rhythm: covered her head with a black shawl and entered the light rain: she stood at the turn of the road.

And beyond these technical considerations, it is possible to watch the evolution of the poet's sense of how to speak from where he was in the world, the development of what came to be the myth of himself: the man at the end of a culture cycle who stood at continent's end beside a house and tower he had built himself and told his culture bitter truths.

This aspect of his transformation in the early 1920s does not suggest slow change but a bolt of lightning, a gnosis. If he did not have a vision, he had a series of insights that came to have the quality of a vision. There is first of all a sense of terrible and tormenting violence at the center of life, from the hawk's claw to the fury of war to the slow decay of stone. And there was also a sense, sharply, of something pained, decidedly and deeply sick in the human heart, at the root of sexual desire and religious longing. And finally there was the leap—to

the wholeness of things, a leap out of the human and its pained and dis-eased desiring into the permanence and superb indifference of nature. The possibility of this leap became at first the central wish and, finally, the doctrine of his poetry.

Speculating about the origin of it has occupied his biographers and critics. His father was an older man when he married his mother, and some have guessed that they created for the poet an Oedipal conflict that he acted out by stealing Una from her husband, and that the guilt of that transgression fuels the poems. Others have argued that he experienced divisions of desire after the marriage—William Everson has specu-lated that Jeffers had other relationships in the period between 1917 and 1919—which led to both the yearning identification with stone and the torment of guilt. And it has been pointed out that in the poems the very violence of the western landscape, geologically young, haunted by a sense of recent and prehuman catastrophe, seems to tease his mind toward such an insight. Still others have observed its connection with Calvinism, with the philosophy of Schopenhauer and the German Romantics that he absorbed as a boy in school. In any case, it is an ancient movement of the soul—from anguish at life to the idea of God.

When the poet himself attempted to speak about what happened to him, he did so in a poetry reading at Harvard University in 1941—it will tell you how much the world has changed to know that it was his first public poetry reading; he was fifty-four years old—and he sin-gled out the vision of Orestes in his verse drama "The Tower Beyond Tragedy." As in Aeschylus, Orestes has, at his sister's urging, killed his mother to avenge his father's death. In Jeffers's version of the story, once the pair have isolated themselves by their crime, when they are in some sense beyond crime, Electra offers herself to her brother. It is Nietzschean, I suppose: beyond good and evil; it is also a metaphor for the mirroring and inward-turning of human desire, mixed up with crime against the parents. There is evidence that Jeffers had been reading Freud, but the passage doesn't feel like the application of an idea gotten out of a book; it dramatizes the poet's own sense, shared with Freud, that human desire is fundamentally incestuous and blind. Orestes refuses his sister. What is most haunting about the way he does so is, for me, the glimpse it contains of Jeffers's own moment of vision. Electra, spurned, threatens suicide. Orestes is unmoved. "I have," he says, "fallen in love outward."

The verse Orestes speaks, he told the Harvard audience, was intended to express "the feeling—I will say the certitude—that the world, the universe, is one being, a single organism, one great life that includes all life and all things, and is so beautiful it must be loved and reverenced, and in moments of mystical vision we identify ourselves with it." By then his doctrine of inhumanism, as he called it, was well-known and associated with his isolationist's opposition to the war in Europe. His audience did not much like what he stood for. His verses, he said, "also express a protest against human narcissism." He elaborated: "The whole human race spends too much emotion on itself. The happiest and freest man is the scientist investigating nature, or the artist admiring it, the person who is interested in things that are not human. Or if he is interested in human things, let him regard them objectively, as a small part of great music. Certainly humanity has claims on all of us; we can best fulfill them by keeping our emotional sanity and this by seeing around and beyond the human race."

These are the cooler reflections of the older man. What happened to the Jeffers of the 1920s was that he began to write like a demon, like a man possessed. First came "Tamar," a narrative of some sixty pages, then "The Tower Beyond Tragedy," fifty pages, and "Roan Stallion," fifteen pages, followed by *The Women at Point Sur,* which is the length of a novel, and the hundred pages of "Cawdor," plus sixty or so lyric poems. This by 1928. Readers can get a sense of this explosion of work by reading Jeffers's own tracking of it in his *Selected Poetry.* Jeffers kept up this pace without interruption from about 1920 to 1938, when *Selected Poetry* was published. He wrote in the course of those eighteen years fifteen narrative poems ranging in length from ten to two hundred pages, four verse dramas, and almost two hundred lyric poems.

The narratives, like the world they were written in, seemed to become more strained and violent each year, but the life they came out of was uneventful enough. Jeffers's sudden fame intensified his shyness. He wrote. Una ran the household. She was apparently a vigorous maternal figure. Sometime during this period her former husband Teddy Kuster showed up in Carmel and built, not far from the Jefferses, his own larger and more expensive version of their stone cottage. Una befriended his wife—Edith Greenan, who later wrote a biography of her friend, *Of Una Jeffers*—and was in and out of both houses. She raised her boys and saw to it, according to observers, that Robin kept

busy. In her gossipy memoir *Una and Robin,* Mabel Dodge Luhan gives this rather amusing glimpse of breakfast at the Jefferses':

> "Now, dear, you'd better go upstairs," Una says. Robin is always held a little below the surface in the morning, and Una leaves him to it. He isn't taciturn—he is dazed to the outer world. His pulse beats slowly, and his eyes seem to see inward. He is aware of his three, and would be responsive if they wanted him. He would always give up poetry for life—his life. He would rather drive the boys to school than write a poem—thinking life more valuable than its reflection; but Una won't have it. "Now go upstairs, Robin," Una says, briskly.

Jeffers paced as he worked in the bedroom above the kitchen; other observers report that when Una did not hear the characteristic sound of his shuffle, she would rap on the ceiling with a broom.

During those years they took one trip abroad, visiting the British Isles from June to December of 1929. *Descent to the Dead,* which contains some of Jeffers's best work and is interesting for its resemblance to the work of some younger poets—to Seamus Heaney's *North,* in particular, and to some of the work of Ted Hughes—dates from that long vacation; and they spent some part of most summers with Mabel Dodge Luhan in Taos, New Mexico. But mostly they were at home in the quiet of their Carmel life, where Jeffers, as the world lurched toward war, poured out poems that were increasingly nightmarish and misanthropic. This passage from the short narrative "Margrave," published in 1932, shows the extremity of the vision. The poem pauses in its telling and urges the stars to flee the infection of human consciousness, then looks forward to the day when the sun rises over the dust to which time and the weather have reduced the last human skulls:

> The sun will say "What ailed me a moment?", and resume
> The old soulless triumph, and the iron and stone earth
> With confident and inorganic glory obliterate
> Her ruins and fossils, like that incredible unfading rose
> Of desert in Arizona glowing life to scorn,
> And grind the chalky emptied seed-shells of consciousness
> The bare skulls of the dead to powder; after some million
> Courses around the sun her sadness may pass

And against this fury—which always feels a good deal like self-loathing—there is always the life outside of his life, through which, as in the best of these poems, like "The Purse-Seine," the poet tried to reconcile himself to the coming catastrophe and to his own death.

By 1938 the twenty-year torrent of verse seemed to have come to an end and Jeffers was emotionally exhausted. The strain told, as it often does, on his marriage. That summer at Mabel Dodge Luhan's he seems to have had an affair, and when Una heard of it she tried to kill herself. In his account of the incident, James Karman suggests a shaky but nevertheless real recovery. Una had always been passionately possessive. Jeffers always seems to have admired—and been slightly appalled by—the fierceness of her spirit. Meanwhile, *Selected Poetry* appeared and it became evident that the poet had left much of his audience behind. The vision was too dark, the narratives on which his reputation seemed to rest were often repellently violent and hysterical, the sexuality was violent and only violent, and the politics were deeply out of fashion, at least among people who were likely to read poems. Jeffers seems to have been, politically and sentimentally, an old-fashioned Jeffersonian republican. He believed in the American republic as a commonwealth of independent and self-reliant households, and saw himself—educated at a time when small boys knew the history of Rome and had been taught the parallels between the Roman and American republics—as a defender of the spartan and honest American commonwealth against the thickening of the empire. He seems to have wanted this country to be, as he wanted his poems to be, as cool and aloof as a hawk from what was going forward, the inevitable and horrifying collapse of European civilization.

Though this may have been philosophical conviction, it did not in practice appear to differ very much from the view of any wealthy, Republican, Roosevelt-hating citizen of Carmel, living on private income and isolated from the effects of the Depression, and so it did not endear him to the predominantly liberal, socialist, and humanist literary culture of the thirties and forties. The work of the war years is intensely dispirited. This must be due partly to the trouble in his marriage, but the poems are also the work of a man sickened by the war, by political processes so-called, and by the human race. American patriotism sickened him as much as German or Japanese patriotism, and it brought him soon enough into conflict not just with popular opinion, but with his publisher.

When the editors at Random House saw *The Double Axe* in 1948, they balked. After persuading Jeffers to omit ten of the most offensive and blatantly editorial poems—which treated Churchill and Roosevelt as morally equivalent to Hitler and Mussolini—they published the book with an editorial disclaimer on the back cover and a preface by Jeffers somewhat wearily explaining the philosophy of inhumanism. There is something to be said for the bitterness and bluntness of the poems of this period, but Jeffers himself seemed to be, at the very least, discouraged by the task they undertook. As he said in the preface to *Be Angry with the Sun* in 1941:

> I wish to lament the obsession with contemporary history that pins many of these pieces to the calendar, like butterflies to cardboard. Poetry is not private monologue, but I think it is not public speech either; and in general it is the worse for being timely . . . Yet it is right that a man's views be expressed, though the poetry suffer for it. Poetry should represent the whole mind; if part of the mind is occupied unhappily, so much the worse. And no use postponing the poetry to a time when the storms may have passed, for I think we have but seen a beginning of them; the calm to look for is the calm at the whirlwind's heart.

The postwar years brought the Jeffers family other things to think about. Before the furor over *The Double Axe*, there had been the immense public success of Jeffers's adaptation of Euripides's *Medea*, which he had undertaken for his friend Judith Anderson and which opened on Broadway in 1947. And in 1949 the cancer for which Una had been treated from 1941 to 1944 returned; it had spread to her spine. She lingered for some time, nursed by her husband and her son Donnan and daughter-in-law Lee in her room at Tor House. She died on September 1, 1950, in her husband's presence. *Hungerfield and Other Poems* is the book of his grief, with its peculiar title poem, the tender and moving elegy for his wife framing the brutal narrative. The book was published in 1954. Jeffers was then sixty-seven, and his sadness seems to have quickened his imagination, or altered its focus, as he began the work of his last years. The poems in *The Beginning and the End* belong to the increasingly rich American poetry of old age, and it is various enough to make one wish that the poet had been less obsessed and single-minded in his earlier years. His mind has relaxed somewhat.

Though he still hammers away at his religious convictions, he is able to accommodate more wayward observations than he had permitted himself in the furious poetry of the 1930s and 1940s.

He died in January of 1962. Some of the land around the house had been sold off to pay taxes. The home itself had been electrified and acquired a telephone. Most of the trees he planted had been cut down, replaced by suburban houses with large bay windows gawking toward the sea like the open mouths of baby birds. At the end, his disgust with the encroachment was moderate. He seems to have felt that he had had, on the whole, a good life. His poetry at his death was far from forgotten, but he no longer occupied the commanding place in American letters he had seemed permanently to have carved out thirty years before. And it is hard to believe that it was in the end a matter of much consequence to him. He had had his say.

His centenary seems an appropriate time to reconsider his achievement. The least that can be said of it is that he wrote many remarkable and original poems. He was not afraid to stake a large claim. Critics have been inclined to expound his ideas systematically, but it seems to me that he is, in the end, an intuitive, unsystematic, and contradictory thinker. It is as a feeler, not a thinker, that he matters. Looking out at the Pacific landscape, with its sense of primitive violence that weather has not quieted or eroded, he found himself haunted by the riddles of desire and suffering, and he thought he saw a way out of the cycle, and the way connected to his almost mute, though intense, feeling for the natural world—for all the life outside of and imperiled by the rapacity and unconsciousness of the human usurpation of the planet. He came to feel, with tragic clarity, that human beings could be saved, if they could be saved, only by what they were destroying. This is his moral side, his Cassandra voice. As a poet he kept trying to make images from the movements, serene and terrible, of the life around him, for what he had discovered or intuited—for the power at the center of life that reconciled him to its cruelty. One feels him straining toward it, toward what is not human in the cold salt of the Pacific and the great sunsets and the rocks and the hawk's curved, efficient beak. It is in the farthest reaches of his intuitive straining that one feels most in Jeffers the presence of a great poet. And this is the dimension of his work that the poet Alan Williamson had in mind when he identified the poetic tradition to which Jeffers belongs: "Jeffers belongs with Rilke, with Mallarmé,

with Whitman and Hart Crane, to the project of inventing a spirituality which can survive the death of Christianity; inventing, as Jung and Heinrich Zimmer have said, an equivalent of Buddhism which is not Buddhism, but something distinctively Western."

Jeffers's refusal to become a modernist gives him another interest, which is his willingness to speak his mind. It is this aspect of his work that most bothered critics in midcentury. They were busy absorbing the modernist aesthetic: go in fear of general ideas, Pound had said, the natural object is always an adequate symbol of the idea or the inward state. There is much to be said for this view: it is a way of bringing the minimum of conceptual baggage to the fresh encounter with reality. What was death to Stevens? A flock of pigeons that made ambiguous undulations as they went downward to darkness on extended wings. What was the secret principle of order in things to Ezra Pound? A rose in the steel dust. What was the paradise, tucked in memory or hidden just behind misery, to T. S. Eliot? Sunlight and laughter in a garden. These images have immense and memorable evocative power, and they have the permanent sphinxlike and unparaphrasable quality of all powerful metaphors. One feels in them the imagination in the twentieth century pounding on the wall of what it cannot know. This was the context in which Jeffers, risking the banality and lameness of the general statement—and achieving them often enough—said it out, tried to speak what he knew in the language of his time.

There is much to be said against his work, and most of it has been said. The younger generation of California poets, Yvor Winters in the thirties and Kenneth Rexroth in the forties, anxious to dispose of the overwhelming figure down the coast, wrote scathing and not inaccurate criticism of his work. Jeffers, they said, was pretentious, repetitious, bombastic, humorless, fuzzy. What bothered them most was that he was verbally careless. He can write "the weed-clad rocks," which no other poet of his generation would do—because they would not wish the rocks to appear "dressed" and because the figure is, anyway, a cliché. Jeffers uses the phrase because it came to hand. He can write, in the same poem, about "the black lips of the height" and "the thin sleeve of the sea" and not be troubled by the scrambled images he inadvertently calls up.

And yet he can be more interesting than many more careful writers, partly because he was driven by strange expedients: who else would have tried to describe the last moment of an already dead eagle's living

instinct, or the last flickering consciousness in the separate cells of a decomposing brain? Or attempted a poem as peculiar and distraught as "Prelude," with its crucified hawk and its landscape of tormented sexual longing? In "Roan Stallion" the Indian woman California yearns toward a horse, which is an embodiment of the beast-and-god-like power and beauty of life itself, and at the end of the poem, out of an obscure human loyalty to a husband she does not even like— a loyalty that Jeffers the philosopher would have disavowed and one that the poem makes necessary and right—she kills the animal. In his last narrative, the brutal man Hungerfield, furious with the black angel of death, which has dared to invade his house and take the mother who despised him, wrestles death to a standstill. And this story, repellent, psychologically false somehow, as the narratives can be, written in the spirit of a tender gift to his dead and beloved wife, haunts the reader. Everywhere, and usually when one feels least comfortable, one feels the presence of a truly obsessed and original imagination.

The experiments in narrative, mythic and realistic, continue to be relevant, but Jeffers is strongest, seems most apt to survive in his descriptive and meditative lyrics. There his directness gave him the old power of poetry—not to say what no one else had ever thought, but to say what everyone has thought and felt. It is surprising in a writer who wished to be so contrary, but reading him again, reading "The Purse-Seine," for example, I was struck by how much it seemed to say what anyone has thought who has ever stood on a height and contemplated a modern city. We have lived in a catastrophic time. The redundancy of violence and suffering, the sheer immensity of the danger, always threatens to wither the imagination, to make us turn back to the purely personal, as if it were somehow more real because the mind can, at least, compass it, whereas the effort to think about the fate of the planet, about what man is that he has done to himself all the terrible things that he has in this century, comes to us mostly as dark and private musings. And it is just this that Jeffers sought in the verse of his short poems, an art to speak those musings largely, to claim for poetry the clarity and largeness of mind needed to compass the madness.

1987

william everson: some glimpses

I knew of him first as Brother Antoninus. The Beat Dominican. And once, when I was in college, on some errand, I had to deliver a package to Saint Albert's, the Dominican rectory in Oakland where I knew he lived, and, when I asked about him later, was told that he was the tall, lean, mute, quizzical man who had opened the door for me when I rang the bell, and had stepped aside and with a low bow and a gesture of his head had invited me in.

Later I described this to another writer of the same generation—someone, in fact, who had written a story about a character whom I thought resembled Brother Antoninus. I told him about the man I had seen, perhaps the first living writer I had ever seen, at a time when such figures were huge in my eyes. With the particular vanity of the young—here was this man opening the door for *me*—I emphasized, in the telling, his humility. The writer said: "It's theater." I was taken aback. "You mean, he's a fake." "No," his friend said, "I mean it's theater." An aspect of Bill Everson's character and art—and a way of seeing them—I would come later to understand.

Around that time, I think, *Single Source* appeared in the beautiful Oyez edition. Trying to write about the places I had grown up in, I was very taken by those poems. I don't think I had read enough of Robinson Jeffers to understand the ways in which they were derivative. I loved their silences, the solitude in them that felt to me like a single taut string plucked in a place of great remoteness and purity. And I found that one of my college teachers—the best of my college literature teachers, Jim Townsend—had been a CO during the war and sent to a camp where Everson also was and where they had established an anarchist press that had published some of

their poems and those of another young CO, William Stafford. He talked about it with a sort of diffident, amused distance, and very respectfully about "Everson's"—this was a period when it sounded odd to a young man to hear "Brother Antoninus" referred to as "Everson"—skill as a printer. And a few days later he showed me some of the work from the camp and its Untide Press, *The Waldport Poems* and the first *Residual Years*. And on another occasion a copy of his first book, *These Are the Ravens*.

I turned the pages, absorbing some notion of who the man was. Anarchist, printer, poet, pacifist, beatnik, monk.

Lucky for me to be in a time and place when one had such models. Having heard that Antoninus had been an anarchist, I saw not long after an essay by someone named Gary Snyder in the *City Lights Journal*, called "Buddhist Anarchism." Both ideas were fairly exotic to me. I read and read. Hunted up Kropotkin and Suzuki. And Dorothy Day, the Catholic anarchist pacifist whom I had been told Antoninus admired.

Also around this time, a friend of a friend, who was a Dominican novice and was enthusiastic about some piece of undergraduate writing of mine—a short story, I think—showed it to Brother Antoninus, who read it and said, as it was reported to me, "He has the seed." I took this, even then, to be tact. I had hoped for great praise. I took anything less to be the polite dismissal that I feared I deserved. But with that double-thinking through which we are often able, with one part of the mind, to face unpleasant truths, even while we suck the honey of ambiguity with another, I went around for a while feeling like I had the seed. Well, not quite. But like someone had said so.

And—oh, eight years later—I was spending a summer in Kentfield, next door to a Dominican retreat where Brother Antoninus was living. I used to catch glimpses of him across the fence and through an apple orchard as he walked in the garden. I was by that time working hard on poems and also had a much better sense of my neighbor, had read *The Crooked Lines of God* and *The Rose of Solitude* and the study of Jeffers, *Fragments of an Older Fury*. And I think I had heard him read by then, those extraordinary performances in which he paced, inflicted long silences on the audience—equivalents of the silences I had intuited in his early work—and barked out his poems in anguished and ecstatic fragments. It was much too dramatic for my taste then and it

seemed manipulative of the audience—a few of whom were put off, most of whom were ravished in those heady and credulous days.

I remember that what fascinated me, standing in the back of the room—was he reading "A Canticle to the Waterbirds"?—was that he commented on the shamelessness of the performance, seemed acutely self-conscious about what he was doing, and was genuinely ashamed, and also unrepentant. It seemed Dostoyevskian to me. His making himself naked to the audience, the silences that seemed bullying— I think he said "bullying." Something like "Do you feel bullied by this? I do to you what God does to us." Serious chutzpah. And the writing was another matter, the actual content of the readings. I think I had by then decided—a young man's idea, for sure—that he was "uneven"; I didn't like the melodrama and the theology, though I thought he had gotten Jeffers's theology exactly right and had written with great eloquence about the imaginative violence of poetry. What I admired, was eager to learn from, was the eye and the ear. They were not separable from the complicated passion and the self-mocking humor. But it was the other I was able to take in:

In the shoal-champed breakers
One wing of the gull
Tilts like a fin through the ribbon of spume
And knifes under.

And:

You smell pine resin laced in the salt
And know the dawn wind has veered.

I would see him sometimes in the summer on the road and when we passed I would nod to him. Sometimes he would nod back and sometimes he wouldn't. It didn't occur to me to introduce myself; I didn't even have fantasies about it in which I would get him to read my poems. His silence seemed inviolable, and I also had some vague sense that he had his own task, that what he could give me I could get from the poems, not from the personality or the critical intelligence. But there was something in that parallel solitude that was with me as a companion all that summer. As I was learning to

treat writing as my work, I would catch sight of him in his white monk's robes and sandals, tall, slightly stooped, strolling among the almost-blown roses of late July in the buzzing heat, and I imagined that he was pacing verse rhythms, which is what I was doing. And I looked at his poems then as, I imagine, young painters study the brushwork of an older generation, trying to figure out how to take what I wanted, learning from what I liked less in his writing what I did not want.

Antoninus may in fact have been pacing out something other than verse rhythms because sometime after I had returned east I heard the story that he had, in the middle of a poetry reading at the University of California at Davis, torn off his robes and renounced his status as a lay monk.

The next time I saw him, at one of those big benefit readings of which there were many in the late sixties and early seventies—Harold Norse succeeded by George Oppen succeeded by Kathleen Fraser succeeded by Victor Hernández Cruz succeeded by Thom Gunn (so many voices!)—he was William Everson and he was wearing a buckskin jacket that made him look, with his long white locks, something like the old daguerreotypes of Buffalo Bill. *Archetype West* was the name of a book he published around that time. And his poems were about—to borrow a phrase from Milosz—being pinned to the cosmos by the black pin of sex:

> The fate of man
> Turns on the body of woman.
> She takes the long advance
> And the long recession.
> By what she is
> She defines them.

The early 1970s were not an especially auspicious time for males to generalize publicly about "woman." On this occasion, as he paced and recited from "Tendril in the Mesh"—

> Kore! Daughter of dawn! Persephone! Maiden of twilight!
> Sucked down to Pluto's unsearchable night for your husband.

—there was some audible hissing from the audience, which made me feel protective of him. He didn't invent the myth and he was a man of his generation, soaked in Jung, soaked in Jeffers and Lawrence, and like them inclined to feel small next to and to test himself against the great rutting power of the biosphere. I listened, as he read, in his way, really oblivious of the audience at the same time that he was quite attuned to it, for the places where the language came to the landscapes of the coast and took hold, as it does in these late lines:

> Then early last evening
> A thin drizzle, gaining toward dusk. Before dark dropped
> The low hanging cloud slit its belly and the rain plunged.
> All night long the thirsty slopes drank straight-falling water,
> Soaking it up, filling those tilted, deep-shelving seams,
> Blue veins of the mountain, zigzag crevices of fractured shale
> When dawn flared and the rain held
> The runoff began.

I didn't like the slit belly of the cloud or "the thirsty slopes," that way Everson took over for his own purposes Jeffers's projections of human violence onto the landscape. But I envied the "tilted, deep-shelving seams" and the "zigzag crevices of fractured shale." It is a gift, this kind of listening to older writers, learning from them.

And beyond these specifics there was, as I reached my thirties, in Everson as in the other poets of evident power in my place—George Oppen, Robert Duncan, Thom Gunn, and others—a sense of the life of an artist with its metamorphoses and amazements and fragilities and risks.

And a last image, twenty years later again, Bill at a celebration for Jeffers in Carmel, bent almost to the shape of a scythe, palsied in the hands, dressed still in the buckskin jacket, which I had come to understand was for him a way of manifesting the vestiture, that is to say the ambition and the grand failure, of poetry. He seemed quite ill but was full of good cheer. I had met him in the interim, published books, though I'd never found an occasion to say to him the kind of figure he had been for me and to thank him for it. I wasn't even quite sure he knew who I was. But I had recently been given an especially

handsome fellowship and he grinned when he saw me. "So you're the one of us who got the golden fleece." What I noticed was that phrase, "one of us." Later, when he was so bent on the stage that I thought of the crooked man who walked a crooked mile and found a crooked six-pence upon a crooked stile, he recited the elegy for Jeffers again with the same old power and the same silences and the same disturbing witness of his body:

> So the sea broods. And the aged gull,
> Asleep on the water, too stiff to feed,
> Spins in the side-rip crossing the surf
> And drags down.

And now, of course, it is true of him:

> He has gone into death like a stone thrown in the sea.

Long pause.

> The poet is dead.

Long pause. Restless pacing.

1995

maxine hong kingston: notes on a woman warrior

he Woman Warrior was published in 1975. Within a decade it had become the book by a living author most widely taught in American universities and colleges. Its opening sentence—" 'You must not tell anyone,' my mother said, 'what I am about to tell you' "—became as well-known to college students as Huck Finn's famous sentence about going to hell. Indeed one way to begin to think about the book is to ask if there isn't something wrong with a book so popular and so widely respected. Or, perhaps, to ask what the sources of its popularity have been—whether, if it is in fact a classic, it's *Uncle Tom's Cabin* or *Huckleberry Finn.*

It's easy enough to see why the book, for a time, replaced—what? *Lord of the Flies? The Catcher in the Rye? Portrait of the Artist as a Young Man?*—as the *Silas Marner* of composition and introductory literature courses in the 1980s. It's a feminist book, it deals with ethnic and racial issues, it incorporates the procedures of magical realism, was probably the first work by an American prose writer to digest García Márquez's *One Hundred Years of Solitude* and put its methods to work on North American material, and besides its construction is rich, original, and surprising. It is also, deeply, a book about growing up. As much a bildungsroman as an autobiography, it is by its very existence the record of a triumph: it's a success story. Among all the reasons for admiring the book, this may be why instructors like to teach it. That first sentence is now the first sentence many students read in their college careers. It tells them that their task is to wrest an identity from the matrix of family secrets, and the book goes on to demonstrate that imagination, intelligence, and the power of language are instruments of survival and self-making.

The question suspicion might put to all of this is whether the book works its magic by sentimentalizing or falsifying its material. But it doesn't. On the contrary, Hong Kingston has a very clear eye, mordantly clear, and seems likely to be one of those writers, like Mark Twain or Robert Frost, whom later generations will find darker than she first appeared. Moreover, successive readings will make it clear how much the book is about the ways in which it might have falsified its material. *The Woman Warrior*'s tendentiousness is feminist. Its anger is directed mainly at the devaluation of women in Chinese culture, more particularly in the Cantonese village culture Hong Kingston's family came from. In this sense it lets American culture off the hook. And this may also explain some of the book's appeal— it is a success story that looks at racism and sexism through a lens less discomfiting to many American students than some others might find it. But the book is certainly no hymn of praise to the ghost culture that surrounds its protagonist. Assimilation may be the way out of the low status of women in her family culture, but the roles she sees she will be asked to assume in the new culture, American-feminine, American-pretty, send her back into family stories and daydream variations on family stories, looking for alternative sources of identity. This heightened sense of roles, of the fictitiousness of social life, creates the heightened sense of story, talk-story, endless revisions of story, from which the book proceeds.

Thus, Hong Kingston's constant technique—telling a story in several versions of varying probability, reframing and revising narrative detail in the course of the telling—is also her theme: the alternating powers of imagination and intelligence, imagination trying to transform, empower; intelligence trying to discount desire, to distrust, to understand. It is by means of this alternation that the book dramatizes something like the emergency development of a homemade cultural anthropology. Thinking of the story of her aunt's illegitimate pregnancy, she tries out the idea of a lusty, free-spirit aunt. No, she thinks, very unlikely. Confronted then with the helplessness of the aunt and the cruelty of the peasants, she tries to find the motive for their behavior: legitimate sons secured old age. This mix of realism and fantasy, desire and fear, is the interplay that gives the book its poignance, its humor, its agility, and a clear-eyed, uncompromised understanding of what drives human cruelty that can make a reader

gasp. Perhaps there is a certain sleight-of-hand in this, a having it both ways, but it is the having-it-both-ways of a very high art.

And if it does not always count the cost of its heroine's dilemma, it certainly names the risks. Psychologically, *The Woman Warrior* is a book about a mother and daughter, a daughter who has to leave her mother's world and a mother who knows it. This is announced by the mother's introductory injunction—the secret invitation for the daughter to betray (and avenge) her by telling her secret, which gives rise in turn to the narrative of No Name Woman, who is driven to her death because she had "a secret voice, a separate attentiveness." The precision of this phrase is worth remarking. There are kinds of familial and cultural situations in which all it takes to violate the secret is to be attentive, to notice what's happening, in which noticing is itself the betrayal. Hong Kingston has a vein of flaky comedy, but there is, in phrasing like this, always when one comes upon it, the sudden sense of an exact and penetrating intelligence. When the villagers attack the aunt's family to punish her for "believing that she could have a private life," Hong Kingston observes while No Name Woman, having dragged herself to the pigsty and given birth there to fool the gods, then crawls with the baby to the village well to drown herself. And she underlines the fact that the aunt is not entirely a victim, that it was a spite suicide. She had set out to avenge herself by fouling the common well. A complicated image to explicate in this brief space but its dialectic—the danger of betraying the tribe; of separating from the mother, of not separating from the mother; of bringing forth what is in you; of not bringing forth what is in you—plays very darkly through the rest of the book.

If *The Woman Warrior* is about myth and the mother, *China Men* is about history and the father. It has been neglected to some extent because of the popularity of *The Woman Warrior*, but it is an equally remarkable achievement and an even more original book, at least in part because it is less formally precedented. *The Woman Warrior* proceeds from autobiography and magical realism. The one source for *China Men* seems to be William Carlos Williams's *In the American Grain*. Like Williams's book, it sets out to do no less than reclaim for literature the writing of history. One way to think about it is to imagine a course in the as yet unclassifiable genre to which it belongs and which it may help to crystallize. Other texts might include, besides Williams's, Parkman's *The Oregon Trail*, Adams's *History of*

the United States of America During the Administrations of Thomas Jefferson, Dos Passos's *USA,* and Mailer's *The Armies of the Night.*

But the quickest way to get at its quality perhaps is to glance at its relation to the criticism of *The Woman Warrior.* Although that book was almost universally admired, it infuriated some readers, particularly male readers in the Chinese-American community. Some of this was just the outraged howl that goes up in any ethnic minority that feels exposed when one of its children writes about it with insufficient idealization. Richard Wright and Philip Roth have gotten into similar trouble. But other complaints were more specific. One was that autobiography was an un-Chinese, Western European literary form and a sellout of the Chinese-American community to bourgeois individualism. Another was that American culture dealt with Chinese-American men by emasculating them with racist stereotypes and that Hong Kingston's book betrayed the difficult historical experience of Chinese-American males and that she had written "a fashionably feminist work . . . with white acceptance in mind." (The virulence of some of the attacks can be gathered from Sau-ling Cynthia Wong's "Autobiography as Guided Chinatown Tour? Maxine Hong Kingston's *The Woman Warrior* and the Chinese American Autobiographical Debate.")

So it is one of the interests of *China Men* that it seems to respond to the criticism that it tells an individual story at the expense of group loyalty by narrating the history of the group in a masterful book that continues to use the highly individualized techniques of *The Woman Warrior* and so creates a form that interrogates the relationship between history and individual experience, more specifically between fathers and daughters.

Another interest is to consider the small parable with which the book opens from the point of view of this debate. It is called "On Discovery" and it concerns the legend of a Chinese man who sails across the sea looking for Gold Mountain, and comes to the Land of Women, where he is captured, has his ears pierced with hot needles and silk thread sewn into the raw flesh, and then has his feet bound. "They bent his toes so far backward that his arched foot cracked. The old ladies squeezed each foot and broke many tiny bones along the sides. They gathered his toes, toes over and under one another like a knot of ginger root. Tang Ao wept with pain . . ." And once his feet had responded to this treatment, "his attendants . . . strapped his feet to shoes that curved like bridges. They plucked out each hair on his face, powdered him white, painted his eyebrows like

a moth's wings, painted his cheeks and lips red. He served a meal at the queen's court. His hips swayed and his shoulders swiveled because of his shaped feet. 'She's pretty, don't you agree?' the diners said . . ."

Thus Hong Kingston responds directly, it seems, to the male critics' charge that she has exaggerated the sexism in Chinese males in prose that is almost ritually cruel in its detailing what had been visited on Chinese women for centuries. And she is not through. In the next, and last, paragraph of the parable, she suddenly alters the perspective: "Some scholars say that the country was discovered during the reign of Empress Wu (A.D. 694–705), and some say earlier than that, A.D. 441, and it was in North America." Which looks like a bit of Borgesian play but means to say that what Chinese culture did to Chinese woman, American culture did to Chinese men. It is a wise, brutal, ironic, breathtaking bit of writing, and in the wake of it she proceeds to supply a cool, sympathetic, magisterial account of the epic immigration of Chinese men to the cities and work camps of North America and of the world they built here and of the various legal and illegal forms of racist intimidation they had to overcome. It is an amazing, rather defiant performance.

Some of the reviewers of *Tripmaster Monkey: His Fake Book* have described it as Hong Kingston's "debut" as a novelist, which seems absurd, since both *The Woman Warrior* and *China Men* are either novels or go a long way toward blurring such generic distinction. In any case, it is another kind of book, more recognizably like a novel, and it sets out to solve a different problem. Both of the earlier books dealt with the older generation and the hold of the past; to write them Hong Kingston invented a prose style that echoed the talk-story narratives by giving a faintly Cantonese singsong to the sentence rhythms, especially when she was nearest to the voices of the older characters. *Tripmaster Monkey* is a book about the near present, America in the mid-1960s—and it is narrated in a third person that almost merges with the first-person musings of its protagonist, a manic, brilliant, enraged, unstable graduate of the University of California at Berkeley English Department named Wittman Ah Sing.

To write it Hong Kingston had to invent the language of a consciousness that was not only different from anything in her earlier books but had not been represented before in American literature. Wittman Ah Sing is very well educated, an omnivorous reader, drenched in American pop culture, its movie stars, songs, and commercials; his head is full of Cantonese stories; he's read a lot and at random in classical Chinese lit-

erature; he has vague, huge literary ambitions, a rage against American society at the Beat-hippie cusp, an acute sensitivity to racially motivated perception that makes Woody Allen's antennae for anti-Semitism look like a form of serenity; and he is given to theatrical, stand-up comedy surrealism in the style of Lenny Bruce and George Carlin.

The direct formal model for the book seems to be Saul Bellow: that is, it is a series of oratorios by a very smart, disturbed, self-consumed American intellectual. But one shrewd reviewer said that it put him in mind of Nabokov's *Ada* because of the way it needed to heal an exile by finding a voice to merge the materials of two cultures. It is not like Nabokov, of course, in that his Amerrussia is a private universe, whereas Wittman Ah Sing represents a wide historical experience for which Hong Kingston has to find a language. The parallel tasks (and probably the models) are what Joyce did with Irish, Faulkner with Southern, and Ellison with African-American language and experience. Among these possible influences, it is Joyce who comes to mind as one reads, partly because Wittman Ah Sing is a young artist and partly because he is himself Joyce-drunk. He is also Rilke-drunk and throughout the novel he is in an Odyssean and Bloomian way enacting and meditating on various heroes in Chinese and Western literature, including especially Sun Hou-Tzu, the King of the Monkeys, a great trickster figure in Chinese legend. Also warrior stories: because what is at stake in the novel finally is rage—the transformation of a young Chinese-American wounded by racism from a fantasy warrior into a trickster and an artist in the United States of the mid-1960s as the country gears up for an Asian war.

Widely and respectfully reviewed, *Tripmaster Monkey* is an immensely ambitious book, and a difficult one, partly because it is dense with allusion and partly because its main character, while he can be delightful, is something of a pain in the ass. These qualities were remarked in the reviews, which were on the whole less enthusiastic than those of her earlier books. Understandably: the book is demanding, and to write it Hong Kingston set aside her own patented magic, the gift for storytelling. About the reception of the novel a novelist friend remarked to me, "They don't like it as well as the others, because it isn't charming." But it is something more ferocious than that and people are going to be reading it, will be needing to read it, for a very long time.

1991

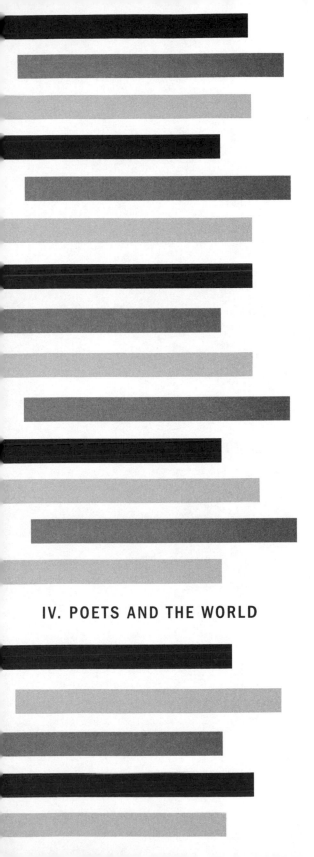

IV. POETS AND THE WORLD

ko un and korean poetry

In the fall of 1988 writers from all over the world had gathered in Seoul, Korea, to discuss issues of censorship and freedom of speech. One night I was taken to a local university campus, where there was an evening of poetry and music. These were the last years of the succession of military dictatorships that had ruled the Republic of Korea since the end of the Korean War. The reading was sponsored by a student democracy movement that also supported the reunification of Korea, though it was a crime in those years to mention the possibility in public. That night the air was charged with the energy that precedes a political breakthrough: it felt more like a political rally than a poetry reading. As the students sang and read their poems, my attention was drawn to a wiry, vigorous man on the back of the stage, gray haired, barefoot, dressed like a peasant farmer, who was pounding a traditional Korean drum. There was something enormously graceful and droll in his movements, and my eyes kept drifting back to him. He seemed to be having a wonderful time. Finally I turned to my guide, a Korean novelist. "Who is that guy whacking the drum?" "That," he said, "is the best poet in the Korean language." My first sighting of Ko Un.

The first volume of *Maninbo,* or *Ten Thousand Lives,* must have just been published the previous year. The story of its genesis has the quality of legend. Ko Un was born in 1933 and attended school under a Japanese colonial administration that outlawed the teaching of the Korean language in Korean schools. He studied Chinese classics at school and learned to read and write Korean surreptitiously from a neighbor's servant. Rejected for the draft because he was so thin, he escaped combat in the Korean War, but he had ample opportunity to witness its extraordinary violence. At seventeen he had a portside job

with the U.S. Army keeping track of the unloaded munitions that were doing the killing, after which he was given a job transporting corpses to their burial places. Appropriate training, it would seem, for his next move. At nineteen he entered a Son (Zen) Buddhist monastery and threw himself into the rigors of Son training.

He published his first book of poems in 1960. In 1963 he wrote an essay disavowing monastic life and denouncing its laxness and corruption. He lived in Seoul for a while, taught school on a remote island where he established a public high school, and by his own account was as drunk as possible as much as possible. He also read existentialist philosophy and tormented himself with the nothingness of existence while he wrote essays and poems that expressed his restlessness and torment.

Sometime in the early 1970s something in him changed and he became, within a few years, one of the leading figures in the resistance movement against the republic's military dictatorships. He was imprisoned four times, tortured on a couple of occasions, as a result of which he lost the hearing in one ear, and during his third imprisonment in 1980, when he had been sentenced to life in prison, while in solitary confinement in a cell so pitch-dark he could not see the glint of the coffee can that served as a latrine, he began to make a mental inventory of the faces of everyone he had ever known in his life. It was an exercise in staying sane that drew on his experience of meditation as a young monk, but out of it he conceived a long poem, or series of poems, that would begin in his childhood village and expand to include everyone he had ever met, including figures vivid to him from history and literature. The project has reached twenty volumes. *Ten Thousand Lives*, from Green Integer Press, is the first full sampling of that work to appear in English translation.

Ko Un was released from prison on the occasion of a general pardon in 1982. In 1983 he was married for the first time, at the age of forty-nine, to Lee Sang-wha, a professor of English literature. They settled in the country two hours outside of Seoul and they had a daughter in 1985. Ko Un, always prolific, set to work on the *Maninbo* poems. He also produced a narrative poem in several volumes on the Korean independence movement against Japanese rule, *Paektu Mountain;* a bestselling novel, *The Garland Sutra,* in 1991; and several books of small, aphoristic Son poems, which return his poetry to its youthful roots in Buddhist practice. In the midst of this immense

productivity he had plunged into the movement for the reunification of the Korean peninsula, becoming chairman of the Association of Korean Artists from 1989 to 1990 and president of the Association of Writers for National Literature from 1992 to 1994. In 1989, as a symbolic act, he attempted to visit North Korea without government permission and was jailed, briefly, for a fourth time. In his introduction to the translation of Ko Un's Buddhist poems, Allen Ginsberg describes him as "a jailbird," a title he has earned, and also as "a demon-driven Bodhisattva of Korean poetry, exuberant, demotic, abundant, obsessed with poetic creation."

There was not much of Ko Un to be read in English in 1988, or of any other contemporary Korean poet. Since 1988 two volumes of his work have appeared: *The Sound of My Waves*, translated by Brother Anthony of Taizé and Kim Young-Moo and published in the Cornell East Asia Series in 1996, and *Beyond Self: 108 Korean Zen Poems*, also translated by Brother Anthony and Mr. Kim, and published by Parallax Press in 1997. It became possible to get a sense of him and the extraordinary arc of his career.

American readers, for the most part, know almost nothing about Korean culture and still less about Korean poetry, partly because not much of it has been available in English. The one study of classical Korean poetry in English, *The Bamboo Grove: An Introduction to Sijo*, by Richard Rutt, an Anglican bishop living in Korea, published in 1971, provides a way in. *Sijo* is the classical Korean song form; it consists of three fourteen-syllable lines—long lines that tend to break in half, so that the translations seem to turn naturally enough into five- and six-line poems in English. Here is a poem from the sixteenth century that has some of the qualities of Chinese Buddhist work. It comes from a group of poems called *The Nine Songs of Ko San:*

Where shall we find the ninth song!
Winter has come to Munsan;
The fantastic rocks are buried under snow.
Nobody comes here for pleasure now.
They think there is nothing to see.

And this poem from the eighteenth century has one of Ko Un's themes and something of his colloquial pungency:

A boy comes by my window
shouting that it's New Year's.
I open the eastern lattice—
the usual sun has risen again
See here, boy! It's the same old sun.
Come tell me when a new one dawns!

Let me juxtapose this with a passage from the preface Ko Un wrote to *Beyond Self* in 1993:

The whole world renewed! I want to offer water to all who thirst for a new world. I want to light a fire so they can warm themselves on a cold evening. I long to give them bars of iron to hold on to, to prevent them from being swept away by raging storms. But people made of mud cannot cross streams, people made of wood cannot go near a fire. And people made of iron will rust away in less than a century.

Here stands a good-for-nothing who let himself get soaked until the mud dissolved, set fire to himself so the wood disappeared, and whose iron finally rusted away in the wind and the rain. Go now. The new world is found wherever new life comes to birth.

The hopefulness in this, and the bardic sense of responsibility, and the irony and absence of irony seem to belong to a particular kind of historical moment. They put me in mind, because of my long experience of translating Polish poetry, of something Czeslaw Milosz said: "Woe to the poet born to an interesting piece of geography in a violent time."

The parallels between the geographic and cultural situations of Poland and Korea are very striking. Given their long histories as the playgrounds of imperial powers and the kind of suffering that has come from it and the impact it's had on poetry, I don't think it's an accident that important work in poetry in this last half century has come from Poland and Korea. Such suffering is not a fate anyone wishes on anyone, and it is certainly not the case that every time there is a catastrophe, poetry rises to the occasion. But in the case of Korea, it seems to have done so in interesting ways. The reason is not, I think, that it is dramatic to live inside violence or terrible injustice, but that it is numbing and that numbing incites a spirit of resistance.

Not only were limitations placed on the Korean literary tradition by the immense human suffering of the war years, there was also an active pressure by the Japanese colonizers between 1910 and 1945 to eradicate Korean culture.

Milosz has said that the difficulty with writing in Polish was that, for historical reasons, the blossom on every tree in a Polish poem was a Polish blossom. My sense is that something quite similar happened to Korean poetry. Because the Japanese spent almost fifty years trying to extinguish Korean culture, the pressure to preserve a national tradition must have been enormous and likewise the pressure to preserve traditional literary forms. This was complicated in Korea by a Confucian tradition in which a good deal of the poetry produced by the scholars and the literati over many centuries was written in classical Chinese. Korea was looking back at and recovering its own tradition of vernacular poetry just as it was opening itself to the influence of the West, particularly to French poetry, just as Japanese poetry had, and a sort of symbolist lyric entered Korean literature. The mix of a modernizing idiom with colonialism must have been complicated for poets to negotiate. My impression is that the best early twentieth-century Korean poets tried to solve the problem by fusing the symbolist lyric formally with the folk tradition. But that lyric itself was transformed by the historical situation, so that a certain delicacy and intense melancholy in the late nineteenth-century French poems, which was not particularly political in French, was quite political in Korean.

The vagueness of French symbolist poetry, its desire to detach word from thing, to give the mind a little room to float and make up new values, was in only that broad sense political in French poetry. In Korean, however, especially in early modern Korean poetry, suggestiveness became a kind of code that could both acknowledge and subvert a severe censorship. This was apparently intensified by the use of rhythms that echoed a folk tradition. In the last few years, as more Korean poetry has become available in translation, notably *The Columbia Anthology of Modern Korean Poetry*, edited by David R. McCann (Columbia University Press, 2004), and *Three Poets of Modern Korea*, translated by Yu Jung-yul and James Kimbrell (Sarabande Books, 2002), it has been possible to get a sense of these tendencies. According to McCann, the ablest scholar of Korean poetry writing in English, Kim Sowol, was the central figure in Korean poetry in the

early years of the twentieth century. He was born in 1902; published a single volume of poems, *Azaleas*, in 1925; and worked as a journalist in Seoul until his death from an opium overdose in 1934. The title poem from that book, "Azaleas," is among the best-loved of all Korean poems. McCann describes it this way: "The title poem is an exquisitely balanced yet oddly unsettling lyric with a prophetic rather than reminiscent point of view. Formerly presented in Korean school textbooks as expressive of the resigned sadness of the Korean people in the 1920's following the unsuccessful demonstrations of 1 March 1919 for Korean independence, it is now appreciated for its aesthetic, literary qualities rather than its nationalistic sentiments."

Neither the political nor the aesthetic qualities of "Azaleas" is apt to be apparent to readers of an English translation. Here is McCann's:

When you go away,
Sick of seeing me,
I shall let you go gently, no words.

From Mount Yak in Yongbyon
An armful of azaleas
I shall gather and scatter on your path.

Step by step away
On the flowers lying before you,
Tread softly, deeply, and go.

When you go away,
Sick of seeing me,
Though I die; No, I shall not shed a tear.

Not much comes across, or probably could be brought across, except a delicate and wistful sorrow. If the form of the poem represents a stubborn and beautifully achieved effort to preserve a specifically Korean expression when the literary pressure was to be modern and Japanese, this effect is something we can only imagine. If azaleas, the gorgeous late-spring wildflowers of a mountainous countryside, carry some poignancy akin to the wild orchids or snowy woods of Robert Frost's New England, they are lost on a foreign reader. Perhaps it has a motion, for

Koreans, that a lyric like "Red River Valley" has for us. As for the fact
that the poem is seen as the expression of a whole nation's experience of
colonialism, that has to be taken on faith. History can do that to poetry.
It is easy to imagine how Kim Sowol's one book could look like a career
cut short and the circumstances of his death like political despair, but
reading the poem itself, in translation, feels a bit like being given a
small glass bottle of a stranger's tears.

If Kim Sowol was the traditionalist of early twentieth-century
Korean poetry, Yi Sang was the modernist, and in that role he has been
embraced by young Korean readers. One of his translators reports hear-
ing in a taxi a DJ on a Korean pop radio station shout, "Yi Sang is
the greatest poet of the twentieth century!" He was born in Seoul in
1910, studied architecture, cultivated a bohemian existence in Seoul,
and wrote his poems and stories principally in Japanese. According
to McCann, even a significant portion of Yi Sang's Korean-language
poems may have been written in Japanese and then translated into
Korean. His death, like Kim Sowol's, is emblematic and it carries its
own dark irony. On a trip to Japan in 1937, he was arrested for "thought
crimes" and died of tuberculosis in Fukuoka Prison. In cultural mem-
ory, one gathers, he is a sort of cross between T. S. Eliot and James
Dean. Here, from the translations of Yu and Kimbrell, is a poem called
"Distance." If Kim Sowol's is a poem of separation echoing the rhythm
of a folk lyric, Yi Sang's looks like a surrealist prose-poem in the man-
ner of Max Jacob:

—a case in which a woman absconded—
 Lines of a railroad laid out on white paper. This is the diagram of
my mind cooling. Each day, I send a telegram in which untruths are
written down: arrival tomorrow evening. Each day I send my neces-
sities by parcel post. My life is becoming better acquainted with this
distance that resembles nothing so much as a disaster area.

So there was a struggle inside Korean poetry between the old
and the new, in a situation that might have caused any writer to feel
ambivalent about both, since it was not evident how either could con-
vey the historical experience of the Korean people in the twentieth
century. In such a literary moment, somebody has to find a way for-
ward. Somebody has to be the one who says what has to be said. If

those who do it are also artists of enduring power, they will find ways of refocusing the lens of a tradition. Reading modern Korean poetry in translation, reading through the evolution of Ko Un from the early poems to the *Maninbo,* I began to suspect that this is what must have happened in his case.

It is striking to see the kind of tuning fork he has been, reinventing himself in every decade through the turns in Korea's postwar political and social history. It is my impression that in his early work he was writing in some version of the received tradition of Korean nature lyric with symbolist overtones, touched by the Korean folk tradition, touched by Son Buddhism, which, compared to the sense of refinement in Zen Buddhist poetry, seems earthy and intellectually tough. In the period between 1962 and 1973, less well-documented in the existing translations, after he left his life as a monk, the poetry seems to change. The vision of this work is dark, but the poems themselves have a sense of naturalness and spontaneity, even a cultivated raggedness, not unlike American experimental poetry of the same period.

Between 1973 and his imprisonment in 1980 was a period of intense political involvement. It can be a disaster artistically for a poet to write an explicitly engaged political poetry, however morally admirable the impulse is, and the wariness of poets is well-founded. Ko Un, like Whitman or Neruda, seems to have had no aesthetic difficulties with the idea of giving himself and the trajectory of his art to a national project. The project had several elements. One was resistance to censorship. A deeper one was resistance to the series of military dictatorships underwritten by the United States. And the third was an intense longing—necessarily metaphorical in the culture of the republic—for the final healing of the wounds of colonialism and war that would come from the reunification of his country. The poet who had thrown himself into this project was the one I'd seen that night pounding the drum on the stage at the university. *Maninbo* seems to have been his way of turning the quarrel inside the Korean literary tradition into poetry. A Korean critic, Choi Won-Sik, described it this way: "The unique space where anti-traditional modernism and anti-Western traditionalism meet is where the poetry of Ko Un originates."

Here is a poem from Ko Un's first book, published in 1960. It's called "Sleep":

No matter how deeply I sleep
The moonlit night
Remains as bright as ever.
If I wake with a start
Turn
And nestle down again
Once my eyes have closed
The moonlight trapped inside them
Becomes part of me.
But are the clouds washed pure?
Pure enough for the moon
As it drops behind the western hills?
Now my sleep is a shadow of sleep,
A shadow cast on a moonlit night.

This is an inward poem, quietly beautiful. As English readers, we're deprived of any sense of what it reads like or sounds like in Korean. It seems like midcentury American free verse, put to the use of plainness or clarity. The sensation of the sleeper, having opened his eyes and closed them with a feeling that he was still holding the moonlight, is exquisite. The turn in the poem—the shadow cast by the hunger for an entire purity—seems Rilkean.

Here is a poem from 1974 called "Destruction of Life":

Cut off parents, cut off children!
This and that and this not that
And anything else as well
Cut off and dispatch by the sharp blade of night.
Every morning heaven and earth
Are piled with dead things.
Our job is to bury them all day long.
(Translated by Brother Anthony of Taizé and Young-Moo Kim)

This has, to my ear, the tough-mindedness of Korean Buddhism and the kind of raggedness and anger I associate with American poetry in the 1950s and 1960s, the young Allen Ginsberg or LeRoi Jones. I've read that Korean poetry is not so aesthetically minded as Japanese poetry

partly because it stayed closer to oral traditions rather than traditions of learning, which may be what gives this poem its quality. It's more demotic than "Sleep," more spontaneous and tougher, less satisfied to rest in beauty.

Maninbo seems to flow from a fusion of these traditions. For anyone who has spent even a little time in Korea, the world that springs to life in these poems is instantly recognizable, and for anyone who has tried to imagine the war years and the desperate poverty that came after, these poems will seem to attend to a whole people's experience and to speak from it.

Not surprisingly, hunger is at the center of the early volumes. Their point of view is the point of view of the village, their way of speaking about the shapes of lives, the stuff of village gossip. They are even, at moments, the street seen with a child's eyes so that characters come onstage bearing a ten-year-old's sense of a neighborhood's Homeric epithets: the boy with two cowlicks; the fat, mean lady in the corner house. The poems have that intimacy. Most of them are as lean as the village dogs they describe; in hard times people's characters seem to stand out like their bones and the stories in the poems have therefore a bony and synoptic clarity.

Terrifying legends of cannibalism are one moral pole of this world and a sweet and clear-minded kindness is another. The stories are as pungent as kimchi, the Korean garlicky, fermented cabbage, and one of the things that gives them their poignancy is the wide net they cast. We are always aware that their social world is defined by an individual's effort to recall every life that has touched his, to make a map of the world that way. It's what makes an early poem in the sequence, "The Women from Sonjei-ri," so affecting. Here's the beginning of it:

> In darkest night, near midnight, the dogs
> in the middle of Saet'o begin their raucous barking.
> One dog barks, so the next one barks
> until the dogs at Kalmoe across the fields
> follow suit and start barking as well.
> Between the barking of the dogs,
> scraps of voices echo: eh ah oh . . .
> Not unlike the sound the night's wild geese
> let fall upon the bitter cold ground

as they fly over, high above,
not unlike that echoing back-and-forth.
It's the women from Sonjei-ri on their way home
from the old-style market over at Kunsan
where they'd gone with garlic bulbs by the hundreds
in baskets on their heads,
there being a lack of kimchi cabbages
from the bean fields.
Now they're on their way home,
after getting rid of what couldn't be sold
at the clearing auction at closing time —
several miles gone,
several miles left to go in deepest night!

It's hard to think of analogs for this work. The sensibility—alert, instinctively democratic, comic, unsentimental—is a little like William Carlos Williams; the project is a little like Edgar Lee Masters's *Spoon River Anthology* or the more political and encyclopedic ambitions of Charles Reznikoff's *Testimony*. The point of view and the overheard quality remind me of the Norwegian poet Paal-Helge Haugen's *Stone Fences,* a delicious book that calls up the whole social world of the Cold War and the 1950s from the point of view of a child in a farming village. For the dark places the poems are willing to go, they can seem in individual poems a little like the narratives of Robert Frost, but neither Masters's work nor Frost's has Ko Un's combination of pungent village gossip and epic reach.

The characters, village wives, storekeepers, snake catchers, beggars, farm workers, call up a whole world. Here is "The Wife from Kaesari":

Although she brought up three sons
As stout as big fat toads,
The wife from Kaesari never so much as once
Coughed out loud after she got married.
No matter what anyone said
Her only reply was a reluctant *mmm*.
And even that didn't really leave her lips,
A tiny sound, eager to crawl back in again.
Among the neighborhood women

No one had ever been seen with such a tiny voice
As the wife from Kaesari had.
Once her eldest son was married,
She never spoke harshly
To her daughter-in-law
But merely stitched away at a torn hemp jacket.
She took care that no one heard the sound
When she blew out the kerosene lamps.
The wife from Kaesari went into a decline in the last year of her life.
No one knew just what was wrong with her.
When she was dying, her three sons were in her room
Waiting for the end to come.
Knowing no eloquence in her lifetime,
She was incapable of any decent last words.
She was more or less heard to say
The lid of the soy-sauce up on the terrace
Ought to be opened to the daylight
And also, it seems,
That the lining in father's jacket ought to be replaced.
Then in a flash she expired.

Here is "Pyong-ok":

If you're born a yokel out in the backwoods,
Once you've reached five or six
There's no time left for play,
Forced to become a drudge
Following your father
And the work piling up like the hills.
When autumn comes,
If mother tells you to bring home mud-snails,
You go rushing out to the rice-paddy:
Foraging for snails for half a day
In the wide open spaces out there
Is great, really great.
Being away from his rotten job is great.
Pyong-ok,
Expert snail-catcher Pyong-ok,

Drank lye by mistake and died.
None of the neighborhood kids know
Where he's buried.
If a kid dies, there's no tomb, no offerings:
There'll be another born by-and-by.

Here is "The Widows of Chaetjongji":

If you ask for the widow's house in Chaetjongji,
It's well-known everywhere.
In that widow's house
Live a widow of eighty
And her elderly daughter of sixty-four.
Both buried their husbands early on,
Then planted plantains and balsams along the fence
And lived peacefully together like elder and younger sister.
At last the mother-in-law, being old,
Grew chronically ill.
Her daughter-in-law cleared away her excrement.
She had difficulty even trying to clear her throat of catarrh,
And what a stench of piss in the reed mat!
The daughter-in-law seemed to grow older,
Her back bent,
But even on snowy days she went wandering over sunny slopes
Grubbing up shepherd's-purse roots,
Always serving her mother-in-law.
When she boiled those roots in bean-paste soup,
The perfume spread throughout all the village.

And here is "The Well," a more mysterious poem:

There's a well in the yard of that house,
A well more than ten fathoms deep.
In Pullye's snug family house,
Pullye's mother, bright as a gourd flower,
And little Pullye, a lily-flower,
Live together, just the two of them.
The mother, a widow, young,

Discreet in every word,
Never dousing herself with water,
Even in midsummer heat.
When I used to go on errands there,
If I took one sip of the blue-black water,
Of that water's silence and the dread
That Pullye's mother,
Letting down the heavy bucket,
Drew up from her ten-fathom well,
My whole body would tremble, my heart would pound.

Even with the generous selection of poems in the first volume of *Maninbo*, we do not have the whole shape of the work in hand, and perhaps it is enough to notice the fertility of Ko Un's poetic resources. One would think that the poems would begin to seem formulaic, that the ways of calling up a life would begin to be repetitive, and they never are. In that way it is a book of wonders in its mix of the lives of ordinary people, people from stories and legends, and historical figures. They all take their place inside this extraordinarily rich reach of a single consciousness.

Ko Un is a remarkable poet and one of the heroes of human freedom in this half century. American readers have often been drawn to poetry in translation because of the dramatic political circumstances that produced it rather than by the qualities of the work itself. But no one who begins to read Ko Un's work will doubt that what matters here is the work.

1999

milosz at eighty

Czeslaw Milosz is eighty years old this year, and he will be publishing three new books—two in English and one in Polish. This should astonish no one. He has by my count published ten books in English in the last ten years and at least six in Polish. During this time, of course, many of his earlier works were reissued in English translation, and many, though not all, of his books, long outlawed, have been published in Poland. At the same time, his best-known work—his poems; his classic study of writers and totalitarian politics, *The Captive Mind;* and his autobiography, *Native Realm*—have been translated into almost every language in the world. So it isn't as if there were a drought of Milosz books on the market.

Last summer when we were in the office of his Grizzly Peak home working on the galleys of one of the new books, a collection of poems written during the past five years and called, in English, *Provinces,* I remarked on his industry and pointed out that, if he kept writing at the present rate, he had a very good chance of getting tenure. He frowned at the joke, looked momentarily rueful, even sad, and then exploded into laughter, the wild eyebrows that artists and caricaturists like to draw leaping high. "It is true," he said, "I did not perish."

Though he is more inclined to celebrate his name day—the feast of Blessed Czeslaw, an obscure Czech monk of the fourteenth century who never quite made it to sainthood and with whom Milosz seems to identify—than his birthday, one would think that this time around the poet had a number of events to commemorate.

Forty years ago, in 1951, he had published a one-page essay entitled "No" in a Polish-language cultural journal in Paris, resigning both his position in the diplomatic service of the People's Republic of

Poland and his citizenship, an act that is for anyone, but especially a poet severed from his language, a leap off a cliff and into a void.

Thirty years ago, after a decade in exile as a freelance writer in France, he accepted the offer of a position in the Department of Slavic Languages at the University of California at Berkeley—a profession for which he felt entirely unsuited, having been educated in the law, employed as a writer of radio scripts in the late 1930s and as a teamster for the libraries during the Nazi occupation of Warsaw, and then as a cultural attaché until his resignation from the government—and began a second and more strange exile, settling into a house in the Berkeley hills facing San Francisco Bay and the Pacific Ocean as he began lecturing young Americans on the literature of a country fifty-seven hundred miles away where his own poems could not, by state law, be published.

It was ten years ago that, at the age of seventy, after thirty years of exile, and fifty years of writing poems, essays, and novels that were weapons in a private war undertaken against the currents of history that had carried him so far from the life he might have had, and sometimes, it seemed, against the very frame of reality as the twentieth century had conceived it, that he was summoned to Sweden so that the world could honor his work.

And this year he witnessed the collapse of the regimes in Eastern Europe that he had spent most of his life in philosophical struggle against—and with that event came the liberation of Lithuania, where he was born and spent much of his childhood and youth on his grandparents' farm in a country of pine forests, sandy soils, glacial lakes, and meandering rivers.

His has been, by any account, a remarkable life. He was born before World War I, in an era when contemporary journalists were predicting a new age of peace, a new cosmopolitanism, and an unprecedented European future, when grandfathers wore thick mustaches and grandmothers received their journals of fashion from Berlin and Paris, delivered by a postman with a dog cart in which he also carried the latest French novels with pale yellow covers and uncut pages, bought by subscription for the advanced young people of the family.

And he grew up in a province on the fringes of the Russian Empire where the gentry spoke Polish, the peasants Lithuanian, and currents of Yiddish, Ukrainian, and Belorussian also played through the mixed

culture of the old Polish-Lithuanian grand duchy, with its strong Roman Catholicism and its underlayer of folk paganism. A tide of new ideas, optimistic and visionary ideas, also played through that world— millenarianism, utopian socialism, Nietzschean superhumanism, communism, Zionism, mystical nationalism—dreams and philosophies that would strike the coming century with a force that must, then, have been inconceivable.

Milosz's poems, especially his later poems, written in California fifty or sixty years after the fact, return to that early world with wonder, recall small details—the look of a blacksmith shop; the sudden sight of an old peasant in buskins carrying a birch-bark horn; the bagels one bought from Jewish vendors on market day; the silvery gray, elaborately coiled coiffure of a respectable old woman in Wilno, who lived alone, gave piano lessons, and kept a parakeet; the olive-green color (later it would become for him the color of war) of the zigzag chevrons on his father's uniform—as if they might verify the improbable idea that the world he remembers ever actually existed. Milosz's father was in the Russian Empire's engineering corps, and one of his earliest memories is of accompanying his parents on a trip: the gray plush seats of a coupé on the Trans-Siberian Railway, and a bell that rang three times before every station, and the astonishment of the family's Lithuanian maid, who, trying to express her awe at the mountains they were traveling through, exclaimed reverently, "Why, they look like the apostles!"

These images from the later work are not the ones for which he is best known. Perhaps the most famous scene in all of Milosz's writing comes from the war years. There was the moment, recorded in *The Captive Mind*, when the young Milosz, pinned to the ground on a city street while a German machine gun strafed it, saw the cobblestones struck by bullets stand upright suddenly like the quills of a porcupine. He had a copy of T. S. Eliot's *The Waste Land* tucked in his back pocket—he had been studying it in English—and he records that he lay there, cheek pressed to the stones, thinking that the reality he was living in might require a different kind of poem from Eliot's.

It was perhaps this scene, more than anything else, that staked the claim for the importance of Eastern and Central European writing in the postwar years. At a stroke it made the argument that moved the writing of Poland and Czechoslovakia, Hungary and Yugoslavia from the "literature of minor nations" status to the center of European con-

sciousness. And, eventually, it made the argument for the centrality of Milosz's own poems, the ones for which he is best known, like "A Poor Christian Looks at the Ghetto," with its grim accounting of the fate of Polish Jews and the responsibility of Christians in the Holocaust, and "Dedication," with its equally clear-eyed and harrowing view of the two hundred thousand victims of the Warsaw Uprising, and "Child of Europe," a bitter, cool assessment of the condition of the European conscience in the war's aftermath.

In a curious way Milosz would pay for the brilliance of that image. It typed him as a political writer in a heroic mold, a characterization of his work that has always bothered him. When his *Collected Poems* appeared in English in 1988, review after review evoked the crucible of Eastern Europe and the ashes of the Holocaust and cobblestones in the street leaping like porcupine quills. An English critic, A. Alvarez, in the influential *New York Review of Books,* wrote a review recalling these images and declaring the book one of the indispensable works of the century and its author one of the indispensable poets. This same indispensable author, to the surprise and bemusement of the literary world, responded with a letter of protest. It may have been the first time in history that a writer wrote a letter complaining about a rave review.

The substance of Milosz's objection was that he was always being seen either through the lens of the Second World War or through the lens of his rejection of the Communist government of Poland and his exile. And that this was a kind of double jeopardy. Having had to deal with what history inflicted on him, he then had to deal with being seen always in terms of it, whereas what was at stake for him as an artist and a thinker—the nature of reality, the meaning of human fate, and what one can say about either—was at stake whether the great dramas of history chose to drive an armed convoy through the middle of his life or not.

From his point of view, to be seen always in political terms was particularly ironic because his argument with Marxism, indeed with the modern world, was that it had pinned the wrong kind of hope on politics. He had been, as he records in his autobiography, attracted to Marxism as a young man not so much because of its millenarian dream, but because it was based on the idea that the world was made not out of freedom, but out of necessity and power. In the end, this view of the world, though it had the look of frank realism, seemed to a mind

like his, steeped in both Christianity and Polish Romanticism, servile, and its promise of some realm of absolute justice seemed a failure of the religious imagination. Or, to say it another way, it valued becoming more than it valued being. He believed that justice was a continuous struggle in human societies, not an absolute that the world was evolving toward. And therefore he didn't think it was the end of history that mattered or its processes, but its individual moments. It was being, the very fact of the existence of things, that always seemed to him to be mysterious, to be the place where the meaning of existence—mute, perhaps, specific beyond the power of language, singular, not quite graspable—lay.

And if being was a mystery to him, so was ceasing to be. If there was an enemy, in this view of things, besides whatever brought so much unnecessary suffering into the world, it was oblivion, the abyss of nature and time into which all earthly endeavor seems to disappear. Against it there were only the resources of the human imagination, religion, philosophy, and art. And this is perhaps why Milosz always remained a Roman Catholic, though of a particularly restless and tormented kind. Christian theologians had not, he thought, done much of a job of explaining how an all-loving God created a world full of evil, but Christianity remained for him a symbol, enduring in history, of the refusal of the human imagination to bow down before nothingness and worship.

Which is perhaps why, in 1980, when newspaper reporters hunted up the new Nobel laureate and asked him what he was working on, he said he was working up his Greek and translating the Gospels into Polish. Not the quaint occupation of an old scholar-poet, as it seemed in the press, but an act of radical, sometimes wavering, sometimes tormented hope—and another guerilla raid in his war against the force in bullets that stands cobblestones upright.

It is probably also why his response to the collapse of the Soviet Empire this year seemed to many people puzzling. Here, after all, was a man who had won. He had not only outlived his enemies but witnessed their defeat. He had read his poems, written in the middle of the night in a foreign country in the obscurity of exile, to vast crowds in Warsaw, had seen his words carved into a monument in Gdansk where the Solidarity movement began. He had stood on a platform in Berkeley with Elena Bonner, the wife of the dissident Russian physicist Andrei

Sakharov, and spoken plain words in the name of human rights, while
the Russian Communist Party was engaged in a panicky and ineffectual
struggle to survive. When the Czechoslovakian minister of defense vis-
ited San Francisco this year, Milosz received a call from the American
Department of Defense to ask if he was receiving visitors. The minister
did not want to see defense contractors or Silicon Valley; he wanted to see
a poet. It is not surprising that people were very curious to know how he
was taking all of this. And the answer was, as the list of his publications
makes clear, that he noticed, but he was busy.

Milosz has watched with interest, of course, and he has participated—
leaping, for example, into the debate that arose over the issue of con-
tinued government support of abortion, which has been opposed by the
Catholic clergy in the new Poland, and making the argument for the
separation of church and state. But mostly he was writing new poems
and essays, indefatigable at eighty, and still obsessed with the themes
that have haunted him for a lifetime: the mystery of being, the nature
of evil, the power and inexpressibility of human experience, and,
increasingly, the astonishments of memory and of time, where it's gone,
where it comes from.

Some of the latest poems have the old torment and the old sobriety.
Those emotions are at the core of his art. But some of them are unchar-
acteristically serene, and many of them have a wonderful lightness and
playfulness. And all of them are shot through with the wonder at exis-
tence that is also at the core of his art. Since I worked on getting the
poems into English, I am no doubt prejudiced, but it's hard for me to
think of any recent book by a young poet—or novelist, for that matter—
that can match the freshness and urgency of these poems. The passion to
understand is in them and the passion to save the world of his memory
from extinction, but there is also the joy of a master practicing his craft
for the pleasure of it and from an unabated fascination with the world. In
one of his poems he has written with admiration of the elder Breughel,
who was said to have died from a heart attack while attempting to thrust
his head between his legs to see his ass so he could draw it more accu-
rately. I have had occasion to think about that image as I read through
the new poems.

When we were working one gray afternoon last summer ("It is foggy,"
he had grumbled in one of his early poems about his adopted home, "so
it must be July"), I thought I saw some signs that he was excited about

what looked then like the long slow tug-of-war that might lead to the independence of the Baltic states. He had set aside his reading, interested and dutiful, of a new study of his writing, *The Poet's Work,* by two of his Berkeley colleagues, Professors Arthur Quinn and Leonard Nathan, which had just appeared from Harvard University Press—a book, by the way, that provides a good introduction to the evolution of Milosz's ideas— and he had taken up instead, with a somewhat truant air, a Lithuanian grammar; he was brushing up on a language he had not heard since he was a young man. "So," I said, "you *are* thinking that you may yet get back to Lithuania." He gazed out the window at the flower beds, heavy with peonies and bright mums, at the Monterey pine just visible in the pearly fog. "Not really," he said. And his eyes lit up a little. "But I have an idea that it may be the language spoken in heaven."

1991

milosz at ninety-three

Czeslaw Milosz was born in Lithuania in the village of Szetejnie in the valley of the Niewiaza River in 1911. He revisits his childhood very often in his poetry, and in his prose he tried to explain to himself and to others the meaning for him of the circumstances of his birth, so some sense of his roots, his region, and his difficult and eventful life may be useful to readers of his poems.

Most of Lithuania was a province of the Russian Empire in 1911. Its culture was the culture of what had been the grand duchies of Warsaw and Lithuania. His grandparents' world, he has remarked, was an Eastern European version of the one we glimpse in the novels of Thomas Hardy. It was a world of manor houses presided over by a Polish-speaking gentry and worked by a Lithuanian-speaking peasantry. Both sets of his grandparents came from that gentry and both had a mixed Polish and Lithuanian ancestry. Milosz's father was a military engineer in the Czarist Army, so as a very young child he traveled with his parents a good deal. His prose recalls his wonder on seeing his first motorcar in Saint Petersburg on Nevsky Prospect. His poems remember travel on the Trans-Siberian Railway and relatives gathered for a party to watch, through smoky glass, the total solar eclipse of 1917. He went to school in Wilno, as Vilnius was called in Polish, and returned there to go to high school and to the university, but summers, and in the years of the First World War and after, when his father was away, he and his mother lived in the manor house of his grandparents near the village of Szetejnie. It is some 125 miles north of Wilno, and I'm told that one could walk down to the river from Milosz's grandfather's estate, get into a boat, and float downriver to Wilno in about six hours. Isaac Bashevis Singer was born in Wilno, when it was known as the Jerusalem of the West. If you traveled another 125 miles

south, you'd come to the shtetl of Most on the Lithuanian-Belorussian border. From there the parents of the American poet Louis Zukofsky emigrated to Hester Street in Manhattan in 1899. Zukofsky always reported to his friends that his parents were born in Russia, but Most was only "Russia" in the sense that a village in Ireland could have been said to be "England," a complexity and richness Milosz often contemplated, looking back across a century of horrific violence.

Within the circle of this world, the gentry in the country and ordinary working people in the cities, if they were not Jewish, spoke Polish. The country people, if they were not Jewish, spoke Lithuanian. The population, according to *Conversations with Czeslaw Milosz*, was 50 percent, perhaps 60 percent, Jewish. Among Jews the language of the lower classes and of country people was Yiddish. Upper-class Jews spoke Russian. In his grandparents' house Polish was spoken and his parents spoke it at home, but, to quote his account of the matter, "there was a strong influx of Russian because my father and the people who visited us in Wilno were fond of switching to Russian when the subject was humorous, something Poles are known to do . . . I was under the sway of the Russian language until the spring of 1918. I was bilingual. I didn't have much of an idea why I spoke one language to some people and the other one to other people . . . I used to play with two children, Yashka and Sonka, who lived in our courtyard in Wilno. They were from a Jewish family and they spoke Russian rather than Yiddish. Playing with them gave me practice with my Russian."

His mother, he has remarked, ran an elementary school founded in the spirit of "Positivism and Organic Work," a sort of nineteenth-century Montessori school that was charitably funded to teach poor Lithuanian children to read and write—in Polish. Milosz reports that when he began school, though the pronunciation of Polish by the Lithuanian gentry was—and still is—the upper-class standard, his papers would come back underlined in red ink, with exclamation points beside them, because his Polish was so full of expressions that the teachers considered to be regional curiosities, Russian and Lithuanian and Yiddish and Belorussian borrowings that had belonged quite naturally to his speech. And, one should add to this, the Latin of the Mass and, once he was in high school, the schoolroom. He began to learn French in grammar school, and his first attempts at poetry writing in Polish came from schoolboy translations of Ovid.

Polish, written Polish, was the language of books, which was for

him, as it has been for so many readers, the language of pleasure and the language of the promise of the world. Milosz tells the story that when he visited Salem, Massachusetts, and walked into one of the faithfully reconstructed seventeenth-century houses, he thought, This is it. This is where I belong. He was in his grandfather's manor, with the door off the dining room leading to the kitchen as in a Dutch painting. And the kitchen itself, he said, was a Chardin. Chardin and Dutch painting, except for the couch in the parlor, in the Empire style and covered in oilcloth, where, in 1918, when he was seven years old, a pretty, older cousin came to visit, and sat him down and began to read him one of the novels of Henry Sienkiewicz. It was an event he described as an initiation. It was, or at least, for the purposes of this telling, it can stand for, the moment when he entered the enchantment of the language that would define his life. His early poems with their turbulence and prophetic violence were written in Wilno/Vilnius when he was a college student and after.

For a young writer Wilno was the city of the romantic origins of Polish poetry. Adam Mickiewicz, the Pushkin of Polish poetry, also in his time a political exile, had gone to the university, and so had Julius Slowacki, the Shelley or Keats of Polish Romanticism. Vilnius is the city Milosz remembers in his poem of exile, "City Without a Name," and the place where, in a group of poets who called themselves Catastrophists, he published his first books. "Song" and "Slow Rivers" from his second book, published in 1936 when he was twenty-five, will give readers a sense of his writing in that period. It was during this time also that Milosz visited Paris for the first time and was introduced to French literary society by his uncle, the Lithuanian-born French poet Oscar Milosz. In the midst of the Depression, he explored the city to which he would return first as a middle-level Communist diplomat and where he would later survive for ten years as a freelance writer and something of an outcast in the pro-Communist milieu of French literary life.

The war took him from Wilno to Warsaw, where he worked in public radio as a writer and then, after the German occupation, as a teamster carting books for the university library. He continued to write poems, edited underground anthologies of poetry—one of them was called *Invincible Song*. He also translated and distributed through clandestine publishers an essay by the French philosopher Jacques Maritain

on resistance to collaboration with the Nazi regime. Now the language of government was German and Milosz began to study English, reading Shakespeare and the poems of William Blake and T. S. Eliot. In Washington after the war, as a cultural attaché to the Polish embassy, his English got put to use, and he was able to improve it by reading the *Partisan Review* and, in Polish, summarizing its contents by way of supplying "briefings" on American culture to the home office. By the 1950s, in exile in Paris, he survived with the French he had learned at school and on summer visits to France and in his reading of French literature during one year on a fellowship, while he wrote in Polish—besides *The Captive Mind*, the book that made his international reputation—the prose books that looked back to the world of his childhood; a novel, *The Issa Valley*; and a work of autobiography, *Native Realm*.

English, his fifth or sixth language, brought him to California, where, in Berkeley, on a hillside above San Francisco Bay, he wrote poems in Polish for another forty years. During that time he improved his Greek and worked up some Hebrew and translated the psalms of David into Polish. He also, toward the end of his life in Berkeley, hired a tutor to help him improve what remained of his childhood Lithuanian. He told his friends that he wanted to be fluent in case Lithuanian turned out to be the language spoken in heaven. He got to return to Poland after the fall of the Communist regime in 1989 and then to Lithuania and to the riverbank of his childhood a few years later, after the collapse of the Soviet Union. It was a very remarkable closing of the circle of his life, one that had seemed inconceivable during his many years of exile and travel.

In his last years he and his second, American wife, Carol, lived in Krakow, in a beautiful old high-ceilinged apartment just off the city's main square, so English was his language at home, but in the city and among guests, especially the young Polish poets who gathered around him, he was returned, with enormous happiness, to the sounds of the Polish language in all its living forms. After his wife died unexpectedly and rather cruelly—she was so much younger than he and they were so happy together—he was alone with Polish again. He said to friends, in the difficult days after her death, that he was surviving by incantation. One of the forms that incantation took was an elegy to his wife framed as a retelling of the story of Orpheus and Eurydice, the myth that he had read in Ovid and that, as a schoolboy, he attempted to translate from the

Latin in his first effort at writing Polish verse. This time it had its setting in the foggy San Francisco where Carol Milosz died.

He survived her for a year and was buried this August after a high funeral Mass in the Basilica of Saint Mary in the great square in Krakow, which was filled with his admirers in the thousands. The altar and the casket were heaped with calamus and wild ginger—the white flowers of the Lithuanian summer—and after the funeral, at the graveside service, under a chestnut tree in the courtyard of the Church of Saint Peter of the Rock, a part of his poem "In Szetejnie" was read in Polish, Russian, Lithuanian, English, French, and Hebrew by his poet friends. It was a poem written when he returned to Lithuania after leaving it fifty-one years before. Its subject, appropriately enough, is learning how to write, and it's addressed to his mother:

In Szetejnie

You were my beginning and again I am with you, here, where I
 learned the four quarters of the globe.
Below, behind the trees, the river's quarter; to the back, behind
 the old out-buildings, the quarter of the forest; to the right, the
 quarter of the Holy Ford; to the left, the quarter of the Smithy
 and the Ferry.
Wherever I wandered, through whatever continents, my face was
 always turned to the river.
Feeling in my mouth the taste and the scent of the rosewhite flesh of
 calamus.
Hearing old pagan songs of the harvesters returning from the fields,
 while the sun on quiet evenings was dying out behind the hills.
In the greenery gone wild I could still locate the place of the arbor
 where you forced me to draw my first awkward letters.
And I would try to escape to my hideouts, for I was certain that I
 would never learn how to write.
I did not expect, either, to learn that though bones fall into dust, and
 dozens of years pass, there is still the same presence.
That we could, as we do, live in the realm of eternal mirrors, working
 our way at the same time through fields of unmowed grasses.

2004

poetry and terror: some notes on *coming to jakarta*

ote: Peter Dale Scott is a Canadian-born poet, diplomat, and writer about the underside of international politics. In 1988 he published a long poem—"a brilliant and devastating book," Michael Ondaatje called it—about terror that drew on his diplomatic experience. The poem—borrowing something from the Cantos *of Ezra Pound—traces the early history of the CIA and the development of the influential Council on Foreign Relations from its early strategic anti-communism, the "containment" strategy that was the linchpin foreign-policy doctrine of the American empire as it emerged after the Second World War. It argues that it led to the CIA instigation of and support for the slaughter of more than a million Indonesians by the Sukarno government and the forces that the Indonesian military and the CIA unleashed between 1959 and 1966—and that this perceived success in scotching communism (also liberalism, socialism, secular humanism, and the labor movement) in a Muslim country led to the U.S.'s counterinsurgency war in Vietnam. It is a remarkably readable poem about political terror, the male warrior ethic, and the shadowy world of power that people choose mostly not to know about. This essay was written for a good literary magazine,* AGNI, *to draw attention to the poem. I think it can be very usefully read without knowing the poem but it is probably best read with the poem in hand.*

1. A Short Quiz

Identify the author of the following quotation:

> Because Communism is so blatantly an international and not an internal affair, its suppression, even by force, in an American country, by one or more of the other republics, would not constitute an intervention in the affairs of the former.

Answer: Spruille Braden, an assistant secretary of state for inter-American affairs in the Eisenhower administration, and later, not surprisingly, an advisor to the United Fruit Company. In 1952–53 Braden led a Council on Foreign Relations study group on political unrest in Guatemala. The group's report provided the justification for the American invasion of Guatemala in 1954 and U.S. military intervention in the region since. Braden shows up in section II.xvi of Peter Dale Scott's *Coming to Jakarta.* I came across this quotation from a speech by Braden when I looked him up in a side note, which sent me to a study of the origins and history of the Council on Foreign Relations, Laurence Shoup and William Minter's *Imperial Brain Trust* (Monthly Review Press, 1977). I was testing to see how Scott's annotations work. The speech was printed in *Vital Speeches of the Day* 19 (May 1), 432–37.

Now identify this:

> Military defense against direct and indirect aggression must be a fundamental objective in Southeast Asia, for without security all other goals collapse like a row of dominoes when the first is pushed over.

Answer: the author is—but let me quote the poet:

> . . . Russell H. Fifield
> sometime State Department official
> professor of political science
>
> at the University of Michigan
> and the National War College
> Secretary of the Association
>
> of Asian studies

Professor Fifield, on leave from Ann Arbor, was a visiting fellow at the Council on Foreign Relations and director of the Southeast Asian study group for the years 1959–63, when the United States was formulating its policy toward Indonesia and Vietnam. This first catastrophic formulation of the domino theory appeared in Fifield's *Southeast Asia in United States Policy,* which was published under the auspices of the Council on Foreign Relations in 1963. Fifield appears in sections II.xvi and II.xvii of the poem. I found this quotation in Shoup and Minter. The annotations really do seem to complete the arguments, stories, and historical constructions to which the poem refers.

2. GISTS

Coming to Jakarta is, as its subtitle informs us, a poem about terror— the subliminal, half-repressed terrors of private consciousness, terror as political violence, often tribal or ethnic, the savage kind we know mostly from newspapers because it occurs in countries where poverty or chronic instability has bred the rage to fuel it, and also terror as a reasoned instrument of political policy. What makes the poem so unexpected is not that it is about the first kind of terror, or even the second, but that it is also about the third, and that it tries to understand the relation among the three, for it has not been the case in the twentieth century that anyone who knew enough to write such a poem would write a poem at all. Our political and literary cultures are so separate that only very occasionally does a Washington reporter's or a foreign correspondent's novel attempt to bridge them. Our political poetry is a poetry of moral feeling or, more rarely, of witness, but even the poetry of witness has had for the most part something like a foreign correspondent's perspective. The poetry of homelessness can express anger at the sight of the sick and poor huddled in growing numbers over subway vents. It may even record what it is like in a refuge for homeless women, or portray the lives there, or enter them imaginatively, though this would more likely be the territory of literary prose. What it would not do is attempt to describe and analyze the whole network of causes, from the deinstitutionalization of the mentally ill to the cuts in federal housing to the effect of the Reagan tax cut on real estate speculation in the inner cities and the boom in fraud this created for federal bureau-

crats and the savings and loan business, even though this would begin to be a fit subject for Dante. In fact, the writing about this set of connections would leave literary prose behind as much as poetry. It would be relegated to investigative journalism.

So what Peter Dale Scott has undertaken in his long poem is both immensely ambitious and mostly unparalleled. A new reader, trying to take bearings, will see that the poem is an heir to Ezra Pound's *Cantos,* this time with footnotes. Or rather side notes in the manner of Coleridge's *Rime of the Ancient Mariner,* to which it also seems, in its obsessive telling of a strange tale, to allude. It is a powerfully literary poem, and like *Cantos,* it does not so much assume as propose an education most of us do not have—not only in, say, how American foreign policy toward Chile was developed, but also in epic poetry. It wants to integrate these materials—and Pound's ideas about Martin Van Buren's ideas on the U.S. banking system, and the gradations of class in Scott's childhood in Montreal, and the ideas of duty proposed by Krishna to Arjuna—not just in order to understand the nature of terror, but to produce an aesthetic effect that might be called the sensation of understanding, the formal feeling of understanding. That effect amounts to an assertion that the quieted anxieties and nightmare terrors of private life, and the political violence we glimpse in the newspapers, tortures, starvations, hysterias, mob frenzies, and the secret world through which arms, money, drugs, and agendas of political manipulation pass, that we also glimpse, though more fleetingly, when fragments of a pattern emerge in the investigation of some scandal or other, also the visible and semivisible processes of government, and the common sense that our world is spinning out of control or sunk in a deathly inertia of habitual closed circuits of action—that all these can be integrated in a poem, despite the fact that our lives among these phenomena do not feel integrated and the fact that these materials are, therefore, the ones that would seem to sink the very possibility of poetry.

To get a sense of the huge, healing integration that Peter Scott has intended in *Coming to Jakarta,* it helps to have a handle on some of its literary and political contexts. I'm far from having a handle on them myself, but I've begun to study the poem, and these notes are an effort to help other readers find their way in it.

Coming to Jakarta begins with a speaker, a poet, professor, former diplomat, who has spent a lot of time doing investigative research on

the political underworld and has begun to feel sick at the center of his life. The strategy is then to bring forward memories of childhood summers on a lake where rich American families also summered, and to trace the evolution of the U.S. foreign policy elite in the histories of those families, particularly the Dulles clan, which produced John Foster Dulles, secretary of state in the Eisenhower administration, principal architect, many think, of the American side of the Cold War, and his brother Allen Dulles, first director of the CIA. One of the mechanisms of that evolution was a curious, privately funded, semi-official institution, the Council on Foreign Relations, situated by its membership halfway between American government and American banking, and in a position—by virtue of its funding from the most powerful American corporations, the prestige of its journal *Foreign Affairs,* and its fellowships and research grants—to exert considerable influence on the direction of scholarship in politics, government, anthropology, sociology, geography, and history as it was then practiced at American universities. The poem also gathers to itself, therefore, figures like Spruille Braden and Russell Fifield, scholars and intellectuals who figured in the formation of American foreign policy in the early days of the Cold War. By looking from the council to the scholars and the CIA, the poem is able to trace the patterns of overt and covert violence—which form the poem's central theme—from Guatemala in 1954 to Indonesia in 1959–66 to South Vietnam in 1959–74 to Chile in the 1970s and, implicitly, to El Salvador, where we financed paramilitary and military death squads, and to Nicaragua.

At the center of the poem is the fact and metaphor of the killing of half a million people, the subject discovered and announced in section II.iv—

I am writing this poem
about the 1965 massacre
of Indonesians by Indonesians

—and though it is at the center of the poem, very little effort is spent evoking the horror of the massacres. Scott is much more concerned with understanding how it came to be that American universities and perhaps the CIA assisted the right wing of the Indonesian army, which then initiated the killing with a systematic purge of some five thou-

sand members of the Indonesian Communist Party, and the leaders
of labor unions, women's organizations, and youth groups, after which
a general slaughter began, mostly landlord against peasant, Muslim
against Hindu, until almost all the most active members of the three-
million-strong Communist Party were dead, the rivers clogged with
bodies. It was only then that the army

> . . . finally stopped the bloodletting
> as the smell of burning houses
> overpowered the customary
>
> fragrance of the rich island flora.

3. As for the Art of Poetry

If the first thing that strikes a reader of the poem is the boldness of this
subject matter, the next is the suppleness of the verse. Its three-line
stanza must have been suggested by terza rima, but Scott's deployment
of it, the way complex sentences play over the three-line pattern, the
relation of line to line, stanza to stanza, is often so deft and sinuous that
it puts one in mind of Latin poetry, especially Virgil, who also figures
in this poem. I have been trying to define for myself how the effect is
achieved. I think it's the weaving of sentence across stanza intensified
by the suppression of punctuation, and the convention of usually, but
not always, marking the beginning of new sentences with capitaliza-
tion. The reader doesn't always know where he or she is in the sentences
and sometimes doesn't find out until the meaning is completed. It's this
that produces the surprising turns in some of the individual sections
of the poem and gives it its feeling of Latinity. The verse that has to
carry documentation, straightforward narrative, and lyric description
is remarkably serviceable. Its classicism depends in turn on its being
at its best very careful about enjambment; the lines have to feel like
lines, and they do. One feels the presence of the verse moving even in
the most densely and recalcitrantly bureaucratic materials of the poem,
and it has elsewhere an almost velvety suaveness of movement.

For what a long poem needs is a prosody that will carry it when the
writing isn't especially brilliant, when the interest in a passage is not in

its vividness or in the originality of individual lines or stanzas but in what
they move toward. Look, for example, at the construction of II.1x, which
begins with the comedy of a boy's sexual education and moves to the tacitly
prurient masks behind which European ethnography expressed its fascina-
tion with the bodies of the people they were exploiting or hoped to exploit,
and from there moves to an instance of the terms of that exploitation. The
beginning of the section is also an instance of the poet's sometimes acute
self-awareness. The little boy with his rational education peering into the
book of the sexual customs of savages is a rehearsal of the adult scholar-
poet poring over books about the cocaine trade and the Mafia:

Despite my careful upbringing
 according to the handbooks
of the post-war twenties

which urged that all family
 interaction be conducted
in an adult manner

when I went back to the rectory
 of my father's father the Archdeacon
it pleased me to hear grace

and despite my precocious
 enlightenment about sex
through a book about pollen and frogs

I still almost tremble
 when I think of those unexpected nights
in the darkest corner

of my father's study
 reading his Sexual Life of Savages
my introduction to the third world

with its terrifying permissiveness
 licit childhood intercourse
customary rape

This is every well-brought-up child's version of *Heart of Darkness*, and the question, of course, is permissiveness for whom and by what standards. Scott underscores the relation of this to his larger theme by eliding into another book, this one about Indonesia, he came across while

> crouching this afternoon
> > in the library stack
> with the sepia photographs
>
> of Krause's Bali
> > the Markszene of the young pig
> muzzled and bound with raffia

and links it back to his own sexual curiosity through the *Badeszene* of the woman washing her hair, with its lugubrious pose, and a photograph from which some earlier reader has conscientiously excised the bared breasts. And this he links in turn to the actual economy of desire in the exchange between Balinese and European in that market:

> I have read elsewhere
> > how this same market Bangli
> grew from nothing in the nineteenth century
>
> when reached by international trade
> > which is to say opium
> at controlled British prices
>
> 87 per cent of imports
> > at Singraja in 1859
> the rest mostly Manchester goods
>
> until by the very end of the century
> > nearly every adult Balinese
> male and female was an addict
>
> the smoke
> > so dense in the place
> lizards fell from the walls in a stupor

And the conclusion of this section ties the political to the personal in a way that the poem often does:

> the world like myself
> > in its unintegrated desires

Scott has taken formal qualities of his great models—Osip Mandelstam guessed that the braiding and unbraiding of Dante's terza rima was connected to the arts of Florentine textiles—not only for guides to a style but as a theme; his poem wants to begin to integrate the terrors and denials of both the private and the public worlds.

4. Secrecy, Voyeurism, and Paranoia

Another fascination of *Coming to Jakarta*, perhaps its main fascination, is that it locates its political themes in personal life through its meditations on secrecy, voyeurism, and paranoia. This is clear in the first section of the poem when the narrator makes the world's secret mutterings his muse:

> wind-driven ghost of snow
> > down the side of the dark
> oak outside my childhood window
>
> with the blind flapping all night
> > Why are you here?
> Have you something to tell me?

He repeats this theme in the second section:

> the surly rebellious trees
> > beyond the muttering window
> (the maples of course of my childhood
>
> but no more full of branches
> > and black openings than
> the laurels out in California)

have always concealed voices
> too low and too obscene to be heard
except as revelation

and in II.i it is linked directly to the summer lake

where I stare down deep between the boards and see

beyond distorted caricatures of self
> green furtive shadows
the slime of bottom weed

and among the dim stones
> the blind crawlings
not willingly remembered

the warped plank pressing against my cheekbone
> I begin to discern now
to my relief this is to be

beyond the confines of my mind
a poem about terror

In II.ii the narrator and his young friends, "those rich American strangers," have "the rare privilege of invading" the "sinister uninhabited houses" on the lake, and the theme of secrecy and violation is connected to sexuality:

in the vacant Westmount mansion
> where just that once we boys
and girls went to play goose

to search over Aileen's
> too solid body
as Roger whispered

outrageous urgings in my ear

This is followed by the first glancing reference to the CIA, and in II.iii, in one of the poem's truest turns, all these themes are connected to the mystery of social class, the summer lake where

> the names on the mailboxes
> along the American side
> were of a compact so invisible

> and seamless as to exclude mere wealth

This is very neatly done, and leads directly to his enunciation of the Indonesian theme and the account of the origins of the Council on Foreign Relations in III.x, xi, and xiii. As we have seen, it has also been tied to sexuality, the third world, and the marketplace in the loops of association in II.ix, so that, as the poem proceeds to make an account of the speaker's life, it suggests by allusion and side note a hidden world of power and violence. We listen with an ear turned to uneasy inward urgings, shadowy muttering, the world with its unintegrated desires.

5. POUND AND WORDSWORTH

As the poem cat's-cradles, to use Michael Ondaatje's appealing and accurate phrase, between autobiography and world politics, it seems also to move back and forth between two great models, Pound's *Cantos* and Wordsworth's *Prelude*. Pound's presence, of course, is explicit. He is addressed in II.v and the debt acknowledged:

> and I was moved to reject
> the blind man's prophecy
> Odysseus

> shalt lose all companions

Scott needs Pound not only because he provides a model of the long poem with history in it, but also because he agrees with some fundamental part of Pound's economic analysis of modern culture, as he says in II.x:

EP however nuts
　　you may have been
in your Wagnerian way

you were right to talk about banks
　　the problem of stored desire
that is no one's

But Pound provides no model for the autobiographical passages, and if one thinks about the poem with the documentation of its political argument removed, it looks from the beginning very much like an autobiographical poem about the formation of a poet's imagination, beginning like Wordsworth with spots in time, those childhood moments on the lakeshore when the "green furtive shadows" and "the slime of bottom weed" teased the boy's mind with a meaning of the world.

It is useful, in fact, to think about Pound and Wordsworth in relation to the overall organization of the poem. It is divided into five parts; the first and last, made up of three short sections each, make an introduction and conclusion. The body of the poem consists of books II, III, and IV, and Pound is the guide to book II. He is invoked in II.v, x, xi, xiii, and xvi, and the development of the themes—the power of international violence, the rise of the CFR, the history of the Dulles family, the co-option of American scholarship by the foundations and the CIA—is presented as a kind of dialogue with the master.

But the third book of the poem sets that argument aside and becomes, except for the development of the Indonesian theme in the first and last cantos and in III.xii, with its description of the *wajang koelit,* the Indonesian shadow play, a fairly straightforward account of the poet's life in the manner of the *Prelude.* Political education is one of its themes, family history is another; caste and failure and the relation of both to power still another. It's extremely readable because it gives an account of the person we have glimpsed in I and II, this third-generation Canadian poet, with the archdeacon grandfather who served in World War I and the socialist-lawyer-poet father who seems to have moved in very distinguished literary and political circles. We see something of his childhood in Montreal; his Wordsworthian taste, or maybe it is just Anglo-Saxon and middle-class, for hiking in the mountains; his college years at McGill in the late forties with its

political agitations; the years at postwar Oxford, a passage in which
Wordsworth is explicitly acknowledged—

> But where the theatrics of the gown
> > turned Wordsworth back
> on his inner tranquility

> they left me self-conscious

—and in which the narrator, reading political theory, can't quite get the
hang of it and is sent down. There follows an account of his return to
Canada, teaching at a prep school (the classic failed Evelyn Waugh char-
acter's Siberia), a marriage, some time at Harvard, a Ph.D. in political
science, and a brief career as a Canadian diplomat in New York at the
United Nations and in Poland, the account, in short, of how there came to
be the very unlikely person with the literary and political education, the
political experience, and the particular relationship to the world of power
to have written this poem. And it is presided over by something like that
combination of daydream cadence and alertness and self-absorption that
make the middle stretches of the *Prelude* oddly comforting and hypnotic.

6. CASTE

From the point of view of political education, III.ix is particularly inter-
esting for the candor and comedy and anger in its treatment of social
class. The narrator is recalling not having passed his exams in political
philosophy at Oxford and wonders if there isn't "something to be said

> for being marginal
> > and even insular
> at the vortices

> like Oxford and Harvard
> > where the sons of the wealthy
> at the Eliot club breakfasts

> ate only the yolks of their eggs

It's this narrator, paying his peers the tribute of this pained mixture of contempt and very close attention, who reflects that at least his failure has taught him not to be so lordly. But there is another agenda here as well, his discovery that he can cultivate political views that have the power to unnerve. If everybody got sent down, he reflects,

> then no one would have
> > needed to look shocked
> that night in New York
>
> when in the company of
> > my friends the Rhodes scholars
> and Junior fellows
>
> gearing up to publish
> > their policy dissertations
> to burst upon the world
>
> of think tanks the CFR
> > and consulting for agencies
> as yet unnamed
>
> I said that's why
> > some people in Europe
> are not so upset
>
> to see Russia get the bomb
> > and you could hear the drinks
> of the future ambassadors
>
> being set down

This has fury in it but also has some of the deftness of English social comedy. What the narrator is saying may be true, but we understand that he's saying it partly out of jealousy to needle his friends, or, in Dostoyevskian fashion, to ruin his social chances since he understands that they're fairly dim anyway. The scene's distant echo is in those passages in the *Prelude* in which Wordsworth, attending a country ser-

vice, feels absolutely cut off from his countrymen by his support for the French Revolution. But here we're not in a village church, we're among young apparatchiks on the make, and the scene chimes with others on the themes of paranoia and social caste. Exclusivity, as Scott describes it, is not secrecy, but in the foreign policy establishment they are more than kissing cousins. They are cousins who got into each other's underpants in childhood. And that relationship is one of the ways that the flattery of success reinforces ideology.

But, if I am reading the poem rightly, one of its ironies is that class is not, finally, the issue. The reversal occurs at the very end of section IV. The narrator, at another dinner party—he seems to go to a lot of them in the course of the poem—meets a woman, and having learned to control his terror of the world, if not the world's terror, with research, he immediately identifies her as the daughter of a man who worked for the OSS; and then the Dulles brothers' law firm, Sullivan and Cromwell; and then Standard Oil. She is also the granddaughter of a law partner of the son-in-law of J. P. Morgan. All this and more comes immediately to mind, since he has made himself, by trying to understand how power works, into a sort of American version of *Burke's Peerage*. Toward the middle of the section he addresses her:

> but why tell you this
> who married a French-Canadian
>
> lawyer from Westmount
> and are serious about the piano
> now it is the new blood
>
> from the Reagan entourage
> who meet with the Aginter
> veterans of the Guatemala bloodbath
>
> and no one in your
> generation seems to have preserved
> that ancient appetite for power

This recognition seems to release him from some old fear. Freed from the power of what has seemed the seamless mystery of caste and perhaps

from his young man's fumbling sense of being marginal, déclassé, he walks outside at the end of the section and hears the night sounds that at the beginning of the poem had disturbed him,

> what is the whir
> of low wings in the darkness

> of the ornamental pine?

> and the answer that comes back and returns a word to him:

> it is the owl

So—the poem seems to suggest—class is not itself the issue. And as that theme fades from the poem, others emerge more clearly, particularly those that focus on the exercise of power: ideology and violence.

7. Virgil and the *Wajang Koelit*

The poem begins with Virgil—

> There are three desks in my office
> at one I read Virgil's
> descent into the underworld

—and it was a while before it dawned on me that this fact contained a sardonic pun. The obvious intent of this allusion seemed to be to foreshadow the poem's descent into the psychological world of secrecy and fear and the underworld of covert political violence. But once I had been through the treatment of Lockheed bribery and money laundering in section IV.i and looked at Anthony Sampson's *The Arms Bazaar* (Viking, 1977), to which the notes sent me, I saw that beginning with Virgil underlines the issue of the political poem in the twentieth century. It has to begin—one way or another—by echoing the first line of the *Aeneid*. It has to begin by saying, "Arms dealers and men I sing."

Though there are no other references to Virgil in the poem, section II.xi, in which the Roman poet is not mentioned, is probably the one

in which the author has Virgil most firmly in mind. It is an account of the male lineage of the Scott family and is meant, I think, to remind us of the procession of warrior-kings in book six of the *Aeneid,* which reaches from the founding of Rome to the death of Augustus's nephew Marcellus. All three of the great epics are about maleness, in their different ways. And so, Scott will remind us, is the Bhagavad Gita, which is an account of the battlefield education of the warrior Arjuna. But the *Aeneid* is particularly a poem about manliness, if a man can be said to be a male with a social code to live up to. The figure for it is Aeneas carrying his father on his back and holding his son by the hand as he leaves the burning city. Section III.xi gains force if it is read against this background.

It begins when a biographer arrives to interview the narrator about his father. (Scott's father, F. R. Scott, was a distinguished Canadian poet, a lawyer, and one of the founders of the Canadian socialist party.) The narrator is reminded of his grandfather, a chaplain in World War I, who wrote a book about his experience (*The Great War as I Saw It,* Vancouver, 1934), in which he describes walking in no-man's-land after a battle and seeing

> the hand of my uncle Harry
> > with the Scott family ring
>
> the bloodstone fake crest I wear myself

This initiates other memories: three of his uncles killed or badly wounded in that war, a cousin torpedoed in the Saint Lawrence in World War II, and—more nearly—a pacifist father maimed by the war in a way that got passed on to his son. The father "was only prevented from enlisting

> at seventeen by the rifle
> > which exploded into his hands
> and blew out one eye
>
> life after that
> > so concentrated in his tingling limbs
> he became like his own father

poet reformer domestic tyrant
 the father whom as a child
he had avoided sick in bed

This set of themes, the Virgilian themes of war, empire, fathers and sons, the warrior ethic, violence, resonates through the second half of the poem, especially V.i, for example, where we are reminded that the Bhagavad Gita's "true sage" learns "to kill with detachment." This plays back through earlier sections like II.viii, where it gives a bitter poignance to the relation between Allen Dulles and his son, killed in the Korean War. At this point, about halfway through the poem, the Virgilian themes are contrasted with those emerging from the *wajang koelit*, the traditional Indonesian shadow play that descends from the Ramayana and other sources in the Hindu epic tradition, but that, passed into folk art, no longer sounds the imperial themes, delighting audiences less with its warrior heroes—the five Pendawas of the Hindu epic—than with the servants, the clowns, Toealen and Semar, of Indonesian origin who embody craft and cunning and the knockabout comic wisdom of the people.

The shadow play enters the poem in III.xii and could be said to embody the whole theme of the poem. Scott describes the drama that Indonesians could watch all through the night during festivals, one in which there is combat "between the terrible witch Rangda

her long hanging breasts

realistically made
 of bags of white cloth
filled with sawdust

not only a fear-inspiring figure
 she is Fear
afraid as well as frightening

and the good dragon Barong

whose sheepdog coat
 glitters with mica

moving among the kris dancers
 entranced by Rangda
to return them to consciousness

gentle Balinese father

In the *tjalonarang*, the trance drama in which this story is danced, the story of the war between fear and consciousness (and the bad mother and the good father, apparently), the exorcism can last toward dawn:

the actor possessed
by the real Rangda

is brought with effort under control
 one old actor is said
never to have regained

his mental balance
 and the great battle is
once more a standoff

This ends the section. It is very deft and resonant. The two sections, II.xi, about the Scott family males, and III.xi, about the shadow plays, sit at the center point of the poem, and read together they suggest the richness of the poem's reach and the carefulness of its design.

8. A Note on Ideology

"I was always going along / at first," the speaker says in II.xii, "with whatever / sounded reasonable," which is in a way a definition of ideology—the care and maintenance of an interpretation of reality that seems reasonable and serves the interests of power. It is, as Scott writes about it, a Dantesque theme, because ideology seduces reason. That is why the poem is about scholars as well as statesmen, bankers, Cold Warriors, it is why the apparatus of the poem—its bibliography of literary and cultural historians, anthropologists, social scientists, pol-

icy intellectuals—is also a subject of the poem. Central to the working out of the theme is an account of the public debates about the role of political influence in their field that took place among U.S. scholars of Asia during the Vietnam War.

The subject is introduced in II.vii, which recalls Senator Joseph McCarthy's attacks on two distinguished China scholars, John Fairbank and Owen Lattimore, in the early 1950s. Both men appear in II.xii, in which the narrator recalls a time during the Vietnam years when the annual meeting of an organization of Asia scholars was held in San Francisco. A group of dissenting, mostly younger scholars, critical of the war and of the role American scholarship played in the formation of U.S. policy, created a counter-organization called Concerned Asian Scholars and held an alternative meeting in a downtown church opposite the official meeting in the Hilton Hotel. Most of this can be surmised from the poem, but perhaps it is easier to follow if one has the basic story in one's head.

Both Lattimore and Fairbank were present at the alternative meeting, and Fairbank, a Harvard professor and by then the eminence in China studies, cautioned his younger colleagues: "the great danger then and now / is politicized thinking / either right or left." In those years it seemed to many younger professors that what the older professors meant by "politicized thinking" was thinking in politics different from the politics the older professors thought in. In reaction to the McCarthy attacks in the 1950s, most American scholars defined themselves by insisting on the idea of independent, objective, value-free research—and then signed on to do research for funding agencies like the Ford Foundation and the Council on Foreign Relations, which had very distinct political agendas. The line between scholarship and political activity, which they insisted could be drawn, was even on their own terms blurred, and in the late 1960s, as the war escalated, the younger scholars felt that they were seeing the results of that blurring. So John Fairbank at the San Francisco meeting found himself challenged to account for his links to the Ford Foundation and for the $30 million he had received from the Social Research Control Group to undertake and direct research in Chinese history.

One of the organizers of the Committee of Concerned Asian Scholars was Franz Schurmann, a UC Berkeley China scholar and an active opponent of the war, who had been Fairbank's student at Harvard and

who had begun to write (and to collaborate with Peter Scott on) influential essays about the motives of U.S. policy in Southeast Asia. This is the context for the scene in II.xiii in which the narrator and his wife have tea with the wife of John Fairbank, who laments to them that Schurmann has abandoned "a promising scholarly career / for simple journalism," which Scott and Schurmann could only take to mean that he had stopped playing the academic game and begun to speak out on matters of life and death. This is the operation of ideology as manners, good sense, good taste, which may be its most powerful form. The narrator, because these issues are always entangled in private life, helplessly remembers an earlier visit to the Fairbanks with his parents, an idyll of

> canoeing among the
> > waterlily pads
> of the upper Charles

In II.xviii—the "I was always going along" section—Scott presents Fairbank's defense of himself, which is what sounded reasonable in the late fifties, that the cash grants, whatever their source, "would be an important means / for bringing that is to say the / Cold War to an end," and which sounded less reasonable in the seventies when it had become clear that there was "a considerable correspondence" between the research undertaken (under the supervision of a committee Fairbank helped set up) and what one U.S. general called with military redundancy "research needs in the social sciences / relevant to U.S. Army limited war needs." Scott does not seem to pass a final judgment on this matter. For the narrator some years later it seems the disputants might "with a little reflection / have understood each other." But the rest of the section comments implicitly on Fairbank's stance in two ways. First of all it draws a clear distinction between the kind of research Fairbank supervised and the research undertaken by Guy Pauker, who set up a program to train the Indonesian army command and in 1964, before the massacre, castigated his protégés in print "for lacking / the ruthlessness / that made it possible / for the Nazis to suppress / the Communist party / a few weeks after the elections / in which the Communist party / won five million votes." So, one sees, from the narrator's

point of view, that even if Fairbank was by his own standard of political disinterestedness co-opted, it was nevertheless a different thing from the position of a Cold War political scientist who helped to provoke the terror and violence that overwhelmed Indonesia in 1965. Fairbank, in this brief portrait, emerges as an honorable man, guilty at worst of having the mental coloring of his time. And between Fairbank and Pauker, Scott has ranged other figures like Professors Braden and Fifield, who shuttle back and forth from government to business to the university, skillful at serving up the interests of their employers as the aims of Western civilization.

Another way in which this passage comments on Fairbank and on the issue of ideology is by providing an instance in which the narrator himself makes use of one of those small concessions to politeness that constitutes denial. Writing about Indonesia in 1975, in the very context of investigating the corruption of scholarship by the military and intelligence agencies through which they worked, he discovers that he has himself passed over a connection—"Those whom at first / I decline to mention" in II.xviii—with scholars at his own university, "the so-called Berkeley mafia": Indonesian civilians trained in military economics in Berkeley who in turn taught the military cadres in the school founded in Java by Guy Pauker. In the previous section, we have seen the narrator at a Vietnam War teach-in debating this same Guy Pauker, not yet knowing who he was, and having said in the course of that debate, "you / political scientists / are part of the problem," apologizing for what had seemed an accusation: "of course / not you personally." So academic civility prevails, and the narrator, once comically and inadvertently, and once in the middle of his own research, has committed those small acts of denial through which ideology works its hegemony. To underscore this, Scott juxtaposes his own act with Nadezhda Mandelstam's explanation of the success of Stalinist intimidation in the early thirties in the Soviet Union: "in our sort of life / people of sound mind / had to shut their eyes / . . . with devastating consequences." It is here that book III of the poem ends, the first movement of it, with an image of the pervasiveness of the self-deceptions, and also with the connection between denial and violence not just in nightmare but in the world.

It is remarkable, of course, that Scott has taken on this material, complicated, parochial, full of the kind of detail and nuance that would

seem to require endless explanation and qualification, and made poetry from it. The technique that makes this possible is Pound's. He does not explain and he does not qualify—he refers and alludes. The fragment stands for the explanation and often lies athwart some other fragment, some pith or gist, that also stands for a larger matter. Which is to say that the poem presumes commentary such as I'm attempting here. Once you get the story down—you will have to make your own assessment of the cases of Professors Scott and Schurmann and Fairbank and Pauker—the poem does its work, moving materials into a constellation like that at the end of book II, which is both an image of how the world is and a moral argument.

9. THREE MEN

Toward the end of the Bhagavad Gita, Arjuna the warrior is vouchsafed a vision of the godhead: "If hundreds of thousands of suns were to rise at once, their radiance might resemble the divine effulgence." It can be a rather terrifying and dismaying experience to a first-time reader who thinks this classic work is going to issue in something other than monarchic, soldierly monotheism, light within light, sun of suns, the single sun that lights up everything. This passage came to Robert Oppenheimer's mind when he watched the first atomic bomb being detonated in the Nevada desert, and it enters the poem through Oppenheimer's recollection in V.i, where we are meant, I think, to think about nuclear destruction as an apotheosis of the warrior ethic that the poem has been describing. And its appearance is, after all, not theater; the danger is real, and the poem has described convincingly how nearly out of control are the forces that brandish weapons. It enters, however apocalyptically, as a quite rational fear—a hangman's noose to concentrate the mind.

 Part of the force of this passage comes from what precedes it, particularly IV.xv, which is an account of the way the CIA used the example of Jakarta in the course of engineering the coup against the Allende government in 1973. The results, not as unthinkably grim as the half million dead in Indonesia, were grim enough, and are even described—by Amnesty International—in imagery that has become very familiar, as if horror in the twentieth century had a particular encoding:

before PyL
> joined with the military
in the mop-up brigades

many of whose
> maybe 30,000 victims
were tortured to death

their bodies sometimes
> disfigured beyond recognition
headless corpses like logs

clogging the Nuble river

These deaths are what provoke the observation with which the section begins. It is in many ways the conclusion toward which the entire poem has tended:

But when you control
> most of the world
you cannot stop

it has been managed before
> so you are expected
to manage it again

the cunning plan
> becomes in the streets of Santiago
a biblical whirlwind

Jakarta is coming

The argument here is not complicated: the clever men who, managing the world, helped to instigate the killing of five hundred thousand people in Indonesia and thirty thousand in Chile are apt to kill us all.

This is the issue parts IV and V of the poem try to confront. The argument is intricately woven, and though the mix of autobiography and documentation continues, neither Pound or Wordsworth seems

the formal model. Since the poem has proposed a moral problem and thus set up the expectation of a moral solution, it has occurred to me that Scott has Eliot's *Waste Land* in mind. That poem was faced with a similar dilemma. What to say in response to such a devastating portrait of social and spiritual ruin? The problem—artistically, let alone in the world—is that problems are so much more pervasive than answers. Eliot's solution has both a desperate truthfulness and a certain cunning. He gives the answer in "What the Thunder Said," in the old wisdom of the Sanskrit syllables, but makes them seem both desirable and out of reach. They are thunder, not rain, not the saving rain, and the poem reiterates its mad fragments and ends in a prayer: *shantih, shantih.*

Scott has likewise given us a description of the world that is tremendously convincing—a world driven by the disorder of desire, which is stored as money, stored as power; driven by fear that takes the form of secrecy; driven by class, which is the stylishness of power; driven by ideology, which is the desire to belong; driven by the warrior ethic, which is ancient in us, and by rape and hubris and the human appetite for destruction. And against this—in the old Indonesian shadow drama, the war between fear and consciousness—he weaves rather slender threads. One is an analysis of the philosophy of growth—it occurs in IV.vii, IV.ix, IV.xi, and most explicitly in IV.xii; it is an argument against the irrationality of capitalist rationality, the restless, endless flow of capital toward trouble and opportunity, a counsel of moderation, perhaps the shakiest moment in the poem for me aesthetically, and unlikely—IIV.xii is a sermon, really—but an alternative to the stance of hapless prayer.

Another thread has to do with the question of how to act toward such a world. "The word *act*," the narrator says in V.i, conjuring the word simply as a puzzle while he thinks both of moral action and of theater, especially the Indonesian audience that preferred clowns to soldiers. "Action!" he exclaims at the beginning of IV.v, a brilliant section describing the failure of nerve of a group of professors attempting civil disobedience. "No!" he cries in IV.x after flirting with the idea of writing off twentieth-century violence as a kind of Malthusian fatalism, "despite such choices / it is clear we must resist / the black shirted gangs." And among the forms of resistance that appear is action as theater, ludic gesture, Allen Ginsberg and Daniel Ellsberg lined up on the tracks at Rocky Flats in V.ii before a train to the nuclear warhead

plant. And this also becomes a slender thread—the need for conscious moral and symbolic resistance to violence.

The issue is most persuasively framed, I think, in a series of portraits of the way some men have lived in the world. I won't offer an elaborate reading of them here, but as they appear one after another in the latter part of the poem, they focus its themes wonderfully. There is first of all Raleigh of North Hatley in III.xvi, the decent Montreal investment banker who persuaded General Motors to build a plant in South Africa and "kept to his station / as the best of us have done." And there is Clifford Geertz in IV.viii, perhaps the most gifted American anthropologist of his genera-tion, an expert on Indonesian society who produced in his "Notes on the Balinese Cockfight" one of the classic pieces of American anthropology, a psychoanalytic reading, ironically enough, of the violent impulses in Indonesian (and other human) societies that tended, under the auspices of the usual granting agencies, to take the politics out of the actual vio-lence in Indonesia. It is Geertz who wrote that "the imposition / of mean-ing on life / is the major end of human existence." Focusing the poem on the somewhat evasive and self-serving meaning this talented and in some ways representative (to use Emerson's word) man imposed on the massacre is one of the poem's brilliant, complicating strokes. And finally there is the figure of Mahatma Gandhi, who enters the poem in IV.vi by way of the Bhagavad Gita and the Hinduism of Bali and who had a clear idea of how to act. Scott's portrait of Gandhi's life and death puts it where it has to be, at the center of our thinking about the twentieth century. It is, for me, the argument of these three lives that gives the poem force as it weaves to its end. That and, in the struggle between fear and consciousness, the example of the poem itself, its urgency, intelligence, and reach.

10. WHERE TO HIDE

II.vii . . . at night I read / about Yvain in the forest / com hon forenz at sauvage

III.iix: send them back to the forests / like Yvain or Erlangga / like the heroes of all good tales

III.xii: aloof esoteric Arjuna / banished to the forest

III.xii: She is Fear / afraid as well as frightening / whose deathly plague has / destroyed the kingdom / of her son Erlangga

III.xiii: I was then reading / by Curtius and Auerback / on imperial
 pastorals / parola ornata / ascent from the depths / and forest
 romancers / commissioned by the wives / of absent crusaders
IV.vi: it would be unbecoming of Arjuna / as a hero and ksatriya / to
 refuse to fight
V.i: the Great war / in which the good Penddawas / return from the
 forest / of solitude strong again / to oust their evil cousins
V.i: the forests are dying

11. NEWS THAT STAYS NEWS

The *San Francisco Examiner* for May 20, 1998, carried a headline that
reads EX-AGENT SAYS CIA COMPILED DEATH LISTS FOR INDONESIANS, and the
subhead "After 25 years, Americans speak of their role in extermina-
tion of Communist party." The article, by Kathy Kadane of the States
News Service, is based on interviews with various officials, princi-
pally Robert J. Martens, who is described as "a consultant to the State
Department" and who was sent to the U.S. embassy in Indonesia in
1963, where he headed an embassy group of State Department and CIA
officers who spent two years compiling lists, village by village, prov-
ince by province, of all the leaders of the Indonesian Communist Party,
which then numbered three million members and had an estimated
seventeen million sympathizers and was the third-largest Communist
Party in the world, after China's and the Soviet Union's. The list
included, according to Kadane, "a detailed who's who of the leadership
of the party . . . and leaders of the 'mass organizations' such as the PKI
national labor federation, women's and youth groups."

The lists were turned over to the Indonesian army—"I know we
had a lot more information than the Indonesians themselves," Marshall
Green, then U.S. ambassador to Indonesia, is quoted as saying—and
they were used, systematically, to hunt down and kill party leaders.
According to Joseph Lazarsky, CIA station chief in Jakarta in 1965,
General Suharto's headquarters reported back to the embassy, which
reported in turn to CIA analysts in Washington. Lazarsky: "We were
getting a good account in Jakarta of who was being picked up . . . They
didn't have enough goon squads to zap them all, and some individuals
were useful for interrogation. The infrastructure was zapped almost

immediately. We knew what they were doing. We knew they would keep a few and save them for the kangaroo courts, but Suharto and his advisors said, if you keep them alive, you have to feed them."

William Colby, later director of the CIA, then director of the agency's Far Eastern division, notes that the success of the Indonesian operation (notice the language: *success, operation*) led to the establishment of a similar program in Vietnam, which failed: "That's why I set up in Vietnam the Phoenix program—that I've been kicked round for a lot. It was an attempt to identify the structure . . ."

Robert Martens: "They probably killed a lot of people and I probably have a lot of blood on my hands, but that's not all bad. There's a time when you have to strike hard at a decisive moment."

Howard Federspiel, in 1965 the Indonesia expert at the State Department's Bureau of Intelligence and Research: "No one cared, as long as they were Communists, that they were being butchered. No one was getting very worked up about it."

Mark Mansfield, CIA spokesperson for the Bush administration: "There is no substance to the allegation that the CIA was involved in the preparation and/or distribution of a list that was used to track down and kill PKI members. It is simply not true."

1999

zukofsky at the outset

Note: Louis Zukofsky is another of the second-generation modernists who did their work under the shadow of their great elders. Not very well-known to general readers, not very widely anthologized until recently, he became a crucial figure in the 1980s and 1990s for young American poets trying to figure out how to combine a revolt toward abstraction in poetry—more of the verbal play of Gertrude Stein and less of the personal drama of Allen Ginsberg and Sylvia Plath—with a radical political perspective. Studies of his work are pouring out of the academy engaged by these questions. Zukofsky was born in New York City and lived there all his life, teaching literature at the Brooklyn Polytechnic Institute and writing his poems. He started his adult artistic life as a committed Marxist and over the years—of the Depression, the Second World War, McCarthyist witch hunts for idealistic 1930s socialists and communists in the 1950s—his work became less overtly political and more abstract and musical, which made him just the poet the young poets of the 1980s were looking for, and he has become an emblem of and for the American literary avant-garde. He was also a young man growing up in Jewish immigrant New York in a Yiddish-speaking household in the 1910s and '20s. He went to Columbia University; read ardently in old and new English poetry; undertook a correspondence with the man who became his mentor and promoter, the notorious anti-Semite Ezra Pound. And in his parents' apartment he launched his literary career by writing an ode—or a panegyric elegy—on the death of his other hero, Vladimir Lenin. That poem is the occasion of the essay that follows. For complicated reasons I can't print the poem here entire, but a reader will have more fun reading this essay with the poem in hand.

I have it in mind to read of one of Louis Zukofsky's early poems—to look at the writing in detail and to explore who he was at the outset of his life as a poet. This has its interests. One is Zukofsky's particular formation and development. He is much admired by the young right now for the combination of his early commitment to the politics of the left and for his later experiments with the foregrounding of language play. Among the modernists he and Gertrude Stein have emerged as the pre-eminent postmodernists or anticipators of postmodernism. Another is the relation of first-generation modernist writing to second-generation modernist writing—glimpsed in a moment of transmission when the formal and artistic identities of the first generation were not set in the way that they are to us now. A third is, for want of a better term, political curiosity. Anyone who has read their way into the Pound-Zukofsky correspondence—which began in the late 1920s when Zukofsky was twenty-three and Pound forty-two and continued through the years of the Great Depression—will have noticed that the two correspondents had in common an assurance that they had a correct analysis of and remedy for the economic ills of those difficult years. Pound knew the remedies were social credit and Mussolini, and Zukofsky was persuaded that the remedy was Stalin.

It seems not unpredictable that a young Jewish poet, born of immigrant stock, raised in a Yiddish-speaking household, first among the tenements of the Lower East Side of Manhattan, then in East Harlem, a graduate of Columbia University, should be interested in social justice and, therefore, in New York in the mid-1920s, in Marxism and in the Communist Party. Readers of Zukofsky know that his long poem, or sequence of poems, *A,* is at the beginning full of politics and the political ideas of the early 1930s. It was also begun in apprenticeship to Ezra Pound's *Cantos,* and *Cantos* had become in the early 1930s a didactic poem, or at least a poem of information, a georgic, and Zukofsky, in imitation of Pound, wrote the sort of poem in which Joseph Stalin, through the use of patchworks of quotation, became heir to the political thought of John Adams; they also know that Zukofsky and *A* had come to the end of something by the time of the Second World War, and that *A* in its second half, written between 1950 and 1968, had become quite a different poem.

A much too simple way to say all of this is that in the beginning of *A,* the subject is the conflict between music and justice. Or perhaps

it is the idea that there ought to be no conflict between them, since each had as its aim a kind of perfection. This is a way of referring to a whole set of possibilities and difficulties that Zukofsky was working out in the tug between content and form, between patterns imposed and patterns given, or between some notion of the music of justice (Marx) and the justice of music (Bach), whether they were or could be the same thing, or whether one, as in, say, Plato's *Republic,* might not naturally be in the service of the other. In which case Bach's music might be, in itself, a political idea, and the building of vast, intricate harmonic structures a political act. This was, quite directly, a continuation of questions and possibilities the first generation of modernists faced, standing at the place where the symbolist and aesthetic poetics met the poetics of realism and naturalism at the beginning of the twentieth century. As all commentators on the poem have observed, *A* ends as music, and in his late projects (a homophonic translation of Catullus, an obsessively punning and allusive nosegay of poems about herbs and flowers—"Thyme," for example, begins: "Takes time where wild the / *thyme* blows poor tom's a / cold relentless-vest muffler jacket coat") a musical and echoic relation to language is predominant. If poetry is, as he wrote early in *A,* "an integral / Lower limit speech/ Upper limit music," Zukofsky ends his career near the upper limit. Interesting, then, to take a look at where he began.

"Memory of V. I. Ulianov" is the first poem in the first section of *All,* the volume of collected short poems that Zukofsky published in 1965. According to his wife, Celia, it was written in 1925, when Zukofsky was twenty-one years old. It is an elegy to, or an ode for, Lenin, who died in January 1924. And it is a place to begin observing the young Zukofsky because it is the place where he chose to mark his own beginning. He was living at home with his parents on East 111th when he wrote the poem. His best friend from college, Whittaker Chambers, who was to play a strange and dramatic role in the anticommunist hysteria of the 1950s, was already active in the Communist Party. Zukofsky had a job of some sort on Wall Street with the National Industrial Conference Board, as what—a file clerk? a messenger? an editor?—Celia Zukofsky does not say. He must have taken the subway downtown. He had been writing poems since high school; he was reading widely in both English and Yiddish, just as he had moved between English and Yiddish in his growing up; and he was beginning to read the newest American poets,

Pound certainly, and Williams, and E. E. Cummings and T. S. Eliot. He had conceived "Poem Beginning 'The'" as a riposte to *The Waste Land*, a satirical but also positive and Marxist rebuke to what he took to be Eliot's despair.

"Memory of V. I. Ulianov" is the earlier poem. It begins with the following line:

Immemorial,

This is Tennyson's word, a Victorian word, drenched in a particular idea of eloquence, and in idealism and, perhaps, sublimity. Perhaps it carries in it, as Tennyson sometimes does, a sort of sensuous Keatsian swoon. Tennyson came to own the word in 1847 when he wrote in *The Princess* a line that must have been in any undergraduate English major's ear in 1925:

The moan of doves in immemorial elms.

(One could be tempted into digression here by the combination of idealism, sublimity, and a sensuous swoon. Quick: what unites (1) the sublimity of Emily Dickinson, (2) the moral idealism of Tennyson, (3) the funerary architecture of Victorian cemeteries, and (4) the butchery at Gettysburg? "The moan of doves in immemorial elms" might do the trick.)

So the word locates our young author in one way. The fact that the word is a line locates him in another. It is surprising to recall just how new a medium free verse was in 1925. Wallace Stevens, William Carlos Williams, Ezra Pound, and Marianne Moore were still young poets writing various forms of metrical verse in 1912. The youngest of the modernists, T. S. Eliot, had ventured the farthest the earliest. He had begun to experiment with a loosely metrical verse, or tightly metrical verse with lines of irregular length and disconcerting rhymes, in the manner of French vers libre in about 1911. The others began to experiment with free verse mostly in 1913 and 1914 and it was in those years that the poems in the new manner were first published in magazines. Pound's imagist manifesto had appeared in the March 1913 issue of *Poetry*. Louis Zukofsky was nine years old. A dozen years later he is trying out the medium:

Immemorial,
And after us
Immemorial,
O white
O orbit-trembling,
Star, thru all the leaves
Of elm;—

This has to my ear nothing of Pound or Stevens or Moore or Eliot. The short line might belong to Williams or to Cummings. The diction is the still-Victorian diction of very early Williams —which Zukofsky was not apt to have seen—and so is its way of hearing a basically iambic verse:

O white, O orbit-trembling star

Thru all the leaves of elm

can be scanned as the tetrameter and trailing trimeter lines of a hymn stanza. They are arranged in the manner of the skinny free-verse poem with its base of dimeter lines like these:

And after us

Of mist and form

And emphatic tetrameters like these:

Yet sometimes in our flight alone

Eclipsed the earth, for earth is power

Williams shared this style with some of the early poems of H.D. and Amy Lowell. It is the liltingly old-fashioned, falteringly new sound of the first decade of free verse. It does not yet have the kinetic energy and the genuinely new relation of syntax to line that Williams came to in his *Al Que Quiere!* of 1917 and had fully, dazzlingly achieved in the rhythms of *Sour Grapes* of 1921 and *Spring and All* of 1923.

In the next few lines, the second and third formal address to the star, the rhythm remains iambic, though the lines are broken in a way that mutes the metrical effect. The diction and word order is complex:

Lighted-one, beyond the trunk tip
Of the elm
High, proportionately vast,
Of mist and form;—
Star, of all live processes
Continual it seems to us,
Like elm leaves,
Lighted in your glow;—

We are still in the territory of a fairly Victorian tonality, high-minded and aspiring, though to my ear (and not entirely to his, as we shall see) we are also in the territory of Williams's influence, which I think I hear in the phrase "of all live processes / Continual it seems to us," with its drier, more analytic diction. This is not to say that Zukofsky was, at the age of twenty-one, merely a copyist, so much as to observe that the young poet—much sooner than the literary critics of the era—had seen through to something of Williams's force and was trying to appropriate it. The influence is clear to a reader of *All* who comes to the poem immediately following this one. It does not begin in the formal mode of elegy and does not, therefore, lend itself to conventions that call up so much of the history of poetry in its dictions and rhythms:

Not much more than being,
Thoughts of isolate, beautiful
Being at evening, to expect
 At a river-front:

A shaft dims
With a turning wheel;

Men work on a jetty
By a broken wagon;

This is entirely the idiom of Williams's descriptive and urban poems, and it even borrows, echoes in the loving and probably half-conscious mode of a young poet's appropriations, the most striking word in a poem of Williams's that Zukofsky has mentioned admiring:

The pure products of America
go crazy—
mountain folk from Kentucky

or the ribbed north end of
Jersey
with its isolate lakes and

valleys,

In the Lenin poem Zukofsky's idiom touchingly straddles two eras, two dictions, two styles of feeling—and if we stand back from describing the brushstrokes to look at what is being delineated, the poem seems to contain another set of homages or imitations. Probably Keats's "Bright star, would I were steadfast as thou art—" was not on Zukofsky's mind, but it is difficult to think that he was not rewriting Whitman's elegy for Lincoln by making his star the image of a great man fallen:

O powerful western fallen star!
O shades of night—O moody tearful night!
O great star disappeared!

This is section 2 of the elegy. Whitman returns to the image in section 8:

O western orb sailing the heavens,
Now I know what you must have meant as a month since I walked,
As I walked in silence the transparent shadowy night,
As I saw you had something to tell me as you bent to me night after
 night,
As you droop'd from the sky low down as if at my side.

And he comes to it again at the end of the poem—

I cease from my song for thee,
From my gaze on thee in the west, fronting the west, communing
 with thee,
O comrade lustrous with silver face of light.

One could pause here over the development of the word *comrade* between 1866 and 1926. The closing lines of "Poem Beginning 'The,'" the first poem in *All*, include these lines:

323 Sun, you great Sun, our Comrade,
324 From eternity to eternity we remain true to you

But there are other stars to consider. Williams's "At Dawn" is part of a nine-poem sequence that either Pound or H.D. published in *The Egoist* in 1914, where Zukofsky may or may not have seen it.

The war of your great beauty is in all the skies,
Yet these receive no hurt! I see your name
Written upon their faces,
Yet the bowl of stars will be refilled—and lit again,
And their peace will live continuous.

O marvelous! What new configurations will come next?
I am bewildered with multiplicity.

This draws one to wonder about the distinction between Williams's *continuous* and Zukofsky's *continual*. The nuance dictionaries insist on for these synonyms is that "continuous" tends to mean "ceaselessly, without end," and "continual" means "repeated regularly and frequently, periodic." Were one to speculate, then, about the possibility that Zukofsky was revising Williams, it would be away from openendedness and toward periodicity—which does, certainly, reflect a divergence in their actual developments.

But if Zukofsky had a Williams star in mind, it is far more likely that it is the one in "Hombre" from *Al Que Quiere!*:

It's a strange courage
you give me ancient star:

Shine alone in the sunrise
Toward which you lend no part!

It is, like the adjective it uses, a stranger poem in its attitude toward
the high and the timeless than either Zukofsky's—which we have yet to
examine—or Whitman's, which, declining, is companion to the poet-
speaker and seems to walk beside him. This star does not traffic with
the earth, a theme that stimulated Wallace Stevens in his "Nuances of
a Theme by Williams":

1.
Shine alone, shine nakedly, shine like bronze,
that reflects neither my face nor any inner part
of my being, shine like fire, that mirrors nothing.

2.
Lend no part to any humanity that suffuses
you in its own light.
Be not chimera of morning,
Half-man, half-star.
Be not an intelligence,
Like a widow's bird
Or an old horse.

It is not exactly derivation that I want to call attention to here,
either from the Romantic genre of the poem addressed to an astral
body or from these particular poems. Whitman's great elegy is, of
course, much more ambitious than Zukofsky's. That poem, in all its
tenebrous and poignant intensity, belongs to another order of art, and
it weaves together at least three sets of imagery—Lincoln as star, the
heart-shap'd lilac leaves as nature and natural grief, and the song of
the hermit thrush for the figure of poetry, for what Whitman calls
"Death's outlet song of life." Zukofsky's poem, brief and focused, stays
with the star, which gives the poem its quiet, intense verticality. There
are the mediating elm leaves, and there is the speaker of the poem, who

is plural, a "we." And there is the interesting fact that Zukofsky, like Whitman, imagines a star that, however far away, touches life. The political contexts of the poems make this so, whereas the power of the stars in Williams and Stevens is that they do not belong to the social world. They are the ideal absconded, and the proposition of the poems is that the imagination is better off for it. This was not, probably, an idea in the range of the young man who wrote this poem. He did not live in the moment of a purely aesthetic rebellion; he was still moving toward his power, still in fact living in his parents' apartment, and had no need so fiercely to declare, as the older poets did, a poetic vocation separate from the duties of a pediatric practice or the law offices of an insurance company.

My hunch is that Zukofsky, with his head full of revolutionary idealism, full of the eloquence of English poetry (which was for him a second language; a third language, the Hebrew of religious instruction that he rebelled against, was probably coterminous in his ears with the English of the street and the public schools), was mostly intent on taking up the new, jazzy instrumentation of the avant-garde's free verse, and poured into it the diction of Tennyson and the imagery of Whitman more or less unconsciously. He was memorializing a man of extraordinary brilliance, single-mindedness, and ruthlessness. Whether one ought to keep one's mind, for the moment, off the sailors in the Kronstadt Rebellion and the eight thousand or so Orthodox religious Lenin had executed—the Soviets, like the Romanovs before them, kept excellent, if selective, records; the victims in 1922 numbered 2,691 priests, 1,962 monks, and 447 nuns—is a subject we will postpone.

Elegies begin with apostrophes, as odes do. The one kind of poem tries to fend off an annihilating grief, the other to get into right relation to a source of creative power. In both cases apostrophe tends to animate the physical world, as if grief or longing required a verbal ladder reaching from a merely natural to a psychic or spiritual space—perhaps as a way of catching the paradox through which death (as absence or felt loss), or the presence of a power (felt as distance) intensifies life.

> Yet once more, O ye laurels, and once more,
> Ye myrtles brown, with ivy never sere,

"Lycidas" begins. Though it thinks about death, Zukofsky's poem does not seem animated by grief. It belongs much more to the ode than the elegy tradition. The short lines, the direct address to the star— three times it addresses the star, as if the number were ritual and prescribed—have in them more of longing than sorrow. Returning to the opening lines, we begin to notice something else in them. They are like waves breaking, a temporal, rhythmic periodicity:

> Immemorial,
> And after us
> Immemorial,
> O white
> O orbit-trembling
> Star,

"Immemorial" means, or it's a word applied to, things whose origin is lost to memory, which is a kind of immortality, backward if not forward. And here, the poem bothers to say that the star is immemorial now, and after we have died, it will still be immemorial. Saying so introduces two ideas. One is that we are all going to die, that there's an "after us." The other is that the site of this subject is consciousness where personal and collective memory reside. It's there that the quality of being "immemorial" occurs, or doesn't. And the exclamation toward something both pure and powerful breaks from those facts: "O white." The next phrase conjures the welter of the world through which the star is seen:

> thru all the leaves
> of elm;—

The punctuation that brings to a close this first small movement of the poem, we might stop to notice, is a semicolon-dash. It is a mark with what will become Zukofsky's characteristic fastidiousness. It is probably a cousin to the comma-dash of Williams, which the poems in *Al Que Quiere!* are marked by in abundance—

> Above shining trees,—

> Against the yellow drawn shades,—

Quickening in it a spreading change,—

With metallic climbings,—

The comma-dash expresses a forward-looking rather than a retrospective pause, which is paradoxical, of course; it is a mark that says stop and go at the same time. In that way, it is typical of Williams's particular energy. The semicolon-dash asks the attention to stop completely and to cast itself forward. It's a mark, then, exactly appropriate to memorializing, to the vertical wonder in the poem and its forward dreaming.

The second invocation intensifies this effect by emphasizing the star's height and immensity:

Lighted-one, beyond the trunk-tip
Of the elm
High, proportionately vast,
Of mist and form;—

"Beyond the trunk tip / Of the elm / High" is the kind of Miltonic inversion that the aesthetics of both *Lyrical Ballads* and the imagist poem were supposed to have gotten rid of. The impulse to alter experience, or to render heightened experience, by echoing the old Latinity of English poetry goes very deep, and here the postponement of the word *high* to the final position in the phrase and to the first position in a line (where it is rewarded by being capitalized) throws a much stronger stress on the central emotion of the poem. To my ear *proportionately* belongs to a dryer and more modern diction, even as it tries to conjure immensity. It has, as Zukofsky sometimes does, a certain mathematical precision—that is, the star is vast in proportion to its great height. The next phrase is more mysterious. How is the star "of mist" or "of form"? And what noun or verb does the prepositional phrase modify? It seems to attach directly to the star, and since stars are fires, it is an odd thing to say that one is made of mist. Perhaps Zukofsky was thinking here not about the star, or Lenin as the star, but the memory and ideal of Lenin as a star. This carries the imagery toward giving to airy nothings a habitation and a name as an activity of imagination. The idea

of *form*—one thinks of "The Idea of Order at Key West," in which the lights on the boats in the harbor, mimicking constellations, give the darkness of the night sky "ghostlier demarcations, keener sounds"— seems to be that Lenin's life and death, the great man or orienting figure's life and death, as a polestar, performs a similar function. A way of organizing history, one could add, that echoes Hegel and probably the good king–bad king pedagogy at Stuyvesant High School.

The third invocation addresses the relation of the star to the lowly world. It contains, as we've seen, a more studiously modernist diction:

Star, of all live processes
Continual it seems to us,
Like elm leaves
Lighted in your glow;—

(I report that in the period when I was thinking about this poem a full lunar eclipse gave me an opportunity to go outside and observe whether leaves glow in starlight; it's my impression that they don't. This is, I think, a metaphorical glow.) The syntax here, as in the phrase "Of mist and form," doesn't really anchor the modifying phrase to anything, so this phrasing is also unhinged a little from strict referentiality. One is inclined to read it at once to mean (a) of all the live processes, you are the one that seems to us continuous, (b) you are a continuation of all live processes, and (c) you are of, descended from, created by, all live processes. And, the lines say, in this you are like the elm leaves. My guess is that the word *process* here comes from Alfred North Whitehead and his "process" philosophy. Several years after this poem was written, when Kenneth Rexroth met Zukofsky for the first time, he reports that they found they had a common enthusiasm for Whitehead. Whitehead had arrived at Harvard in 1924, the year before this poem was written. His *Science and the Modern World*, the first set of his Harvard lectures, was published in 1925, the year this poem was written. *Process and Reality* appeared in 1929. The phrase that Charles Olson liked to quote, "The process is itself the actuality," came from *Adventures of Ideas*, which was published in 1933. Whitehead's particular form of organicism has been useful to a number of American poets. For Zukofsky, if he did have it in mind, it must have rhymed with the dialectical materialism of Lenin and also the celebration of natural

processes in Walt Whitman, who seems to me to be the presiding presence in the second half of the poem.

The three invocations are brought to grammatical completion with a main clause—a line of iambic pentameter broken across two lines, ending in a terminal rhyme:

> We thrive in strange hegira
> Here below.

The most striking thing about it is the strangeness of the word *hegira*. Nothing in the poem quite explicates its presence. Nor how it is connected to the pronoun *we*, which arrives with it to identify the locus of speech in the poem. Who is the "we"? What flight echoes the flight of Muhammad from Mecca to Medina in 622? The word *flight* appears twice in the poem:

> Yet sometimes in our flight alone

And later the same sentence speaks of a "flight of stirrings." To get at it, we probably need to look at the passage whole. It completes the first long sentence in the poem. It is also, for me, its most moving moment. It's when the young writer characterizes himself as he addresses his relationship to this luminous and distant ideal. It sets up—in reverse—a relationship not unlike the one in "A1." There the young poet, on high, is sitting in the balcony at a concert, looking down onto the perfection of Bach. Between him and that perfection, rich people in the loges and the orchestra. They are the manifest injustice and vulgarity of an actual world. In this poem the distance between himself and the ideal is internal and the more poignant for that reason. In his isolation, in his sense of his still-undeclared powers, and in a more existentially vague (and therefore probably more psychologically accurate) metaphor for the mix of longing and futility with which he confronts his life—or with which "we" do—the poem comes, I think, to its initiating emotion:

> Yet sometimes in our flights alone,
> We speak to you.
> When nothing that was ours seems spent

And life consuming us seems permanent,
And flight of stirring beating up the night
And down and up; we do not sink with every wave.

You will notice once again the literary echoes. This time it's Wordsworth:

Getting and spending, we lay waste our powers;
Little we see in nature that is ours;

This, despite the verbal echo, says something different. "When nothing that was ours seems spent" means, I presume, when "we"—at this point, the nature of that "we" becomes clearer *and* more paradoxical, because it is a "we" who is alone; not just a self in isolation, but a self in isolation conscious of itself as belonging among other selves also in isolation, that "we" that is a sort of urban condition, and seems always to be so, most intensely, to the young—have not spent yet the coin of ourselves, have not expressed ourselves in the world, in this world that merely consumes us.

The psychoanalytically inclined might well prick up their ears at this appearance of oral imagery in the poem. The tall, distant and removed, but luminous star and the present orally devouring life, heavy with rhyme, look very much like a familial configuration, and they correspond to what we know about the young Zukofsky's life. But I find myself more interested in the last image. That "beating up" gives us, in more demotic English than the poem is written in, a "flight of stirrings" that is doing violence to the night, a sort of exhausted violence, in the heavy drag of the pentameter line, before the enjambment that asks to reexamine which meaning of *beating* is most principally involved. "Flight of stirring" is, I think, the most original phrase in the poem. Presumably it reaches toward "the stirring of desire" or "a stirring performance," rather than "stirring a pot," though in a metaphorical sense "stirring the pot" is a stirring of desire, just as a vivid artistic experience or the imagination of an idealized revolutionary hero is "stirring."

This is what *hegira* must be—the flight, vaguely evocative and heroic, away from consuming life toward something else, some Medina of safety, perhaps, but also of usefulness, of heroic beginnings. This "flight of stirrings" that beats up the night and—we see, after the

enjambment—down the night and up is the route of escape. The rhythm and image almost mimic a moth beating about a streetlamp. *Beat* gives us the beat of wings, also the hunter's beating of the brush, but here the waves in the concluding clause seem to secure a first meaning—a sailboat tacking against the wind. Presumably with a star to navigate by. So the logic of the poem—however mixed the metaphors—is clear enough. We "thrive" in our flight, because we have a "you" to speak to, when the stirring in us of our unspent powers and the devouring world would drown us.

This brings us to the midpoint of the poem. Its second half is also twenty-three lines long, a symmetry that should surprise no reader of Zukofsky. The second half is made from six sentences—a suite of four couplets, followed by a four-line sentence, which is a declaration of arrival, followed by an eleven-line sentence, beginning with the twice-repeated word *irrevocable,* a counterpoint to the twice-repeated *immemorial* with which the poem begins.

The four couplets mark a sudden shift in the music of the verse. The language is quaint, the rhythm hymn- or dirgelike:

Travels our consciousness
Deep in its egress.
Eclipsed the earth, for earth is power
And we of earth.
Eclipsed our death, for death is power
And we of death.
Single we are, tho others still may be with us
And we for others.

I will not pause over the question of how to assess the almost comic desire for solemnity and grandeur in the writing. It was—what?—1912, when Ford Madox Ford gave Ezra Pound a dressing-down for the antique diction in *Canzoni.* This was the period when Pound, having scarcely stopped writing his vigorously archaic verses, was declaring that "no good poetry is ever written in a manner twenty years old, for to write in such a manner shows conclusively that the writer thinks from books, convention and cliché, and not from real life." Pound was actually writing in a style that was more like sixty years old and he was about to turn to the interesting task of bringing into modern English

an Anglo-Saxon poem that was nine hundred years old and a group of Chinese poems that were eleven hundred years old. I think it is not true that good poetry is never written in a twenty-year-old manner. The history of poetry is full of instances. Clearly, the news had not reached Zukofsky yet, or not reached as deep as his adolescent reading had. But the problem with Zukofsky's style here is not that it's a couple of decades out of date; it's that he's fallen in love with a sort of other-worldly diction that belongs to no date at all. William Carlos Williams read this poem and responded to it. It's an enormously sweet, respect-ful, frank response of an older poet to a very young one, and we will look at it later, but one of the things that Williams does is comment on the rhythms of the poem—"it has a surging rhythm that in itself embodies all that it is necessary to say"—and adds, diplomatically, "but it carries the words nevertheless and the theme helplessly with it. The word 'continual' at the end," he adds, "is fine."

My own response is that, at this point in the poem, I don't mind the awkwardness and artificiality of its intensity. It would be quite easy to lampoon "Single we are." It is a ridiculous phrase. I am fasci-nated to watch Zukofsky think. What do the lines say? That the poet's consciousness—though it is of the earth and death and power; notice how he loves this use of an old-fashioned genitive: "we" are "of earth" as the star is "of mist"—travels deep in its flight, that odd word *egress,* to obtain a rhyme with *consciousness,* and perhaps to underline the con-nection between the two, consciousness being then an exit from the power of earth and death. The last couplet says something about the condition of that consciousness—that it is solitary, or single, though it may be with or for (in several senses) others. This idea seems to pick up on the paradoxical phrasing we noticed earlier, "our flight alone." This wants to worry, I think, a problem that several poets of this gen-eration, conflicted between politics and poetry, would feel the need to address—"Obsessed, bewildered," George Oppen would write in one of the great poems of his maturity, "By the shipwreck / Of the singular / We have chosen the meaning / Of being numerous."

What is the destination of this "flight alone"? The next line answers that question in three oddly stately anapests:

We have come to the sources of being,
Inviolable, throngs everlasting, rising forever,

Rush as of river courses,
Change within change of forces.

If you think you are hearing the rhythm of "The Charge of the Light Brigade" in those second two lines, you would not be wrong:

Plunged through the battery-smoke,
Right through the line they broke.

But neither of Tennyson's lines is as good as Zukofsky's, and this is not, in any case, the British Imperial Army; it is the army of the life force that consciousness has come to, the spring or source from which being flows, liquid, surging, inescapable. The phrasing echoes Whitman in so many places, it is hard to know what to quote by way of example. The absolute locus is probably the third section of "Song of Myself":

Urge and urge and urge,
Always the procreant urge of the world.

Out of the dimness opposite equals advance, always substance and
 increase, always sex,
Always a knit of identity, always distinction, always a breed of life.

Or "Crossing Brooklyn Ferry," which makes the same figure from the river and the city throng:

"Flow on. River! Flow with the flood tide and ebb with the ebbtide! ...
Cross from shore to shore, countless crowds of passengers!"

Or, deeper in Whitman's thought, nearer to his thought about death and regeneration, are these lines from section 38 of "Song of Myself":

Corpses rise, gashes heal, fastenings roll from me.

I troop forth replenish'd, with supreme power, one of an average,
 unending Procession,
Inland and sea-coast we go, and pass all boundary lines,

Our swift ordinances on their way over the whole earth,
The blossoms we wear in our hats the growth of thousands of years.

I don't know how much Whitman the young Zukofsky had read. Hugh Seidman, in a charming memoir of the older Zukofsky, describes him at Brooklyn Polytechnic Institute dismissing a class because he is so moved by his own reading of Whitman's "Columbus" that he can't go on, but that doesn't tell us what the younger Zukofsky read. This thought may not have come directly from Whitman, and there is no metaphor in Whitman exactly like this one—of flight to the source of being, to the place from which life flows forth "inviolable." The Whitman lines from section 38 are an almost intentionally sacrilegious conflation of the resurrection of Christ and the Christian resurrection of the dead, figured instead as a celebration of the generative power of life itself. There are no such echoes in Zukofsky, but one suspects he means for this materialist vision of the knowledge at which consciousness arrives to have a similarly rebellious force.

Having arrived at this place, and having arrived through consciousness, as consciousness that has in some sense "eclipsed" death and earth, the poem comes to its conclusion by addressing the star for a fourth time:

Irrevocable but safe we go,
Irrevocable you, too,
O star, we speaking to you,
The shadow of the elm leaves faded,
Only the trunk of elm now dark and high
Unto your height:
Now and again you fall,
Blow dark and burn again,
And we in turn
Share now your fate
Whose process is continual.

Technically, this is vers libre, that is, it is metrical, purely iambic (though the third line doesn't sound it), with irregular line lengths. The pattern goes like this:

Tetrameter

Trimeter

Trimeter

Tetrameter

Pentameter

Dimeter

Trimeter

Dimeter

Dimeter

Tetrameter

4-3-3-4-5-2-3-2-2-4. A very orderly and musical sequence, emphasized by the full pause at the end of each line, even the unpunctuated ones.

Thematically, I suppose the first thing to notice is the phrase "we speaking to you," which reminds us that whatever the star is—Lenin, or the memory of Lenin, or the orbit-trembling heights of any ideal that one might steer by—the relation of the speaker to it is *speaking*, having to speak as a way of not being alone. This is, of course, the condition of the starting-out poet. The next thing to notice is that the star's light—a little too bright for strictly astronomical credibility in the earlier lines—seems to have dimmed. At least the light has changed in some way, so that the shadow of the elm leaves has faded and only the dark trunk of the elm reaches toward the star's height. The image isn't very exact, but one gets the impression that there is a distinct physical sensation that Zukofsky means to convey and make a metaphor of. It feels as if the mental or spiritual verticality ("beyond the trunk tip / Of the elm / High, proportionately vast") of the opening image has become, absent the light, a more physical and rooted but less magical thing: "Only the trunk of the elm now dark and high / Unto your height."

Perhaps a cloud has obscured the star. Or the line "Now and again you fall" might be intended to refer to shooting stars, but it might also refer—"Blow dark and burn again"—simply to the rising and setting of stars. It's quite possible that at this point Zukofsky wasn't particularly concerned with coordinating the image and the idea. It is only the title of the poem that suggests to us that the star is the memory of Lenin and that its fading refers to Lenin's death. In the journey of

the poem, its strange hegira, the poet has been given a vision of the inexhaustible sources of life. He knows that it is endlessly renewable. "Irrevocable but safe" seems to be some version of that thought, and in the last five lines—trimeter, trimeter, dimeter, dimeter, tetrameter—the poet enacts a music that reconciles him to the hero's death and to his own:

> Now and again you fall,
> Blow dark and burn again,
> And we in turn
> Share now your fate
> Whose process is continual.

So what can one say, on the evidence of this poem, about Zukofsky at the outset? For starters, that he was thinking about serious things; that he had an ear and constructive power, though perhaps not yet any deep originality; that he was literary to the depths of his being. The patterning of the poem, a first sentence of twenty-three lines, which brings it to its midpoint, followed by a resolution of twenty-three lines, some effort at symmetrical structure, and a prosodically deft and orderly conclusion point to the later Zukofsky, but without knowledge of that later writer, I don't think the patterning impulse of the poem is one of the main impressions that it creates. The content of the materials is too turbulent for that. Another distinct impression, perhaps my main impression, is the ardor of the poem, its central urgency. The emotional core of it has two poles, as the poem does; the sense of loneliness and below-ness and small-ness of the poem's speaker—which is partly the archetypal emotion of the tyro, the young man without card of entry and with a name to come—is one of them. The purity and intensity of the adoration for, longing toward, and gratitude to a high, unearthly ideal and mentor is the other. The motion between them in the poem is, surprisingly, perhaps sweetly, flight, but it is flight toward, a sort of thriving.

Finally, there is the sense of Zukofsky's intellectual furnishings—the implicit and explicit ideas in the poem that seem to organize the feeling. (I am not sure they ever do, entirely, in any poem.) This is a convergence of something like Whitman's transcendentalist, democratic, spiritualized materialism with, probably, Whitehead's organi-

cism. This is a guess. I don't know how much of Whitehead Zukofsky knew. But the Whitehead who defined mathematics as "a study of types of order" would have been congenial to Zukofsky, and his *Science and the Modern World*, with its notion of philosophy as an imaginative grasp on order in a world of incessant but rhythmical change, seems to speak to something at the core of the poem. Both of these ideas are grafted to Marxism—Zukofsky's study of Marx was mostly ahead of him—by the thinnest of devices, identifying the star with Lenin by titling the poem with his birth name. These ideas at the center of the poem—the "Travels our consciousness" passage and the "We have come to the sources of being" passage—are the ones that are least successfully embodied, most literary in their treatment; but granted that, the vision in those lines doesn't feel to me, as Pound said of literary and derivative writing, entirely "got from books, and not from real life." It doesn't feel—that source of being—like something he has seen, but it does feel like something he has imagined and felt.

The difficulty, as Wallace Stevens remarks about poetry in general in "The Noble Rider and the Sound of Words," "is not about unreal things, since the imagination accepts them." The difficulty is a certain intellectual indistinctness built into the symbolist rhetoric. The idea seems to be that consciousness, driven by longing and despair, outside of nature, can, guided by the star of an ideal (relatively without content except for being high and vast and connected to all live processes) look back at nature, and, as consciousness, see into the source of being where perishing and becoming everlastingly occur, and are made safe by this vision, freed from fear of the knowledge of death. Put this way, it's also easier to see that the organization of the poem comes from the quasi-allegorical journey motif that characterizes Romantic odes. I think that structure underwrites the poem in a quite powerful way and gives it some of its force and that it works against the contrary impulse toward formal symmetry. Between the two informing impulses, the poem leaves a feeling that in its literary intensity, it has gotten to the other side of some great danger without having quite passed through it. This is, of course, to hold a very youthful poem to an extremely high standard. But another way to think about the poem is that—like Keats, like Pound—the "strange hegira" of the young poet in this poem has really to do with a powerful, idealizing literary ambition, an imagination of a self transformed by literary achieve-

ment. And so it's appropriate enough to hold the poem to a pretty high standard.

William Carlos Williams was in no such position when he received the poem from Zukofsky in the summer of 1928. His reply is dated July 18. The fields around Rutherford must have been full of chicory and Queen Anne's lace, rank with the smells of sumac and summer rain. "And isn't it a fine day!" his letter ends. This was Calvin Coolidge's America, Coolidge who ran the country on a firm platform of low income tax, low inheritance tax, and a strong military, but whom one could regard from here with a sort of longing (O white, O orbit-soothing) since he also, as Samuel Eliot Morison remarked, "exalted inactivity to a fine art." It was fifteen months before the market crash. Herbert Hoover was campaigning against Al Smith, Herbert Hoover who had distinguished himself by organizing Red Cross relief for post-revolutionary Russia in the famine summer of 1921. Williams was forty-five years old that summer, Zukofsky twenty-four. "Certainly," he begins, "the 'Lenin' outdistances anything in the earlier book of poems as the effect of a 'thing' surpasses all thought about it." I have no idea what "earlier book" Williams is referring to. "This is the second poem of yours I like, the first being the long one." That would be "Poem Beginning 'The.'" "In some ways this poem is your best work (that I have seen)." And then the remark I quoted earlier: "It has a surging rhythm that in itself embodies all that it is necessary to say, but it carries the words nevertheless and the theme helplessly with it." My guess is that this is, as I've said, both accurate and diplomatic. In the next paragraph Williams addresses the force of the poem and seems to be thinking out loud about his relation to this young poet. Zukofsky's relation to Williams is not hard to read. I've heard two of Zukofsky's contemporaries, Stanley Kunitz and George Oppen, speak about the intense sense of isolation young writers felt in the 1920s. The literary world seemed universes away. And, of course, in those years, the universities were no home to poetry, and even if they were, it's doubtful that any of these three would have had access to them. Stanley Kunitz, in about this year, was turned away from graduate work at Harvard by a department chairman who told him frankly that it would be inappropriate for a Jew to teach *Paradise Lost* to Christian students. Zukofsky would, two years later, get an instructorship at the University of Wisconsin. But in 1928, for Zukofsky, Williams was contact. Williams himself had

had no such contact with literary elders in his twenties when he was an intern at a Manhattan hospital. Pound had been his lifeline to a literary world and Pound had, God knows, relished the role.

From here, from a culture in which 90 percent of poets make some part of their living criticizing the work of twenty-one-year-old poets, it is fascinating to watch Williams addressing this young man and thinking out loud:

> It is this, the thing that this poem is, that makes you what you are today—I hope you're satisfied! No doubt it is the underlying theme to me of whatever feeling we have for each other. It seems to me surely the counterbass for everything else we may do. If there is not that under our feet (though I realize you are speaking of a star), then we cannot go on elaborating our stuff.

I'm not absolutely sure I understand this. I think Williams is saying in the first sentence, which seems massively tautological, that Zukofsky is making himself by making the poem and that the common recognition of this task is the basis of any relationship they are going to have. It is a roundabout way of saying to Zukofsky that he seems to be a real artist. Then Williams gets down to particulars. He is going to give the young man some criticism and then back off a bit and let his correspondent take it or leave it:

> Sometimes though I don't like your language. It probably is me and not you who should be blamed for this. You are wrestling with the antagonist under newer rules. But I can't see "all live processes," "orbit-trembling," "our consciousness," "the sources of being"—what the hell? I'm not finding fault. I'm just trying to nail what troubles me. It may be that I am too literal in my search for objective clarities of image. It may be that you are completely right in forcing abstract conceptions into sound patterns. I dunno. Anyhow, there you are.
>
> I will say that in this case the abstract, philosophic-jargonist language is not an obstruction. It may be that when the force of the conception is sufficiently strong it can carry this sort of thing. If the force were weaker the whole poem would fall apart. Good, perhaps. Perhaps, by my picayune, imagistic mannerisms I hold together superficially what should by all means fall apart . . .

Whatever effect this letter had, one does notice that phrase "objective clarities of image." It was two years later, in 1930, that Pound cooked up the idea of Zukofsky's assembling a group of new poets and, as he had done in London, identifying them as a movement as a way of elbowing into the literary world. By October of 1930 he could report that Harriet Monroe had agreed, at his urging, to turn an issue of *Poetry* over to Zukofsky to edit, and the objectivists came into being. I also notice that phrase "forcing abstract conceptions into sound patterns." Certainly no poet cared more about formal discovery in his art than Williams, so it is interesting to see the fairly savage force of that characterization. It is, forever, that charge the romantic artist whose model is pattern-as-discovery makes against the classical artist whose model is form-as-radiant-pattern. And if one were to have reservations about *A*, in fact about Zukofsky's oeuvre, this would likely be one of its themes. I know it is what has made a less-than-enthusiastic student of some movements of *A*.

Finally, I want to take a moment to ask what sort of difference it makes that this poem wants to be about, seems to refer to, Lenin, that he is the star, or his memory is the star. The title is actually quite explicit. Not "In memory of," but "Memory of V. I. Ulianov." That is, the memory of Lenin's life and deeds, it tells us, whether it's so or not, is what initiates the utterance of the poem. It's quite possible that the title was an afterthought, because there is, after all, nothing about the star, except possibly the phrase "orbit-trembling"—which might just as well mean "makes the orbits tremble," as a revolutionary does, as "trembles in its orbit," which from the terrestrial perspective is what a star does—that invites us to identify it with anyone in particular. It is amusing to watch Williams reaching for his customary solidities with the phrase "under our feet," and then correcting himself: "I realize you are speaking of a star." It is not a star with much in the way of objective clarity about it. Nevertheless the title asks us to read its particular exaltation of the star as praise for Lenin, and it has been the habit of most literary criticism written by people of progressive tendency to take admiration for Lenin or Stalin in the 1920s and 1930s as the sign of an appetite for social justice—for right intentions—and let it go at that. Don Byrd, for example, describes this poem by suggesting that it is a counterpoint to "Poem Beginning 'The' ": "Against the multiple voices and the tentative musical organi-

zation of 'Poem Beginning "The," ' he poses in the first of '29 Poems' the theoretical and practical clarity of Lenin." As we've seen, there's nothing in the poem to suggest that it refers to either, except for the fact that any reference to Lenin must refer to his clarity, his force of will, and his unwavering perseverance. The question is whether it also must refer to his ruthlessness.

One can document in *A* the occasions on which Lenin shows up as a font of wisdom.

In "A-6":

The time was:
12 years after Ilytch's statement
When the collectivists
Raised the great metallurgical plants
In Siberia,
For a people's idea
As well as their practice.

And in "A-8":

And he said: Der Lenin hat anders getan.
Went to the apothecary, and he said:
You like your business, yet it keeps you in
Twenty-four of twenty-four hours a day.
How would you like it if for the first time in
 twenty-four years
You take a well-earned vacation
 For six months,
While the shop continues as yours
Managed by four qualified youngsters
Each working six-hour daily shifts
During that time?
You say qualified, asked the apothecary? Alright.
And he went and took a vacation
Under the NEP
And mind you there he was after only six weeks' vacation
Satisfied with his qualified helpers
And content to work the six-hour shift himself,

While his son grew up under the Second
 Five Year Plan.
And one day when the youngster was already
 An engineer
He said: papa, do you really think this
 Pharmacy is ours
You know, it's really the state's.
And both realized and had a good time
 over their combined situation.

This particular fairy tale is a purely Poundian exemplum, like the stories about the triumphs of social credit in *Cantos*. It would put one in mind of the English Communist shop steward played by Peter Sellers in the Boulting brothers' comedy *I'm All Right Jack,* who, speaking of Russia, looks dreamily into the distance and sighs, "All them wheat-fields, and the ballet every night," and provoke an amused smile, if the issue of judgment were not so complicated and if the forty-five million dead in the convulsions of the Russian Revolution and the Second World War did not interpose between us and this writing.

"A-6" also contains a statement of the poem's aesthetic commitment at that stage in its development. (It appears to have been written during Zukofsky's brief stay in the Berkeley hills in the early summer of 1930):

But when we push up the daisies,
The melody! The rest is accessory:

My one voice. My other: is
An objective—rays of the object brought to a focus,
An objective—nature as creator—desire
 For what is objectively perfect
Inextricably the direction of historic and
 contemporary particulars.

Even if the object brought into focus is accessory, still a clarity about particulars imposes a certain ethic on our appraisal of poetry.

And an appraisal of poetry that involves an appraisal of Lenin is not a simple matter.

His "theoretical and practical clarity" is not in question, and the

question of what part of the violence, terror, mass deportation, and mass murder that characterized the rule of the Soviet Union under Stalin belongs as well to Lenin is probably not answerable except in a hypo-thetical way. Even the question of how to assess the achievements of the five-year plans that "A-6" celebrates and set them against the crimes—the giant industrial complex at Kuznetsstroi in Western Siberia, say, set against the five million people, small landowners and their children, who disappeared during the same period, is difficult to answer.

What one can look at is Lenin's actions; he thought of the revolu-tion as a war. And, of course, he was right. A revolution, as Hannah Arendt has insisted, is a civil war. And the ethical bearings one brings to it might be—by whatever means necessary—or might not be. Here, a passage in George Oppen's "Route" comes to mind. He is speaking about his experience as an infantryman in World War II.

> Wars that are just? A simpler question: In the event,
> will you or will you not kill a German. Because,
> in the event, if you do not want to, you won't.

In the event, one will call for the extermination of the Romanov family, or one won't. Probably one should read Chekhov's "The Peasants" and take a leisurely walk through the obscene opulence of the Hermitage before weighing in on this question. And, for good measure, walk for a while in the great square outside the palace where Nicholas II turned his army on a peaceful demonstration of unarmed workers and their families in the winter of 1905. They killed and wounded up to five hundred men, women, and children. The snow in the square was red with their blood. And then consider this account in Hélène Carrère d'Encausse's *Lenin:*

> Exiled in the depths of the Urals in Ekaterinburg, the czar and his family had since the Bolshevik seizure of power been subjected to countless privations and humiliations. Their supporters prepared plans of escape that were as absurd as they were ineffective, and con-stant rumors circulated, further worsening their conditions. Although Trotsky had expressed the wish that a trial like the one that Louis XVI went through during the French Revolution take place to decide the fate of "bloody Nicholas," Lenin had very early expressed his inclina-

tion toward summary justice. "Exterminate all the Romanovs, a good hundred of them." This was the proposal acted on on the night of July 16, 1918, when a detachment of Chekhists . . . assassinated the members of the imperial family and the servants that remained with them. At almost the same moment, in conformity with the aim of general extermination of the Romanovs expressed by Lenin, all the other members of the family who were in Perm and Alapaevsk were massacred. None of those who were within reach of the Bolsheviks escaped death.

This leaves aside Lenin's orders for the extermination of the Orthodox clergy, and the army he regretfully but ruthlessly turned on the mutineers at Kronstadt for ten days in March of 1921. It is perhaps tedious to reargue these arguments fought out in the John Reed Club in New York and in left-wing taverns (were there still taverns?) in Chicago and San Francisco. Throughout the winter of 1920–21 workers in Petrograd held countless meeting and strikes protesting the practical consequences of Lenin's theory of the dictatorship of the proletariat. They demanded free elections for all leadership positions on the factory floor, rather than appointment by the Communist Central Committee. The set of demands grew to include freedom of press and assembly, direct elections for all Soviets by secret ballot, prohibition of property searches, market freedom for peasant farmers, and freedom of labor for artisans not employing paid labor. Here is d'Encausse: "The revolutionary flame spread to the Kronstadt naval base, the pride of the regime, where the sailors proclaimed their solidarity with the strikers." When the army charged the island across the ice, the sailors manned battleships locked in the harbor ice. (See Louis Fischer, *The Life of Lenin*, pp. 470–72). "The Kremlin communists wrapped themselves in white sheets for camouflage and stormed the forts and ships under a raking fire. Where shells broke the ice hundreds were drowned. A few forts fell to the attackers on the morning on the 17th, and by March 18th, after cruel hand-to-hand combat, Kronstadt succumbed. Then a quiet massacre began." Some sailors fled across the ice to Finland. Somewhere between five thousand and seven thousand of the mutineers were killed. There was no question in Lenin's mind that he was preserving the revolution.

Zukofsky had no access to the information about the extermination of the Romanov family or the Orthodox clergy. He certainly did hear a version of the event at Kronstadt.

It was the moment of egress from the communist movement for many progressives in America. As if to stake out his position clearly, Kenneth Rexroth's first book, *In What Hour* of 1940, begins with a poem entitled "From the Paris Commune to the Kronstadt Rebellion." It too is an elegy. The opening lines read as follows:

> Remember now there were others before this;
> Now when the unwanted hours rise up,
> And the sunrises red in unknown quarters,
> And the constellations change places,
> And cloudless thunder erases the furrows
> And moonlight stains and the stars grow hot . . .

Another young man's poem of night and politics and consciousness and memory. It is not, in fact, a very good poem. It has all the faults of its earnest kind:

> Remember there were others before;
> The sepulchers are full at ford and bridgehead.
> There will be children with flowers there,
> And lambs and golden-eyed lions there,
> And people remembering in the future.

But it tells us that, because of Kronstadt, at least one American radical in the late 1930s put Lenin and the Red Army on the side of the killers, the enemies of freedom.

I bring this up not particularly to rebuke Zukofsky or his youthful poem or the poets and critics of the last few years who have embraced him so ardently—the record of the political commitments of twentieth-century poets is mostly disastrous; if they were not Stalinists, they were fascists or fascist sympathizers, so he is in a company that includes Eluard, Aragon, Neruda, Vallejo, MacDiarmid, Oppen, Hikmet, and Ritsos, to name a few of the host of poets who were willing to associate themselves with the authoritarian politics and the bloody hands of the Soviet state in the name of some imagination of a just society that was to issue from them. The harshest way of describing Zukofsky's politics and its relation to his art is to say that he began with a naïve set of political commitments and, having ditched content, ended with word

games. This is, clearly, unfair. Probably the unnoticed truth about the structure of *A* is that it is split in half not only by Zukofsky's disillusionment with Stalinism but by McCarthyism. Whatever he might have done with a poem that had proposed the equivalency of John Adams and Josef Stalin, the 1950s was not a time when American poets felt free (with a few rare and brave exceptions) to think through their change of mind in public. Zukofsky's champions among French and American poets and academics have treated his themes and his loyalties as evidence of an admirable concern for social justice and remained silent on all the difficult issues, except to assert, in one form or another, that his real politics persist in the turn away from representation and toward the decontextualization and formal patterning of language. But it seems a great burden to put on punning translations of Catullus or the play of music at the end of *A* to ask them to answer the millions of innocent people killed in the gulags.

In Paris this spring at the museum of the history of the city, I stood in front of a portrait of a mild, clear-eyed Danton. The historical note pinned to the wall called him "a priest-killer" and I thought of Lenin and of Louis Zukofsky in 1923. The twentieth century changed many things, especially the nature of political violence. In the nineteenth century terrorism was the tactic of stateless revolutionaries. In the twentieth century terrorism became, largely through the innovations of aerial bombardment by airplane and guided missile, the principal means by which states waged war. Hiroshima is, in that way, the century's hinge. It was a straightforward terrorist attack on the civilian population of two Japanese cities, designed to break the will to fight of the Japanese government. In that one way it is not different in kind from the stateless terrorism practiced by al-Qaeda or the insurgent Sunni rebellion in Iraq. And bureaucratic efficiency and technology, from high-speed transportation to high-powered explosives to automatic weapons, have also altered the effectiveness of the state's violence against its own populations. Those other hinges of the century, the Nazi concentration camps and the Soviet gulags, are the testimony.

It is not surprising that a philosopher like Hannah Arendt emerged in the midst of this transformation to make a series of useful arguments about the century's experience. She argued, in *On Revolution,* for example, that revolution was, people ought to see, a form of civil war and that war was murderous. She also argued that the metaphors

of biological inevitability that have tracked the rhetoric of revolution since the French Revolution tended to make these wars sound like irreversible historical processes for which human beings bore no responsibility and that therefore were not susceptible to ordinary calculations about ends and means. In the genocidal conflicts at the end of the twentieth century from Somalia to Bosnia to Palestine, nationalist rhetorics of ancient tribal rights, reminiscent necessarily of National Socialist ideology, have been somehow grafted to the universalist rhetoric of revolution and the rights of man to make a still more deadly instrument, and the distinctions between terrorist and insurgent, cell and state, have become so blurred that they have become themselves the center of the propaganda struggle. What this means for writers is that, however kindly we regard the politics of the young Louis Zukofsky embracing the bloody dream of a utopian society in his parents' apartment in Harlem in 1923, not thinking through the issue of political violence—of who, as George Oppen put it, you are willing to kill or see killed—is no longer a luxury available to us.

2004

tomaž šalamun: an introduction

I

I met Tomaž Šalamun in the fall of 1982 in Ljubljana. There had been
a poetry reading and discussion at the Slovene Writers Union in a for-
mal, wood-paneled room lined with bookcases and busts of Slovene
writers from the last century. Among those present was a dark-haired,
lean-faced man of about forty with glittering eyes. In one of the poems
of the Swedish poet Tomas Tranströmer, he describes driving past a
locked-up church on a winter night. Inside, he imagines, is the statue
of a saint, smiling like someone whose glasses have been taken away.
Tomaž Šalamun looked like the saint just after he had found his
glasses. Granny glasses, in fact, and a small, altogether angelic smile.
It was the contrast between the eyes and the smile that made you look
twice. After the meeting there were drinks in the Writers Union bar.
A nicotine haze. I had begun to wonder what it meant to be a Slovene
writer. There was a woman I watched at the meeting, fleshy, tired,
fairly drunk. She had a wonderful face. I asked someone who she was
and was told that she had written the greatest novel in the Slovene lan-
guage. Had it been translated? Into Serbian. I asked Tomaž Šalamun,
who spoke English with almost no accent, what he thought of the book.
It's very good, he said. Somewhat conventional in form, a family novel
about the war years. Very good. She sees, he said, and she can write. I
regarded her across the room. She was about fifty-five, big-boned, with
thick auburn hair and the air of a solitary, as if she were involuntarily
observant and amused at herself for having the affliction. What do you
do, I asked, after you have written one of the greatest novels in the

Slovene language and had it translated into Serbian? Tomaž laughed. You try again. Or you sit on committees. He considered. We were conducting the conversation in the middle of all the noise in the bar, and we had to shout a bit, to lip-read. Maybe it's sad, he said, but not while you're writing.

Still later there were more drinks at the apartment of the American cultural attaché. Poetry in Yugoslavia: a few weeks earlier a young poet had been arrested and jailed in Belgrade. When I asked an older man in the bar about it—he was a cellist, not a writer—he said that it was really a Serbian affair. Tomaž disagreed sharply. Most of the writers seemed to share his view, but they didn't have much information. I told them what I had heard: that the poet's name was Gojko Djogo, that he was young, Muslim, from Bosnia-Herzegovina, that his book had been approved for publication and that when it was printed it contained lines not in the approved text, some of which seemed to refer to Marshal Tito. Tito's photograph was still to be seen displayed with what seemed genuine affection in shops and public buildings all over Yugoslavia. In Belgrade and Sarajevo I had seen high school students wearing Tito buttons. One of Djogo's poems, turbulent, surrealistic, had ended with a line about "the one-armed beast in Liberation Square" (Tito had had an arm amputated as a result of diabetes). When the book hit the bookstores, Djogo was clapped in jail. The writers talked about the case volubly as the night wound down, analyzing it, considering responses to it. If you keep promoting the dream of the good father, someone said, somebody sooner or later is going to have a dream about the bad father and then they're going to have to try to arrest their nightmares.

Later, as we walked through the empty downtown in the middle of the night, Tomaž continued to talk about Gojko Djogo. As it happened, Djogo spent almost a year in jail. During that time, weekly public poetry readings were organized by the Serbian Writers Union to protest the jailing. Tomaž Šalamun and other Slovene writers traveled to Belgrade to participate. It was a cool night, no moon in crisp mid-October. Ljubljana, which is the capital of the Slovene republic and has the feel of a university town, is lodged midway up the eastern foothills of the Alps, and the sky was brilliant with stars.

We also fell to speculating about the cultural attaché. Did diplomats, Tomaž wondered, have the politics of the Reagan administration? Not necessarily. The attaché had been a very large man with the

build of an inside linebacker and an unexpected courtliness of manner. His wife, very handsome, sharp, slightly ravaged, looked like a young Lillian Hellman. They had seemed genuinely pleased to be pouring drinks for a voluble and disheveled bunch of writers at two in the morning. Their apartment had been littered with plastic toys, rubber balls, and cloth books with pictures of cars and steam shovels, a curiously American island in a hillside neighborhood of tall leafy trees and fin de siècle Austro-Hungarian flats. They're from Nebraska, I explained. Nebraskans are supposed to be politically conservative and to have the traditional American virtues, neighborliness and self-reliance. They also supposedly lack guile. I wasn't sure if he would know the word *guile,* but he did. In fact, he had spent two years in Iowa, where people were also supposed not to have guile. Tomaž had been interested in Iowans. They looked complete strangers right in the eye, shook their hands, and said they were glad to meet them. He imitated it for me, shaking my hand and nodding his head. "Damned glad to meet you," he said.

I asked him about Slovenes. We were walking across a square, heading toward the river. A small baroque cathedral, illuminated, looked like an outsized scallop shell through which a thin light was passing. On the opposite bank, a shadowy hill rose, with the shadowy outline of a castle ruin on the top. Slovenes, he said, never break rules. You should see them at traffic lights. It says stop, they stop. It says go, they go. There was a stone bridge that led to the old medieval quarter of the town. The bridge had been built in the second century by a Roman garrison. We sat down on a stone bench and began to talk about poets. He loved Rimbaud and Lautréamont, the Rimbaud of *Illuminations,* the young seer, more than the Rimbaud of *A Season in Hell.* He had spent two years in Iowa, where he had come to know a good deal about American poetry—he was especially interested in Frank O'Hara and John Ashbery, in William Carlos Williams and Wallace Stevens—and he had translated some of them into Slovene. The Russian futurist Velimir Khlebnikov was important to him. Did I know Khlebnikov? I didn't. You should, he said. Khlebnikov had been a great admirer of Whitman. We talked for a while about Pasternak, about Vasko Popa and the uses to which Serbian poetry put French surrealism. Tomaž spoke about the traditions of Slovene poetry, about Edvard Kocbek, a poet of the older generation who,

as a leader of the Christian Socialists, had become vice president of
the Slovene republic and then came under strong attack from the
Stalinists in the 1950s. And we talked about Apollinaire, quoting
back and forth what we could remember of him. A street sweeper
rolled into the square. The driver sat rigid in the cab, puffing at a
pipe as he made his pass at the cathedral steps. Old women had begun
to unload crates of produce in the marketplace. I had an early flight.
Tomaž said he would leave copies of a couple of chapbooks for me at
the hotel desk, English translations of his poems done by American
poets at the Writers' Workshop in Iowa. I was intensely curious about
his poems, and not much later that morning, very groggy, my plane
circling Ljubljana, the small city in the mountains, a river running
through it, flashing and gleaming in the sun, I opened a book called
Snow, published in 1973 by the Toothpaste Press in West Branch,
Iowa. I was particularly curious about how one dealt with the fact
of being a Slovene poet, what kind of relation existed between a lan-
guage whose very existence suggested a fiercely conservative, tribal
energy and this poet who loved the explosively experimental and
visionary strains in European poetry. There were, I knew, about two
million Slovenes in Yugoslavia, perhaps three hundred thirty thou-
sand people in Ljubljana. There were over three million people in
the Republic of Ireland, two and a half million in Nicaragua, but
the writers of those countries wrote in world languages. When I
opened Tomaž Šalamun's book and read the first poem, "History," I
laughed. The solution he had found, at least in the early seventies, to
any problem of cultural loneliness was the one Walt Whitman had
found to his personal loneliness in Brooklyn. The reader can simulate
my experience by imagining him- or herself on that plane. Ordering
some coffee. Glancing down at the sheer limestone ridges of the Alps,
and considering this poem:

Tomaz Salamun is a monster.
Tomaz Salamun is a sphere rushing through the air.
He lies down in twilight, he swims in twilight.
People and I, we both look at him amazed,
We wish him well, maybe he is a comet.
Maybe he is a punishment from the gods,
The boundary stone of the world.

"Possibly," the poem continues, "he should be pressed between / glass, his photo should be taken. / He should be put in formaldehyde, so children / would look at him as they do at fetuses, / protei, and mermaids."

II

Tomaž Šalamun was born in Zagreb, Yugoslavia, on July 4, 1941. He grew up in Koper, a town just south of Trieste on the Adriatic coast. Koper was Venetian for most of its history, Hapsburg in the nineteenth century, and Italian again between the wars. Trieste and the Istrian peninsula were later divided into two zones, A and B. For centuries Istria had been Italian in its town culture, Slovene in the countryside. Šalamun's mother's family were town Slovenes from Trieste. His father's family came from Ptuj, an entirely Slovene town, somewhat Germanic in culture, in Styria south of Graz. His grandfather had been mayor of Ptuj. Koper, a town of about fifteen thousand in the 1940s, mostly Italian-speaking, was in Zone B. It was administered by the Yugoslavian army. The matter of Trieste was not ultimately settled until 1954. Charles Simic, who has translated many of his poems, remembers that as a small boy he vigorously chanted slogans to the effect that it was better to be dead than to live in a Yugoslavia divested of Trieste. After 1954 Koper became a part of the Socialist Federal Republic of Yugoslavia, and in 1960 Šalamun began his studies in history and art history at the University of Ljubljana. In 1964, as editor of a literary magazine during the last days of Yugoslavian Stalinism, he spent five days in jail and came out something of a culture hero. He took an M.A. in art history in 1965, and his first book, *Poker,* appeared in a samizdat edition in 1966. Fresh, sometimes shocking, full of absurdist irreverence and playfulness, it is said to have inaugurated a modernist Slovene poetry in the postwar years. Its author, who has since published another twenty-four volumes of poems, was off to Italy and Paris to continue his studies in art history. He returned to Ljubljana and became assistant curator of the Moderna Galerija, the modern art museum. He married, received an important literary prize in 1969, and began to exhibit as an environmental and conceptual artist all over Yugoslavia. The summer of 1970 brought him to New York City for an international show by performance art-

ists at the Museum of Modern Art. He returned to Ljubljana to teach twentieth-century art at the Academy of Fine Arts for a year, and then in 1971, at the invitation of the International Writing Program at the University of Iowa, he returned to the United States and stayed for two years. The ambience in Iowa City at that time was formed mostly by the second generation of New York School poets. Ted Berrigan and Anselm Hollo were on the faculty, and among the most gifted of the graduate students were Bob Perelman and Barrett Watten, who later moved to San Francisco and became influential figures in the emergence of the so-called language poetries. It was a congenial time, and the two American chapbooks *Turbines* (1973) and *Snow* (1974) are the result of Šalamun's collaborations with the Iowa poets. By the time they were published, he had returned to Ljubljana, where he worked at odd jobs, translated William Carlos Williams and Apollinaire, Balzac and Simone de Beauvoir, divorced, taught primary school in a village, and worked as a salesman while continuing to write his poems. In 1979 he remarried and received a grant that allowed him to travel to Mexico, where he lived during 1979 and 1980, a time and place that worked powerfully on his imagination. Šalamun returned to Ljubljana in 1981. The pace of the writing in the 1980s has slowed and the vision seems to me, from the evidence available in English, noticeably darker. Over the years his poems were translated into Serbo-Croatian, German, Polish, and Italian.

Šalamun belongs to the generation of Eastern European poets—it includes Joseph Brodsky of Russia and Adam Zagajewski of Poland—who came of age in the 1960s. They grew up not with the searing experience of war and its aftermath that has marked the poetry of the older generation (Zbigniew Herbert in Poland, Miroslav Holub in Czechoslovakia, Vasko Popa in Yugoslavia), but in the postwar years, when the pinched material circumstances of economic recovery and the pervasive intellectual dishonesty of Stalinism were a kind of normality, the world as given. Herbert, Holub, and Popa—very different poets—seem at least in translation to have a good deal in common: their irony, their desire to talk about violence and suffering obliquely but plainly, without heroics. They have the same slightly uneasy relation to the intellectual fireworks and moral pas-

sions of their immediate predecessors, the generations of Brecht and Milosz and Camus, and to the flash and elegance of high modernism. They seem especially distrustful of the potential for destruction in all large-spirited and careless gestures. When the muse whispered in their ears, Trust your heart, trust the shapeliness of imagination, make a teacher of your strangest desires, they seem to have patted her gently and put her to bed like a child or a handicapped relation, and then gone back to work at the kitchen table. And they have seen to it that their poetry is light on cultural baggage. It is part of their power that all of this conscious limitation of means seems moral. It seems based on a desire to mime the unglamorous, undefended rituals of common life. Perhaps the best term for this relation of the artist to ordinary social routine is, not accidentally, solidarity.

By contrast, the younger generation was more impatient than their elders, and more exuberant. They were individualist rather than democratic, and they tended particularly to resent the politicization of all aspects of life. The novels of Milan Kundera also speak to this theme, as do the essays of the Hungarian novelist George Konrad. His "Antipolitics" calls for an effort to push back the frontiers of the political in order to give breathing room to personal, and merely social, life. That some Western European and American artists have, at the same time, made it a project of postmodernism to demonstrate that in consumer societies the personal is a complete illusion fabricated by late-twentieth-century capitalism, and that poets need to create a language that will filter this illusory "I" from the clear water of linguistic play, is one of the peculiar twists in Cold War aesthetics. Šalamun's own sense of the subjective, of first-person agency, seems related to both of these attitudes and radically different from either. "Emptiness, / my only love, /," goes one of his short poems, "give me rest." "Little robin, / bones pinned to the cosmos, / who whistles? who listens?" goes another. And this from "The Tree of Life":

I was born in a wheatfield, snapping my fingers.
A white chalk ran across the green blackboard.
Dew made me lie on the ground.
I played with pearls.

And this whole poem:
You're taking the piece of iron, right?
It's red. So, it was red before too, right?
And what is red? Red is only part of white, right?
Iron is a bit of snow. You are a bit of white.

It is a relation to the self somewhere between shamanism and Buddhism, a quite pure interest in the fluidity and play of imagination. In any case, the political condition that for the older generation of Eastern and Central European writers marked a change, a narrowing of possibilities, seems to have been for the younger generation simply part of the atmosphere of childhood, so they experienced it as a matter not so much of culture but of nature. It belonged to the wearying, bullying repetitions of all social regimentation—in short, of whatever it is they tell you in school to get you to sit still and parrot their idea of the right answers. Joseph Brodsky, in his autobiographical essay "Less Than One," gets the tone. He is recalling his childhood:

All that had very little to do with Lenin, whom, I suppose, I began to despise even when I was in the first grade—not so much because of his political philosophy or practice, about which at the age of seven I knew very little, but because of his omnipresent images which plagued almost every textbook, every class wall, postage stamps, money, and whatnot, depicting the man at various ages and stages of his life. There was baby Lenin looking like a cherub in his blond curls. Then Lenin in his twenties and thirties, bald and upright, with that meaningless expression on his face which could be mistaken for anything, preferably a sense of purpose . . . I think that coming to ignore those pictures was my first lesson in switching off, my first attempt at estrangement. There were more to follow; in fact, the rest of my life can be viewed as a non-stop avoidance of its more importunate aspects. I must say, I went quite far in that direction; perhaps too far. Anything that bore a suggestion of repetitiveness became compromised and subject to removal. That included phrases, trees, certain types of people, sometimes even physical pain; it affected many of my relationships. In a way, I am grateful to Lenin. Whatever there was in plenitude I immediately regarded as some sort of propaganda.

"The real history of consciousness," Brodsky writes, "starts off with one's first lie." Splitting the self off from the tribe, giving it air to breathe and freedom to breathe in, is also a theme in Adam Zagajewski's work. Asked to speak about the freedom to write at a 1987 PEN conference in New York, Zagajewski told his audience that the freedom to write was an important but external issue, that the real issue was, always, the freedom in writing. In his poems that imaginative space is often associated with solitude, and it comes to him as a kind of blessing, but, like Brodsky's practice of estrangement, it seems at first alien. "Three Voices" does not represent Zagajewski's imaginative power, but it does express the attitude:

The cloud of dusk gathers in the room.
The shadows of night are growing, tamed desire.
On the radio, Mahler's Song of the Earth.
Outside the window, blackbirds whistle, carefree and loud.
And I can hear the soft rustling
Of my blood (as if snow were sliding down mountains).
These three voices, these three alien voices,
are speaking to me but they don't
demand anything, they make no promise.
In the background, somewhere
in the meadow, the cortege of night,
full of hollow whispers, forms
and reforms, trying to get in order.
(Is it a procession of shadows staggering
across Red Square?)

Elsewhere, as in "A Warsaw Gathering," Zagajewski simply records his weariness with the language of political life:

Ladies, gentlemen, boys, girls, the province,
the village, decent ones, penitents,
old ones, newcomers, Catholics, converts,
the left, the right, the thumb, lightning . . .

Šalamun's "Tea" is one of his earliest poems and it takes up the same theme in his own distinctive idiom, rapid, playful, absurdist:

tea knows precisely why it is tea
it has no desire to be Catalina
here he comes again that ancient one
how I used to sit in Bruges
in my brown gabardine suit
and eat something resembling calamari
and my friend Sicco van Albada
son of the redheaded Jewess my father's friend
how he used to try to persuade me
incessantly go back go back to the Beffroi
because I left my knapsack there
while staring at the Beguine sisters
at the way they looked on the road
at the swans at the drowning of Memling Gruuthuus
at Christine interpreting the legend of St. Ursula
then all of a sudden a Mr. Content
Belgian gynecologist tells me
I used to know Marini personally what a failure
do you call that a horse
and for the first time there was
this incredible creak in my lining

A gloss, though glosses can be tiresome. Catalina was the Roman traitor, famous until recently because he was denounced by Cicero in an oration favored by compilers of elementary Latin texts. The Beffroi is a tower in Bruges. Memling was a fourteenth-century painter; the drowning is imaginary. Christine is presumably an acquaintance of the poet. Marino Marini was an Italian modernist sculptor, whose horses do in fact resemble horses, whatever Mr. Content's opinion. His philistine views begin to separate the poet from his own social person, the one who visits art museums and knows what tea is, in just the way that his dreaminess had separated him from his knapsack. He has begun to be Catalina, traitor to his tribe. (Most of Šalamun's poems do not lend themselves this easily to an anecdotal accounting. "Krakow" does. It simply records the speech of a Polish woman who is more or less another Mr. Content. But behind "Peace to the people of this earth," for example, I think there lies a very early memory of the armistice in Koper, but you have to live with the poem awhile to glimpse it.)

"Tea" is a young man's poem, sweet, deft, and funny. It is another account of the process of estrangement. "Proverbs," which looks like a political poem, is also about imaginative freedom:

1. Tomaz Salamun made the Party blink, tamed it dismantled it, and reconstituted it.
2. Tomaz Salamun said, Russians Get Out! and they did.
3. Tomaz Salamun sleeps in the forest.

I am not sure how much the self-mythologizing in the early poems is meant to be political, to play off the cult of personality: every man his own Lenin. The political current is certainly there in "Dead Men," which is a spell against social torpor, and in his parodic reference to "the pan-Šalamunian religion" as "a terribly democratic peoples' institution." Some of it is just cheekiness and high spirits, and in this it resembles Walt Whitman. Not only because of the self-mythology, but because of its cheerfully, pointedly unfounded confidence in the power of imagination. One of Whitman's poems resembles "Proverbs." In "What Place Is Besieged?" Whitman asks if there isn't a fort somewhere out on the frontier that is in trouble. Don't worry, he says. I'm sending reinforcements, the deadliest that ever fired gun. It is Blakean. The manacles are mind-forged, so take them off. But the poems acquire another kind of power when Šalamun intensifies the paradoxical relation between imagination and the ordinary world. Then the vision gets darker, as in "Folk Song":

Every true poet is a monster.
He destroys people and their speech
His singing elevates a technique that wipes out
the earth so we are not eaten by worms.
The drunk sells his coat. The thief sells his mother.
Only the poet sells his soul to separate it
from the body that he loves.

In some of the later poems the sense of estrangement is fiercer yet. "Man with the Golden Eye" belongs to a very powerful group that was written in Mexico around 1980. Often, in the recent poems, the persons addressed, the objects of desire, are spoken to in a tone of impatience or

challenge, as if by provoking his desire they had become agents of the other world, but were unconscious of their power, had to be awakened to it, or as if the poet were now in the other place speaking back into this one with something like bitter urgency:

> Yesterday I saw the feathers of Montezuma
> and how he longed for his ruin, for some foreign
> god to drink up his soul. The Empire is eternal.
> Eternal are the mirrors. The water evaporates,
> only the gaze remains. Who hoards it up?
> A chariot with a golden shaft—
> I'm not that yellow fruit.
> I'm not that mob staggering from the Coronation.
> I ate the ticket to the Anthropological Museum
> while I spoke to a tourist,
> while I kept looking at you.

And here, I think, is a poetics not of rebellion but of quest. Šalamun's tradition has been the disruptive, visionary side of European experimental art, Rimbaud, Lautréamont, the German expressionists, the French surrealists, the Russian futurists, the tradition in which poetry is an instrument for glimpsing a supreme reality, and for which all art is, finally, the scattered bits and pieces of that larger vision. This accounts for Šalamun's eclecticism, for the sense of improvisation in his poems, the surrealist lists, the New York School fast jottings of what's going on at the moment, the disjunctions and sense of play. They are tactics to set the centrifuge spinning, to start the dervish dance, in which some breakthrough might occur. "Drums" is an example:

> I am the people's point of view, a cow,
> the tropical wind, I sleep under the surface.
> I am the aristocratic carnivore, I eat form.
> I drum on the cooks' white caps . . .

In his early work, I have been told, Šalamun, influenced by Velimir Khlebnikov, uses puns, neologisms, and various lexical and syntactical outrages to turn the Slovene language inside out. None of this work has

been translated, because it is untranslatable. It is interesting to think that Šalamun probably first came to Whitman through Khlebnikov. Americans are not apt to think of the Whitman absorbed—circa 1885–1890, Rilke's youth—by a generation of European symbolists who saw him not as the realist and vernacular poet who descends to us through Williams, but as the poet of visionary recitals, of mysterious apprehensions of death, as a poet for whom the first claim to the other world is the claiming of one's own body. One understands Šalamun better, I think, by seeing Khlebnikov respond to the Russian Revolution through the medium of "Song of Myself":

Russia has granted freedom to thousands and thousands.
It was really a terrific thing to do,
People will never forget it.
But what I did was take off my shirt
And all of those shiny skyscrapers the strands of my hair
Every pore
In the city of my body
Broke out their banners and flags

In the same way, Šalamun's use of American poetics looks familiar to us but has somewhat different intentions. It is one thing to have the Whitman descended through Williams to Frank O'Hara, who, having moved from Worcester, Massachusetts, via Cambridge to the edges of the brilliant, rowdy art scene in Manhattan, could write in the last line of a poem, "and here I am / the center of all beauty," pledging himself to art and freedom and the playfulness of art; and it is another to inhabit a Whitman out of Khlebnikov and to stand in the middle of Ljubljana, or to be a young European reading O'Hara and Plotinus and Tibetan Buddhist texts in the middle of Iowa City, or later Querétaro under the tutelage of César Vallejo and the Gnostics, and to try to leap past art by coming to the center of one's own imagination and claim that space with all its monsters and demons as the ground of freedom.

The translations gathered here have two sources: the work done in 1970–1971 by the poets in Iowa City in collaboration with Tomaž Šalamun, and the recent ones by Charles Simic, who worked with Serbian translations of the Slovene originals and then consulted with

the author. The earlier translations, especially those of Anselm Hollo, have, appropriately, a raffish and anarchic spirit. The later ones by Simic feel more meticulous, and indeed the poems have changed. They cast denser shadows. It is a good thing to have his work in English. Some of it is very funny and graceful, with a grace midway between that of a dancer and a pickpocket. All of it has provocation and imaginative intensity and aesthetic risk.

1998

Some Readings

George Konrad, *Antipolitics*, tr. Richard Allen (New York: Harcourt Brace Jovanovich, 1984).

Joseph Brodsky, *Less Than One: Selected Essays* (New York: Farrar, Straus & Giroux, 1986).

Adam Zagajewski, *Tremor*, tr. Renata Gorczynski (New York: Farrar, Straus & Giroux, 1985).

Velimir Khlebnikov, *The King of Time: Selected Writings of the Futurian*, tr. Paul Schmidt, ed. Charlotte Douglas (Cambridge, MA: Harvard University Press, 1985).

A note: I traveled in the former Yugoslavia on behalf of the United States Information Agency (as it was then called) in the fall of 1984 and, as a member of the American PEN Center, a writers' organization concerned with issues of freedom of speech, made inquiries, wherever I went, about the imprisonment of the young poet Gojko Djogo. As it happened, Djogo spent almost a year in prison. And had, after that, a surprising career. He was one of the founders of the ultra-nationalist Democratic Party in the last days of Yugoslavia, a parliamentary leader of the party in Serbia, and an associate of Radovan Karadžic, also a poet, now on trial in the Hague for crimes against humanity.

a bruised sky: two chinese poets

T he sky over Beijing on an October morning in 2008 was the color of a bruise, a livid yellow-brown. It was the effect, my friends explained, of a sandstorm off the Gobi Desert, plus inversion, plus smoke from the coal that heats and powers the city, plus automobile exhaust. Visibility was minimal. You could make out cars going by in the street and barely make out figures walking on the opposite sidewalk. They looked like people wading through morning haze in a T'ang Dynasty poem. It seemed a metaphor for contemporary China: the Gobi Desert for the vastness of it; the coal smoke for the industrial revolution, phase one; and the carbon dioxide for the industrial revolution, phase two.

By the next morning a wind had come up, a light rain had passed through, and the sky was pure azure. From our slight elevation in the north of the city we looked out over crisp blue air and high clouds, the mazy sprawl of endless neighborhoods, and, hovering over them, a forest of cranes, Beijing transforming itself. In the interim, I'd sat in an auditorium listening to a poetry reading in Chinese and English and seen the premiere of a new Chinese film. Both of them, the reading and the film, were so surprising that it made the suddenly transformed weather also seem like a metaphor.

The film *24 City*, directed by Jia Zhang Ke and written by him and a poet named Zhai Yongming, told the story of the closing of a factory in the city of Chengdu in Sichuan Province. The factory, a dinosaur of the planned economy, was situated in an immense, paternalistic company town where thousands of people had worked at jobs and lived their lives, performing the tasks involved in fabricating airplane engines and refrigerators. The story was told through interviews with people who had spent most of their adult lives inside the buildings and

also fictional interviews with imagined characters performed by very well-known actors. The combination of long slow pans of the empty buildings; the animated faces of the storytellers; the way their stories made a fifty-year history of the revolutionary era in their country; the sudden, meditative cuts to spaces of silence in which objects spoke made a sense of elegy and wonder, at the shapes lives take and at the way people live inside the worlds given to them, and this mix gave the film a terrific sense of aesthetic risk and surprise.

Zhai Yongming, the poet who had cowritten the film, was born in 1955 in Chengdu, so she was writing about a world that she was deeply familiar with. I knew that she had been sent away for two years of rural reeducation during the Cultural Revolution and that she had published her first book of poems, work about the lives of women, in 1981. That was about the time that a new generation of poets appeared in China who had broken with the official aesthetic line of the Communist Party. Critics who disapproved of their militant subjectivity labeled them "the Misty School," and many of them went into exile after the Tiananmen Square massacre of 1989. But they were a clear sign that Chinese poetry had come alive, so that, settling in to hear another generation of poets, I was full of curiosity and had no idea what to expect.

The reading consisted of one live and surprising voice after another. The poets, men and women, ranged in age from their late thirties to early fifties. They belonged, as Zhai Yongming did, to what the critics were calling the New Generation. All of them seemed to me interesting, and—the most surprising thing—interesting in different ways. Over the years I'd attended a few international literary gatherings at which Chinese poets had read their work. In those years, in the 1980s and 1990s, you did not, in the first place, know whether the poets you were hearing were the real poets, given the People's Republic's control of its public culture, but you did know that, if they were the real poets, they were, nevertheless, writing in some utterly opaque code. Read in Mandarin, and then read again in quite awkward English translations, the poems seemed inert and the poets noticeably constrained. These occasions brought together poets from all over the world, from Vietnam and the Netherlands and Brazil and Canada. The writers were all quite different from one another, and they came from quite distinct literary traditions, but they were part of the same conversation. They were trying to invent in language, trying to say what life was like for them, to bear witness to

it, to sing, to find fresh ways of embodying the experiences of thinking and feeling and living among others, to make new and surprising kinds of verbal artifacts. That was what I did not hear from the Chinese poets who were allowed abroad in the 1980s and 1990s, and it was suddenly what I was hearing in Beijing—that familiar, exhilarating sound, not so much of poetry, but of the power of the project of poetry. It felt like something very alive and new was stirring in China.

Later I did a mental scan of the history of the People's Republic.

1949: The founding.

1957: The first anti-rightist campaign, involving a crackdown on independent-minded writers.

1966–76: The Cultural Revolution, a second, more brutal crackdown on "bourgeois elements."

1976: The death of Mao Tse-tung.

1978: The beginning of economic reforms under Deng Xiaoping; this also happened to be the year in which a group of young poets issued the first nonofficial literary journal, *Today*, which helped to launch the "Misty School."

June 4, 1989: the massacre at Tiananmen Square, after which a number of poets, notably Bei Dao and Duo Duo, lived abroad for some years. It was through the translations of their work that American and European poets began to pay attention to contemporary Chinese poetry.

The new generation had been born between 1951 and 1971. They had been teenagers or young adults in the years of the Cultural Revolution; the oldest of them would have been thirty-eight or forty at the time of Tiananmen Square. The youngest would have been eighteen. They grew up in what looks from the outside like a period of extraordinary change. The first anthology of Chinese poetry—it may be the first anthology of poetry ever assembled—was commissioned by an emperor who sent scholars out to collect and transcribe folk songs because he wanted to know how people were living and what they were saying about it. I found myself listening to the new poets in the same spirit. I was curious about what kinds of poems this new generation was making, but also about what they had to say about their lives.

Yu Jian is one of the most powerful of the emerging poets. Born in the southern province of Yunnan in 1954, he is five years younger than the People's Republic. However, the first drama of his life was not political: a childhood illness left him with severely impaired hearing. When the Cultural Revolution broke out in Yunnan, he was twelve; his schooling was interrupted and his parents, who were intellectuals, were sent to the country for reeducation. At sixteen Yu Jian went to work in a factory as a riveter and a welder. The brief biography of him in a journal called *Poetry International* reports that, "influenced by his father's interest in Chinese poetry and aided by frequent power failures in the factory," he became a voracious reader. In those years of adolescence and exile from his formal education he discovered Walt Whitman (in a Chinese translation, of course), who became a decisive influence. At the age of twenty, that is, after the death of Mao, in the reign of Deng Xiaoping and the economic reforms, he returned to school to study Chinese language and literature. At the age of thirty-six, in 1986, two and a half years before the Tiananmen demonstrations, he published his first poem in a prestigious and official poetry journal. The poem, in the translation I've seen, couldn't be plainer. A few lines go like this:

> No. 6 Shangyi Street
> yellow French-style houses
> Old Wu's pants hung out to dry on the second floor
> ***
> the big public toilet next door
> the long queue outside first thing every morning
> usually with the onset of twilight
> we open packets of cigarettes open our
> mouths
> turn on lights
> *(translated by Simon Patton)*

Later, in 1992, he published a sequence of poems about the years of the Cultural Revolution, entitled "So Hot Then." Here is the beginning of the first poem from that series:

So hot then
red trucks loaded with
adults' burning tongues
forward forward again
disappearing down to the core of resolve
escaped schoolchildren pinching
screaming sparrows rolling toward hometown
ah the summer of the era schools closed
theaters closed weeds in parks
loudspeakers hanging over basketball courts
a revolution full blast in Mandarin
only teenagers on the bank of the ancient river
felt the call they opened their pants
gripped that little thing that always brought them
pleasure like cavemen drilling on a piece of wood
til it spurts white flame
(translated by John A. Crespi)

There are bits of this one doesn't get without knowing the land-scape. The red trucks are presumably the ones that hauled off people like Yu Jian's parents to be reeducated. The children torturing spar-rows may or may not be a reference to the lingering effects of Mao's Four Pests Campaign, an effort made during a famine in the late 1950s to encourage people to kill all the sparrows in China because they ate grain. It is reported that on one day in 1958 the people of Beijing killed 83,249 sparrows. (As it turns out, sparrows eat locusts and their disap-pearance intensified the food shortages.) But what writing! I love the "ah" in the middle of the poem—the child's experience of freedom in the chaos—and the final image, which overlays the imagery of fire, Stone Age violence, adolescent masturbation, and the violent enthusi-asms of the Red Guard, is quite amazing.

The breakthrough for Yu Jian, according to the various narratives I was patching together, came in 1994 when he published a long poem called "File Zero." The title makes reference to the *dan'ang*, or dos-sier in the form of a life history, kept for every citizen of the People's Republic. A bit of it, from the period of his schooling, reads like this:

appraisal: respects teachers cares for his classmates
opposes
 individualism never comes late
abides by discipline delights in hard work never quits early is no
 foul mouth bothers
 no women
tells no lies fights the Four Pests is hygienic takes not needle or
 thread from the masses
 trims his fingernails
*(from Maghiel van Crevel, "Fringe Poetry But Not Prose: Works by Xi Chuan
and Yu Jian,"* Journal of Modern Literature in Chinese *3:2 [Jan. 2002], p. 42)*

The three poems suggest something of Yu Jian's range and concerns: the attention to ordinary life, the antiheroic language, the sardonic attitude toward the authoritarian state, and—in "So Hot Then"—the pure poet's leap to metaphor.

Xi Chuan, a decade younger than Yu Jian, grew up in Beijing. His father was a soldier in the People's Army, which made him eligible for the country's best schools. He began high school at the elite Foreign Languages School in Beijing as the turmoil of the Cultural Revolution was subsiding. At the university he studied classical Chinese and English Romantic poetry and wrote a thesis on Ezra Pound. The first poem of his that caught my eye was "My Grandma":

My grandma coughed, and woke one thousand roosters.
A thousand roosters crowed and woke up ten thousand people.
Ten thousand people walked out of the village, the roosters still crowing.
Then the roosters' crowing stopped, but my grandma still coughed.
My grandma, still coughing, talked about her grandma, her voice
 growing dimmer and dimmer,
as if my grandma's grandma's voice was growing dimmer and dimmer.
My grandma talked and talked and then stopped, and closed her eyes
as if my grandma's grandma actually died at that moment.

This poem has a lightness and quickness of imagination that is not much like Western notions of Chinese poetry, and whether its magical realism and its unnerving structure take a light or dark view of history, it's

hard to say. In 1988, when he was thirty-five, Xi Chuan and some friends launched a new unofficial literary journal, *Tendencies*. He was translating Pound and Tomas Tranströmer, Czeslaw Milosz, and Jorge Luis Borges, and the poetry he was writing has a corresponding sophistication and aesthetic range. Here is a little of a prose poem called "Free Association":

> The bald man doesn't need a comb, the tiger doesn't need weapons,
> the fool doesn't need thought. The person with no needs is practically
> a sage, but the sage needs to go and count the great big rivets on the
> iron bridge as a diversion. This is the difference between the sage and
> the idiot.
> Nietzsche said a person must discover twenty-four truths every day
> before he can sleep well. First of all, if a person found that many truths,
> the supply of truth in the world would exceed demand. Secondly,
> a person who discovers that many truths isn't going to want to go to sleep.

And here is the beginning of a poem from the mid-nineties in which he sounds a bit like Wallace Stevens and a bit like Frank O'Hara:

> The twelve swans shining on the lake
> Have no shadows
>
> Those twelve swans, reluctant to part from one another,
> Are hard to approach.
>
> Twelve swans—twelve musical instruments
> When they call
>
> When they wield wings like silver
> And the air sustains their heavy
> Bodies
>
> An era withdraws to one side, with its
> Wisecracks
>
> Think of it, twelve swans and me
> Living in the same city!

I would read later that in the late 1990s, Yu Jian and Xi Chuan would get into a tangle over the future of Chinese poetry, Yu Jian staking a claim for regional and vernacular Chinese and for a direct treatment of ordinary life, Xi Chuan defending a colloquial handling of Mandarin and freedom to draw subject matter from the whole range of human culture. From a distance it looked like a familiar quarrel, like the one between, say, T. S. Eliot and William Carlos Williams. Talking to them in Beijing, and listening to them and to other Chinese poets talk to each other, I sensed how intensely they were trying to feel their way through the moment in which they were living. They were only mildly interested to hear that they were beginning to receive some attention from the academy and in the literary magazines in the U.S. and Europe. They were very much aware that the interest in the "Misty" poets had been political as much as, or more than, aesthetic. There seemed to be a sense that they were judged for the political content of their work inside as well as outside China. They didn't speak about this in terms of censorship, so much as in terms of the high expectations that the historical reverence for poetry placed on their work. Meanwhile they were trying to figure out how to slip the noose of both kinds of expectation and make an aesthetically fresh poetry in a very quickly changing cultural landscape. I came away thinking that it was going to be very interesting to see this work emerge and develop.

Listening to their poems, listening to them talk about the projects of their poetry, I was moved by their intensity and seriousness and playfulness and quick wit, and I found I couldn't estimate what political and aesthetic valences their writing must have had in China at that moment, any more than I could tell what role state censorship continued to play in what I was seeing. But I could see that my way of formulating the question to myself was part of what they found frustrating in their situation, and I began to understand why. For mirroring reasons they must feel that both their own literary critics at home and the poets in the West are reading them for their ideological drift, which is exactly the expectation they are trying to find their way through and around. The Chinese poets of my generation—the Misty Poets— had made a break with official literary culture by claiming inwardness and subjectivity. They had practiced the politics of antipolitics. This generation wanted that freedom and they wanted to reclaim the right to register—to find the idioms in which to register—the social reality

they were living in. They seem to be a generation for whom all the possibilities of poetry are up for grabs. That was the excitement I was hearing in Beijing that evening.

I think it was Tomas Tranströmer who said that poetry was like the notes kids pass back and forth in the classroom (now they are texting each other), while that teacher History drones away at the podium. We are going to be hearing a lot about China in the next decade, about its economy, its foreign and environmental policies. It's going to be the work of translation that will give us glimpses—human glimpses—at what's going on.

2010

V. TWO ESSAYS ON LITERATURE AND RELIGION

reflections on the epistles of john

In my grade-school classroom in Northern California, there were pictures pinned to the bulletin boards representing the Last Supper—not an item of spectacular interest, but something to think about through long stretches of afternoon. Each of the apostles wore a robe in a different shade of bright pastel. They looked like flavors of ice cream. Judas, off to one side, was, of course, chocolate—detestable Judas, the class treasurer, who betrayed the Lord and hanged himself later in his loneliness and remorse. Only Peter with his iron-gray beard and his impetuous brow and sky-blue robe did not suggest a flavor. There was no flavor then the color of the sky. It is one of the special pleasures of the story that the rock upon which the church was to be built was a somewhat comic figure: Peter, who rushed forward to chop off the centurion's ear, so that the Lord had to pick it up and put it back on; who swore that he would be faithful to the last and then, hours later, while Jesus was being grilled by the Sanhedrin, was spotted by one of the servant girls of the high priest warming himself at a fire in the courtyard. "You were with Jesus, the man from Nazareth," she said. And Peter: "I don't know what you're talking about." And, as in a fairy tale, the cock crowed.

The pretty young man who rested his head on the breast of Jesus wore a robe of goldish yellow, a sherbet color, something fragrant and a little exotic, perhaps pineapple. I knew, from the stories the nuns told us, that he was John, the Beloved Disciple. It was a role I understood: younger brother and best loved. I also knew that this boy grew up to write the most profound and mysterious of the Gospels, and that as a very old man, almost a hundred, and years past the triumphal procession into Jerusalem when the crowd waved palm leaves, and the vigil in the upstairs room, and the arrest by torchlight in the garden, and the

cry of despair from the cross, and the sunny morning and the rolled-back stone, he wrote an account of a vision he had been given on the island of Patmos of the coming of the end of the world.

The Epistles of John did not figure in this legend, and I am pretty sure I did not read them, since Catholics are tellers of stories and enumerators of lists—the four cardinal virtues, the seven fruits of the Holy Ghost, the ten Sorrowful Mysteries of the Rosary—and arguers of fine points of moral theology, rather than readers of Scripture. I must have heard fragments at Mass on Sundays when brief excerpts from the Gospels and the Epistles were read from the pulpit in English. In the course of a summer when I have been reading the Epistles and thinking about them, I've twice heard passages from the First Epistle read at Christian services, once at a wedding and once at a funeral. It is why we need sacred texts, I suppose—to read them at occasions in human life. The Second and Third Epistles are hardly more than business letters dealing with housekeeping in the early church; I doubt that they are much used in the liturgy. But the First Epistle is written in a spirit of some urgency, and it rises to moments of sudden, aphoristic brilliance, when the language seems as alive as the current of a river or the touch of a living body. Still, it is an odd thing that this letter, written from no one is sure where, in a language that the learned are not sure they understand entirely, to a community of people it is hard for us to imagine, has become the text of festivity and bereavement on another continent two thousand years after the fact. At the wedding I noticed that I was aware, because I had also been reading scholarly commentaries, that the lines read on the bright, hot morning, with an air of floral triumph, came from a particularly obscure passage in the Greek of the First Epistle that may very well have meant exactly the opposite of what the English translation seemed to say.

It was in the course of these studies that I learned the word "Johannine." It means something like "relating to or characteristic of the apostle John or the books of the New Testament ascribed to him," though there are problems with this definition, since it's possible that the books ascribed to him have nothing to do with the apostle John.

The *OED* cites use of the word beginning in the 1870s and 1880s, which is a clue to its actual significance. It stands for the solution to a problem created when Europeans began to apply the methods of

secular textual and historical scholarship to their own sacred books. When they did, it became apparent that the traditional attribution of the fourth Gospel, the three Epistles, and the book of Revelation to a single common author could not be sustained by their standards of evidence. But the texts that tradition had passed down together did seem to have common elements of thought and expression that distinguished them from the synoptic Gospels and the Epistles of Paul. If they were not written by John, they belonged together nevertheless. And if the Gospel was at least in a tradition of teaching connected to the apostle, then the Epistles were, like the Gospel, Johnish.

Hence, Johannine. To know the term is to see that one stands on the other side of a rather painfully constructed bridge in the history of—what? I was about to write "Western Christian thought"—of one's culture's relation to the sacred, as it is more or less unconsciously absorbed.

The Epistles were written, most scholars seem to think, between 90 and 110. By this time all the great events are over. The ministry of Jesus in Palestine has ended with his execution at Passover sometime between 30 and 33. The word of his miraculous resurrection from the dead has been carried by his disciples to almost all the cities of the Roman world. The ministry of Paul, begun with the conversion vision on the road to Damascus seven years after the death of Jesus, has ended with his martyrdom in Rome, where Simon Peter is also said to have died. Tacitus remarks that Nero "inflicted most exquisite tortures on a class hated for their abominations, called Christians by the populace." Paul is supposed to have been beheaded on the Ostian Way. Peter was crucified (upside down, according to tradition) in the Circus of Nero just south of Vatican Hill. At about the same time, the Jews of Judaea rose against Roman rule and were crushed. The great Temple at Jerusalem, only recently completed and one of the wonders of the world, was razed to the ground. Masada fell in 73. Sometime later, perhaps twenty years, perhaps thirty, the Epistles appear. We have them in texts edited from old manuscripts and papyri, copies of copies of copies in Greek, Coptic, Latin, Syriac: two brief letters and a homily, or sermon.

To the compilers of the New Testament, they must have seemed precious fragments of what remained of the original vision. They were, like the letters of Peter, James, and Jude, the last words of the last witnesses.

Though the process of establishing a canon went on until the middle of the fourth century, one list of canonical books was made at Rome by a bishop and theologian named Hippolytus around 200. Discussing the doctrines of the fourth Gospel, Hippolytus comments on the Epistles. It is one of the earliest references to their existence, and one gets a sense of the force they had for him as testimony: "What wonder, then, that John so emphatically brings out the several points in his Epistles, saying in his own person, 'What we saw with our own eyes and heard with our own ears, and our hands handled, these things we have written you.'"

To modern scholars, the interest of the Epistles has been the glimpse they give of a Christian church coming into being. The context of the First Epistle, one realizes as one reads it, is heresy and secession. For scholars the striking fact is not that its author is claiming the authority of direct witness but that he is appealing to it to settle a controversy. Though he does not know it—he writes, for example, with a vivid sense of the coming apocalypse—he comes not at the end but at the beginning. The age of the miraculous had passed. What had begun was the puzzle of its meaning, heirs quarreling over the estate, a church.

The scholarly reconstruction of that church starts with the fact that no one can say with any certainty who wrote the books attributed to John. The last verse of the last chapter of the Gospel identifies the author as John, son of Zebedee. "This is the disciple who is bearing witness to these things and is writing these things." But most scholars think that the last chapter is a later addition. The author of the book of Revelation also announces himself; he has had a vision, he writes, that God gave to Jesus and that Jesus sent by an angel "to his servant John, and John has written down everything he saw and swears it is the word of God." But once again the consensus, based mainly on considerations of style, genre, theology, is that the Gospel and the apocalyptic book were written by different people. The Epistles were attributed to John in the first references made to them by the church fathers, some hundred years after they were probably composed, but there is no internal evidence to support this attribution. Though it was customary for an Epistle to carry an introductory phrase identifying its author, the First Epistle carries none. The author of the second and third calls himself "the elder" (*presbyter*) only. Nor is there any sure evidence that the author of the First Epistle wrote the other two.

Scholars solved this problem by assuming the existence of a first-century community for which the main teachings about Jesus and his life derived from the apostle John. In effect, they accepted the tradition in general but not in particular. The point for them is that the Gospel, the Epistles, and perhaps Revelation came out of teachings, oral and written, passed down in the sixty years between the death of Jesus and a particular moment in the life of the community that the Epistles imply. They have added to this assumption the perception that the Greek of the Gospel and the Epistles has an Aramaic cast, as if they were written by people who were thinking in Aramaic or who spoke a Greek idiom that had Aramaic coloring. And many of them have accepted the tradition that John's apostolate was centered on Asia Minor. This comes from Revelation, which, as we have seen, may or may not be related to the other writings. There is also a second-century anecdote that places John at Ephesus, a Roman merchant city on the Aegean coast of what is now Turkey, where he is said to have departed a bathhouse abruptly because a Gnostic teacher had come in. From this slim evidence a picture emerges of a group of Jewish Christian communities in the Roman cities of Asia Minor, which developed a Christian teaching somewhat different from that founded by Paul and based on his Epistles and the synoptic Gospels.

A Johannine tradition. Out of which came those startling formulations—"In the beginning was the Word, and the Word was with God, and the Word was God"; "God is light, there is no darkness in him at all"; "Anyone who fails to love can never have known God, because God is Love"—that seemed to connect Christianity with Greek metaphysics, with the symbolic dualisms from which Gnostic thought emerged, and with the sensibility of the mystical and purifying sects that were becoming increasingly common throughout the empire. It is a cast of mind that has influenced all European theological thinking. What the Epistles, especially the first, give us, in Greek "more remarkable for energy than lucidity," as a French scholar has observed, is a brief look at that tradition in the process of formation.

In his *History of Christianity* Paul Johnson cites a telling fact. During the life of Jesus, he estimates, there were a million and a half Jews in Palestine, and four and a half million scattered around the cities of the Mediterranean. These overseas Jewish communities were prosperous, well integrated into the civic life of the empire, connected

to one another by Roman roads and by the relatively swift channels of trade and commerce. They contributed substantially to the building of the Temple at Jerusalem. News of events in the Jewish world circulated through them rapidly, and it was through their synagogues that news of the Jesus sect spread. The church at Ephesus—or wherever the Johannine tradition was taking root—most likely emerged from such a synagogue.

There has also developed a scholarly tradition, since the discovery of the Dead Sea Scrolls, that John the Baptist, and perhaps Jesus, had connections to the Essenes, a Jewish sect that had withdrawn into the desert at Qumran, where the scrolls were found, in order to practice a purified Judaism. The Essenes developed a dualistic theology, an imagery based on light and darkness, and an insistence on brotherly love, on doctrinal and ritual purity. Since the fourth Gospel seems to be at greater pains than the synoptic accounts to establish the relationship between John the Baptist and Jesus, and since there are similarities between the language of the Dead Sea Scrolls and the language of the Gospel, there has been a further guess that the synagogue or synagogues from which the John tradition emerged were colored by Essene thinking. It seems likely that by the time of the Epistles the community included Gentiles as well as Jews. So the moment of the Epistles may have marked a secession by Christians of Gnostic leaning from a community of Greek-speaking, urban, probably middle-class Jews and Gentiles who were themselves a Christian secession from a synagogue of Essene tendency somewhere in Asia Minor.

This reconstruction is speculative and no doubt too refined. There are others, perhaps equally plausible.* All of them are efforts to set the stage for the controversy implicit in the Epistle. It is hard to tell exactly what the opponents of the author, the secessionists, think, and as much scholarly ingenuity has been spent attempting to reconstruct it as has been spent on establishing the outline of the Johannine church, with possibly even less certain results. But the heart of the controversy is clear.

* I found the most helpful summaries of the scholarship in Raymond Brown, *The Epistles of John* (New York: Yale University Press, 1982); Rudolf Bultmann, *The Johannine Epistles*, tr. O'Hara et al. (Philadelphia: Fortress Press, 1973); C. H. Dodd, *The Johannine Epistles* (New York: Harper and Row, 1946); and Kenneth Grayston, *The Johannine Epistles* (London: Eerdman's, 1984). Raymond Brown's *The Community of the Beloved Disciple* (Mahwah, NJ: Paulist Press, 1979) is a detailed treatment.

It is about the understanding of the relation between spirit and matter, a problem that troubled the roots of Christian thought from the beginning.

Actually the issue is more astonishing that that. It is the understanding of the relation between matter and spirit as it bears on the question of eternal life. What the author of the First Epistle says, in the Jerusalem Bible translation, is this: "The Word who is Life, this is our subject. That life was made visible: we saw it and we are giving our testimony, telling you of eternal life which was with the Father and has been made visible to us." Eternal life. Years of Catholic education had, when I began to read the Epistles, dulled for me the extraordinary proposition of those words. I have come to tell you, the Christian said, about living forever. The phrase in Greek is *zoe aionios*.

Raymond Brown in the Anchor Bible edition of the Epistles glosses it as follows: "Eternal life is qualitatively different from natural life (*psyche*), for it is the life that death cannot destroy. Duration (everlasting, or even without beginning) is not the primary issue; it is life from another eon (*aion*, whence *aionios*) or sphere." This must be, of course, an educated guess. We can't know what coloring exactly the phrase had for speakers of Hellenic Greek in Beirut or Alexandria or Smyrna in the year 100: *zoe aionios*.

The Gospel of Mark tells a story about John. He and his brother James—they were sons of a Galilean fisherman named Zebedee—asked Jesus for a favor. "Allow us to sit one on your left and one on your right in glory." In the version the nuns told us, Jesus answered them indulgently and diplomatically: "As for the seats to my right and left hand, they are not mine to grant; they belong to those to whom they have been allotted." The tone of the telling suggested to us that these boys in their charming and literal-minded way could only conceive of an afterlife in which there were chairs and lefts and rights, and that we, of course, knew better. I suppose that we tried to compose facial expressions to indicate that we did.

Thinking about these childhood stories, I realize that they inhabit the two eternities I know: childhood and stories. When I was describing Peter warming himself at the fire, beginning to inhabit whatever place in my imagination those stories dwell in, I started to write that he was warming himself against "the raw cold of early spring," and

noticed the absurdity of the pretension. Then, on sudden impulse, I called a friend and asked him what the weather was like in Jerusalem at Passover. Mild during the day, he said, but cold at night. You'd want to wear a sweater. I thanked him and returned to my desk with the feeling that I had just crossed from one sphere to another and back again. *Aionios.*

It reminded me of going to see a pair of paintings by Caravaggio in the church of Santa Maria del Popolo in Rome on a sultry, overcast morning in early summer. The paintings, one of the conversion of Paul, another of the crucifixion of Peter, once you have left the light of the square and entered the dark of the church, come swimming right at you out of the gloom. Sinew and light is what they seem to be about, musculature and torque and chiaroscuro. One of the centurions is so tensed with the effort of torturing Peter to death that his nose is wrinkled, his upper lip drawn like a rabbit's.

Afterward I had a beer and a sandwich in the heat of the day at a café in the Piazza del Popolo. First crucifixion, then crostini. I was a tourist. I thought about how long a time these stories have compelled the European imagination, about the way Caravaggio had used them to speak about the body, to provoke wonder at the sheer force of bodily life. The rediscovery of that force, of the beauty of that force, had, I knew, invented the tourism I was embarked on. For speakers of English, it began with John Ruskin, who had used Italian art and the vivacity of Italian life as a weapon against the Christian and evangelical culture of Victorian England. Sitting in the piazza, watching the pigeons, watching the little surf of beer foam play against and cling to the surface of my glass, I knew I was enacting a piety, not one that had much to do with Peter. It wasn't to an idea of spirit and the eternal that I was making this visit, but to an idea of art and mortal life.

I don't remember exactly when, in what stages, I shed Catholicism. I see now that it was a completely predictable development. It is, after all, the existence of Christian artists that needs to be explained in the second half of the twentieth century, not infidels and aesthetes and Buddhists and spiritual drifters. "You must not love this passing world," the author of the First Epistle wrote. *Kosmos* is the word in Greek. It probably meant the worldly world, or just the known social surround; it still has that meaning in some dialects of modern Greek,

in which, according to one commentator, a gossip is someone who tells your business to the whole *kosmos*. At eighteen or nineteen the passing *kosmos* and its mortal glory were exactly what I thought I loved. I was also in love with writing. I read the books of my time and entered their way of looking at and thinking about things.

There was, of course, Joyce. Not just the figure of Stephen Dedalus, who assimilated Catholic thought so brilliantly to some idea—right out of Ruskin—of the artist as priest. "Joyce," said one of my professors, an Irishman, "wanted to have his Eucharist and eat cake, too." We all saw that Joyce had, in fact, undercut Stephen's pretensions with the figures of Bloom and Molly, those paracletes of the ordinary. I wasn't reading the New Testament (if I ever had) at the time of my poring over *Ulysses*. But if I had read Paul in Galatians, who wrote, "those who belong to Christ Jesus have crucified the flesh," or the twelfth chapter of John, in which Jesus says, "Anyone who loves his life [*psyche*] loses it; anyone who hates his life in this world will keep it for eternal life," it might have been with the figures of Bloom and Molly that I would have tried to fashion a reply.

Or perhaps with these lines from Wallace Stevens's "Sunday Morning":

"The tomb in Palestine
Is not the porch of spirits lingering.
It is the grave of Jesus, where he lay."
We live in an old chaos of the sun,
Or old dependency of day and night,
Or island solitude, unsponsored, free,
Of that wide water, inescapable.
Deer walk upon our mountains, and the quail
Whistle about us their spontaneous cries;
Sweet berries ripen in the wilderness;
And, in the isolation of the sky,
At evening, casual flocks of pigeons make
Ambiguous undulations as they sink,
Downward to darkness, on extended wings.

For there is not much question that there is a seed of world-and-flesh hatred at the root of Christianity. It is also true that the tradition is full of life and that the founding doctrines are contradictory. The same

Gospel of John that urges us to hate our lives in this world says that God loved the world so much, he gave his Son to save it. Still, it would be meaningless to think of the historical emergence of Christianity as a manifestation of respect for and celebration of the processes of physical life. It began in the idea of triumph over them, or perhaps in the hunger for triumph over them.

And of course there is every reason for that hunger, not just in the desire to evade death or to protest the cruelty of life and the horror of existence. It seems to emerge quite naturally from the conditions of consciousness. Wallace Stevens, having diagnosed the illness of Christianity in its desire to escape death in "Sunday Morning," came to think about the difference between the mental quail and sweet berries in his poem and actual quails and berries in the world, and therefore about imagination. And his is full of palpable spiritual loneliness, haunted not by nature but by some other elusive or illusive object of thought. "The palm at the end of the mind," he would write in nearly his last poem, "rises in the bronze distance." And then he revised the phrase: "rises in the bronze décor." Distance or décor? Was it out there or in his head? In the poem he settled on "décor." If the imagination makes the world, it is a stage.

And this same argument between the word and the world—it has become an argument between nature and art—rages in the poems of William Butler Yeats. It comes to its most dramatic and lucid form in the prayer at the center of "Sailing to Byzantium":

> Consume my heart away; sick with desire
> And fastened to a dying animal
> It knows not what it is

and issues in this vow:

> Once out of nature I shall never take
> My bodily form from any natural thing,
> But such a form as Grecian goldsmiths make
> Of hammered gold and gold enameling
> To keep a drowsy emperor awake;
> Or set upon a golden bough to sing
> To lords and ladies of Byzantium
> Of what is past, or passing, or to come.

I think when I first read this passage it seemed merely eccentric. To want to be a mechanical bird: I wrote it off to Yeats's aestheticism. It seems to me now near the heart of the human wish for eternal life, one in which we are not touched by pain, and are beautiful, and get to gossip forever about the *kosmos*. But, then, I was much more interested in the assertion that Crazy Jane made to the Bishop:

> A woman can be proud and stiff
> When on love intent;
> But Love has pitched his mansion in
> The place of excrement.

That seemed to make the right insistence on the relation between body and spirit. I did not know then what I know now, that the passage in the Gospel of John that enunciates the doctrine of the Incarnation, in honor of which I had been taught as a boy to kneel whenever it was uttered—"And the word was made flesh, and dwelt among us"—uses a Greek verb, *skenoun*, for "dwell" that means, literally, "to pitch a tent." Yeats is echoing this locution in "Crazy Jane Talks to the Bishop." Spirit and flesh: it is the same quarrel as in the Johannine Epistles, and the same mystery.

The First Epistle, it has to be said, rambles. It rambles so well that generations of its students—Augustine, Luther, Calvin, even Isaac Newton—have not been able to adduce a secret order in its rambling. But for all the circling and repetition and contradiction—the first contradiction is that it preaches brotherly love while bitterly denouncing its enemies as the Antichrist; the second is that it urges our capacity for sin (rather than our sinfulness) throughout and then, in 3:9, says that no one who has been begotten by God sins—for all this, it is quite clear what the letter is about. That it concerns secession is evident from 2:19: "Those rivals of Christ came out of our own number, but they had never really belonged to us; if they had belonged, they would have stayed with us; but they left us to prove that not one of them ever belonged to us."

What the secessionists believed is not so clear. The author of the Epistle, however, keeps insisting on two points: first, that Jesus is the Christ, the Anointed One and promised Redeemer, and second, that he

came in the flesh. "The man who denies that Jesus is the Christ, he is a liar"; "Every spirit which acknowledges that Jesus the Christ came in the flesh is from God: but any spirit which will not say this of Jesus is not from God, but is the spirit of Antichrist." This makes it seem likely that the secessionists have denied, in one way or another, either the humanity of Jesus or his divinity. They did not believe that the Word pitched a tent in the physical world.

The writer of the Epistle seems anxious to refute another idea as well. Exactly what that idea is has also been a matter of scholarly debate. "If we say we have no sin in us," he writes, "we are deceiving ourselves." "Anyone who says 'I know him' and does not keep his commandments is a liar." And again, "To say that we have never sinned is to call God a liar." At my first reading of these passages, I groaned. I thought it was simply denunciation of human sinfulness in the grand manner. But the argument is more nuanced than that. Its point seems not to be that we are sinners but that we are *capable* of sin. This suggests that the secessionists believed either that they were incapable of sinning or perhaps that what one did in this world didn't matter very much. "Flesh begets flesh," the Gospel of John says, "spirit begets spirit." As he argued against the idea of the unalloyed spiritual nature of Christ by insisting on the mystery of an incarnate spirit, he argues against this ethical idea by insisting on the gospel of love. "This is the message as you heard it from the beginning: that we are to love one another." "His commandments are these: that we believe in the name of his son Jesus Christ and that we love one another."

The whole upsurge of antiworldliness and asceticism in the ancient world led—even two hundred years or more after the Epistle, at the time of Augustine—away from the world, from the empire and its cities, and into the desert, which was both an actual wilderness and a metaphor for some place in the self that did not belong to the world. The secessionists were Gnostics, or—there is a debate about when Gnostic thought may be said to have emerged—crypto-Gnostics. They did not believe that the divine Word trafficked with the human body. They were inclined to discount the importance of bodily action. And in this they seem a natural development of Johannine Christianity. The synoptic Gospels, after all, belong to the eternity of story, as Yeats's golden bird does. They are full of legends of the marvels of this world: the curing of lepers, the multiplication of loaves and fishes, the man

who walked on water and died and rose from the dead. Though these same stories appear in John, it contains what the others do not—that astonishing leap to what is not figurable in human art, not tellable: the Word that was in the beginning and was with God and was God. This is not Jewish eschatology with its chairs in Paradise. It is something else that pulls away from the earth, wants to leave it behind. And clearly it speaks to a very deep place in the human imagination.

Writers know a version of it, because all art drives toward either representation or abstraction, or tries to negotiate the tension between them; it wants to render the thing and to be its pure essence, and never quite succeeds at either, fails to render human experience entirely, fails to soar free of its materials. *Logos* and *kosmos*. The First Epistle is fascinating because it is the place, among the canonical Christian texts, where this issue reaches a kind of resolution. The Word that preexisted the world and will outlast it came, nevertheless, into this world, the teaching says, was born not of water only but also of blood. It not only saved souls; it made the physical world sacred by its presence. It planted eternity here in the moments of human existence. That this argument emerges so flickeringly in a somewhat wandering and repetitious letter with an air more of valediction than of apocalypse gives it an odd sweetness: "My children, we live in the last days."

Some scholars think that the Gospel of John was an essentially Gnostic document and that its inclusion in the New Testament was made possible only by the inclusion of the Epistles, which were, in effect, a non-Gnostic revision of the Gospel. Elaine Pagels, in *The Gnostic Gospels*, has suggested that the motive for this compromise, in the fourth and fifth centuries, was political. A doctrine that embraced the world opened the church's way to earthly power." *

This is probably what made possible a church with universal appeal. In this sense, the Gnostic Christians were—to draw an analogy with Buddhism—the "small boat," a Hinayana tradition, which went underground only to keep emerging in the history of the West, in Manicheanism, Catharism, in the poetry of William Blake. And Roman Christianity was the "big boat," a Mahayana tradition, which somehow managed, with its Johannine dualism and its Pauline fear of sexuality, to include large measures of Mediterranean earth religion

* *The Gnostic Gospels* (New York: Random House, 1979). See also her earlier book, *The Johannine Gospel in Gnostic Exegesis.*

in its worship of the mother of God, its seasonal rituals, and its pantheon of saints. This church preserved its core of asceticism, its insistence that man must not be reconciled to his own nature, and to this it grafted, through the doctrine of Incarnation, a liturgy rich in stories and human iconography. It also tied the promise of eternal life to a political institution deeply patriarchal in structure and deeply suspicious of the unruliness and ingenuity of human sexuality, which it has always treated as, in some sense, a rival repository of the mystery of body and soul—with results that, even if one loves the passing world, need to be loved selectively.

1990

notes on poetry and spirituality

An old friend of mine asked me to come and give a poetry reading at Brigham Young University. He was a serious but maverick Mormon, my office mate in graduate school, where I used to tease him with my ignorance of the Mormon Church and my prejudices about it. He was a few years older than me, much more intellectually sophisticated, writing a dissertation on the nineteenth-century American poet Frederick Tuckerman, and reading Emerson and Thoreau. Some warm California afternoons when we both sat reading student papers at our desks, I would look up at him, his head down diligently, his hair cut short in those years when we were all cultivating luxuriant locks, and say something like, "So you actually believe that this guy Joseph Smith received a revelation from the angel Moroni on golden tablets and then buried them in Illinois somewhere?" He would look up, give me a Clint Eastwood squint, and say, "You ever been to Utah? You're never out of the sight of mountains. Sometimes the snow on the peaks lasts through summer."

I took him to be saying that his religious beliefs were mixed up with childhood and geography, which seemed a plausible response to me. I had a friend in college who said that the thing that kept him in the Catholic Church was the fact that there were seventeen different churches in Italy that claimed to be sole possessors of the foreskin of Jesus of Nazareth. Or perhaps this is something that he claimed James Joyce had said. I had grown up inside, or halfway inside, a religious communion. My mother was, not devoutly, but deeply, culturally, a Roman Catholic. My father was, I had assumed, a skeptic, raised inside some unspecified Protestant denomination, who seemed, for whatever private reasons, to like the idea of sending his children to school to priests and nuns, and managed also to convey a sense of mild wonder at the church and its doctrines that never

quite crossed the line into derision. I was at that time, in graduate school, a reader of Sartre and Camus, Freud and Darwin, and I had a certain affection for my childhood religion and had come to think that, in the history of the world, religion had probably done more harm than good.

Not long before I was to leave for Salt Lake, my friend called to ask if I would be comfortable giving a talk to some students on the subject of poetry and spirituality. I said that I could probably put something together and that I would think about it. I had in mind T. E. Hulme's remark that Romanticism was "spilt religion" and the Anglo-Catholicism of T. S. Eliot and Gary Snyder's Buddhism and the conversion and unconversion to Catholicism of Robert Lowell, and also of the poems of Denise Levertov, whose father was a Russian Jew who became an Anglican priest, and how her poems, with their echoes of Hasidic and Christian traditions, seemed more formed by Bloomsbury culture than the religious culture she had grown up in, and how she had, at the end of her life, joined the Roman Catholic Church. I had come in fact to think that most American poets had taken something of their language and vision from the religious traditions and vocabularies of their childhoods, Robert Bly an outriding Swedenborgian Lutheran, Allen Ginsberg a Hasidic rabbi, Gwendolyn Brooks an African-Baptist church lady. I thought I could somehow make a talk out of these notions.

I was picked up in Salt Lake. My old schoolmate, I knew, had been editing a journal on the Mormon Church that had him in constant trouble with church authorities. He had gray hair at the temples and when we came out of the airport the air was sparkling and there were snowy mountains in the distance. When we arrived at Brigham Young, he took me by a side door into the front of a large, mahogany-paneled auditorium that was filling up with students. I had been expecting a classroom and a dozen creative writing students.

It felt a little bit like *The Thirty-nine Steps*. I was introduced to the dean of the School of Humanities, who said that he was going to introduce me. I settled into an episcopal-looking chair of some gleaming dark wood and watched the students come in, watched the way they carried themselves, and knew, more or less, what I wanted to say. Growing up a Catholic, having, from the age of six to thirteen, marched into church for the children's Mass at nine o'clock every Sunday morning under the eyes of parents and of the nuns who were our teachers, and later, in high school, having been gathered into assemblies with

other adolescents for lectures and liturgical occasions, I thought I knew, watching the Brigham Young students, what I was seeing. They came in looking like they had just adjusted their expressions to a certain appropriate solemnity. Their bodies, also adjusting, looked obedient and biddable, intending to convey that the personalities inside them were good Mormon personalities, and I thought that what I wanted to say to them was that, from my point of view, spirituality was in some ways the opposite of everything that got cultivated by being a member of a religious community.

And this, it seemed, would require definitions. I'd heard Susan Sontag describe religion once as a community gathered around commonly held symbols of the sacred. That seemed like a place to start. One of the paradigms of religious behavior in my head had to do with the public approval in a small town for being a good Catholic. And for coming from a good Catholic family. I thought about sitting in church with my dysfunctional family watching the good Catholic families on Sunday morning parade in and sit down. All the kids were scrubbed and looked great; there was an air of prosperity about them that was equivalent to virtue as they came in. One knew on sight who the good ones were. They were radiant, and my spirituality probably began with hating them. Of course, that feeling was an evilly compounded mix of envy and resentment. And probably there was longing beneath that, a desire for beauty, to be beautiful, such as the angel Lucifer must have felt in the presence of God. But I didn't experience it or think about it in a particularly refined way. I just didn't like them and didn't want to be them and didn't know what I wanted to be instead.

About those people: I would come to understand, as most of us do, that they were not necessarily what they seemed to me, and that the children among them may very well have been feeling something like what I felt or were harboring their own quite different fears and longings and resentments. That is the kind of thing that you can learn from poetry, from listening to stories. American children are apt to come across it fairly early.

In Edwin Arlington Robinson's poem about Richard Cory, who is the envy of everyone in his New England town and in the last line of the short poem blows his brains out, we come to understand that people are not their public presentation, that their relationship to their own existence is something we may or may not be getting a glimpse of. And

we may begin to be more observant and to imagine our way into their lives. One could make an argument that this experience of an expanding circle of sympathy is the beginning of whatever we mean by a spiritual life. But I think it isn't. It is crucial, certainly, to the development of community, and religion, I was thinking, was a matter of community. One part of community must be that sense that other people's inner lives are as real as one's own. Another part, the part I was paying attention to watching the Brigham Young students file into the auditorium, had to do with seeing and being seen, with the way in which the eyes of a community, real and imagined, can give a person's actions the glow of piety, or their faces composed to an innocent cheerfulness can make them see themselves being seen as a perfectly acceptable sort of person.

Sitting there I found myself thinking that those Mormon kids could be good Mormons for their entire lives without getting in touch with their spirituality, whatever their spirituality was. And that the discovery of that possibility must turn on some kind of break from trying to be the kind of person they thought they were supposed to be seen to try to be, that, for me, the content of spirituality was almost always everything in me that rebelled against whatever the pattern of being a socially approved and good person was, even when I experienced that rebellion as failure. And that for me, the content of poetry, or at least what drew me to poetry—the way in which I could say to myself it was spiritual—had to do with negation, with some version of saying no to the plausibly constructed world, and of being drawn through that negation toward—what? I didn't like any of the words. I tried out *mystery* and *wonder*, and more helpfully I thought of Emily Dickinson.

And coming to her I knew I needed another definition. If religion is a community created by common symbols of the sacred, and is not the same thing as a spiritual life, then the first thing to say about spirituality is that it is almost always a private matter. It has to do with the soul's relation to its own meaning, or (a way to avoid defining *soul*) each person's private relationship to the mystery of being alive or (to avoid any vagueness in the word *mystery*) to the inexplicable fact of being alive. And it may or may not have anything to do with forms of behavior. I remembered reading something about a Polish philosopher who had said that spirituality had absolutely nothing to do with morality, and that religion, for that matter, shouldn't either. I had guessed that he meant that to be in the presence of

the spiritual, of the mystery of one's own existence and of the existence of others and its meaning, was not to take on any of the burdens of community behavior, and I thought also of my adolescent readings of Dostoyevsky in which it seemed that only the sinners had been afflicted with religious depth, were, to use the language of my present reverie, spiritual.

Of course, it had occurred to me by this point that I was cooking up an impromptu sermon against sermons, an impulse that seemed to verify my notion that the language and many of the attitudes of American poets were formed by the sense of the sacred and the traditional forms of discourse—the sermon, the prayer—in the communities they grew up in, however tenuous those forms and practices were in their families and communities. And that that was one connection between poetry and religion and one of the reasons for my presence in that auditorium, which presumed that poets would have something to say on the subject. Another reason for that presumption was the remark made by Ezra Pound's friend T. E. Hulme that Romanticism was "spilt religion." The connection between poetry and religion, of course, is ancient. Prayer—the songs of David; the Homeric hymns; Sappho's prayer to Aphrodite, which is the oldest almost-intact poem in the European tradition—is one of the primary poetic forms. But Hulme, who died in the trenches in World War I, had a classical turn of mind and a modernist sensibility and meant the phrase disparagingly. The Romantic poets in the last decade of the eighteenth century and the early years of the nineteenth had turned to nature for what Nietzsche would later call a revaluation of value. A religious poetry was written from a religious tradition and its doctrinal and devotional core. The Romantics want a poetry of whatever was divine or immanent or immortal in either the self or the world to emerge fresh from new perceptions. And this—think Wordsworth or Hölderlin, Shelley or Whitman—might lead, from one point of view, to mere effusiveness, messy outpourings of excited verse. Hulme wanted a sane art with formal limits, new, of course, but new in a way less wet than the old poems, an art that was plain, hard, and dry.

It would seem there has always been in religious traditions this argument between a religion of the spirit and a religion of the book, of the doctrines and practices as set down and vetted by authority and experience. There's an interesting book on this subject by Ioan Lewis, an English anthropologist who did his fieldwork in Africa. It's called *Ecstatic Religion* and its thesis, as I remembered it, was that there had been a pat-

tern in African religion of an authoritative religion centered on male shamans and recurrent and sudden appearances of cults in which people, usually women, had ecstatic and visionary experiences of direct contact with the divine or with earth or ancestral spirits without any mediation from male authority, that the history of religion was a history of new visions, which emerged from the powerless on the periphery being contested or assimilated by the whole community as it was embodied in its various forms of priestly authority.

There were several traditions in English Christian poetry in the sixteenth and seventeenth centuries, high church and low, and one way of describing the history of English poetry is to say that the Romantics took the inwardness of the English Christian tradition, the habit of self-examination, of prayer to an eternal and scarcely knowable deity to reveal his meaning, and applied it to the direct experience of nature or to the pure experience of oneself as a conscious and perceiving being. They wrote, in these terms, a spiritual poetry that was not a religious poetry. English Victorian poetry and some American Victorian poetry was famously a poetry of doubt and an anguished desire to believe, or a resigned abandonment of belief. "For we are here," Matthew Arnold wrote in one of the most celebrated poems of the era, "as on a darkling plain / Swept with confused alarms of struggle and flight, / Where ignorant armies clash by night." It's a poem that has seemed more prophetic of the terrors of the twentieth century than its author could have known. It was written in 1867. A few years later Gerard Hopkins, another Oxford poet, half a generation younger, would write a poem from directly inside the religious tradition. He had become a Jesuit priest and almost anyone who knows English poetry knows the opening lines of his "God's Grandeur": "The world is charged with the grandeur of God. / It will flame out, like shining from shook foil; / It gathers to a greatness, like the ooze of oil crushed."

This was the legacy Hulme was uneasy about. And there is something fastidious and perhaps limiting in his uneasiness. In one of his novels, I don't remember which one, Saul Bellow says that American writers handle success like ecstatic hillbillies handling a rattlesnake at a revival meeting. I think there is some of that in Hulme's attitude toward the Romantics, in the response of the clergy to a bunch of outriders speaking in tongues. Hulme did not live to trace the trajectory of his thought in poetry or in philosophy, and he's remembered now, I think, mainly for

that single phrase that I found myself mulling over by way of explaining why a poet might be invited to address such an audience on such an occasion. I don't know how successful the talk was. I said what I had to say about spirituality and religion, and tried to say it clearly enough that it was at least a little disturbing. I could imagine, even as I was speaking, my wry Utahan friend asking me afterward whether I was recommending to them the model of Raskolnikov, who murdered the old moneylender, or merely of Stavrogin, who ruined a party by biting a provincial governor's ear. I could have said that there was much to be said for religion, for the community it makes, for feeding the homeless and making soups for sick neighbors, and visiting the elderly and the ill, and keeping an eye on troubled kids—for behaviors that emerge sometimes from communities organized, however spasmodically or hypocritically, around an idea of love or the good. But I thought that wasn't my job or for that matter a subject I could speak about with much authority. My business was with the taste of the solitary self, and I got as quickly as I could to Emily Dickinson.

The poem of hers that came to mind begins with a feeling that comes over the speaker on an afternoon in New England in the wintertime. Handy because I knew it by heart and could say it: "There's a certain Slant of light," it begins, "Winter Afternoons— / that oppresses, like the Heft / Of Cathedral Tunes." There is that wondering presence of a self in the unmediated experience of some mix of feeling and perception. Well, not exactly unmediated, since Emily Dickinson grew up in a two-century-deep Puritan tradition and knew very well the Gospel of John and must have been, consciously or unconsciously, echoing it. (I was chatting with the poet and translator Willis Barnstone, who is working on a project of editing a canon of outrider texts for a Gnostic Bible. "How widely are you casting your net?" I had asked, and he said, "Well, wide enough so that I'm including the Gospel of John," which makes of the fourth Gospel a heretical text.) It's an interesting maneuver, and I think Emily Dickinson was doing something similar in this poem. It was written in 1861 or 1862 when she was around thirty-one years old, in the grip of terrible suffering, terrible spiritual suffering, that produced three hundred sixty-six poems, the scholars think, in one year, two hundred of which anybody would cut their wrists to write. But without going through the experience, I think, that made her capable of producing them, though it must also, in the paradoxical way of art-making,

have been a time of artistic concentration and exhilaration, so perhaps one would take one in order to have the other. The poem is written in the meter of the New England hymn, with the first syllable knocked off—eight syllable, six syllable, eight syllable, six syllable—rhymed on the second and fourth line; this is seven, five, seven, five. As you probably know, Emily Dickinson—and this marked a person whose life was spiritual more than it was religious—did not publish most of her poems in her lifetime. She published three or four poems in her lifetime, wrote her poems, sewed them up into little packets. Her friends knew that she wrote poetry; in her circle she had a considerable reputation as a poet. When she died, her sister went into her room and found over twelve hundred poems neatly sewed up into packets. They were published after her death. This is one of the poems that *did* get published, and *when* they were published, people experienced what was original in the sound of her poems as clumsiness, and her two friends "corrected" them a little bit. They thought the word *heft*, for example, was probably a little vulgar, so they changed it to *weight*. Poets and scholars have been making fun of their labors ever since, though, given their limitations, we are permanently in their debt for getting the poems out. Still, this revision does seem to demonstrate a perfect instinct for making live language dead language. It also takes the wit out of her mocking sense of the cathedral as an oppressive force. Which matters partly because it tells us that this is a private song of her own spiritual life that she's making.

> There's a certain Slant of light,
> Winter Afternoons—
> That oppresses, like the Heft
> Of Cathedral Tunes—
>
> Heavenly Hurt, it gives us—
> We can find no scar,
> But internal difference
> Where the Meanings, are—

Let me say two things about this part of the poem. One is that Emily Dickinson said once that you can tell when you're in the presence of poetry because it takes the top of your head off. The thing that takes the top of my head off is "But internal difference / Where

the Meanings, are——." And she did another very strange thing that, of course, did not show up in the first edited version and has only shown up in later versions of the text. She put a comma after "Meanings." Which would have no grammatical sense. "Where the meanings are." Period. She had, "Where the Meanings," comma, "are——" dash.

> Heavenly Hurt, it gives us
> We can find no scar
> But internal difference
> Where the Meanings, are——
>
> None may teach it——Any——
> 'Tis the Seal Despair——
> An imperial affliction
> Sent us of the Air——

Again, her grammar, "None may teach it——Any——," could be "None may teach it any way," or "Not anybody can teach it"; it's not parseable, or it's parseable in so many different ways that it's just like language is when it emerges into consciousness. And so it has that spiritual freshness of language that's alive.

> None may teach it——Any——
> 'Tis the Seal Despair——

This is after all a poem whose only starting point seems to be low blood sugar in late afternoon in wintertime and a slant of light like that——and it's taken her down to a seal like a royal seal, I guess, "An imperial affliction," she says. It's the royal seal. So it's some kind of a divine seal.

> None may teach it——Any——
> 'Tis the Seal Despair——
> An imperial affliction
> Sent us of the Air——
>
> When it comes, the Landscape listens——
> Shadows——hold their breath——

When it goes, 'tis like the Distance
On the look of Death—

And there's a dash, and that's the end of the poem. I'll say one
other thing that I have become aware of, thinking about this poem.
Death was women's work in the nineteenth century in New England.
They were the ones who sat with people when they died. They
watched them die. They closed their eyes. They washed the bodies.
They sat with them until the service began. So a young woman in
Emily Dickinson's world had seen that moment, which I've seen only
twice in my life, that astonishing moment when a person becomes a
body; it's an unmistakable experience. She's talking about, very accu-
rately about, a thing she's seen more than once. When this feeling
of despair, this hurt, comes on her, the landscape is alive, and when
it goes, when the hurt goes, it's like the soul leaving the body. And
deadening in just that way.

So, in this poem about a mood that everyone in America is medicat-
ing themselves for right now, she's talking *only* about *only* being alive
with this painful sense of absence, but a divine sense of it, or at least it
seems to me a sense of absence, or at least a sense of an intuition whose
namelessness is its quality, so much its quality that it hurts. Let me just
say the whole poem to you now:

There's a certain Slant of light,
Winter Afternoons—
That oppresses, like the Heft
Of Cathedral Tunes—

Heavenly Hurt, it gives us—
We can find no scar,
But internal difference
Where the Meanings, are—

None may teach it—Any—
'Tis the Seal Despair—
An imperial affliction
Sent us of the Air—

When it comes, the Landscape listens—
shadows—hold their breath—
When it goes, 'tis like the Distance
On the look of Death—

For me, just as an act of breathing, just as a regulation of breath and a using of the American language, it's an astonishment. But the bravery of what it says, for this thirty-one-year-old woman in a provincial town, that the choice is between a kind of pain and a kind of deadness, and she would choose the pain any day, is something like one of the things I mean by spirituality in poetry and the presence of the numinous. Numinous in this case really being some inarticulate feeling that rose up in her with that quality of light, which of course is the old image of the relationship to the divine, so tenuous here in the poem, but powerfully strong for its being tenuous.

There are poems of not-knowing that are, for me, very connected to this and have the same quality. One of my favorite haiku is by Basho, who is a poet I think of as actually having many connections to Emily Dickinson. It's a poem that takes the classic, almost cliché subject of the haiku, the middle high part of the autumn season—the phrase in Japanese is *aki fukaki,* usually translated "deep autumn" or "autumn deepens," and there are many such poems: "deep autumn the leaves are falling . . ." "deep autumn even now the quinces . . . ," deep autumn this and that; the poem of Basho's on this subject goes:

Deep autumn—
 my neighbor,
how does he live, I wonder?

Paraphrasing haiku, I know, is like explaining jokes; it's a sort of hopeless enterprise. But what is deeply moving to me about this poem is the way it gets whatever it is in our bodies that groans with gorgeous and painful knowledge in the turning of the year. And it gets the feeling of separateness from other people that accompanies it. And the longing to be connected back to them. Or an awakened curiosity about them, as if, waking to the fact that there are other people with other lives, the speaker in the poem has a sudden taste of his own self, of his

having one and being one. Both these poems borrow on long religious traditions. One might not think so, but to speak of "deep autumn" in the Buddhist tradition is to speak of a fundamental idea about nature, that it is impermanent and contingent, as much as talking about light recalls the Gospel of John for a Christian—both of them are poems of essential loneliness that have in them a long experience of religion and a longing for it and a deep separateness from it. And what they have pledged themselves to, as a representation of spirituality, is the work of imagination.

1992, 2011

VI. THREE PHOTOGRAPHERS AND THEIR LANDSCAPES

robert adams and los angeles

L os *Angeles* gathers photographs Robert Adams made of the Los Angeles Basin over a period of about six years, from about 1978 to 1983. It is easy enough, in one way, to describe them. They are the record of an abandoned garden or a ruined kingdom.

Robert Adams, 1982: *"The operating principle that seems to work best is to go to the landscape that frightens you the most and take pictures until you're not scared anymore."*

At least that is what one sees at first glance (*opposite*): hills and valleys scarred by road cuts; bewildered-looking trees, with an air of having once had an ecological context that made their existence comprehensible; skies like the absence of sky, as if the heavens were the movie screen of some disused drive-in theater; desert scrub, telephone wires, telephone poles, litter.

Robert Adams, 1995 (on photographs made in and around Denver): *"The pictures record what we purchased, what we paid, and what we could not buy."*

And yet they are beautiful. No photographer I know makes you so aware of the silence of the photographic image. In Adams that silence feels like a riddle. It has been a tactic of his art from the beginning to submit the landscapes of the western United States—somewhere between 1930 and 1950 it began to seem false to call it "the American West"—to the steady, unnerving, contemplative gaze of his camera. His formal impulse, I think, is classical. The composition of his photographs, at least to an unprofessional eye like mine, is slow to reveal itself, but you feel the authority of his images at a glance.

Robert Adams, 1978: *"As I understand my job, it is, while suggesting order, to make things appear as much as possible to be the way they are in normal vision."*

In the end, the formal authority of his work is more disconcerting than his subjects.

Those skies: the Los Angeles Basin has always been hazy; it was probably hazy ten or twelve thousand years ago when the first humans came upon it. It was marshy grasslands then, watered by three seasonal rivers that flowed out of the mountains in that semiarid climate. The hillsides were covered with coastal scrub, as they still are in places, low-growing, herb- and sage- and vanilla-scented, fire-loving plants. They were watered by cold, moisture-laden sea air. The cold air didn't rise easily in that climate and had trouble getting over the mountains, and the plants made use of it, made it a relatively lush place for its kind of Mediterranean climate. In the last eighty years human development added to this naturally occurring phenomenon the exhaust of millions of automobiles, which, trapped in this inversion layer of cold air, reacts with sunlight to produce smog. Adams's images give us the visual effect. It is as if the idea of sky were being erased.

We see this so clearly in his photographs because we are seeing it

through the lens of art. The whole tradition of landscape photography, in fact of European landscape art, has been about the relation between earth and sky. So, looking at the photographs, we see, in a way we might not walking through it, that there is no sky, that it has been replaced by a kind of gray backdrop. The Hungarian critic Georg Lukacs once described the nineteenth-century novel, with its everyday realism, as the epic of a world abandoned by God. The absence of sky in Adams's photographs has a similar effect. The way light in European art has always been a metaphor for the conversation between heaven and earth is so muted in them that we seem to be looking at a world that has had to struggle along without having heard even a rumor of that conversation.

It's hard to say whether they make tragic, or poignant, or desperately comic the idea of "available light." Probably there are different emotions in different pictures. Anyone who grew up in California could discourse for hours about the riddle of "Interstate 10, east edge of Redlands." But my eye is drawn finally to two values in that completely ordinary and almost somber image: the small gleam of light on the hood and windshield of the car and its shadow, the one black bird perched on the telephone wire.

And the trees. They grow, of course, toward the sun. In landscape art they represent, stylize, the human longing for light, the reach for transcendence, so it is no accident that our architectures, when they want to address this desire, borrow from their forms. The columns of Greek temples are stylized trees. The towers and branching interiors of Gothic churches imitate their leafy thrust. Our horticulture has even imitated our architecture, cultivating genetic oddities like Lombardy poplars with their up-thrust limbs because they resemble Gothic spires that mimic trees. And the downward pull of the limbs of trees, heavy with leaves and fruit, has been made, over and over in all the arts, a metaphor for the way in which our vertical longings return to the earth again under the weight of their own ripeness.

The trees in Adams's Los Angeles photographs have the intimacy and particularity of human portraits. It's hard to think of any modern artist who has invested them with so much individual life.

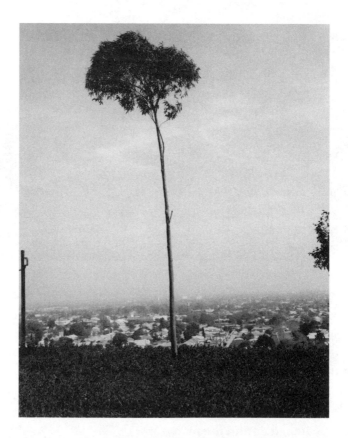

Most of them are not native to the places where they are growing. Throughout the basin the coastal scrub of the lowlands gives way to hillside communities of chaparral. Scrub oaks were, in the years before European settlement, the most characteristic tree. There were California laurels and toyons—the holly trees that gave Hollywood its name—in the wet canyons and thickets of ceanothus, the California lilac, and, higher up, madrone and manzanita, all thick-leaved drought-resistant plants. There are still places where you can walk in this aboriginal vegetation. But it is no longer what gives Southern California its characteristic look. It was transformed by citrus groves, by the fast-growing Australian eucalyptus planted as windbreaks by farmers all over the valleys, and by large numbers of nonnative ornamental trees, European sycamores and Italian cypresses and Monterey pines and the canyon live oaks of the California interior. These belong to the early boom days of modern California, to that first American dream, shared by land developers and visionary horticulturists alike, of a new and golden place—the one dreamed of by Ordoñez de Montalvo, who wrote, in the sixteenth-century Spanish potboiler that gave the state its name, "Know ye that on the right hand of the Indies there is an island called California, very near to the Terrestrial Paradise . . ."

Robert Adams, 1980: *"What a landscape photographer traditionally tries to do is to show what is past, present, and future at once. You want ghosts, and the daily news and prophecy."*

The only native tree that shows up in these photographs—it's the one most traditionally associated with Southern California—is the fan palm. It's a relict of a million-year-old tropical climate and it survived the drying out of the land because it grew in earthquake country. Water seeps to the surface along the edges of the San Andreas Fault, and it was there, even as the surrounding land turned to desert, that the fan palm survived. According to Allan Schoenherr, in his *Natural History of California,* you can follow the fault from the air by observing the outline of the groves of palm trees.

But the palms in Adams's photographs, though they are native to

the region, are a long way from home. They were planted in the basin and on its hills by the gardeners who had imagined paradise.

Robert Adams, 1986: *"Southern California was, by the reports of those who lived there at the turn of the century, beautiful; there were live oaks on the hills, orchards across the valleys, and ornamental cypress, palms, and eucalyptus lining the roads. Even now we can extrapolate an Eden from what lasted—from the architecture of old eucalyptus trunks, for example, and from the astringent perfume of the trees' flowers as it blends with the sweetness of orange blossoms."*

 They are all here in the photographs. The abandoned and disheveled still-blossoming orchards, the scraggly windrows of eucalyptus, the misshapen pines above the expressway near Colton, the somber and dignified Italian cypresses in a dry field near Rancho Cucamonga that look like a portal to the land of the dead. Each image evokes a distinct emotion. What the trees have in common is that they feel out of place. It matters, I think, that they are not native. One of the narratives of the American landscape, of course, is its human

despoiling. Probably, since the invention of the plow about six thousand years ago in central Europe, human beings have been uneasy about wounding the earth to grow things in it and have invented rituals to allay their sense of violation. And these feelings haunt still our conquest of the American earth. But this isn't that narrative. These trees replaced and competed with the native vegetation. They are where they are because of our own practical and aesthetic imaginations. They are the abandoned remnants of a not-very-old pastoral ideal.

Robert Adams, 1986: *"Whether those trees that still stand are reassuring is a question for a lifetime."*

Consider "Redlands Looking Toward Los Angeles." We are looking upward at a fan palm with a cropped top, somewhat asymmetrical—it seems to have more branches on the right side than the left. Near it—nearer, one would think, than makes any sense—a slender pine with odd sprigs of bunched needles sprouting directly from the trunk, perhaps through some genetic peculiarity. Next to it and behind it—the distances are hard to judge—a profoundly asymmetrical and

leafless tree of indistinct species, dead, or perhaps it's winter. To the right of the picture a bushy, leaved tree, much smaller or farther away, making a kind of lyric messiness as it spindles five or six trunks or trunklets toward light. The light itself has caught in the ridge of the palm's trunk in a way that seems almost tender. Beyond and below this strange botanical collection, in the left half of the picture, there is a carved-up valley, a freeway perhaps and a dry aqueduct, next to which are a few more trees, possibly cottonwoods or Fremont willows, which suggest that the aqueduct and freeway had once been a riverbed that encouraged these natural configurations. On the embankment above the ribbon of freeway, what is possibly a train—it looks like a long dark caterpillar—and beyond that, little serpentine curves of white, roads probably, though it looks like the glint of light on water. For the far background, two or three ridges of bare hills, and that L.A. sky, almost entirely effaced by something in the atmosphere, smoke or smog, which seems also to give everything else in the picture, except perhaps the ridges of the palm, a hazy, softened, slightly out-of-focus look.

What emotion does it evoke, and what thoughts? The palm tree stands for Southern California; so do the freeways and the aqueduct. The first thing we notice, looking at it, is where we are. For me the second was some mix in the composition between the stark darkness of the tree silhouettes and the gentle and hazy light. Then, looking more closely, the slightly grotesque aspect of the trees. And the sense of space, and the dissolving distances. By then we have absorbed the fact that this image is in a wild, odd way very beautiful. And then, as if it were an almost comic afterthought, we might notice how much our responses depend on the way in which what we are looking at is an almost classical composition. Foreground and distance, a rivery space winding through the middle. It could be John Constable or, for that matter, Ansel Adams. The question that came to me was whether or not the composition was ironic. It doesn't feel ironic, but it has a way of evoking an ideal of beauty that holds us responsible for what we are seeing.

Robert Adams, 1989 (on a photograph by Edward Weston): "*It records accurately a mystery at the end of every terror, the survival of Form.*"

One of the pleasures of this book is that plate 11, "Redlands, Edge of San Timotoe Canyon," gives us another view of the same scene. It's rare in Adams's work that he gives us a chance to see him coming at

the same material from a different angle or in a different light, like
Monet with his haystacks. But here we get another look at those trees,
this time with nothing behind them, lined up next to one another in
all their oddness. Like a police lineup or a casting call. They all have
an air of being guilty of whatever the charge is or of not getting the
job. It's comic and poignant to me, partly, I suppose, because of the
almost velvety softness of the light on the grass in front of them. Who
on earth planted them? What did they have in mind? There are a
couple of unreadable black objects that suggest some previous human
use. My response to this image is to cheer for the trees. All right, you
guys, hang on.

Robert Adams, 1970: *"For a shot to be good—suggestive of more than just
what it is—it has to come perilously near to being bad, just a view of stuff."*

What has made Adams so fierce and necessary an artist, espe-
cially to anyone who has grown up in the West in the postwar years,
is the shock of familiarity in his work. His images can be painful to
look at and, if one is inclined to loathe human civilization or at least

the heedlessness of modern American civilization, bitter. But the first thing one feels is gratitude and wonder. Image after image of things we have seen but not noticed, or noticed and not seen, or don't remember having seen or noticed, while recognizing that we've been seeing them all our lives. It's as if, on the road between the photographs of Western photographers like Ansel Adams and Edward Weston and the sunny pastels of the beach at Santa Monica or the lush gardens of San Marino, we have simply, out of aesthetic habit, been editing out the entire visible world, and he has taken it upon himself to show us what we haven't been seeing.

And what we make of it he leaves mostly to us. It would be easy, from his own eloquent prose, to get the impression that his vision is essentially moral, or from what has been written about him that his images were elegy or prophetic lament. But none of those things seem to me the final effect of his art. Things change, after all. We live our lives, each of us with differing but usually deep attachments to place or to an idea of place, while forces larger than our lives are changing those places faster than we live them out. There may be places in America, old neighborhoods in Cincinnati or Buffalo, the hilly farm country of southern Missouri, the red dirt and pine forests of southeast Mississippi, that have not changed much in our lifetime. But for most Americans change and loss are part of the landscape we hold in mind and have anesthetized ourselves to. Many of the forces of change have been destructive. Some, at least, have made a possible life for people excluded from the pastoral romance of an earlier republic. It's our task to make of this as we can what we can. But first we have to be able to see it.

Robert Adams, 1981: *"Landscape photography can offer us, I think, three verities—geography, autobiography, and metaphor."*
So we return to the photographs themselves, to the complex ways in which they are beautiful and ugly and mysterious and funny and bitter and poignant and dark, and to all the ways in which their complexity mirrors our own seeings and apprehensions of the world around us.

Finally we return to their silences. They are like the silences of certain great paintings and of some poems. Often looking at Adams's images, I've thought of a haiku written in the eighteenth century by Buson:

A village
without birds
at the evening meal-time

What are we to make of that?

And sometimes, because of the impulse in some of the photographs to celebrate the resilience of things, I've thought of another haiku. I don't remember who the author is:

Cut flowers
in the drainage ditch—
they're still blooming.

Or this by Issa:

Insects on a bough
floating downriver—
still singing.

Mostly Adams's images exist in a tension of seeing that doesn't quite allow the viewer to settle comfortably in any one attitude. That is, of course, the territory of art.

Robert Adams, 1989 (on the paintings of Edward Hopper): *"Precisely what it is that he helps us to see must be carefully talked around . . ."*

2000

robert buelteman and
the coast range

These photographs were made while Robert Buelteman was a resident in the Djerassi Resident Artists Program at Woodside, California, in June of 1996. The sprawling campus of the program, one of those dream places where artists in various disciplines are given food and lodging and a chance to work for a space of time without the world's ceaseless interruptions, is situated on six hundred acres atop the Coast Range above the Pacific some thirty miles south of San Francisco. So this book is, first of all, a record of what happened to one artist when he was given time and freedom and turned loose in that landscape.

And in this way they almost make a narrative. It's as if we were walking these hills and woods with him, seeing with his eyes. When he came to the Djerassi program, he'd just lost his mother and his wife's mother to cancer and had received the news that his sister was dying of the same disease. The photographs are not necessarily about mourning or grief, but the walk we are invited to take with him seems informed by those emotions. Looking at them, we come to understand that even their formal qualities are bound up with the artist's state of mind. The black border of the prints is made by clear film around the edge of the negative: it tells us that none of these images have been cropped. What Buelteman found with the camera lens is what we see. Or, rather, what we see is the composition his eye found.

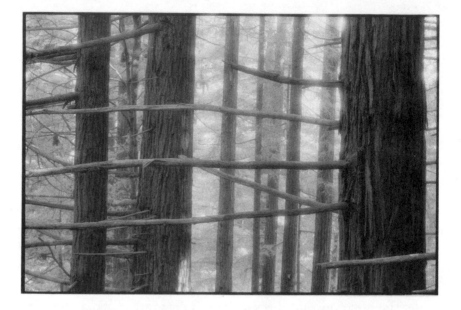

But the black band that frames each one belongs, beyond its techni-cal meaning, to something like the formality of bereavement.

Another technical aspect of the photographs is the brilliances of light in them, and the thick darknesses, and the muted silvery quality of some of the backgrounds. It gives a few of the photographs, and patches of almost all of them, a strangely antique quality, as if they were tintypes, as if time in them were layered and the images were emerging somehow from the history of photography itself. When I first looked at them, I knew enough to know that this must have something to do with the film stock and that the final image was the work of the darkroom, and guessed that the darkroom work must have been—for the artist—one of the places where the work of discovery occurred. And part of that dis-covery must have been the silvery tintype grays that haunt the forest background in many of the photographs. It makes time tender.

We are so accustomed to the conventions of black-and-white pho-tography that we hardly notice the fact that it is not how human beings see the world. Color photography, nearer to human sight, because it developed later and because the color in color film is so variable, never seems to us quite as real as black-and-white images. The association of black-and-white images with realism is an old one—counterintuitive, you would think, but deeply ingrained in our habits of seeing. Part of the drama of Buelteman's images is the way in which they make

us reconsider that association. There is a strangeness in them, a quiet foregrounding of artifice, that reminds the viewer that this is not quite how we ever see the world. The whites and grays and silvers and blacks of the medium impose their own subject, and that subject is light, what it is and what it does. You do not have to look at *Eighteen Days in June* for very long to see how much it is about time and light.

All of these photographs were shot with a 35 mm camera and infrared-sensitive film. Though Rob Buelteman didn't say so, it's hard not to think that this choice was itself a metaphor. Infrared film is sensitive to wavelengths of light the human eye can't see. It's another way in which these photographs aren't about how we usually look at things. For the artist, this may or may not have meant that he was in search of the invisible, that he was looking for something in the world that was pitched just beyond our senses, but that is one of the effects of these images. And the metaphor gets more complicated than that. The chlorophyll in plants, that most sensitive sense material, reflects almost all infrared radiation—because if it absorbed it, it would kill the chloroplast. Plants evolved their green color to reflect the red radiation in light. That's why the reflections in these photographs are so brilliant. June is still spring in much of the Coast Range, especially if the spring has been wet, as it was in 1996, and the fluorescent green of new growth is at or near its most intense. It's saturated with chlorophyll to provide food for root growth. The bright whites in these images are the chlorophyll in the plants throwing off what would kill them, or, to say it another way, the film picks up life at its most intense. In shadow, in filtered light, in cold places, the dark picked up by infrared film is darker. Skies are darker. The tingling electrical energy of clouds also reflects infrared, which may be why the clouds in these images look so much like living things. Water absorbs infrared and is at certain angles almost invisible. He is able to render, more vividly than we see it, the conversation between light and dark in the physical textures of this specific place.

The specific place—the subject of the photographs—is the Coast Range south of San Francisco. Time, and grief, and light and dark may be the artist's preoccupations, but his vocabulary is this geography, seen with the special set of nerve endings the small camera and the film stock and the possibilities in the darkroom gave him. It is territory Buelteman has visited before. In *The Unseen Peninsula*, the book that first drew me to his work and made his reputation as a land-

scape photographer, his subject was the nearby Crystal Springs water-shed on the bay side of the Coast Range. In that book and in this one, I think it helps, looking at the photographs, to have some sense of the geological and botanical history that Buelteman was walking in.

The Coast Range is a work in progress. It lifted out of the sea something like thirteen million years ago and it's continuing to rise, according to geologists, because of the continuous motion of the ocean floor as it bumps up against and rolls under the plate on which the North American continent floats. It's an uneasy coast, still in formation along earthquake faults and still working out its shape in a long conversation with the Pacific Ocean. It's hard to know what time frame to think in when you walk its hills and canyons.

As the mountains rose, they created California by creating the great Central Valley, rich with the soils of Sierra runoff. The intimate canyons in Buelteman's photographs came into being, paleobotanists tell us, when the ancestors of the current vegetation, Madro-Tertiary geoflora, to use the technical term, migrated into the newly formed mountains. The main survivor of this epoch in the photographs is the horsetails, among the oldest living things in California. In one of Buelteman's images, "Patricia Leighton/Wake," a patch of them, like a miniature forest, is set against an enigmatic sculpture of three crossed redwood boughs. The horsetails are so new with juice they are almost ghostly in their lightness. And the off-center boughs of the sculpture seem to make a brute hieroglyph whose meaning we can't quite read. Dark and light, certainly, death and life, and the title, which calls up both wakefulness and funereal starkness, intensifies the riddle, and so does a knowledge of local botany. The youngest things in this image are also the oldest.

Much more recently, five to eight thousand years ago, the seas rising from the glacial melt of the last ice age had brought the contour of the coast to something like its present shape, and the weather pattern we live with today of rainy winters and dry summers and steady visitations of sea fog, neap tides in January and foggy upwellings in June had been established, and the aboriginal flora had transformed itself into the redwoods and madrones and bay laurels and coast live oak and pinyon pines that give California its characteristic appearance. The ferns came then too, or evolved out of the larger Paleolithic ferns; they are the ones that the light seems to dance with in so many of Buelteman's images.

This landscape was first seen, anthropologists guess, by Paleolithic hunters who followed large game animals across the Alaskan land bridge and then tracked them down the coast of the continent ten or twelve thousand years ago. Among their ancestors were the Costanoan peoples, who inhabited this land for ten millennia before the Europeans arrived. It evolved with them: they were a hunting and gathering economy; they used fire for hunting and also as a farming technique to increase the abundance of some of the staple plants they used for food and medicine and basketry. They weeded and cultivated around the plants they depended on; it was part of their practical knowledge that growing things didn't like to be neglected. The wild places in the Coast Range, which looked to early European settlers like land that the hand of God brought into being, had in fact something of its appearance from ten thousand years of Native American gardening.

And something of its appearance it got from Europe, especially the grasses on the hills. The Spanish, when they arrived in Northern California, brought with them horses and cattle and sheep and—it is thought—in the fetlocks of the animals the seeds of Mediterranean grasses. They did so well here, especially the brome and foxtail fescue and wild oat that give Coast Range hillsides their summer gold, that in a generation or two they almost entirely replaced the native bunch grasses. The luminous grasses on the bare hillsides in Buelteman's photographs are, like us, recent arrivals to these shores. To this last transformation of the Coast Range vegetation, we have added only a grace note here and there in the last hundred and fifty years.

Most notable in these photographs is the foxglove, a European garden plant escaped into the wild. It's instantly recognizable by its spires of

white and purple bell-shaped flowers. Foxglove likes disturbed ground.
You can walk through whole avenues of it, head-high, on old paths on
moist slopes near the sea. It's probably not more than a hundred years old
as a wild plant, but it gives the Coast Range forests of May and June one
of their most spectacular and characteristic effects. In "Mark Oliver/
Mona Lisa" Buelteman again sets a plant against a sculpture: the bright
bells of the foxglove, rising from even brighter leaves on the floor of the
woods, lean toward Mark Oliver's black tombstone-like sculpture while
another cluster of bells seems darkened by the sculpture's presence. The
riddle here seems to lie in the small square of—what is it? tin?—tacked
to the gravestone, but it adds something to the poignance of the image
to know that the flowers have escaped from gardens, from the human
impulse to make beauty, to wander in these hills.

 Add to this, in the vocabulary of these photographs, the marks of
the specifically human world: roads, old farmhouses, fence posts, and
the other sculptures of the artists of the Djerassi program who have
made their own marks in this palimpsest, and you have the world
Buelteman went into with his camera. He has made of its many ele-
ments a complex and moving work: grief, the artist's search for light
and life; mourning and bereavement, which seem to have meant in
this case giving back the seen world to lost loved ones; the layerings

of time in the grays and silvers of the darkroom work and of the place itself, the old volcanic and primordial time of the configuration of the hills, the postglacial time of the redwood forest and the luminous oaks, the crosshatchings of time in grasses and ferns and wildflowers, each with their own story to tell. And our part of the story: roads, fence posts, and farms. They mark a human presence and mark what is implicit in all the photographs, the way in which this magical landscape, beyond the six hundred acres of the Djerassi ranch itself, which has been preserved with the help of the Peninsula Open Space Trust, is under continuous pressure from suburban sprawl. This gives to the black bands of film that frame the images another level of meaning. Then, in the sculptures set among these scenes, there is a record and a celebration of the company of artists that the residency provided. And, finally, a record of the time and place and freedom to work he was given and has given back to us as art.

2000

laura mcphee and *the river of no return*

Note: Laura McPhee's River of No Return *was published in book form by Yale University Press in 2008, where the photographs are reproduced in a 12½-by-10-inch format. The book is based on an exhibition of the photographs in a large 6-foot-by-8-foot format. So there are both epic and relatively intimate versions of the photographs. Some of them can be seen in color and small format at lauramcphee.com/ronr.php*

The name first. "The River of No Return" is a nickname for the Salmon River, which originates in the Rockies and flows through central Idaho, where it joins the Snake, which joins the Columbia in eastern Washington. The Salmon River got its name from the swiftness of its current. It drops seven thousand feet out of the mountains into the Sawtooth Valley, which is the subject of many of these photographs. The Nez Perce have lived along the Salmon River and so have a Shoshone people, who called it Big Fish River. Lewis and Clark, trying to find their way from the headwaters of the Missouri to the mouth of the Columbia River so they could report back to Thomas Jefferson on the question of whether or not the passage was sufficiently navigable to consider including the Pacific coast in some future United States—by the time they had followed streams into the Bitterroot Valley, they decided the answer was no—passed just north of the Salmon.

And then a little more history. Fur hunters must have passed through in the intervening years, but the Sawtooth Valley was settled by European stock when the prospectors arrived in 1867. They

brought names with them: Lucky Boy, Sunbeam, Custer Mill. They mined for gold and silver and quartz. In 1879 the mine at Custer Mill took out a million dollars in gold in its first year of operation, and five to eight million before it closed in 1888. Lucky Boy closed in 1904 and Sunbeam in 1911. The area was, by then, known as Custer County. And it had turned to farming and ranching. (You probably do not get more American or more mythic than to locate yourself at Fourth of July Creek Ranch in Custer County with the Sawtooth Mountains in the distance and the River of No Return flowing through your pastures.) The Silas Mason Company of Shreveport, Louisiana, bought up all the old mining properties in 1940, brought in a huge gold dredge to work the river, and churned out of it an estimated 80 percent of the remaining gold. They closed down in 1952. The Nez Perce called it the River of No Return because it was easy to get down and almost impossible to get back up. Rivers, of course, are metaphors for time—and for nature, and for history, all of which are irreversible processes. The hydrological cycle, however, is circular, though the Sawtooth Valley doesn't get a lot of precipitation. And so is the cycle of the seasons.

Laura McPhee made these remarkable photographs between 2003 and 2005 on successive visits to the valley. Her chosen instrument was a large-format camera, which allowed her to capture a sense of space and an enormous amount of very fine detail. *The River of No Return* was exhibited at the Boston Museum of Fine Arts from May to September of 2006. In that show the photographs—forty of them—were huge, eight feet by six feet, and the effect, to judge by the reviews, must have been very powerful. This book of sixty-seven images arranged by the artist is a different work of art and makes for a different, more intimate experience. It reads, in fact, very much like a book of poems. And like books of poems it accumulates meanings through echo, repetition, statement and counterstatement, digression and return. I didn't feel this paging through the photographs the first time, taking my bearings among the images. On the second or third time through it began to dawn on me what Laura McPhee was up to, that *The River of No Return* is organized like a long poem or a piece of music, that it is, as well as a stunning look at an actual place, a meditation on rivers, nature, history, cycles and linear progressions, the his-

tory of landscape photography, of the American West, and of the idea of the American West. And—while I am piling theme on theme—the nature of fact and the nature of myth, and how we hold the world in our hands.

It is a book that tends to reverse the roles of fact and myth, and this probably has as much to do with the recent history of central Idaho and the Sawtooth Valley as it does with the history of photography. The Silas Mason Company pulled out of Custer County in 1952, and it isn't too hard to imagine the condition in which they left land and river. The country, in those years, was busy fighting the Cold War and constructing the postwar system of national highways and must have left the valley to itself for a decade. In the war years and in the 1950s the country had returned to its pell-mell exploitation of its natural resources. It was a little schizophrenic about this, since this was also the period when the genre of the Western film flourished with its myth of unfettered freedom and wide-open spaces, when the most popular form of landscape photography was the cinematography in the films of John Ford. The country was celebrating an imagined past that it also seemed it could not erase fast enough.

But then in the early 1960s for a startling few years the country began to take account of the damage that had been done in the headlong development of the previous two centuries and to do something about it. One form this something took was the Wilderness Act of 1964, which set aside nine million acres of land that were already owned by the U.S. Forest Service and deemed to be "untrammeled by man" to be managed "for the use and enjoyment of the American people in such manner as will leave them unimpaired for future use and enjoyment as wilderness." No roads were to be built on this land, no structures erected, and motor vehicles were to be excluded. The Wilderness Act was followed by the Wild and Scenic Rivers Act in 1968, and that was when this new legislation touched the Sawtooth Valley. It specified that the middle fork of the Salmon River, along with several other rivers or sections of rivers, be kept "in free-flowing condition, and that they and their immediate environments shall be protected for the benefit and enjoyment of present and future generations." The Sawtooth National Recreation Area set aside 756,000 acres of Forest Service land in 1972, and in 1980 the Central Idaho Wilderness Act added another 125 miles of the Salmon River to the

Wild and Scenic Rivers system. In 1980 the River of No Return Wilderness was established. It set aside 2.3 million acres of land, the largest protected wilderness area in the continental United States. In 1984 the Frank Church–River of No Return Wilderness was renamed to honor the legislator who had passed the bill. Custer County, whose chamber of commerce's slogan is "We Are What America Used to Be"—4,938 acres, pop. 4,185—had become the center of this new federal enterprise of enjoying and not trammeling.

This is the place to which the Alturas Foundation invited Laura McPhee in the summer of 2003.

First impressions: I found myself returning to the second photograph in the book, "One Car Passing, Valley Road, Sawtooth Valley, Idaho, 2003."

It is difficult to think about photographs of the American West without thinking of the history of photographs of the American West, but I didn't think about much of anything looking at that image. I was in the car raising that dust and in the distance watching it, the sense of space, the hazy mountains in the distance, a hawk's distance, that dry high desert landscape, the time of year that raises that dust, the curious grandeur and poverty and toughness of the arid inland

West. It's all there, and so is that elegant and orderly punctuation of those fence posts, which almost seem to be there to remind the reviewer of Charles Olson's remark that the history of the West is the history of barbed wire. Above all, I loved and can make no particular account of that sudden swerve of the road and the car and the dust in the middle upper right of the image. Where is that pickup (Jeep? old Chevy?) going? Somewhere. Going about its business in this astonishing and mysterious enactment of intention.

It is a wonderful image, odd and beautiful and witty and strange, and I found myself wondering just how acutely self-conscious this assignment, or opportunity, had made Laura McPhee. How could she not have in mind the work of Ansel Adams (and the cinematography of John Ford's cameramen) or, for that matter, of the great U.S. Geological Survey work of Timothy O'Sullivan, whose "Shoshone Canyon and Falls, Idaho 1873" could not have been shot very far from the Sawtooth Valley?

My impression is that the critique of, or at least the rethinking of, the whole business of the sublime and the beautiful in American landscape photographs began around the time of Robert Adams's *The New West* in 1974, the celebrated New Topographics exhibition at the George Eastman House in 1975, and the photographs of Frank Gohlke in that decade and since. All of that work was read as a reaction against the work of Ansel Adams and Eliot Porter, against what

might be called the Sierra Club photographers. It has also been read, therefore, as a critique of some of the ideas and feelings that have underwritten wilderness preservation. The critique begins by observing that the photographs in this tradition are static, ahistorical; that there are no people in them, and no work; that they permit an observer's perspective that would in fact not exist were there a person—let alone a handful of backpackers with their high-tech paraphernalia or a crowd of overheated tourists in their earnest summer shorts or bulging winter parkas—present; that the images participate in the ethos of—and used the techniques of—corporate advertising to give us rain forests and mountain wildernesses that exist only in the mind as a form of history-erasing nostalgia so that, like advertising, they are apt to sicken us with impossible desires, especially the desire to be entirely at one with some wild and beautiful place with which, if you were there, you would not, by definition, be at one. So much for Ansel Adams's "Moon and Half Dome, Tenaya Creek Dogwood Rain, Aspens, Mount Williamson, Clearing Winter Storm."

An argument can be made, of course, against this criticism. What art, if not photography, can defend the metaphysics of the glimpse, of the sudden look into a territory we find immensely beautiful and alive but cannot inhabit? That we longed for them and could not inhabit them became a way of saying to their viewers that there were places on earth that it is a better thing to keep our hands off of, that we can only get what we need by not possessing them. When the still-surprising public consensus for wilderness preservation got built in the 1960s, it was the work of photographers like Ansel Adams and writers like Wallace Stegner that clinched the deal and persuaded the public to set aside and leave more or less intact some remnants of the American wilderness—*wilderness* here being defined as places where most plants and animals were still living in the complex web of weathers and biological relationships in which they had evolved and were evolving. With, of course, the unspoken proviso that such places had only survived in the first place because they were geographies in which it was tough for humans to make much of a living. Hence the Frank Church–River of No Return Wilderness set aside, and hence the idea, uncomfortable to a certain native anarchism in the American imagination, that from now on, *wilderness* meant land managed by a federal bureaucracy according to the best-judgment principles of ecological science.

Mixed up in this from the start had been some ongoing quarrel or marital negotiation between the formalist and documentary impulses in American art. Ansel Adams belonged to the generation of modernists for whom the formal clarity and force of an image was still part of a case that they were making for photography as a fine art, rather than a mere craft. And it remains a curiosity that as dedicated and impeccable a formalist as Adams is, he became, through his photographs of Yosemite, a popular artist and propagandist. It is this formal exactness in his work that turns glimpse into myth and seems to make time stop. And it is probably what made photographers like Robert Adams look back past Ansel Adams to Timothy O'Sullivan and the documentary tradition. Where Laura McPhee, who teaches photography, stood in all of this was clear from the first image in her first book, the collaboration with Virginia Beahan that produced *No Ordinary Land: Encounters in a Changing*

Environment in 1998. It is entitled "Graffiti on the Rim of Volcano Crater, Mythical Home of Vulcan." It is an image of a sweep of bare volcanic mountain, steam and smoke, under a slice of cloudy sky with a boulder in the foreground on which someone has scratched initials in capital letters. A tagged volcano: the mark of human presence, at the god's cauldron.

But another look at "One Car Passing, Valley Road, Sawtooth Valley, Idaho" complicates this reading of her genealogy. The sense of movement created by the dust gives us the documentary glimpse. But the image, with its series of horizontal zones, is exquisitely composed. The horizontal line made by the three vertical fence posts doesn't just echo the line made by the road dust; the parallel makes them seem like two kinds of time, nineteenth-century time and twentieth-century time, and this makes the mountain range, hazy in the distance, seem like geological time presiding over both, and these various senses of location and movement in place speak somehow to the exactly rendered foreground of high desert sage. And the whole image of quick passage, therefore, stands still and has its say about wide spaces and mountains and sagebrush and the size of human will and, in my reading anyway, the comedy and melancholy of human endeavor. It may not even be a metaphor entirely absent from this picture that the angry Republican movement to undo wilderness protection took the name of "the Sagebrush Rebellion."

The whole of *River of No Return* keeps staging this complexity because of the subtlety of its compositions and the richness and intelligence of its seeing. One way to see this is to notice the sequence of the first nine photographs that brings us to the quotation by Thomas Cole, a preeminent painter of sublime landscapes, and the powerful string of historical memory that he plucks: "I cannot but express my sorrow that the beauty of such landscapes is quickly passing away."

The first image in the book almost announces its location in the New Topographical landscape. The title, "Irrigator's Tarp Directing Water, Fourth of July Creek, Custer County, Idaho," instructs us in how she is going to use titles in this book, to give us information that the photos don't, to explain and locate in time and place what we are seeing.

We would not know that the tarp was directing water if she hadn't told us. It would simply have been an odd, bright mark of human presence in the landscape. And the presence of the tarp reminds us that the fence, which seems so entirely naturalized, is also a mark, an older one, of human presence. I believe this fence is constructed in the style that used to be called a "worm fence," as in Walt Whitman's evocation of it: "And mossy scabs of the worm fence, and heaped stones, and elder and mullen and pokeweed." The tarp gives us the creek, which seems to parallel the fence; and the creek gives us the clouds by way of the water cycle; and the clouds give us that bright scattering of wildflowers, some kind of daisy; and the daisies give us the season—this is an early summer storm. And the blue of the tarp picks up on the blue of the mountains and the blue of the storm clouds. It is palpably, physically early summer in the mountains and this theme of human presence in the landscape (echoed in the little distant irregular sticks of another fence) is set out.

Then comes "One Car Passing" to restate the theme. And then we come to Mattie. Here she is, "Mattie with a Plymouth Barred Rock Hen, Laverty Ranch, Custer County, Idaho." And she looks to be another development of the theme, if, because of her deadpan and her beauty, a slightly disconcerting one; this Mattie looks a bit like a 4-H Club photograph shot by Diane Arbus. A farm girl, a farm girl holding a hen, a Plymouth

Barred Rock hen. "One of the foundation breeds for the broiler industry in the 1920s," a poultrymen's website remarks, it was "developed in New England in the early 1800s from Dominiques, Black Javas, and Cochins probably" and first exhibited as a breed in 1869.

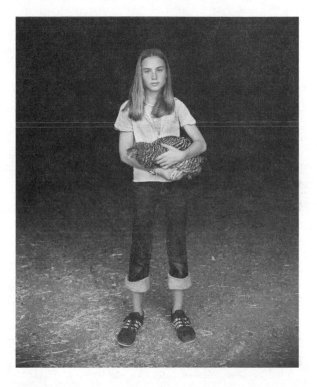

All of which is to say that Mattie, stark against a black background, expressionless, cradling the foundation of the broiler industry of the 1920s in her arms, is not yet a figure for Mother Nature or Artemis, or for the need to nurture, or for the future, though by the end of the book, with her repeated and haunting appearances she will become all these things, now holding a Bourbon Red turkey (bred in Kentucky from a Pennsylvanian stock of Buffs); now holding a robin's nest containing four blue eggs (while she wears an Isadora Duncanish eighth-grade graduation dress); now, in the same dress, holding a very beautiful northern flicker, her arms and elbows mimicking the dead bird's wings.

The fourth image is of a field of grass and sagebrush in the mist with the repeated emblem of the fence. The fifth, "Sorting Black Angus Cow/Calf Pairs, Morgan Williams Ranch, Custer County, Idaho," explains the fences and gives us emphatically one kind of

work in Custer County. Mattie then returns in the sixth image—which seems to have become the most iconic in this book, dead-pan Mattie holding the dead turkey, white wings wide, scarlet head pointed earthward—and announces that the matter-of-fact world of the farm and the myth world have been introduced to each other. The seventh image, "Isaac Babcock, Biologist for the Nez Perce Tribe, Tranquilizing and Radio-Collaring Wolves, Fourth of July Creek, Custer County, 2003," is a very remarkable one to me and it introduces the complex theme of wilderness in the book.

If the figure of the hunter were not in the photograph, "Isaac Babcock" would look like one of those stunning Eliot Porter photographs that looks like a Jackson Pollock painting. And even though the hunter is there, the image still gives the kind of pleasure that a Porter photograph gives. This is the territory—in landscape painting—of the beautiful rather than the sublime. The gold of that autumnal landscape is delicious and the energy of the thicket is the tingling sense of life that spring had given the leaved-out brush and that fall is taking away. But the hunter is there and so is his gun, and different viewers would no doubt make different meanings from him (or her) depending on how they feel about the craft of hunting and its two ancient and subsidiary arts, stealth and patience.

This is an image for which the title matters a lot. It matters that Isaac Babcock is a Nez Perce. How long did the Nez Perce people summer in the Sawtooth Valley? Perhaps twelve thousand years. And what change is implied by his profession? Somewhere between a very considerable change and none: men are still studying critters. And what is he doing? Tranquilizing wolves so they can be monitored? Here the whole complexity of the theme of modern wilderness enters the image. Sixty-six gray wolves were reintroduced into central Idaho and Yellowstone Park. Today there are seven hundred wolves in central Idaho and they have been removed from the endangered species list. An Idaho Department of Fish and Game document describes the effect:

> Wolves play a key role in their ecosystem by culling weak and old elk and deer (Smith, Peterson and Houston 2003) and reducing the long-term concentration of elk herds on sensitive meadows and wetlands (Ripple and Beshta 2004). In what is known as the cascade effect, the presence of wolves affects a multitude of species within the ecosystem. Elk, wary of the new top predator, have altered their grazing behaviour. With less grazing pressure from elk, streambed vegetation such as willow and aspen are regenerating after decades of over-browsing. As the trees are restored, they create better habitat for native birds and fish, beaver and other species. In addition, wolves have reduced the Park's coyote population by as much as 50 percent in some areas, which led to increased populations of pronghorn antelope and red fox (Crabtree and Sheldon 1999).

And to keep in focus the relation here between fact and myth, one sees that Isaac Babcock's posture somewhat resembles Geronimo's in that most memorable of American photographs, and that we are in Custer County on Fourth of July Creek, and that the witchery of golden streamside willows is gorgeous.

The next image gives us a breached dam, nature returning to nature in the managed wilderness, and the sweeping, smoky rush that the camera gives to the movement of the water. It's as if this image were there to remind us of the book's title and to evoke some Taoist idea about water, how it flows, where things come from, and where they are going. And finally "Rocks from Sawtooth National Forest for Landscaping in Sun Valley, Pettit Lake Road, Blaine County, Idaho"

with its five great rocks and its unhitched trailer—a dust of snow on the mountains, so it must be October—to remind us again of how people continue to make a living in the National Forest, quarrying rock for the swank skiers' terraces of Sun Valley.

The photograph seems to reference, almost helplessly, or perhaps slyly, the great boulders among shafts of paradisal sunlight and clouds and mountains in Ansel Adams's "Mount Williamson, Sierra Nevada, from Manzanar, 1944," reminding us once again of the argument being conducted and that a deep love of the history of her art partly informs McPhee's own work.

There are other thematic suites of photos in the book—the Mattie series; a mines and miners sequence that includes two photographs of old photographs left behind at the abandoned mines, one from a 1940s women's magazine and one from a 1970s *Playboy,* to provide another kind of meditation on time and photography; there is a brief sequence of fences in different weathers that puts one in mind of Monet's haystacks; a sequence on river restoration ("the civil rights movement we need in the twenty-first century," Bruce Babbitt said) and the endangered sockeye salmon; a butchered moose sequence; a winter snow sequence; and a final meditation on fire. They make an amazingly rich story about people and land and creatures, the past and the future. Near the core of it, through the figure of Mattie, is the lived life in this place: feet in a cool stream, a bored child in the front seat of a pickup on a hot day. Much of this sense of a present magically informed by history lies in the image, near the end of the book, of Mattie in her grandmother's wedding dress. The white billows of the dress resemble the billows of smoke from a midsummer forest fire on the page opposite. Attention, Simone Weil said, is prayer. There is an abundance of it here. *River of No Return* is a book to make you love the photograph and the book of photographs as an art form.

2008

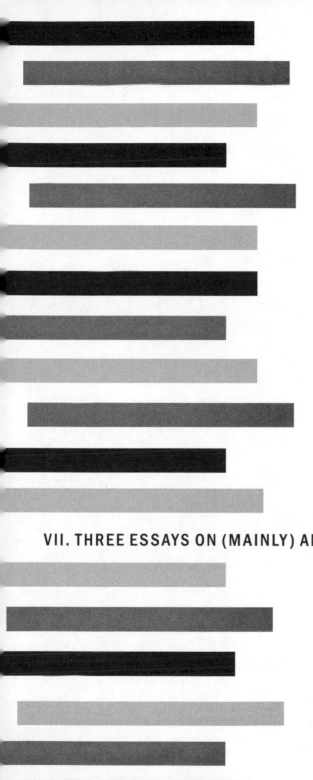

VII. THREE ESSAYS ON (MAINLY) AMERICAN POETRY

on teaching poetry

Note: This essay was written as a lecture to inaugurate an annual series of endowed lectures at Berkeley on the subject of teaching poetry. The series was established by the family of Judith Lee Stronach to honor her memory. Judith was my friend, an activist on behalf of human rights, nonviolence, women's issues, and poetry, which she had begun to write in the middle of her life. The lecture was delivered on an evening in early May. Judith had killed herself the previous fall.

Well, it is an honor to inaugurate this lecture series on the teaching of poetry, established to honor the memory of Judith Lee Stronach, and to be here among Judith Stronach's friends and colleagues, among my colleagues and friends and some of my students.

It's an honor and it's also a bit daunting to think about how to think about the subject of the teaching of poetry on this occasion and in this context.

Most of you know about—many of you have experienced firsthand— Judith Stronach's extraordinary generosity and the fierceness and steadiness and persistence of her commitment to others and to the life of the community, especially perhaps her work with Amnesty International and the Buddhist Peace Fellowship, and its magazine, *Turning Wheel*, the subtitle of which is *The Journal of Socially Engaged Buddhism* and for which she wrote articles, and then a column, on subjects ranging from a meditation class in a women's prison to political torture.

And you probably know something of the depth of Judith's commitment to poetry and to the possibility of poetry in many kinds of lives. The Stronach Prize, a gift of money and praise and encouragement aimed specifically at returning students, was one of her ideas. At *Turning Wheel* Judith also funded the Young Writer's Award. In the

early 1990s, she edited *Visible and Invisible,* a book of poems and stories by the homeless of Berkeley. She was on the board and a crucial supporter of River of Words, the environmental education project here in Berkeley that encourages children all over the country to learn about watershed stewardship and to find ways of expressing their experience of their environments in poetry and art. More to the point, Judith taught poetry herself in enough different venues to make clear what I meant by steadiness and fierceness and persistence. She taught poetry at the Women's Shelter in Berkeley, at the juvenile hall for girls in Contra Costa County, in the I Have a Dream program at Prescott Elementary School in Oakland, for three or four years as a volunteer poet in the school at Martin Luther King Middle School in Berkeley, and in the months before her death at Willard Middle School in Berkeley.

As a writer Judith came to poetry late—or felt that she had—and I think that was one of the reasons why she established the Stronach Prize, to give encouragement to others like herself who were perhaps rediscovering or a little belatedly discovering the force of the written word in their lives. I came to know Judith in the late eighties and early nineties when I began teaching at Cal and found myself for the first time in many years giving large lecture courses on poetry. Judith took to auditing my classes. She did so, I supposed then, for what I could give her in the way of information about the art of poetry, since I had been thinking about it in one way or another most of my adult life and she felt that she was catching up. But whatever her reasons, it was a pleasure for me to have an observer in the room, somewhere near my age, while I was trying out what was to some extent a new métier. And Judith, with her sure sense of style and her sense of humor, of the droll and the contradictory, was, in her way, very generous about it and very frank, quite free with praise and also with practical criticism and with argument. It was a very lucky thing for me. And it was what I thought of when I was asked to give this talk.

The next thing I thought of was more complicated. And that is the fact that Judith with her passionate love of poetry and her missionary zeal to bring it into the lives of others had taken her own life.

"What is poetry," Czeslaw Milosz wrote in his great poem "Dedication," composed in the wake of the terrible violence that the Second World War visited on Warsaw, "if it does not save people or nations?" Whatever poetry was to her—at least this thought crossed my mind—it did not save her.

Of course, one has no way of knowing. People who knew Judith only somewhat, as I did, understood that she struggled with depression. Most of us had no idea of the depth and intensity of that struggle and cannot know how long her love of poetry and her spiritual practice and her social activism and the deep gift of love in her life buoyed her up, kept her from being overwhelmed by whatever it was, the tide of suffering or injury or despair or self-violence that took her from us.

So this lecture series, the idea of honoring her memory in this place that she loved, for years to come, with a series of reflections on what we do when we teach poetry, what it does, how it is done, what gifts it confers, seemed to me a brilliant idea, a lovely idea, and a very fitting way to honor her memory, and also, to say the whole truth— and since it's poetry we're talking about, we're bound to wander as near the truth as possible—a slightly terrible one: a riddle about the nature of what we do, we writers and critics who profess literature, and what the limits are, and—for readers of poetry or gazers at paint- ings or films, listeners to music, for all of us who have found there comfort and consolation and instruction, unnervings, adumbrations of meaning, echoes of intuitions we hadn't even understood that we had—a riddle about where we go and what self or world we find in the vivid interiors of works of art.

One way for me to begin to think about that riddle was to wonder what Judith herself had said about what poetry meant to her—that is, the writing of poetry—and I looked to the beginning of her small book *Two Summers*. It was written in a time of trauma and of healing, after her mother died, and it is made of two sets of poems, one located in summer in the Hamptons and the other in Italy; it is a time of domes- tic peace and reflection, of the rich and not always easy healing inside a marriage after the trauma of a loss. "I was trying in my poetry to understand and get close to my experience," she writes at one point, "and then to find a language for it."

Not much information, but enough and of exactly the right kind to help us imagine in the voice of those poems someone who was com- ing into language and beginning to sink into it as a way of—I say "voice" but I really mean something more like the "sensation" of the poem, something conveyed unspoken in the speaking of the poems— emerging from shock. Emily Dickinson's line comes to mind: "After great pain, a formal feeling comes." That unforgettable line: you feel

it all through these poems of Judith's, especially in the beginning of her sequence.

She writes that she did not like these first poems so well. She felt they were too abstract and thought-bound. The poems written in Italy seemed more filled with what she called "the sensual reality of this sun-drenched life" and there was an emotional resonance in the poems of that second summer that seemed to her an advance.

That is what the prose tells us of her thoughts. But, with the poems, it is enough to give us a glimpse of what the practice of poetry was for her, a centering, a way of being clear-eyed, of discovering feeling in verbal rhythm, and—this is surely the paradox of poetry—of understanding and getting close to her experience. A paradox because it could as well be argued that language is not what gets us close to experience but what mediates between us and experience. Eating a peach, after all, is not the same thing as a description, however vivid, of eating a peach.

So the third thing I thought about, thinking about this lecture, was what I thought I was doing when I taught poetry in those days when Judith was listening to me and writing little note-critiques of my lectures. The phrase that came into my head by way of first handhold on the question was the title of a book of essays by W. H. Auden, a phrase that he borrowed from Shakespeare, *The Dyer's Hand*. In Shakespeare, I think, the phrase is connected to ideas of blood-guilt; in Auden it is connected to a notion of someone so immersed in their trade that they are permanently colored by it.

When I began teaching poetry, one of my doubts about my ability to do it had to do with the fact that I was never not interested in it, and so I didn't know how to put myself in the place of people who were bored or intimidated by it. My inclination, therefore, was not to go to the students and bring them along from my imagination of some place of trepidation or suspicion, but to assume their interest, and at Berkeley for the most part that's been a reasonable assumption.

In talking about this with Judith, I was able to quote a haiku that I love by the nineteenth-century poet Kobayashi Issa, which goes like this—seventeen syllables in the Japanese:

> The man pulling radishes
> Pointed my way
> With a radish.

Can you imagine the situation? The narrator of the poem is hiking along a road. He stops and asks for directions. And the fellow working in the field waves his radish—it's a daikon, one of those long skinny Japanese radishes—and says, "Oh, it's about four miles down the road on the left." That's my image of myself teaching poetry: I was the guy with the radish.

One of the pleasures of this poem is that it is written from the point of view of the traveler. And it is in the past tense. So, saying the poem, we are in the mind of the traveler after he has received directions from the farmer. One imagines a slight smile on his face as he records to himself his own observation of the farmer's small, revelatory gesture. It is the smile the poem gives us. And, as readers, we are in a position to notice that the traveler is doing what travelers do, noticing and telling afterward. It is, famously, one of the reasons for travel: to be given the fresh pair of eyes that an uprooting from our normal routines gives us. That is, the traveler in the poem is behaving exactly like a traveler in the same way that the farmer is behaving exactly like a farmer. Everyone, the poem observes, is subsumed to his element, and the metaphorical contexts of this observation are rootedness and uprootedness and also the seeking out of direction.

So it turns out to be a poem useful for thinking about the teaching of poetry in several ways. Because if I, teaching poetry, am the man pulling radishes, the students are the travelers asking for direction. And they are not just asking for direction, as students electing to receive an education are doing; they are also getting educated by their observation of the process. It is a useful thing for a teacher to remember, especially a university lecturer, that the students are learning not just from the content of your teaching, but from the privileges that go with the observer standpoint. They get to watch you with detachment, perhaps with amusement. They can listen with sympathy and without. One hopes that they are as alert as Issa, or that Issa's poem can instruct them in such alertness. Sometimes they would be inside the poems, learning what the poems have to teach, and sometimes they would be outside the poems, watching this person waving his dyer's or radish-puller's hand and giving them what he took to be directions.

It was therefore my plan, since it was my inclination, not to lecture much about the aims of poetry or the value of poetry or the nature of poetry, but to talk about poems, because, the truth is, I am much more

interested in poems than in the nature of poetry in more or less the same way that someone might be more interested in eating than the theory of cuisine.

Having said all this, I should add that, beginning to teach, I came to realize that I had forgotten my own experience. It's true that I was always interested in poetry, but it's not true that I was never intimidated by it. I had, in high school and college, skulked around the edges of what I understood to be the great modernist masterworks by Pound and Eliot and Williams and Stevens and Moore and others—feeling their importance, catching flickers of whatever it was that poetry held and that I desired—in some of the bits of them that I could make out, and wishing to be, though in a somewhat defiant way and with somewhat mixed feelings, the sort of person who could understand them.

I'm not sure what name to put to what I wanted. "Life" occurs to me, that they had more life in them than seemed available to me; for example, the poem by Ezra Pound, called "Alba," that goes:

As cool as the pale, wet leaves
Of lily-of-the-valley,
She lay beside me in the dawn

I loved that poem, I'm pretty sure, because no one had as yet lain beside me, warm or cool, in the dawn. If that was what poetry was about, I was definitely ready to sign up.

"Wisdom" also occurs to me, as the name of the thing I was hungry for. I remember an experience of standing in the library in my freshmen year of college and picking up T. S. Eliot's *Four Quartets* and reading in it and feeling complete incomprehension and a desire to be able to comprehend it or to find someone who could explain it to me, open it up for me, so intense it felt like physical nausea. Even though I didn't know what it was that I thought was in that poem. Not so much "life," perhaps, but knowledge of it and its great mysteries, love and sex and death and the amorphous and puzzling self and the meanings of suffering and injustice and the nature of things. Drawn to poetry by these strong but somewhat undefinable impulses, also perhaps by the fact that putting words down on paper and composing phrases in my mind seemed like something I could actually do, I came to the writing of poetry and the reading of poetry at more or less the same time, and I took to it, entered its terri-

tory more or less poem by poem, as this or that poem—lifeless words on a page—came alive for me. So it was very much my impulse in the teaching of poetry to pass on to my students in the classroom that experience, and so teaching poetry for me has been mostly about reflecting on what makes particular poems come alive to me and trying to convey that experience to others.

Sometimes the simplest way to bring a poem alive is to utter it. One way of thinking about what's special about poetry as an art that has lately occurred to me is that it's a kind of speech that's meant to be said by others. In most of our speaking—for example, "I need a job" or "I'll take the roast chicken with summer vegetables" or "You can have the car, but you have to be home by eleven thirty," we have no expectation that we are forming the utterance so that someone else will speak it. There are kinds of utterance and forms of writing that are designed to be easily remembered and repeated—"Waste not, want not," "*I* before *e*, except after *c*, or when sounded as *a*, as in *neighbor* and *sleigh*," "Reeds are round, sedges have edges"—but it is not necessarily part of their design that they be uttered. They don't enact the drama of their being spoken. It is the particular quality of song lyric, and poetry, and prayer, that they're said and imagined to be said. More than that, they're imagined to be said by almost any speaker and that speaker is expected to assume, to put on, the experience that the poem conveys.

So the aliveness of poetry begins with this primary act of identification and it enters our bodies that way, through its rhythmic character. We take in, put on, the physical breath of the spoken utterance. The example of this fact that I like to give to my students comes from a poem I fell in love with in high school, John Keats's "La Belle Dame Sans Merci." The narrator of that poem comes across a knight who is "alone and palely loitering" around a withered lake. The narrator asks him what his ailment is, and the knight tells the story of a beautiful woman, or some kind of female creature, who took him into her cave and made love to him and abandoned him before he woke in the morning; and he, the knight, can't leave the place because she might come back again. The poem is the still-adolescent Keats's metaphor for being consumed and paralyzed by ideal beauty.

Its great moment is its description of the wild creature's seduction of the young knight. It was the sexiness of the sound of it that caught my attention in an interminable, early afternoon English class in the springtime. The knight is describing how the woman came on to him:

> She looked at me, as she did love,
> And made sweet moan.

Say it aloud. "And made sweet moan." Enough to get the atten-
tion of any young man watching dust motes fall through sunlight in a
classroom. Say it again. "And made sweet moan." What you will notice,
if you articulate just the sequence of vowels sounds—anhhh, aayyy,
eeeee, ooooh—is that they begin in the far back of the throat, move to
the mid-back, to the mouth, and then breathe out through the lips, in
a perfectly modulated release of breath. That's one of the first things
poetry is: a physical structure of the actual breath of a given emotion.

And so the first thing for me about teaching poetry has been put-
ting that breath into people's bodies—either by having them say the
poem aloud, or saying it to them, or having someone else in the class
say it to them. Shall we visit Keats's line once more?

Say it again. "And made sweet moan." I've come to think that the
physical sensation—even if we read it silently, the mental equivalent
of the physical sensation—of the rhythms of a poem get planted in us
far more deeply than any ideas we may come to have about its meaning
and that, trying to bring poetry alive, we need to attend to them.

Another way: sometimes a bit of information is all it takes to
bring a poem into view. Take this little scrap of a song from one of
Shakespeare's plays:

> Golden lads and lasses must
> Like chimney sweepers turn to dust.

As a truism, set to a sweet lilt, this is a pleasing piece of writ-
ing. But to get the richness of it and to get something about the way
Shakespeare's verbal imagination works, a modern reader needs a piece
of information that was immediately available to an Elizabethan audi-
ence and has been lost to us. "Golden lad" was, in the 1590s, a term
for *dandelion,* and the word for the dried dandelion with its nimbus of
seeds that children like to blow into the air was *chimney sweep.* The
folk metaphor adds another, magical—rueful, sweet, terrible, tonally
complicated—layer to the poem.

One can stand back at that point and notice the way the language
works—the roundness of the word *golden* and the liquid of "golden lads

and lasses," and the difference between those sounds and the sounds of the *ch* and *sw* in *chimney sweeper.*

Or speak about symmetry and asymmetry in poems. For example, in the small rhythms of these lines, the poem begins on the beat— "Gold"—just as most rock and roll lyrics do: "We all live in a yellow submarine"; and the second line—"like chim"—begins off the beat, like a 1940s torch song: "Night and day, you are the one." It's the nearest you can come to doing a major and then a minor in the sheer rhythms of verse. That's one thing. Another is that the couplets lock the two together, which deepens the fusing, natural to metaphor, of the cycle of flowering weeds and of human life. And that rhyme, of course, "dust," "must," fuses the ideas of necessity and death.

One could talk about symmetry, asymmetry, inevitability, and surprise, and probably at that point it would be at least interesting to talk about social class and asymmetry. Another piece of information useful to students here (if they haven't read *Oliver Twist*) is the fact that chimney sweeps were typically children—young boys, children of the poor, sold into apprenticeships—and this should in turn remind us of all the contexts of *golden,* that it conjures not only the sun and high summer, but the luminosity conveyed by money. For us, latecomers to these lines, with a different, more fluid relation to social class, "golden lads and lasses" is likely to suggest any version of that golden blessedness when you are young and can feel that everything is there for you—all that's going to blow away.

So, in this case, teaching poetry is a matter of providing some information that makes the entire verbal texture of a poem more present and then calling attention to that texture, to the depth and swiftness and complexity of it when it's doing the work of poetry.

Another easy example is a haiku by the eighteenth-century Japanese poet Buson. It is a poem that didn't mean much to me the first time I came across it in translation. It goes like this:

> Pear blossoms,
> And a woman in moonlight
> Reading a letter.

Seventeen syllables in Japanese. What commentaries will tell you is that the seasonal references in haiku are intensely specific in Japanese poetry. Plum blossoms, as in Berkeley, mean mid-February. It's the blos-

som of the icy-sharp early spring. Cherry blossoms are late April and early May, high spring, and they have in Japan a rich range of accumulated symbolic meanings. Cherry trees were cultivated around palaces and in temple gardens. Pear blossoms are late; they're associated with the fullness of late spring and its warmth, going into summer, when the air seems to soften, so they have a kind of mellow association and are often connected to ideas of romantic love.

So the blossoms in this poem are white pear blossoms. Another fact that matters to the poem is that women of the court in the eighteenth century made up their faces quite heavily with white powder. Still another fact that's important is that Buson was, as well as a poet, one of the most important painters of his age, and one who was particularly fascinated with color. As soon as you know that, you know that the poem is a study in white. It's late spring, early summer. The air is sweet. There are white blossoms in the moonlight and under them a woman is reading a letter by moonlight. The paper is also white, like her face. And it's a private letter because she's gone outside in the dark to be by herself to read it. It's a love letter of some kind. And the moon in the sky is solitary and bright. So this is a study in white that is about desire and about the intensity of it figured as the first summery nights in late spring. The woman, in her isolation, could be a figure in a Hopper painting, but the aesthetic insistence of all the shades of white suggest Whistler's *The White Girl*. Three or four facts to call up the traditions available to a Japanese person reading the poem, and it is alive in front of us.

Another example of the way information can help involves Blake's great poem "London." Let me read it to you. It doesn't necessarily need anybody to bring it to life, so fierce it is, probably the greatest political poem in the English language, written at the time of the French Revolution, when rage was causing people to re-see the disparities of social class that were, in Shakespeare, almost facts of nature.

> I wander thro' each charter'd street
> Near where the charter'd Thames does flow,
> And mark in every face I meet
> Marks of weakness, marks of woe.
>
> In every cry of every Man,
> In every infant's cry of fear,

In every voice, in every ban,
The mind-forged manacles I hear:

How the Chimney-sweeper's cry
Every blackening Church appalls,
And the hapless Soldier's sigh
Runs in blood down palace walls.

But most thro' midnight streets I hear
How the youthful Harlot's curse
Blasts the new-born infant's tear,
And blights with plagues the marriage-hearse.

There is much for an attentive person to sort out in the poem, after having been taken by the hammer strokes of the rhythm. Though, when I first read it, I didn't understand how the images were connected, there was something about the clarity of the images, line by line, and the force of the rhythm and the fall of the rhymes that was thrilling. Later, studying the poem, the thing that interested me most was discovering a crucial revision that Blake made that altered his first writing of it. The first stanza in an earlier draft went like this:

I wander thro' each dirty street,
Near where the dirty Thames does flow,
Mark in every face I meet
The marks of woe.

Charter'd was a second thought, and *charter'd* had two meanings; one referred to the Magna Carta and the chartered rights of all free-born Englishmen, and the other referred to the charter of the city of London. In making the revision, he turned a protest against cruelty and squalor into a protest against an intentional human order—made by people, on purpose—that gives special force to the phrase "mind-forged manacles." Our first unfreedom, this line says, is the unfreedom in our own heads. From it springs a social order that allows us to live daily, obliviously, with the monstrous cruelty of the inequities of the distribution of social goods in the world.

Another example of the way in which information about revision,

even of a small detail, can bring a poem alive is one of the last poems written by Wallace Stevens before his death in 1955. He was, as you know, a vice president of the Hartford Insurance Company and he brooded over the nature of reality and the imagination's quest to define it in the weathers of New England. Like many New Englanders, he vacationed in Florida, whose palm trees symbolized for him some sensuous fullness of life that was only semiavailable to his Puritan temperament. So, just before his death, he could write a poem like this. It's called "Of Mere Being":

> The palm at the end of the mind,
> Beyond the last thought, rises
> In the bronze décor.
>
> A gold-feathered bird
> Sings in the palm, without human meaning,
> Without human feeling, a foreign song.
>
> You know then that it is not the reason
> That makes us happy or unhappy.
> The bird sings. Its feathers shine.
>
> The palm stands at the edge of space.
> The wind moves slowly in the branches.
> The bird's fire-fangled feathers dangle down.

One of the things I'm able to tell students about this poem is that when Stevens first wrote it, he wrote

> The palm at the end of the mind,
> Beyond the last thought, rises
> In the bronze distance.

And then he changed "distance" to "décor." It's as if he had, in one stroke, made the philosophical leap from Romanticism to postmodernism, from the idea of the meaning of the world as attainable but just out of reach to the idea of the world as a stage set, a set of fictions.

In a delicious book of interviews with people who knew Stevens—

including one with his chauffeur—I found out that one of his favorite
songs was "It's Only a Paper Moon." You know the lyric:

It's only a paper moon,
Hanging over a cardboard sea,
But it wouldn't be make-believe
If you believed in me.

And about the time that I made this discovery, I heard one of the
very elderly authors of that song—Yip Harburg, born in New York—
one of the last great songwriters of the generation that wore Hawaiian
shirts and smoked cigars and went to the track—being interviewed on
the radio. The interviewer asked him if the songs he had written many
years before still meant much to him, and he described himself going
into the room where his wife of however many years was sleeping and
serenading her with "It's Only a Paper Moon," and he sang it on the
radio. This was about ten years ago. I think he is now long dead. But he
sang "It's Only a Paper Moon" for Terry Gross in a growly, gravelly voice
with a young man's lightness, and he sang the phrase "Without your
love, it's a honky-tonk parade," as if *honky-tonk* were the most raffish
and up-to-date slang. "Without your love it's a melody played in a penny
arcade." One would have to explain to students that a penny arcade was
an antique version of a video arcade. Does everyone know the words?

It's a Barnum and Bailey world,
Just as phony as it can be,
But it wouldn't be make-believe
If you believe in me.

I could say to students: if you substitute *imagination* for *love,* you
have in hand one of Wallace Stevens's persistent thoughts about the
world, and our experience of it, and the nature of knowledge. *Bronze*
then becomes a word to think about, the bronzes of autumnal New
England and the sun-gilded bronzes of the tropics. We live, the poem
muses, in a bronze décor. And it contains a sort of final palm tree, and
a horizon, because in the imagination, which is really no space and
no time, there are nevertheless horizons. So one could say that post-
modernism has not so much superseded Romanticism in this poem

as swallowed it. Probably that bird in the palm with its fire-fangled feathers is the sun seen through palm leaves. It could be the sun coming up or the sun going down; you can't tell. In the imagination it could be both, and the fact that this was one of his last poems gives this ambiguity another resonance. To notice all this is to put someone's state of mind—or someone's construction of the fiction of a state of mind, that of a man who's worked at poetry his entire life, haunted by the mystery of whether language can get hold of existence at all—to put that poem, its breath, its second thoughts, its strange metaphor, into other people's possession. Something like this is surely the gift poetry gives us and that, teaching poetry, we give to others.

I want to share one more example with you to complete this impromptu anthology.

It's a passage from a poem of Judith's, which I was reading the other day that suggests one more way of thinking about how one might try to transmit to others what is most difficult to convey about the experience of poetry. Having picked up *Two Summers* to look at what Judith had had to say about what poetry was for her, I found myself rereading the poems. I was, at the same moment, teaching T. S. Eliot's *Four Quartets,* those poems that had been so mysterious to me when I was an adolescent. I have come to understand them a little, to love the poems in certain parts and hate them in others. Students still find them quite fascinating, moved by, among other things, I think, as I was, a sense of their gravity and depth, and I always sense the intensity of their—*interest* is not quite the right word; the right word would split the difference between *curiosity* and *desire,* if the object of desire was unformulated. So, in that case, one wants to give students the poem, to give them one's own access to the poem and also to stay out of their way, to not overformulate the poems in a way that would give them the impression that the poems were a closed book, fully understood, settled in some way by the shelves of commentary in the library, so that they did not need to bring to them their own best resources.

And I thought I found a way of doing that this time because I recognized in the second of Judith's *Two Summers* poems very distinct echoes of *Four Quartets.* Eliot has things to say in these poems. And poetry, to my understanding, is not about saying things, though obviously poems that have interesting things to say are more interesting than poems that don't. And it is not quite accurate to say that they are about dramatizing

the act of saying things or, in the case of an inward poetry, thinking things or, in a quicker and more visceral poetry, perceiving or sensing things. Or at least saying that poetry does these things only takes us partway into them. To go the rest of the way in, one needs a formulation that somehow says that poetry inhabits the interior of the rhythm of its way of seeing, its way of dramatizing what it is to say a thing, or think it, or perceive it, or—taking writing as an act like painting—do it.

In the *Quartets* Eliot is thinking about and has things to say about time. When he was a young man in the 1910s time had been an important philosophical subject and Eliot had, in a postgraduate year in Paris, heard lectures on the subject by the French philosopher Henri Bergson, whose thinking about time had also influenced Marcel Proust. Bergson's subject was lived time, time almost as the fluid we swim in. What the lectures meant to the young Eliot I am not sure. To the middle-aged man in the middle of a war who had survived a very painful marriage that had left him with feelings of irreparable guilt, who had articulated for a generation a sense of chaos and hopelessness and had found his way to Christianity from a longing for order and meaning, and whose path as an artist had taken him to the particular effort at plainness in these poems, time is a resonant subject in ways most of us, I think, recognize instinctively without recourse to philosophical definitions of *temps durée*. In the second of the poems, "East Coker," Eliot puts his subject this way:

> Home is where one starts from. As we grow older
> The world becomes stranger, the pattern more complicated
> Of dead and living. Not the intense moment
> Isolated, with no before and after,
> But a lifetime burning in every moment
> And not the lifetime of one man only
> But of old stones that cannot be deciphered.
> There is a time for the evening under starlight,
> A time for the evening under lamplight
> (The evening with the photograph album).
> Love is most nearly itself
> When here and now cease to matter.

One of the traditional ways of teaching poetry is to discuss, to explicate, what Eliot is saying here to make sure that students (and

the teacher) understand what's being said, for the reason that what's being said might be useful to them. And one can try to characterize the feeling of what's being said. And leave it at that. In fact, in teaching poetry, that is quite often what we settle for. We hope that the deeper thing that we can't communicate has gotten communicated, passed directly from the poem to the student reader without our aid or interference. We do what we can with content, especially if, as in this case, the content is rich, psychologically or philosophically. And we do what we can, harder but still manageable, with affect. And we leave the deeper thing in the work of art, which is also famously the most ineffable, its tone or mood, which is like a sensation of echo, which we often take away quite mutely and quietly, in the same way that people do coming out of a concert hall or a theater. In those deepest reaches of a work of art, the truth is that we mostly cannot teach.

But a way of teaching there is by teaching echoes. The deepest response to a work of art is, in fact, another work of art, and occasionally we can find ways of gesturing toward that transmission. The past, Eliot had said elsewhere, is modified in the guts of the living. The way a new work of art grows out of an old one is an instance. It is a process of transmission much like transmission in spiritual traditions and in crafts like painting and acting. I once stood outside a classroom in New York City waiting to pick up a friend who was taking an acting class. I listened from the hallway to the last moments of the class. I had been told that the instructor had studied with Uta Hagen, the actress who had been in the class taught by Lee Krasner where she and Marlon Brando had done a first sight-reading of Tennessee Williams's *A Streetcar Named Desire*. My friend was receiving a transmission. I once heard Ezra Pound's daughter read her father's poems (on a sunlit fall afternoon in California where squirrels were chasing each other in an oak tree outside the large window behind her and the sunlight glinted in those strands of silk insects produced on oak trees). I had heard recordings of her father reading his poems and I had also heard recordings of William Butler Yeats—who was tone-deaf and had a particular very musical way of chanting the cadences of his poems. Pound had picked up from his elder mentor Yeats exactly his cadence, and Mary de Raschwitz, Pound's daughter, had picked up his cadence, so that almost three-quarters of a century after Pound met Yeats in

London and half a world away, that rhythm of hearing the movement of language was still alive and still being transmitted. It was one of those echoes that I thought I heard in Judith's poem.

The last of the quartets, "Little Gidding," centers on the ruin of an old Roman Catholic church associated with Charles Stuart. The narrator of the poem is at once a traveler and a tour guide to this place on a sunny day in midwinter, with brilliant light blazing on the ice, so that wet and cold and fire are gathered to a single image, to a psychological as well as a physical place that seems to be a midwinter summer—outside time, cold and burning at once:

> If you came this way,
> Taking the route you would be likely to take
> From the place you would be likely to come from,
> If you came this way in may time, you would find the hedges
> White again, in May, with voluptuous sweetness.
> It would be the same at the end of the journey,
> If you came at night like a broken king,
> If you came by day not knowing what you came for,
> It would be the same, when you leave the rough road
> And turn behind the pigsty to the dull façade
> And the tombstone. And what you thought you came for
> Is only a shell, a husk of meaning
> From which the purpose breaks only when it is fulfilled
> If at all. Either you had no purpose
> Or the purpose is beyond the end you figured
> And is altered in fulfillment.

This is Eliot, the artist who turned from the wild and expressive disjunctions of *The Waste Land* to the philosophical verse of these later poems with its dryness and steadiness of tenor. The second-person address seems that of a man speaking to himself about himself and also a voice urging the reader to feel that the experience being described is everyone's experience of journeying, intuitively and a bit blindly, toward some personal meaning.

Earlier, at the beginning of the first poem in the sequence, "Burnt Norton," there is another passage—the one that initiates the poem—that is a more abstract statement of this theme. It is the passage about time

that undergraduates have been explicating for fifty years, encouraged (or tortured) into wrestling with the passage by people like me:

> Time present and time past
> Are both perhaps present in time future,
> And time future contained in time past.
> If all time is eternally present,
> All time is unredeemable.

My desire and bewilderment at nineteen had specifically to do with the feeling that I would never understand what that sentence stood for. I see now that I could only have felt that way if I had already understood the feeling the lines communicate, the quiet dryness and the perplexity at the circularity of thought and the implicit desire for escape or change. And now, also, I think I do understand the lines a little. If one thinks about personal loss, about Judith Stronach, for example, and the difficulty of getting beyond it, and imagines a poetry written by someone who wanted to strip away all sensuous detail, who imagined that sensuous detail didn't need to be there anymore or didn't imagine that it needed to be there, who in a certain way chose to fail to imagine it from a barrenness of grief, one might see how Eliot would come to the desire for an idiom such as this, and would proceed from it in such a way that the sensuous world we hold in the mind would enter the poem only through memory and as it needed to:

> If all time is eternally present
> All time is unredeemable.
> What might have been is an abstraction
> Remaining a perpetual possibility
> Only in a world of speculation.
> What might have been and what has been
> Point to one end, which is always present.
> Footfalls echo in the memory
> Down the passage which we did not take
> Toward the door we never opened
> Into the rose garden.

Now I tell the students that T. S. Eliot grew up, one boy among three sisters, in a large house in Saint Louis that had a large yard with a hedge and a garden wall and a school for young girls on the other side of the wall whom the young Eliot could hear at their games and with whom he was not allowed to play. It is information that has helped me with these lines:

> But to what purpose
> Disturbing the dust on a bowl of rose leaves
> I do not know.
> Other echoes
> Inhabit the garden. Shall we follow?
> Quick, said the bird, find them, find them,
> Round the corner. Through the first gate
> Into our first world, shall we follow
> The deceptions of the thrush? Into our first world.

When I read these lines now, I also hear the echo of a poem of my wife's that I love. In the first poem in her *Death Tractates*, a sequence of poems about grief at the loss of a close friend and mentor, there are these lines in which the speaker addresses some of the birds of our California coast as if they might be spirit guides, in that way that grief has of looking for signs everywhere:

> Tell now red-tailed hawk
> (for we have heard the smallest thing cry out beneath you):
> have you seen her?
> (Red hawk). Thrush walking up
> the ragged middle:
> have you seen her?

This gives a glimpse of the afterlife of the poem, a sense of its transmission, and it also supplies some literal help with Eliot's phrase "deceptions of the thrush." It reminds me that, in California in the early spring when the thrushes, birds that are rarely visible, build their nests in the thickets along the sides of roads and paths, they will sometimes break out of the thicket when walkers approach and walk down the middle of

a path, trailing a wing, as if injured, to lead the intruder away from the nest. So the deception of the thrush is literal. Though Eliot's anguish took the form of ascetic longings and it is likely that he also meant the figure to imply being deceived by nature and distracted from the demands of spirit. But back to his lines:

> Into our first world.
> There they were, dignified, invisible,
> Moving without pressure, over the dead leaves
> In the autumn heat, through the vibrant air,
> And the bird called, in response to
> The unheard music hiding in the shrubbery,
> And the unseen eyebeam crossed, for the roses
> Had a look of flowers that are looked at.

And a bit later:

> Dry the pool, dry concrete, brown edged,
> And the pool as filled with water out of sunlight,
> And the lotos rose, quietly, quietly,
> The surface glittered out of heart of light,
> And they were behind us, reflected in the pool.
> Then a cloud passed, and the pool was empty.
> Go, said the bird, for the leaves were full of children,
> Hidden excitedly, containing laugher.
> Go, go, go, aid the bird: human kind
> Cannot bear very much reality.
> Time past and time future
> What might have been and what has been
> Point to one end, which is always present.

Writing criticism, I would want to make the fullest account that I could of my own understanding of these lines. As a teacher, I don't necessarily want to do that. Or I don't always want to do it. I am inclined to do it sometimes to model for my students how I go about thinking through a poem. But in teaching I think I am often more concerned with bringing them to the poem, to the intensity of life in the poem, in a way that will make them want to do their own thinking about it.

And sometimes setting one poem next to another, showing how the difficult-to-communicate depths of a poem get passed from one writer to another, can be a way of doing that. Which is why I want to end by reading you part of a poem of Judith's called "Every Word Leads to Every Other and No Spaces in Between." Imagine now an American woman in Italy, having read *Four Quartets* and having had some experience of Buddhist practice, thinking about her life and, like Eliot, trying to understand it as a path.

> We do not speak of geography,
> So shortcuts cannot affect our way.
> I cannot even permit your saying, "No shortcuts,"
> because the blackbird must sing three notes,
> before it sings a fourth,
> because there are (movements
> to be passed through)
> no shortcuts,
> because the bubbles that rise to the pond's surface
> must work their way through the lily roots
> and each concentric circle touch the shore.

I think any attentive reader will hear what the poem takes from Eliot. It is somehow in the tone of Eliot's verse or of his syntax that the arrival desired and described is already there in the feel of the poem, delicately and precariously, before the arrival at a kind of peace, a place of rest, is announced. It is that combination of straightforward saying and the quiet of the just-sketched-in physical details and the precariousness of its sense of spiritual peace—as if it were a saucer brimming with water that needs to be carried carefully so that it doesn't spill— that I hear in Judith's poem. Listen:

> This is not geography,
> because we cannot foretell
> where we are going,
> seeing as how we are carried
> and know only where we have come,
> if we are lucky
> by where we were last.

The rose leaf has no destination
when it drops through the trellis
and could not land on the bench
without drifting by the hedge
and does not after all stay

anywhere. A breeze lifts it
beside the cat who comes round the corner
of the hedge to find the lizard,
a surprise impossible to fall upon
by crawling through the hedge
with any idea of shortcut.
I find myself
In a garden of no geography,
And could not have come another way
When I did not even know
This as a place where we would arrive.

I think I can end there.

2003

families and prisons

I've had it in mind to write something about an odd and very particular subject—some of the emotions that arise from the representation of family relationships in recent poetry, or perhaps I should say autobiographical representations of family in recent American poetry. I even had a title in mind, if it were going to be a straightforward historical investigation of the subject: "Poor Monkeys and the White Business in the Trees." I can think of good reasons not to write about this subject—one of them is that "subject" never seems to be a very fruitful approach to poetry—so let me mention some reasons for it.

One is that there is so much autobiographical poetry about families, and another is the fact that, in the history of poetry, it is such a new subject. Which is surprising when you consider that family is one of the fundamental subjects of literature. Almost all the great Greek tragedies are about families, and so are many of the great novels of the nineteenth century. The greatest American play of the twentieth century is about family—take your choice among the ones worth reading, *A Long Day's Journey into Night, Death of a Salesman, The Glass Menagerie, A Streetcar Named Desire.* Even *Who's Afraid of Virginia Woolf?* is about family rather than a couple, because an imagined child is at the center of that play. And the best American novel of the twentieth century—here you choose, I suppose, between *The Sound and the Fury* and *Absalom, Absalom!*—is about family. And yet before the appearance of Robert Lowell's *Life Studies* and Allen Ginsberg's "Kaddish," it's hard to think of a serious work in poetry, except for half a dozen poems by William Carlos Williams, that touches on the subject, even though it has, in the last thirty years, become fundamental, as commonplace and omnipresent a subject in American poetry as erotic love was in the sixteenth century or man's relationship to God in the sev-

enteenth. American students of literature may know something about Allen Ginsberg's Aunt Rose or Elizabeth Bishop's Aunt Consuelo, but it is a fact that they can learn nothing from the body of past literature about the aunts or grandmothers of John Donne, Thomas Traherne, Anne Finch, Alexander Pope, Samuel Johnson, Thomas Grey, John Keats, Emily Dickinson, or Robert Browning. It's also the case that it is an almost exclusively American subject. American poetry is full of aunts and grandmothers, but French poetry isn't, or Serbian poetry, or Arabic or Brazilian or, for that matter, English poetry.

So an explanation for this phenomenon would seem to have to do with American culture and American mores. It may possibly have to do with the fact that class is a somewhat less explosive subject in American society than in most other literate societies. It may be that it's a little easier to talk about family, if you want to, without seeming either to be bragging or complaining. It's possible that family life is more important or less important in American culture than in other cultures in some way that makes it a subject. It's possible that the family has shrunk to the unit of parents and children in a way that makes parent-child relationships loom larger in the imagination. This unit of parent and child has come to be called in the last decade the nuclear family, borrowing a metaphor from the physics of matter, and the associations of that metaphor may not be an accident. There may be something about the middle-class family in the post-Hiroshima era that gives a certain sense of nakedness and peril, some desperate absence of assumed context, to postwar American life, that made this subject seem pressing. And the growth of psychiatry and psychoanalysis in the twentieth century, the idea that the roots of human unhappiness can be uncovered from an examination of childhood, must certainly be part of it. But, whatever the causes, the fact is that many American poets have wanted to write about the families they live in and the families they grew up in, and that seems not to be so of other cultures.

I remember, a few years ago, hearing an American poet who has tried to write seriously about politics quoting with some relief and approval a Peruvian poet who said he had no stomach for Americans and "their little, personal poems." Another version of this reaction comes from a Czech poet who is supposed to have said of an American woman writing in the autobiographical mode, "That's not poetry; it's gynecology." Like the original scandal of Walt Whitman's *Song of*

Myself, the implicit and explicit self-absorption of much of this poetry remains—not for American culture at large, which in this case shares and mirrors the preoccupation of the poets, but for international intellectual culture—something of a scandal.

Still, it's not autobiography that I'm concerned with, but the subject of family in autobiography. What distinguishes writing about family from writing about other relationships is the presence, I think, of the idea of the child. Even a poem dealing with two adult sisters is *about* sisters because a shared childhood is implied. Which is why one term of this talk might have been *poor monkeys. Poor Monkey* is the title of a study of childhood in literature by an English scholar, Peter Coveney. The phrase comes from Shakespeare's *Macbeth.* Young children rarely show up in the art of the Renaissance, and so we get a glimpse, a bare glimpse, of the feeling that attached to them in the one phrase uttered by Lady Macduff in response to the bright chatter of her young son who has been left undefended by his father and is going to be killed by unloosed Macbeth's rage. "Now God help thee, poor monkey," she says.

It is the pathos and tenderness in that phrase, the emotions called up in literature by familial feeling, that interest me. Another emotion connected to family feeling is rage, and all the buried forms that that emotion can take. I should say that my thinking about these feelings isn't disinterested. I've written in the past about family life from the point of view of a parent. I have only lately been trying with some difficulty to write—I don't know if *about* is the preposition I want; perhaps *in* or *with*—some of my childhood experiences. In my early childhood my mother was chronically alcoholic, which filled my days, or some of them, with instability, sorrow, and some terror. Also, and more problematic for a writer, a certain amount of amnesia. This is the context that led me to this subject and also the cause of a certain mild suspicion I have of my own motives for wanting to talk about it. So let me list a quick series of thoughts I've had about the first subject, the child in literature:

The subject of the child enters literature with Romanticism, which is also to say that it enters literature when the middle class becomes its main creator and audience;

So its appearance is connected to most of the propositions of Romanticism—subjectivity, radical freedom, radical inwardness, sincerity, visionary innocence, transparency of language, realism as a mode of representation;

So it is also connected to Romantic political thought; that is, the child emerges not long after the idea of the rights of man emerges; the kind of political feeling that descends to us through Blake, Dickens, Hugo, Dostoyevsky, and Chekhov braided together our feelings about the abuse of power and the abuse of children; *Oliver Twist* can stand for this, or *Les Misérables;*

An even more brutal simplification: Romanticism invented psychoanalysis, which has, if not shaped, deeply colored our way of thinking about the child, the family, and the human person;

The child actually appears in English literature in the latter part of the eighteenth century in what is often called the age of sensibility, at the same time as work associated with the development of the Gothic novel, and the literature of sentiment, and the theory of the sublime; it has had this association with tears and terror, sentimentality and awe; so there is always this suspect sentimental side to the subject;

The literature of sentimentality emerged when the middle class emerged and when mercantile imperialism was well under way; the child emerged in literature—Blake saw this in a flash and so in his way did Dickens—shadowed by a dark, unhappy child who was elsewhere; the age of the child was the age of revolution and the age of slavery.

These observations, hunches, are drawn from a sense of the history of literature; what their active use to a writer is I'm not sure. There are other kinds of observation to draw on as well. That feeling of pathos, the lump-in-the-throat feeling that shows up in movies about families is at least one of the elements of an actual social bond, of a particular imagination of civility, morality. Tears in a movie theater: some part of one's mind always feels immersed in this sea of tender, bruised feeling with its heavy tidal surgings and withdrawals, and some part of many of us—Oscar Wilde on Dickens's Little Nell—is made uneasy, demurs. A few years ago in a divorce court I saw a young woman sitting in the courtroom, well dressed, back straight, ignoring the proceedings and reading a book with a title like *How to Survive Unspeakable Psychological Pain.* Outside in the corridor there was a young man in a baggy suit sitting on the polished oak bench, bent over a laptop, intently performing what looked like complicated equations: the husband. It seemed funny and perhaps sad, and then when one instinctively thought that there were children involved, probably two, probably under eight, being kept for the day by the wife's sister, a

different emotion qualified the scene. You see what interests me about this. Families are built around a core of very painful wishing. It's palpable in the atmosphere of the world we live in.

One more element in this survey, a more writerly consideration. I have been reading an extraordinarily interesting critical book by Wendy Lesser called *His Other Half.* It's about male artists writing about women, and in a chapter about writers who write about their mothers, she remarks that we are always in such work in the presence of a split subject, of a division between the point of view of the adult writer and the point of view of the child self. And, of course, she points out that child self is irrecoverable, it can only be approximated in language, the way the taste of a pear can only be approximated, or something seen in the street. As for the adult self, every word one writes issues from it presumably, but if one turns one's attention to it directly, one sees that it is also unknowable. It's busy creating itself, and when it interrogates the child self in that process—did this really happen? is this how it was?—it gets, of course, no answer. That's how the literary history comes to be important. The gaps in the act of writing where the unknowable and the irrecoverable occur are rarely empty; one's unconsciously absorbed sense of the territory, in the form of genre, ideas, emotions, even phrases, rushes in to fill that void. It's how tradition actually works on the individual talent and it's why literature most often reproduces literature.

Anyway, you can see why a writer might take a practical interest in this subject and I will come back to it, but I want to turn now to the matter of self-justification. The French poet Pierre Reverdy remarked that all talk about poetics by poets is more or less indiscreet praise of one's own method. This is no doubt true, though not flattering to one's sense of disinterested inquiry, and it is only partly true. Poets, like painters, film-makers, have had things to say, beyond themselves, about the uses and the power of their art, and they've also, consciously and unconsciously, found ways to express their uneasiness. I read recently a lecture by the poet W. D. Snodgrass on *A Midsummer Night's Dream.* At a certain point in the lecture he writes: "The artist's open rendering of his emotions may have such unpredictable effects on the public that totalitarians from Plato to Stalin have been willing (with some justice) to muzzle or exterminate these unacknowledged and unconscious legislators." It's interesting to me that Snodgrass might have characterized poetry in various ways, and he chose to describe it as having to do with "the artist's open

rendering of his emotions." Snodgrass was especially thought of in 1974 as one of the initiators of what was called "confessional poetry," so his definition of the danger of art might be what Reverdy had in mind. He's found a way to flatter poetry by enlisting its powerful enemies.

But about Stalin, Snodgrass was absolutely right. He had Osip Mandelstam and Isaac Babel exterminated, just as Lenin had Nikolai Gumilev exterminated, who died before a firing squad, with a volume of Homer clutched to his breast. There are poets in jail in the Republic of Korea right now, and it is at least arguable that our tax money helped to put them there. There are poets in jail in Iraq and Syria and China and it seems likely that before long there will be poets in the prisons of Kuwait. It's possible to argue that these poets are the victims of their own success and that the only reason they are in jail is that they have succeeded in deluding their rulers into the conception of their importance that put them there.

It is a complicated matter, thinking about poets in prison, once you have said that they shouldn't be there and that civilized people should be doing something in their lives to get them, and all other political prisoners, out. One of the Korean poets who was in jail in 1986 when I was in Seoul to participate in an international conference of writers on the freedom to write was a young man named Kim Nam-ju. Last name Kim, as Korean custom is, first name Nam-ju. Kim Nam-ju had been in prison for three years, was permitted the use of writing materials for an hour once a month, was reported to have blood in his urine and no access to a doctor. The Korean government allowed members of our group to visit him and spoke in general terms of forthcoming amnesties as the process of democratization and reconciliation progressed, but they did not release him from jail, and there were intense discussions among the visiting writers about whether it was appropriate to attend lavish banquets sponsored by Samsung and Hyundai so long as he was there. The argument had basically to do with whether we would do the writers more good by being polite to our hosts or rude to our hosts. Perhaps to sharpen the issue, the imprisoned writers announced a hunger strike. In the end the Americans, West Germans, Poles, Swedes, Danes, and Norwegians boycotted the banquets. Everyone else attended; the French, English, Japanese, Yugoslavian, and Canadian delegations were particularly eloquent on the subject of diplomacy and scornful of what they called "moral showing-off." Or so a French phrase was

translated. It was interesting to see writers from all over the world lobbying each other, in the corridors of a hotel named after an American general, about whether it was better to kiss the dictator's hand or not kiss the dictator's hand in order to get their colleagues out of prison. It was an argument, I suppose, that had to occur. And afterward some of the poets sat down in the hotel to feasts of *bulgogi* and fresh fish and fowl, pungent with the odor of Korean spices, chili, and pickled cabbage. A Russian poet who has taken political risks in his life sat down to those meals and so did a very good Japanese novelist known for his tormented conscience. The others, the dissenters, went out to dinner instead. One has to eat, and they ate in alleyway restaurants where the fish was so fresh the waiters brought to the table as a first course pieces of the tentacles of octopus, carefully cut and still squirming.

I did not get much of a sense of the poetry of Kim Nam-ju. It was, of course, unavailable. The few poems I did see were unpublished English translations of what seemed like youthful work. There was a description of a field, I remember, seen from a prison train, a sense of homesickness. Another poet who was in jail had been imprisoned for a violation of the publishing law because he'd printed a book-length poem about a farmers' revolt in 1947 on an island on the southern tip of Korea. It was a sensitive subject. Korea, as you know, was occupied by the Japanese from 1905 to 1945, and no society is ruled by an invading power for that long without a lot of collaboration and bad conscience. I helped translate the peroration of his long poem, working in a hotel room between convention sessions with a very brave and intelligent Korean poet. "And so," it began, as I recall, "the authorities who were the running dogs of Japanese imperialism / changed their uniforms and became the running dogs of American imperialism / I write this down in 1986 when the blood of Korea cries out / and the tears of Korea burst forth." The language of the literal translation sounded to me like the slogans one saw on the banners at student demonstrations. My cotranslator had expressed no opinion about the quality of the poem. I asked him if its language was interesting in Korean. He smiled at me, nodding, as if he had an amused, distant recollection of the state of mind in which one might ask such a question, and then shrugged and said that the language had a certain vigor.

When I was in Yugoslavia in 1982, the poet who was in jail in Belgrade was named Gojko Djogo. He wrote in Serbian, and he came

from a peasant family, I was told, in Bosnia-Herzegovina, and, because of his background, he had been especially encouraged. His first book was published when he was quite young. His second book was approved for publication—by then he lived in Belgrade—but when it appeared in print there was a line in one poem that had not been in the approved manuscript. It was a nightmarish poem and it ended with a line about "a one-armed monster in Liberation Square." Serbian poetry is surreal, but everyone knew that Marshal Tito had lost an arm in World War II, and Djogo went to jail. I know a Cuban poet who was in prison for seven years and was released on several conditions, including his refraining from reading his poems in public. He immediately read his poems in public and went back to jail for, I think, five more years. His poems, I am sorry to say, are terrible. There is fairly wide agreement among people competent to judge about this point. His story belongs to the history of courage rather than to the history of literature.

I'll tell you a story that may or may not be true because it belongs to the history of marvels. The French poet Robert Desnos was in Buchenwald, not because he was a poet but because he was a Jew. The story is that Desnos and all the men in his barracks were marched to a room and told to strip in preparation for being deloused in an adjoining room. They understood what that meant, and Desnos turned to the man next to him and said, "I read fortunes. Let me see your palm." The man, stoop-shouldered, eyes wet with fear, held up his palm. Desnos looked at it and shook his head. A long lifeline, he said, but I see trouble in business down the line and trouble with your daughter. The man, stunned at first, laughed. And others laughed. And soon all the men in the room were standing around naked, laughing, with tears in their eyes, reading one another's palms. The guards were so disconcerted that they ordered the men to get dressed and marched them back to their barracks. The next day a transfer order came through and many were sent to a work camp and some survived to tell this story. Desnos was not among the survivors. Surrealism began with the idea that freedom of imagination could transform life, and in this instance, if the story is true, it did.

Many of you must know by now the story of the Russian poet Irina Ratushinskaya, who composed her poems in prison, sometimes by scratching them with a matchstick on a bar of soap. It is a story people like to tell, and it has crossed my mind to wonder if it would have made any difference in the telling if the poems were terrible, or simply mediocre, heart-

felt, and full of clichés. Tadeusz Borowski, the Polish writer who wrote the brilliant and terrible stories about Auschwitz published under the title *This Way for the Gas, Ladies and Gentlemen*, also wrote poetry when he was in the concentration camp and what interested me about it was how conventional it was. The moonlight in the barracks was "ghostly," the sheets were "lambent," the silence "deep." And so on. It seems the lines could have been written by any undergraduate about his dormitory room. And, later, after the war, in a DP camp in Germany, having survived the inferno and witnessed its workings, he wrote bitter poems against the new order he saw emerging in the occupation, and the symbol of it in the poems is ugly, laughing, black American GIs consorting with blond women in the cafés of Berlin. There are not many of these images in the poems—perhaps three or four—but they are enough to demonstrate that the experience of Auschwitz didn't necessarily cure racism.

Which brings us to another famously imprisoned poet—Ezra Pound. And to an interesting question. If an American poet—perhaps she developed an interest in Sufi mysticism—were living in Baghdad, were pro-Palestinian, knew a little Arabic, had translated poets of the Taf'ila Movement in Iraq, and, having been treated well by the Baathist government, believed in Saddam Hussein's anticlerical, anticommunist approach to Arab socialism, and even wrote a little book published by a small press back in the States comparing Saddam Hussein to Thomas Jefferson, describing him as a sane, tough-minded, disciplined, and visionary politician, if this woman (how could she be so stupid?) had during the recent war made radio broadcasts from Baghdad denouncing the war and Bush and the oil companies and the coalition, would she have been guilty of treason? Should she have been locked up in a facility in Basra and brought to Washington, charged with her crime, allowed to plead insanity to save herself from hanging, and been put into a relatively pleasant mental hospital (of course, this assumes that the government still maintained such institutions, had not yet discovered the therapeutic benefits of the streets) for ten years or so? Pound, after all, was not arrested for the anti-Semitic poison that seeped from him in the Rome broadcasts and for which I think I have always vaguely imagined he was punished and deserved to be punished; he was charged with betraying his country, because he didn't like the war and was on the other side. It is quite possible to argue that he should not have been, and to add the United States to the list of countries that imprison their poets.

And there are more stories, the brave and rather old-fashioned Hungarian poet Tibor Tollas in 1956 reading the English poet Thomas Hood in a jail cell and pacing to his rhythms, the very good Hungarian poet Miklos Radnoti dead in the camps, the Greek poet Yiannis Ritsos imprisoned for communism, the Turkish poet Nazim Hikmet for communism, the Peruvian poet César Vallejo for communism, and, finally, indelibly, the Russian poet Osip Mandelstam for anticommunism.

If we tell these stories, if we mention the great poets and the poor ones, if we recall them in some detail, Mandelstam jumping from the window of a psychiatric hospital to try to kill himself, writing odes praising Stalin to try to save his skin, hounded from town to town with his wife, writing those stinging last poems; the family of Kim Nam-ju getting up subscription dinners in lower-middle-class restaurants in Seoul to finance a petition for his release; Pound writing poems about angels and light in Saint Elizabeth's Hospital while taking a lively interest in the John Birch Society; the untalented Cuban poet reading novels aloud to his illiterate cellmates—they look more and more like the spectacle of human life, and less and less like the special distinction of poetry.

Not that heroism and the task of witness have not fallen to poets as they have fallen to others, but that, when we survey the scenes evoked by W. D. Snodgrass, we see that this heroic circumstance is mysteriously like everything else—that some poets with a great gift might lack courage and some with the courage might lack the gift; that some were steadfast, some faltered; some were duplicitous and redeemed themselves; some were pure victims, helpless as crickets in a cage; and some were wrong, and did harm. A few of their stories belong to the history of literature, some to the history of contrariness, valor, cowardice, to tragedy, and to loss so sickening and pointless it is not tragic.

I have found myself thinking often about the figure of Mandelstam—or rather about people thinking about the figure of Mandelstam. There is hardly a poet alive, it seems, who has not written a poem about him. Since most of us know his difficult poems mostly in translation, this strength of feeling about him is to some extent a tribute to his wife's art—to the power of her portrait of him—rather than to the poems themselves. He is a tremendously moving figure. But I am made uneasy by our fascination with him for a couple of reasons. The first is the suspicion that our fascination exists because his martyrdom flatters us. One stubborn poet hunted to death like a wild

animal by the organized violence—the *intellectual* violence as well as
the police power—of the state. It is a compelling image in this cen-
tury. But what I fear is that in our admiration for this image there is
a confusion between the task of poetry when it finds the burning coal
of history has been pressed to its lips and the task of poetry in general.
The danger of this is that there is something wrong with admiring the
calamitous. Also to mistake the power of poetry in our need to praise it.
Writers, like everyone else, need examples to teach them courage and
responsibility—Akhmatova waiting outside the prison wall in Moscow
for news of her son, Whitman in the hospital wards of the Civil War, Ai
Qing nursing the socket of his blinded eye in the wake of an attack by
young Red Guards and continuing to work on his poems—but poetry
needs to be able as well to face toward the world when no one's suffer-
ing gives it special drama. (But someone's suffering is always giving it
special drama, so perhaps the falseness is in the sense of specialness.)

Let me read you a fragment of a poem that haunts me when I think
about this subject. It was written by Czeslaw Milosz in 1943 during the Nazi
occupation of Warsaw. The poem is called "The Songs of Adrian Zelinski."
Milosz used the figure of Zelinski to write poems that do not rise to the
occasion of history, that are spoken by someone who simply feels cursed at
having to live in an ugly, dangerous time and place. Zelinski mostly doesn't
think about others; he just feels sorry for himself. I'll read you a little of a
translation of the beginning of the poem to give you the flavor of it:

The fifth spring of war is beginning.
A young girl is weeping for her lover.
Snow is melting in the Warsaw streets.

I thought my youth would last forever,
That I would always be the same.
And what remains? Fear in the early hours,
I peer at myself as at a plaque of blank, gray stone,
Looking for something I have known.

A carousel drones in the little square.
Somebody is shooting at somebody out there.
A light squall blows from the torpid river.

But what is all that to me?
I'm like a child who can't tell a dandelion
From a star. This isn't the wisdom
That I bargained for. What are centuries,
What is history? I hack out each day
And it's a century to me.

O Lord, throw me a tiny plume of pity.

The passage I had in mind occurs in the middle of the poem, where
Adrian Zelinski imagines an elsewhere:

Somewhere there are happy cities.
Somewhere there are, but not for certain.
Where, between the market and the sea,
In a spray of sea mist,
June pours wet vegetables from baskets
And ice is carried to a terrace cafe
Sprinkled with sunlight, and flowers
Drop onto women's hair.

The ink of newspapers new every hour.
Disputes about what is good for the republic.
The teeming cinemas smell of orange peels
And a mandolin hums long into the night.
Before sunrise a bird flicking the dew of song.
Somewhere there are happy cities
but they are of no use to me.
I look into life and death as into an empty winecup.
Glittering buildings or a rout of ruins.
Let me go away in peace.
A whisper of night breathes in me.

They are dragging a guy by his stupid legs,
The calves in silk socks,
The head trailing behind.
And a stain in the sand a month of rain won't wash away.

Children with toy automatic pistols
Take a look, resume their play.

To see this, or to enter an almond orchard,
Or to stand with a guitar at a sculpted gate.
Let me go away in peace.
This is not the same; possibly, it is the same.

"But not for certain" is probably the key phrase. Still, I had the sensation the first time I read this poem that Adrian Zelinski was peering into a mirror at us, while we, living in a space cleared of political violence, deprivation, censorship, peered back through the mirror at him, with fascination, and perhaps even a certain secret envy. If there are happy cities, we live in them. And though they are full of violence and deprivation and are partly supported, most of us suspect or think we know—by the export of violence and deprivation, and of censorship, which we then send out our writers on cultural tours to denounce, and though one tries to acknowledge all of this and to specify that "we" in this case means most people in Western Europe and the United States who read and write books, and not everyone, nevertheless it is true that the cities we live in are, with their newspapers, oranges, roads without barricades, careers, flower stalls, lectures on the condition of the culture daringly exposing its ideological biases, plus movies, plus late-night cafés with music—more or less the places Adrian Zelinski had in mind.

And in those cities, at least in the American ones, the poets have been writing poems about families. The poems they write are not necessarily happy ones. It's perhaps useful to distinguish between poems about the families the writers are living in and poems about the families they came from. Because the poems about current family life tend, in one way or another, to be about hope, and the poems about the past, often much darker, tend to be about fate. Not all poets have written these poems, of course. Some seem to have avoided the subject assiduously and others to be, simply, not interested. But the subject is everywhere. There is John Berryman's preoccupation with his father's suicide; Robert Lowell's meticulous, affectionate, and contemptuous (as I read it) catalogue of the articles in his father's room; Sylvia Plath's rage at her father; C. K. Williams's admiration for his mother for having the

sensitivity and strength to stop moving her lips when he talked; Robert Pinsky's equally complicated settling of accounts with his mother in "History of My Heart"; Sharon Olds's funny, terrible, hyperbolic account of the punishments parents inflicted on well-brought-up children in the 1950s; Frank Bidart's philosophical despair at his inability to speak meaningfully with his mother; Gary Snyder's account of bathing with his family; Anne Sexton's poems to her daughters. Even poets who are leery of subject matter, like Michael Palmer in *First Figure* and Lyn Hejinian in *My Life,* find themselves working in language constituted by an idea of family. The list could go for a very long time.

I can't say that I understand why. Certainly what it looked like at the outset was a reaction against the doctrine of impersonality in high modernism, especially in the ideas and practice of T. S. Eliot. At the outset there was a sense of masks being ripped off. There are various accounts of the chronology. In one of them W. D. Snodgrass was a student of Robert Lowell's at Iowa, where he wrote *Heart's Needle,* a suite of what seemed then extremely personal poems about a divorce. Lowell, whose work was changing, was given a clue from his student for the work in *Life Studies.* He in turn taught Sylvia Plath and Anne Sexton in a night class in Boston and they borrowed the autobiographical mode from their teacher, and John Berryman, looking on, learned the lesson from his friends. Allen Ginsberg's evolution was independent, but he took part of his lesson from Whitman. Perhaps it's hard to remember now what Ginsberg meant when he called Whitman in "A Supermarket in California" a "lonely old courage-teacher." It was only a few years earlier that the young Robert Duncan had had a poem accepted at the *Kenyon Review* by Lowell's teacher, John Crowe Ransom, only to have it returned when Ransom saw an essay by Duncan (this was in 1948) proposing the idea of civil rights for homosexuals. Ransom said he didn't mind Duncan's sexual preference, he minded his advertising it. In this context "Howl" and "America," with its memorable patriotic ejaculation "America I'm putting my queer shoulder to the wheel," were as crucial to the sense of tossing out the theory of impersonality as the personal poems of Lowell and Sexton and Plath.

But this account is deceptive, because in another way the example of Eliot, and Yeats, and Pound, *was* autobiographical. Everyone who read *The Waste Land* understood that it was among other things the account of a personal crisis. And so while scholars read the footnotes

and tracked down the references and studied Eliot's ruminations on the prospects of Christendom, the young poets understood that both the power and the immense prestige of the poem lay in its sense of personal extremity and in its identification of that personal crisis, the terrible sense of sexual unhappiness and impending madness and exile from a father's authority, with the predicament of Western civilization. The lesson of Eliot for young writers was that their most intimate suffering was a powerful metaphor, and the obvious step in the evolution of modern poetry was to speak about that suffering directly.

The first name given to this upwelling was "confessional poetry." It is, in the end, an unfortunate name, but at the time it made for a useful confusion. If you read *confessional* in a Catholic sense, it implied a model of poetry in which the poets made forms that both confessed bad behavior and somehow transformed or expiated their pain. That idea brought the wildness of the content of some of the poems into a traditional context; it connected it notionally to metaphysical poetry and the Anglo-Catholicism of Eliot and the recently shed Roman Catholicism of Lowell, and thus to a dominant and conservative literary tradition. And if you took *confession* in a Protestant sense, or even in the sense that popular magazines gave it, some sense of personal witness or ecstatic blurting or rebirth from sin to the inner light was implied, which would have suited Allen Ginsberg as an account of it and connected the work to the visionary lineage in Romantic poetry. The difference between these two ideas of confession make a difference at the level of the way the poets used language. Lowell was very much interested in poaching on the territory of fiction; he was interested in social detail, in the psychology of objects and people, in social class; he had Chekhov and Faulkner in mind as much as any poet, whereas Ginsberg was interested in William Carlos Williams and Blake and the kind of modernism that hadn't taken in America, surrealism.

The term *confessional* was not particularly helpful with this. It emphasized the sensational aspect of the new writing. It is odd from our present perspective to look back just those few years and see that some of the work of Sexton and Plath got called confessional because it was about the physical experiences of women. What got masked by this account of the unmasking was the obvious fact that a new autobiographical writing had emerged from modernism and that much of the new writing was about intimate and ordinary materials of life that had not before found

their way into lyric poetry. Or at least had not found their way there as autobiography. The shock value they had belonged to the autobiographical impulse, it's true. The poets often said: this happened to me. But it can also be usefully thought of as a collision between the romantic values of transparency and sincerity and the skepticism and dissonance, the expressive violence implicit in modernist technique.

This bit of literary history may not be of much use. It could amount to a kind of genealogical preening. For myself, I think, in its subterranean way, it is a response to the Peruvian poet who spoke about the little personal poems of American poets. It's an effort to describe how the work of catching something of the reality of these most common and difficult human relationships in language came to be taken up by American poets and to say something about why the opportunities opened by that aesthetic might have value. If there were more room, it would be interesting to try to describe as well how in the past thirty years the burden of the tactic of identifying one's personal suffering with the diseases of the age has fallen away from the autobiographical enterprise. This has made some of the human and writerly issues, once they were free of what is potentially falsifying in that apocalyptic ambition, seem focused in a way that is truer and more difficult, and also more open to the accusation of banality. I'm not sure what Adrian Zelinski would make of Sylvia Plath's assertions that what the speaker in her poems suffered from her father was the equivalent of what the Jews of Europe suffered from the Germans. Most of the younger writers have in this followed the way of Williams rather than of Eliot and Pound. They have perhaps tried to understand history, but they are not in competition with its terrors. And that has had a way of making the meaning of their own terrors, rendered to scale, as it were, more problematic.

Which brings me to the "white business in the trees." It is a phrase in "Celestial Music," a poem in Louise Gluck's new book *Ararat*. *Ararat* is a sequence of poems about a family, two sisters and a mother after the death of the father. It belongs fairly decisively to the genre of poems about fate. The language of the poems is spare, remarkably devoid of explicit metaphors. The verse has Gluck's characteristic severity and beauty, though I think it is supposed to be a little more relaxed and conversational than her usual idiom. And nothing happens in the book. It is a world becalmed, and not exactly by grief, as one poem explains:

No one could write a novel about this family:
too many similar characters. Besides, they're all women;
there was only one hero.

Now the hero's dead. Like echoes, the women last longer;
they're all too tough for their own good.

From this point on, nothing changes:
there's no plot without a hero.
In this house, when you say *plot*, what you mean is love
story.

The women can't get moving.
Oh, they get dressed, they eat, they keep up appearances.

The animation in the family, one gathers, had been provided by the competition among the women for the attention of the father, a rather distant figure, so that his removal not only absents the motive for action but lays bare its inner workings in a way that leaves the women languid. Thus the lack of incident. It is a sort of female version of Hamlet's dilemma in which the problem is that there was no murder and no return of the ghost. And the writing about this is somewhere between merciless and wry. But it would be to mishear the poems not to hear underneath their sometimes ruthless, sometimes funny, and always cool surface an intense sadness—that pathos that I have said interested me. Over and over the poems seem to say that to feel is to feel hurt, that the object of feeling is inadequate, that the true forms of feeling are therefore the deflected ones, envy, resignation. This gets stated, in a way that is also characteristic of Gluck, in a series of paradoxes, cruelly plain: "the face of love, to her, / is the face turning away," "the one who has nothing wins," "they are sisters, savages," "the best way / to love us was to not / spend time with us." The sadness comes because, for all the ferocity and toughness and unwillingness to be deceived in the writing, it never averts its face from this scene. There is no question, no real possibility, of simply turning away. And the pathos is in that, in the depth of the attachment.

That's why I think the book begins with the speaker's sense of being wounded. It is the first thing we hear when we open the pages of the book:

Long ago, I was wounded.
I learned
to exist, in reaction,
out of touch
with the world: I'll tell you
what I meant to be—
a device that listened.
Not inert: still.
A piece of wood. A stone.

This rhymes for me in remarkable ways with Allen Ginsberg's struggle in "Kaddish" between feeling and deadness, hope and an imprisoning sense of fate. This self-division is turned in the final line of the poem into a sort of debate between the transcendence of prayer and the cawing of crows:

Lord Lord Lord caw caw caw

It is also apparent in Ginsberg's account of the composition of "Kaddish," which, unpunctuated, unresigned, determined to be in touch but ambiguous about the reality of the things we touch, seems to speak from the same experience:

In the midst of the broken consciousness of
mid twentieth century suffering anguish of
separation from my own body and its natural
infinity of feeling its own self one with all
self, I instinctively seeking to reconstitute
that blissful union which I experienced so
rarely I took it to be supernatural and gave
it holy Name thus made hymn laments of longing
and litanies of triumphancy of Self over the
mind-illusion mechano-universe of unfeeling
Time in which I saw my self my own mother and
my very nation trapped desolate our worlds of
consciousness homeless and at war except for
the original trembling of bliss in breast and
belly of every body that nakedness rejected

in suits of fear that familiar defenseless
living hurt self which is myself same as all
others abandoned scared to our own unchanging
desire for each other.

Odd that it could describe the work of such different poets as Ginsberg and Gluck: "thus made hymn laments of longing / and litanies of triumphancy of Self over the / mind-illusion mechano-universe of unfeeling / Time." But it does.

In this early stage of his work Ginsberg's visionary hopefulness has an optimistically blurred quality. You cannot tell for sure if he thinks the wound can be healed in Time, if Time can be made to feel. Later, as his religious practice deepens, one can see that he doesn't think so. His elsewhere, unlike Adrian Zelinski's, is cosmic. There never was this optimism in Gluck and so her work was from the beginning tragic in tone but pulled toward life in time by sorrow, by a sense of tenderness toward being. This is figured in *Ararat* in the poem called "Celestial Music." She is speaking of a friend who counsels her to love life on earth:

In my dreams, my friend reproaches me. We're walking
on the same road, except it's winter now;
she's telling me that when you love the world
 you hear celestial music:
look up, she says. When I look up, nothing.
Only clouds, snow, a white business in the trees
like brides leaping to a great height—
Then I'm afraid for her; I see her
caught in a net deliberately cast over the earth—

It is a startling moment in this book almost free of metaphor—the snow in the branches, which is always a little like blossoms, as a bride caught there. It is a sort of kore myth transposed upward, a Gnostic retelling in which the love of life, the moment of its blossoming and ceremony, traps us. I had spoken of the split subject in these narratives of family, the distance between the remembering adult artist and the vulnerable wishing child. Here, as in "Kaddish," this separation feels like a tearing. The space between, which art makes use of, which feeling fills, is attachment to life. This is what the last lines of *Ararat* say:

In childhood, I thought
that pain meant
I was not loved.
It meant I loved.

This is perhaps a place to end. But I want to say another word about the lines in "Celestial Music." What is moving about them is that we sense the language is the father's language. The phrase that summarizes both nature and desire so dismissively, the "white business in the trees," seems to come directly out of the particular idiom of a family, of a time and a place. It is another kind of net, that language, the one the world gives us to cast so that we might catch in it a little of what it is and what we are, and we are, among other things, the poverties of the language we inherit. Poignant to see it registered so scrupulously. It puts me in mind of the moment in Lyn Hejinian's *My Life*—a performance in prose from the 1980s that is not autobiographical, despite its title, in the way that Gertrude Stein's great *Lifting Belly* is not an epithalamium—when among its brilliant tessellations, the text tosses up this phrase: "Elbows off the table!" A cheerful and peremptory call to manners that has vast stretches of childhood in it. And of the peculiar impressionableness and vividness of childhood, set among different kinds of language and different moments of a present and quotidian ground, so that the single phrase is enough to make it a miniversion of the impulse of Wordsworth's *Prelude,* to trace in childhood the formation of an imagination, and in that way manages to include a sense of the origins of imagination in childhood without making a personal myth out of it. *Ararat* is new to me. I'm not sure I've got hold of the whole book yet, particularly on the issues of fate and art and the generations, which it tries to confront so unblinkingly. In the past when I've thought about Adrian Zelinski yearning toward freedom, I've thought of "Kaddish" and Lowell's "Memories of West Street and Lepke" and Elizabeth Bishop's "In the Waiting Room," these American poems from the happy cities with their familial languages, intimate and fugitive, and their burdens of sorrow and fatality and grief.

1991

edward taylor:
how american poetry got started

dward Taylor's poems were discovered in a bound manuscript
book in Yale University Library in the middle of the 1930s by
a scholar named Thomas Johnson. Taylor had died in the vil-
lage of Westfield, Massachusetts, in the summer of 1729 at the age of
eighty-seven. He had arrived in the Massachusetts colony sixty-one
years before in 1668, when the entire English settlement in the New
England forests consisted of something between twenty and thirty
thousand souls. The village of Westfield, where he was minister to a
frontier church, was peopled by not much more than a hundred.

Johnson published a few of Taylor's poems in an antiquarian journal
in 1937. A first book of the poems, *The Poetical Works of Edward Taylor,*
followed in 1939, after which poets and scholars began to read him
and write about him. In 1960—just between the publications of Robert
Lowell's *Life Studies* and John Ashbery's *The Tennis Court Oath*—
Donald Stanford's *The Poems of Edward Taylor* put all of Taylor's major
poems before American readers. It was a belated literary debut.

It was also a startling body of work. At the center of it was a sequence
of 219 poems, written from 1682 to 1724, from the time Taylor was forty
years old until he was eighty-two, entitled *Preparatory Meditations
Before My Approach to the Lords Supper. Chiefly upon the Doctrine
Preached upon the Day of Administration.* There were also an ambi-
tious long poem on Calvinist doctrine, made out of thirty-six individual
poems and several thousand lines, called *Gods Determination;* eight
miscellaneous lyrics written, the scholarly guess is, sometime before
1689; a formal elegy on the death of his first wife from 1689; another on
the death of one of Taylor's colleagues, the Hartford minister Thomas

Hooker, in 1697; an undated poem in couplets, called "A Fig for Thee Oh! Death"; two other undated poems in couplets, "The Martyrdom of Deacon Lawrence" and "The Persian Persecution"; and a piece in what was his characteristic form, the rhymed six-line stanza of the poem from *Preparatory Meditations* called "The Sparkling Shine of Gods Justice." There was more work, none of it adding much to our sense of Taylor's accomplishment, and it has been printed in the intervening years.

Almost everything about Edward Taylor and his poetry was unexpected. The unexpectedness of the poetry itself lay in the intersection of its quality, its quantity, its history, and its style, the peculiarities of its style. That a large body of poetry had turned up, written by a Puritan parson in the latter years of the seventeenth century and the early years of the eighteenth in a village on the remotest western frontier of colonial New England, was not so surprising, given the culture of literacy among the Puritan English colonists and the level of education required of Puritan ministers. The first surprise was that it was so good. Scholars in the 1940s were quite prepared to recognize its provenance. Serious study of the intellectual and theological foundations of New England were flourishing, and more crucially, it was the high tide, in English departments, of the study of the seventeenth-century poets, the metaphysicals from Donne through Traherne, to whom modernist practice and the essays of T. S. Eliot had given so much authority. Students of the poems saw immediately what tradition Taylor belonged to and how deeply he had rooted in it. Another surprise was that a poet so good—though the assessments of how good he was were quite mixed—had lain unnoticed for so long.

The next surprise had to do with the ways in which he puzzled notions of Puritan austerity. He was very often a playful poet, on occasion an ecstatic poet, and his imagery was, well, more than metaphysical. By 1941 Austin Warren had published an essay entitled "Edward Taylor's Poetry: Colonial Baroque." Warren was trying to account for lines like these:

Shall Heaven and Earth's Bright Glory all up lie
　Like Sunbeams Bundled in the Sun in thee?
Dost thou sit Rose at Table head, where I
　Do sit, and carv'st no Morsel Sweet for me?

Even if you grant the pun on *rose* and the "risen Christ," there is still a rose sitting at the head of a table carving meat, a rose that is also the sun, and a pun on *son*. This was not the aesthetic of George Herbert; it much more resembled the writing of Richard Crashaw, whose *Steps to the Temple* was published in 1646, and Crashaw was a Roman Catholic. So this was a Puritan minister in the 1680s on the remotest American frontier writing an often ecstatic poetry in a style strongly reminiscent of George Herbert, but verging on a continental, Roman Catholic baroque, a minister who also, it should be added, was the author of a number of virulently anti-Papist works. The Puritans of Boston recognized the baroque style when they saw it. Michael Wigglesworth, the author of New England's most popular poem, *Day of Doom,* sternly rebuked a poetry made of "strained metaphors, far-fetch't allusions, audacious & lofty expressions . . . meer ostentation of learning & empty flashes of a flourishing wit," declaring that such writers "daub over their speech with rhetorical paintments" and "winding, crocked, periphrasticall circumlocutions & dark Allegoric mysterics." This tells us that there was something un-Protestant about this adamantly Calvinist cleric.

The next set of surprises had to do with what must be called the quaintness and homeliness of his style. In his foreword to Donald Stanford's 1960 edition of Taylor's poems, Louis Martz enumerates what were seen to be the deficiencies of Taylor's verse: the clumsiness of his meters and his rhymes; his "strangely assorted diction," mixing low and learned terms with what seem to be coinages and dialect words; and the effects of "his use of the homeliest images to convey the most sacred and reverend themes." To these charges might be added at least two others. Alongside the baroque in Taylor is a curious literalness and methodicalness of imagination: if the Lord is like wine, you are apt to get a solid stanza on every phase of the fermentation process. And finally, for a Puritan, he is, rather surprisingly, inclined to load down the Lord with a profusion of descriptive terms that have the feel of a plain man's idea of high life: precious stones, the finest linen, the best wine, rare sugars, ointments and perfumes. Perfumes, above all. One of the distinct characteristics of the divine in Taylor's world is that it smells wonderful. (This from a poet who, in 1696, twenty-five years after he arrived in Westfield, could still speak of the town's "foggy damps assaulting my lodgen in these remotest swamps." It's not so dif-

ficult to guess why the terms of his praise give the impression that God existed—as Brenda Hillman has remarked—in a sort of eternal duty-free shop.) Martz is at pains to defend Taylor against the charge that he was a bumpkin, "a burlap Herbert," and he does so by appealing to the deeply learned, passionately earnest man discernable beneath what he nevertheless regards as "the surface crudities" of his verse.

This issue, what to make of Taylor's style, is one of the subjects I want to take up, but there remains the last wonder in this inventory of Taylor's surprises to be dealt with. It is that all the evidence suggests that he created this body of work in private and in more or less total isolation. Over the course of his life it is known that he sent a few verses to friends and family members in letters and that he courted his first wife with a popular New England form, the anacrostic poem. But beyond this there is no evidence that he shared his poetry with anyone. There is no correspondence to suggest that he wrote to Cambridge or Hartford friends about it. Though *Preparatory Meditations* seems to have been written on the same subjects as his sermons, there's no suggestion that he ever read his poems to his congregation. He made no effort to publish them, and though he copied out this large body of work very carefully and bound it in rough leather manuscript books, he explicitly forbade its publication upon his death. This doesn't mean that he didn't share his work. He may have had a literary correspondence that has been lost. He may have had a circle of friends among the Westfield farmers who took an interest in verse. He may have read his poems to one or both of his wives, or to his children in his later years. We don't know. We know very little about his life. But there's nothing to indicate it.

It is a set of facts—and gaps—one looks at with a mixture of disbelief and recognition. Emily Dickinson, after all, lived just north and east of him in Amherst some century and a half later, but she, at least, sent her poems to Thomas Higginson and Helen Hunt Jackson, and a few to magazines, and got to enjoy the reputation of a poet, recluse, and snob. Edward Taylor's privacy, like his culture, is a harder thing to read. He was an Englishman. He was born in Leicestershire, in the South Midlands, which made him an atypical colonist. The great majority of them came from East Anglia, the home counties, and the southwest of England. Leicestershire was the birthplace of George Fox. It seems to have been more Quaker than Puritan in its leanings. It's hard

to know how much this means. Michael Wigglesworth, with his dour view of verbal excess, came from Yorkshire. However eccentric Taylor was to the home culture of the other New England colonists, he had an English education and a profoundly Puritan theology.

So one ought to be a little skeptical of any impulse to claim him as an American, or proto-American, poet. In his early years in Westfield, he went through King Philip's War, the last concerted attempt of the New England Indians to drive out the European invaders, and his poems make no mention of it. The imagery of the natural world in his poems is English and his poems are full of English folk technologies and games and turns of speech, recently and wondrously transplanted, it is true, but that new rooting seems not to enter his imagination. He was among the founders of New England culture, certainly of the culture—somewhat different from Boston's—of the Connecticut River valley. Still, the only thing that seems American about him—presciently so—is this strange absence of a social context for his work. He seems—as Anne Bradstreet does in her private and unpublished poems—an early instance of the solitariness, self-sufficiency, and peculiarity of the American imagination.

1. The Issue of His Style

Which is why I want to return to the issue of his style. Here is one of his lines that has stuck in my head, a "volunteer," as they say of garden weeds:

Let conscience bibble in it with her bill.

It's almost nonsense verse: the alliteration of *bibble* and *bill;* the string of assonances in the short *i* sound, *bibble in it with* and *bill;* and the odd word *bibble*. Here we come to the issue of Taylor's diction. He is a poet who sends you to dictionaries. His word of choice is not *dabble*, which, according to the *OED*, came into the language in the late sixteenth century, probably from the Dutch, and which Shakespeare used, in *Richard III*, to describe "a Shadow like an Angel, with bright hair dabbled in blood," and Tennyson used, in *The Princess*, to describe someone "dabbling a shameless hand" in the "holy secrets of the micro-

cosm," and which seems to have been ascribed to the feeding behavior of ducks around 1661, so that Wordsworth could use it in 1789 in "An Evening Walk" ("Where the ducks dabble 'mid the rustling sedge") and John Clare, gorgeously, in 1821 ("The long wet pasture grass she dabbles through"). It is not this word.

Nor *dibble*, which I first came across in Cowper's "Yardley Oak," where there is "a skipping deer, with pointed hoof dibbling the glebe." A dibble was an instrument for poking holes in the ground for planting. The noun shows up in manuscripts as early as 1450, the verb in 1583. Keats found a use for it in "Endymion": "In sowing ne'er would I a dibble take"; and it seems to have disappeared from all but horticultural uses by the end of the nineteenth century. It had an even briefer life as a variant on *dabble*. Michael Drayton's *Poly-Olbion* in 1622: "And near to them you see the lesser dibbling teale." And it is applied to the activities of fishermen by a Mr. Chetham in "The Angler's Vade-Mecum" in the 1860s: "When you angle at ground in a clear Water, or dibble with natural Flies."

So both *dibble* and *dabble* were, theoretically, available to Edward Taylor, but what came to his mind was *bibble*, which arrived in English from French or Norman French in both transitive and intransitive forms. In Stanyhurst's 1583 translation of the *Aeneid* there are "fierce steeds" that "Xanthus stream gredilye bibbled," and its intransitive form—which the *OED* describes as obsolete—gets used by John Skelton in 1529: "Let me wyth you bybyll." The word is applied to ducks as early as 1552, and the last use of it cited in that dictionary occurs in 1862, in a work by M. B. Edwards called *Tale of the Woods*, in a section devoted to "the eider duck":

How pleasant it is to glide through the grass,
And bibble the dew-drops as I pass.

Whether Taylor's choice was dictated by the assonance or the alliteration, or by regional dialect, or by the sheer silliness of the word—it calls to mind a child blowing bubbles in milk—we have no way of knowing. What we do know is that it is not a duck, exactly, but a conscience behaving like a duck that is doing the bibbling. Which is enough to tell us that we are—the provenience of the word aside—in the seventeenth century.

Moreover, there is the matter of what this ducklike conscience is bib-
bling in. It's bibbling in rose water. Here is the stanza, from the fourth
poem of Taylor's *Preparatory Meditations*, in which the line appears:

> God Chymist is, doth Sharons Rose distill.
> Oh! Choice Rose Water! Swim my Soul herein.
> Let Conscience bibble in it with her Bill.
> Its Cordiall, ease doth Heart burns Caused by Sin.
> Oyle, Syrup, Sugar and Rose Water such.
> Lord, give, give, give; I cannot have too much.

Taylor himself was, probably as a matter of necessity, something of a
chemist. As a person of education, he served as doctor as well as minis-
ter to the village of Westfield. His library included a five-hundred-page
manuscript in his own hand, *Dispensatory*, extracted from sources like
The English Physician Enlarged (1666) and *Pharmacopoeia Londinensis*
(1685), which described the medicinal properties of herbs, drugs, oils,
and gums, and the manner of their preparation.

This stanza condenses various ways of turning rose petals into
medicine. But its proposition is to meditate on a verse from the
Song of Solomon: "I am the Rose of Sharon." The rose of Sharon is
a species of hibiscus, not a rose, but let that be. It is a metaphor for a
bride sung by herself in an ancient erotic Hebrew folk song; Chris-
tian typology—to get the full strangeness of it—had converted the
bride into a figure for Christ. So the rose water (and the rose oil and
the rose sugar and the rose syrup) here are imagined applications
of seventeenth-century technologies to the blood of Christ. God is
the chemist who distilled a healing rose water from the blood of his
son's crucifixion—an event of such joy that the seventeenth-century
Calvinist conscience can bibble in it.

It is not surprising that the first twentieth-century commentators
on Taylor found him exceedingly quaint and strange. They were also
inclined to see him as a rather clumsy amateur, and a line like "Oyl,
Syrup, Sugar and Rose Water such" might have served as an example.
One supposes that he means to say that these items also have medici-
nal properties, and the commentators might have guessed that Taylor
has manhandled the syntax to secure the rhyme. But what the word
bibble should tell us is that we can't be sure about this. Given a mind

so embedded in its own time, it seems quite possible that "Oyl, Syrup, Sugar and Rose Water such" was perfectly idiomatic Leicestershire English. We simply cannot know.

And we might have the same trouble with a line that seems a perfect example of what scholars took to be Taylor's naïveté: "Its Cordial, ease doth Heart burns Caused by Sin." It looks as if the poet, having wandered into his pharmaceutical metaphor, has—if not inadvertently, certainly ludicrously—turned sin into a form of indigestion. But there is no doubt that he's making a joke about sin and indigestion—it's, in fact, an instance of the metaphysical "wit" that attracted the attention of midcentury scholars to him in the first place. This does seem to be an aspect of his sense of humor, and also of his theology: given the saving blood of Christ, sin is a mere indisposition. It is also possible that other meanings of "Heart burn" had more force in Taylor's English. The word is first cited by the *OED* with reference to digestion in 1597. It shows up around the same time as a joke in *Much Ado About Nothing*: "How tartly that gentleman looks. I cannot see him but I am heartburned an hour after." It also, however, was used to describe feelings of passionate enmity—"heart-burning Hate," Spenser writes in *The Faerie Queene*. How much sting of this second meaning there is inside the joke I think it's impossible to gauge. In either case, though Donne might have assayed such a metaphor, George Herbert, to whom Taylor is so often compared, would probably not. It is a little too low and a little too risible. And it is for me one of the things that's wonderful about him. He is a poet full of verbal wonders.

And this is one of the pleasures and strangenesses of reading him. His contemporaries, like Marvell, and his great antecedents, like Donne and Herbert and Milton and Vaughan and Crashaw, have become the seedbed of educated English. Their diction defined its possibilities; their lines are the echo chamber in which English verse came to have resonance. Taylor, who was not absorbed in this way, both because he was not naturalized by generations of poets and schoolmasters and because he was always in some sense an outsider, not university educated, not a Londoner, not even an East Anglian like most Puritan ministers— presents us with a fresher and more radical version of one of the main experiences that poetry has to offer: the intimate confrontation with another mind, embodied in the verbal habits of another time. Perhaps this effect will change over the years as poets and schoolchildren come

to know his lines, but now, some sixty years after the recovery of his verse, it still seems newly decanted, as if—I don't know whether this metaphor should refer to rose water or to wine—it had been salvaged from the sea and the bottles opened and the odor as sharp and unfamiliar as the day it was bottled.

2. THE ORGANIZATION OF HIS POEMS

The poem in which these lines occur, "Meditation 4. Cant. 2.1. I am the Rose of Sharon," was written in April of 1683. It is, as the title indicates, a meditation on an image from the bride's song in Song of Solomon. It is a place to continue an interrogation of Taylor's style and to look at the related issue of the organization of his poems. The poem is organized, like all of the poems in *Preparatory Meditations,* as a sort of prayer. Its purpose is not so much union with God, at which the practice of meditation aimed, but preparation for the union that occurred, for Taylor, in the Lord's Supper. Each of the meditations begins by laying out a theme suggested by a scriptural text, the middle part of the poem develops the theme, and the poem ends with a supplication, which is both a way of praising God and an expression of the desire for union with Him. "Lord blow the Coal: Thy Love Enflame in mee," the first meditation ends. "Yet may I purse, and thou my Mony bee," ends the second. And the third, more ecstatically, "Lord, breake thy Box of Ointment on my Head." A bed of coals, cash and a purse, a box of ointment: the range and heterogeneity of his imagery is a bit dizzying, as if the entire world existed to be a compendium of likenesses to this relationship.

It is striking, and moving to me, that the very last of the meditations, written more than forty years after these early poems, takes as its theme another line from the Song of Solomon, "I am sick of Love." It also ends with a supplication—it is his final supplication—that the gift of his poetry might be accepted. This is a theme throughout the second series of meditations, and it is accompanied often by a sense of the inadequacy of his art. The tone is profoundly subdued:

Had I but better thou shouldst better have.
 I nought withold from thee through nigerdliness,

But better than my best I cannot save
 From any one, but bring my best to thee.
 If thou accept my sick Loves gift I bring
 Thy it accepting makes my sick Love sing.

One of the interesting things that this anguish in the later poems tells us about the intention of Taylor's art, and therefore about the formal organization of the meditations, is that they were intended as an offering, and though Taylor believed that no human action could bring man to God, he seems to have hoped that his gift would be accepted. This tells us in turn something about the middle part of his poems, in which he is concerned to develop, or at least elaborate, his theme: it is his way of making a gift of his imagination to his God. This explains something to me about the joy, the giddiness and strangeness, of the early meditations, as well as the feeling of gravity and exhaustion in many of the late ones. This is a subject I will return to shortly, but for now it is enough that we understand what is at stake for Taylor—besides doctrine—in the development of the poems.

Let's look now at meditation 4. The first two stanzas deploy the theme by making a little allegory:

My Silver Chest a Sparke of Love up locks:
 And out will let it when I can't well Use.
The gawdy World me Courts t'unlock the Box,
 A motion makes, where Love may pick and choose.
Her Downy Bosom opes, that pedlars Stall,
 Of Wealth, Sports, Honours, Beauty, slickt up all.

Love pausing on't, these Clayey Faces she
 Disdains to Court; but Pilgrims life designs,
And Walks in Gilliads Land, and there doth see
 The Rose of Sharon which with Beauty shines.
Her Chest Unlocks; the Sparke of Love out breaths
 To Court this Rose: and lodgeth in its Leaves.

This is quaint enough. So far as vehicle and tenor are concerned, it's a bit hard to know exactly what the silver chest represents, but one does not pause long at this literal level in Taylor. The image itself is

probably entirely conventional, but there is something quite pleasing and memorable about that peddler's stall of a downy bosom, and there is a Tayloresque pleasure in the last phrase of the stanza, "slickt up all." The passage has the slight crazing of metaphorical slippage, like a pane of crazed glass, which seems to me so distinctive in Taylor. The speaker in the poem has a silver box and in the box is a spark of love that is feminine in gender. Then, Love, the spark inside the box carried, presumably, by the speaker, goes walking in Gilead and encounters a rose, wherewith she, Love, unlocks the box she is in, and out of it breathes the Spark, now converted by a pun into a beau or suitor—this sense of *spark* appears in Shakespeare's *Timon* in about 1600 and was stage slang by the time of Etheredge—who is prepared to court the rose. The last line of the stanza, which is perhaps the only one that is graceful in a traditional way, gives a luxuriant rhythm to its slightly erotic sense of arrival.

The slippage at the literal level has been treated by the critics I have read as either an instance of his crudeness, though most of them have found it a charming crudeness in the way of folk art, or have tried to make a case for it as an effect of the baroque. I think it is an effect of the baroque and that saying so doesn't take us very far. I also think that it is charming, though not crude, if by *crude* one means inadvertent. There are, after all, only a certain number of guesses one can make about this writing. One is that Taylor did not notice the inconsistency or the unsettling malleability of his metaphors. Another is that he noticed and it was in fact an aesthetic effect that he aimed at. A third, somewhere between the two, is that he noticed and didn't mind because it was theological or doctrinal or— perhaps—emotional exactness he was aiming at. A fourth, slightly different, is that he noticed and, though it was not at the center of his intention, he liked the effect of the slippage, liked the freedom and the oddness of it, had what might be thought of as a cheerfully Platonist disregard for mere consistencies that resembles and anticipates in a curious way (as the baroque sometimes does) the attitude of surrealism. To say it another way, it seems likely that he saw and liked the aesthetic and cognitive effects of his imagery. He may have felt they mirrored his mind. In any case, they became one of the habits of his mind.

Here are the next two stanzas in which he contemplates the rose:

No flower in Garzia Horti shines like this:
 No beauty sweet in all the World so Choice:
It is the Rose of Sharon sweet, that is
 The fairest Rose that Grows in Paradise.
Blushes of Beauty bright, Pure White, and Red
 In Sweats of Glory on Each Leafe doth bed.

Lord lead me into this sweet Rosy Bower:
 Oh! Lodge my Soul in this Sweet Rosy bed:
Array my Soul with this sweet Sharon flower:
 Perfume me with the Odours it doth shed.
Wealth, Pleasure, Beauty Spirituall will line
 My pretious Soul, if Sharons Rose be mine.

This is the spark's courting song. He has rejected the downy bosom of the sluttish world and fallen in love with the blushing rose. The writing, like much of Taylor's writing in the meditations, would be conventional if it were not so odd. There is, first of all, something appealing in its exhilaration. The music—"the fairest Rose that Grows in Paradise"—is in places like this reminiscent of Broadway lyrics. And then there are Taylor's particularities of imagination: the dew on the rose becomes "Sweats of Glory on Each Leafe," and this leads to what can only be described as sexual euphoria in the next two lines (they are hard to read without thinking of Blake's "The Sick Rose" as their underside). And finally there is this sort of showering dispersal of the image. The bower of the rose becomes a bed, and then apparel, and then perfume, and then some luxurious spiritual lining—he does not say what kind, a rose-petal lining, presumably, in place of sable or lamb's wool. And there is also the suggestion in "pretious" that the soul has become a jewel in a rose-petal setting.

These two pairs of stanzas are instances of two of the ways in which Taylor's effects occur. In the first two stanzas, being literal about the allegory (one notices, for example, that the world courts the soul, but the soul is not courted by the rose—that would be contrary to Calvinist doctrine; the rose does the courting) releases the imagination to dream silver boxes and downy bosoms and pedlars stalls and clayey faces and walks in Gilead and courting sparks in a

whirligig of images. In the second pair of stanzas, not being literal
in the elaboration of the metaphor of the rose as a blushing lover cas-
cades insensibly into beds and flowery raiments and the soft linings
of garments and a jewel.

The next stanzas are characteristic in a different way. George
Herbert in his poem on this trope had mentioned the restorative prop-
erties of roses and hence of Christ, but Taylor the physician-poet is
downright methodical in his development of this conceit, and, once
it has seized his attention, the courtship metaphor is abandoned alto-
gether, having served its purpose. The next passage—in a manner
that's almost Joycean—sits right at the edge of parodying a pharma-
ceutical manual:

> The blood Red Pretious Syrup of this Rose
> Doth all Catholicons excell what ere.
> Ill Humors all that do the Soule inclose
> When rightly usd, it purgeth out most clear.
> Lord purge my Soul with this Choice Syrup, and
> Chase all thine Enemies out of my land.

> The Rosy Oyle, from Sharons Rose extract
> Better than Palma Christi far is found.
> In Gilliads Balm for Conscience when she's wrack't
> Unguent Apostolorum for each Wound.
> Let me thy Patient, thou my Surgeon bee.
> Lord, with thy Oyle of Roses Supple me.

(The *OED* records uses of *supple* as a transitive verb, meaning "to
soften or mollify a wound," from 1526 to 1688. The last use is by Bunyan:
"Lord, supple my wounds, pour Thy wine and oil into my sore.")

> No Flower there is in Paradise that grows
> Whose Virtues Can Consumptive Souls restore
> But Shugar of Roses made of Sharons Rose
> When Dayly used, doth never fail to Cure.
> Lord let my Dwindling Soul be dayly fed
> With Sugar of Sharons Rose, its dayly Bread.

(The verb *dwindle* first appeared in print in Shakespeare's plays; it was used to mean a shrinking in size or value; usages with the shading "degenerate" show up in several seventeenth-century texts. "Shugar" was made by crystallizing the juices of many different plants, often for medicinal purposes. The word *succor* derives from one pronunciation.)

> God Chymist is, doth Sharons Rose distill.
> Oh! Choice Rose Water! Swim my Soul herein.
> Let Conscience bibble in it with her Bill.
> Its Cordiall, ease doth Heart burns Caused by Sin.
> Oyle, Syrup, Sugar, and Rose Water such.
> Lord, give, give, give; I cannot have too much.

The final stanza in this passage brings us back—with what seems like artistic self-assurance—to the metaphor on which it has been floated:

> But, oh! alas! that such should be my need
> That this Brave Flower must Pluckt, stampt, squeezed be,
> And boyld up in its Blood, its Spirits sheed,
> To make a Physick sweet, sure, safe for mee.
> But yet this Mangled Rose rose up again
> And in its pristine glory, doth remain.

And the poem concludes with two more stanzas, which gather up its praise and frame its supplication:

> All Sweets and Beauties of all Flowers appear
> In Sharons Rose, whose Glorious Leaves out vie
> In Vertue, Beauty, Sweetness, Glory Cleare
> The Spangled Leaves of heavens cleare Crystall Sky.
> Thou Rose of Heaven, Glory's Blossom Cleare
> Open thy Rosie Leaves and lodge me there.
>
> My Dear-Sweet Lord, shall I thy Glory meet
> Lodg'd in a Rose, that out a sweet Breath breaths.
> What is my way to Glory made thus sweet,
> Strewd all along with Sharons Rosy Leaves.

I'le walk this Rosy Path: World fawn, or frown
 And Sharons Rose shall be my Rose, and Crown.

The middles are usually the best of Taylor's poems. The endings,
like this one, sometimes have an air of haphazard recapitulation. But
it is not always easy to tell. It's hard to know, for example, whether
the triple repetition, "Glory Cleare," "heavens cleare Crystall Sky," and
"Glory's Blossom Cleare," is a horn flourish of insistence—it picks up
on a superior medicine's ability to produce clear purges—or a failure of
invention. The one definite invention in it is the final transformation
of the dew on the roses into stars in the sky. And that vernacular phrase
in the second-to-last line—"World fawn, or frown"—seems to try to
make some gesture back to the little Bunyanesque allegory with which
the poem began. One does not mind the ending, but one notices that
when he strings together abstract nouns, he is at his least compelling.
One grants the breathless ardor that "In Vertue, Beauty, Sweetness,
Glory Cleare" is intended to convey and prefers the strange mix of
homeliness and sublimity in the metaphors.

George Herbert addresses this problem of adequate praise in "The
Windows":

Lord, how can man preach thy eternal word?
 He is a brittle crazie glasse:
Yet in thy temple thou dost him afford
 This glorious and transcendent place,
To be a window, through thy grace.

But when thou dost anneal in glasse thy storie,
 Making thy life to shine within
Thy holy Preachers; then the light and glorie
 More rev'rend grows, & more doth win:
Which else shows watrish, bleak, & thin.

Doctrine and life, colours and light, in one
 When they combine and mingle, bring
A strong regard and aw: but speech alone
 Doth vanish like a flaring thing,
And in the eare, not conscience ring.

Herbert, as he worked his way out from under the influence of Donne, developed a style of impressive clarity and simplicity, but even he does not do much with a line like "this glorious and transcendent place." He does not, however, risk rapture, and so he does not, when he uses this diction, invite the distaste that some of the commentators have expressed toward Taylor's batteries of abstract nouns and adjectives. The style allows Herbert to achieve quietly brilliant effects— "Which else grows watrish, bleak, & thin," "but speech alone / Doth vanish like a flaring thing." Taylor's surfaces are too animated for such accuracies of perception and description. His famous lines, like the ones about the creation in the preface to *Gods Determination*—

Who Spread its Canopy? Or Curtaines Spun?
Who in this Bowling Alley bowld the Sun?

—or the ones in meditation 8, where his subject is a line from John, "I am the Living Bread"—

Doth he bespeake thee thus, This Soule Bread take.
 Come Eate thy fill of this thy Gods White Loafe?
 Its food too fine for Angells, yet come, take
 And Eate thy fill. Its Heavens Sugar Cake.

come not from precision and purity of diction but from the sense of an unpredictable imagination taking delight in its own inventions. Though meditation 4 ends with the triple insistence of God's clearness, the poem itself elects to be a "crazie glasse." As a writer, one might have to choose between the styles of Herbert and Taylor, but as a reader, happily, one does not. Herbert's "The Windows" is a clearly marshaled argument without a word to spare. Taylor's organization, such as it is, is a kind of rough framework on which to spin out the rush of constantly self-transforming metaphors that are his gift: flaring things, one after another.

The third meditation, "Thy Good Ointment," is one of the strangest of Taylor's poems and one of the most vivid examples of his practice. And more than enough, I think, to give a sense of what the baroque means in him. It's a sort of homemade verbal equivalent to a Bernini fountain, sweetly eschatological, and Calvinist to the core. It begins by taking up the odor of ointments:

How sweet a Lord is mine? If any should
 Guarded, Engarden'd, nay, Imbosomd bee
In reechs of odours, Gales of Spices, Folds
 Of Aromaticks, Oh! how sweet was hee?
 He would be sweet, and yet his sweetest Wave
 Compar'd to thee my Lord, no Sweet would have.

Reek in the seventeenth century was applied—the *OED* says—to any "dense or unctuous smoke." The modern sense of a disagreeable odor didn't come in until the late nineteenth century. *Fold* was a pen or enclosure; it was also a wrapping or covering, and, interestingly, an embrace. Shakespeare, in *Troilus and Cressida:* "Weak wanton Cupid shall from your neck unloose his amorous fold." *Wave*, in the seventeenth century, meant both the displaying on an ensign—important for, possibly the source of, the military metaphor to come, as well as any motion of swaying to and fro. Herrick: "A winning wave in the tempestuous petticoat." The run of "Guarded, Engarden'd, nay, Imbosomd" is particularly wonderful, I think. He does manage to imbosom us in reeks of odors, gales of spice.

In the next stanza he elaborates. Perhaps unnecessary, but the baroque principle seems to be that if you can keep inventing metaphors, you do:

A Box of Ointments, broke; sweetness most sweet.
 A surge of spices: Odours Common Wealth,
A Pilar of Perfume: a steaming Reech
 Of Aromatick Clouds: All Saving Health.
 Sweetnesse itself thou art: And I presume
 In Calling of thee Sweet, who are Perfume.

And then, having glossed the scriptural image, he proceeds to the development. Watch what happens. As the poem proceeds, nostrils get mixed up with nipples, and the military metaphor wanders in, with the bore of a gun, called to mind presumably by the shape of nostrils:

But Woe is mee! who have so quick a Sent
 To Catch perfumes pufft out from Pincks, and Roses
And other Muscadalls, as they get Vent,

Out of their Mothers Wombs to bob our noses.
And yet thy sweet perfume doth seldom latch
My Lord, within my Mammulary Catch.

"Muscadalls" are probably muscatel grapes, from which a strong sweet wine came. The Puritans took the grape from England to New England. "These muscadel grapes," a grower wrote in 1601, "like wel and love cold countries." But there was also a muscatel pear brought from Norfolk to Massachusetts. And best of all, "muscadines" were a kind of sweetmeat perfumed with musk; a cookery book from 1655 says that they went by the name of Kissing Comforts. As for *bob*, here is a description of a fight from 1605: "The fellowe got the foole's head under his arme, and bobd his nose." The "Mothers Womb" is presumably the earth, but that line is wonderfully strange.

The curious, in fact startling "Mammulary Catch" gets taken up in the next stanza:

Am I denos'de? or doth the Worlds ill sents
 Engarrison my nosthrills narrow bore?
Or is my smell lost in these Damps it Vents?
 And shall I never finde it any more?
 Or is it like the Hawks, or Hownds whose breed
 Take stincking Carrion for Perfume indeed.

This is my Case. All things smell sweet to mee:
 Except thy sweetness, Lord. Expell these damps.
Breake up this Garison: and let me see
 Thy Aromaticks pitching in these camps.
 Oh! Let the Clouds of thy sweet Vapours rise,
 And both my Mammularies Circumcise.

Shall Spirits thus my Mammularies suck?
 (As Witches Elves their teats,) and draw from thee
My Dear, Dear Spirit after fumes of muck?
 Be Dunghill Damps more sweet than Graces bee?
 Lord, clear these Caves. These Passes take, and keep.
 And in these Quarters lodge thy Odours sweet.

Explicating this is probably as hopeless as explaining a joke, but bear with me. The general idea is pretty clear: have I lost my sense of smell, he asks, that I can't distinguish the scent of the Lord from the foul vapors of the world? *Muck* in the seventeenth century meant, unequivocally, animal dung. This conflict is made elaborate at first by the military metaphor. The nostril becomes the bore of a gun, which suggests the idea of warfare between the Lord and the World, whose army has pitched camp in the speaker's nostrils. And Taylor prays for the Lord's army to expel them—with more puns on the nostril in the ideas of clearing caves and taking passes.

Complicated enough. But "Mammulary Catch" sets off another set of metaphors that could perhaps have only occurred to a seventeenth-century physician. *Mamilla* refers to the nipple of the female breast. *Mamillary* was a technical term for any nipple-like projection and came to be applied to the papilla of the tongue and nostrils. The *OED* cites Crook, *The Body of Man,* 1615: "The mamillary processes which are the Organes of smeeling." By 1648 the poet John Beaumont had made a joke of this bit of technical jargon in *Psyche:* "By the Mammillar Processions, I Embrace those pleasures which my Sweets impart." That clears up "Mammulary Catch." And perhaps even "Mammularies Circumcise," i.e., scour my nostrils, which are dulled to the sweetness of the Lord. But not "both my Mammularies," even if the phrase means "both my nasal passages," because Taylor's mind has already been nudged from papillae to breasts:

Shall Spirits thus my Mammularies suck?
 (As Witches Elves their teats) and draw from thee
My Dear, Dear Spirit after fumes of muck?

So, "And both my Mammularies Circumcise" is as surreal as it seems. It refers to no known surgical procedure. He wants the foreskin off the nipples of his spiritual sense of smell. That elves sucking at the teats of witches should wander into this is quite delicious. And there is a final set of puns on *spirit,* which means here not just "soul" or "sprite," but also "wind," conceivably "strong spirits," and most probably "professional kidnappers." The *OED* cites two instances from the seventeenth century. Whitelock, 1645, "An Ordinance against such who are called Spirits, and use to steal away, and take up children,"

and the *London Gazette,* 1686: "The frequent Abuse of a lewd sort of People, called Spirits, in Seducing many of his Majesties Subjects to go on Shipboard." It is a wild run.

The poem ends with the supplication, which is smooth and conventional enough, save for the exuberance of the first line; the somewhat less strange second line in which the hair is powdered with the talcum of grace; and the need to tie things up, which introduces food for the nose into the fifth:

> Lord, breake thy Box of Ointment on my head;
> Let thy sweet Powder powder all my hair:
> My Spirits let with thy perfumes be fed
> And make thy Odours, Lord, my nosthrills fare.
> My Soule shall in thy sweets then soar to thee:
> I'le be thy Love, thou my sweet Lord shalt bee.

Meditations 3 and 4 are not untypical of the early meditations. They do, in a general way, follow the prescriptions in Richard Baxter's 1650 account of meditative practice, which Professor Martz has demonstrated to inform the organization of meditative poems throughout the period. The organization is tripartite, corresponding, as Martz points out, to the division of the faculties of the mind into memory, understanding, and will. The first part recalls a scriptural text, the second submits it to understanding, and the third disposes the will, though in Taylor's case, will doesn't count for much. He simply asks his God to close the gap between them. It is the idea of understanding, the development of the theme, in Taylor that makes this organization seem the roughest of structures. Inside the development, it is certainly not rational understanding to which doctrine is submitted, but a wild, playful floresence of imagination. He makes poems as vigorous, strange, dreamy, and sometimes comic as any Joseph Cornell box, and like Cornell he makes them out of the smallest oddments and particulars of his culture.

Meditations 3 and 4 were not among the poems Thomas Johnson printed in the journal article that announced the discovery of Taylor's manuscript and they were not among the poems published in the *Poetical Works* of 1937. They were perhaps too peculiar altogether to excite Johnson's admiration, or possibly he decided to introduce Taylor

to the world in less eccentric modes. Nor are they included in any of the anthologies of American poetry that I am aware of. What usually represents the early meditations is "Meditation 8. I am the Holy Bread," and it is through the lines I quoted earlier—

> Come Eate thy fill of this thy Gods White Loafe.
> Its food too fine for Angells, yet come, take
> And Eate thy fill. Its Heavens Sugar cake

—that most readers, if they read him, come to know the mix of homeliness and literalness and imaginative play that characterizes Taylor's images. They also get another Tayloresque line in the last stanza, delicious in its rhythms:

> Yee Angels, help: This fill would to the brim
> > Heaven's whelm'd-down Chrystal meele Bowle, yea, and higher.

That run of six strong stresses does its work triumphantly. A whelm was a wooden drainpipe. Originally, whelms were made from tree trunks, split in half vertically, hollowed out, and "whelmed down," or, as the *OED* says, "turned with the concavity downward to produce an arched watercourse." The word is said to survive to the present in Midlands dialect. It's one of the lines that gives me the impression that Taylor's rhythms are at their surest when he is nearest the language of the particulars of his world.

And the opening of the poem is also like Taylor in that it does not—as if he cannot, or like a playwright would not, do without a double plot—simply develop the imagery of bread. Look:

> I kening through Astronomy Divine
> > The Worlds bright Battlemen, wherein I spy
> A Golden Path my Pensill cannot line,
> > From that bright Throne unto my Threshold ly.
> > And while my puzzled thoughts about it pore
> > I find the Bread of Life in't at my doore.

> When that this Bird of Paradise put in
> > This Wicker Cage (my Corps) to tweedle praise

Had peckt the Fruit forbad: and so did fling
 Away its Food; and lost its golden dayes;
 It fell into Celestial Famine sore:
 And never could attain a morsell more.

Alas! alas! Poore bird, what wilt thou doe?
 The Creatures field no food for Soules e're gave.
And if thou knock at Angells dores they show
 An Empty Barrell: they no soul bread have.
 Alas! Poore Bird, the Worlds White Loafe is done
 And cannot yield thee here the smallest Crumb.

This movement from the stars to the lie of a threshold, and the introduction of the bird of the soul tweedling in its cage, and the move from that to the pecked fruit of Eden and celestial famine is very different from the conceits of Donne and Herbert, which are brought under the control of the intellectual force of their arguments. The cascade of metaphor and analogy in Taylor is restless and vertiginous, and it was probably the formulaic structure of meditative verse that allowed him both to loosen his imagination and to give it a form. This perhaps explains why, having come upon the form of the meditations in 1682, he persisted in it for forty years. It gave him access, as John Milton described it in "The Reason of Church Government," to "what the mind in the spacious circuits of her musing hath liberty to propose to herself."

The term *baroque* was introduced into critical discourse about art by the German scholar Heinrich Wölfflin. He used it to describe the difference between what he saw as the harmonies of the high Renaissance and what came after. "The Baroque," he observed, "never offers us perfection and fulfillment, or the static calm of 'being,' only the unrest of change and the tension of transience." It was this, perhaps, that the form of the meditative lyric allowed Taylor both to explore and to fend off, just as the worldly specifics in his poems, the processes of brewing and baking and metallurgy, the unguents and powders and medicines, the children's games and gambling games, allowed him to celebrate a world he was bound in conscience to deplore.

3. HIS DEVELOPMENT

It's hard to read him without wondering where these poems came from, or to wonder that they came at all, let alone that they came from what was, literally, the remotest edge of European civilization. When Ezra Pound invented the belatedness of Hugh Selwyn Mauberley—

> For three years, out of touch with his time,
> He strove to resuscitate the dead art
> Of poetry, to maintain "the sublime"
> In the old sense . . .

—he did not have before him the example of Taylor's belatedness. John Donne died in 1631, George Herbert two years later. Richard Crashaw was dead in 1649, when Taylor was seven years old. Henry Vaughan, twenty years younger than Taylor, died in 1695, but he had written and published almost all his poetry by 1655, when Taylor was thirteen years old. Long before Taylor arrived in New England, the style of English poetry had changed, as styles do. This was already reflected in the first book of poetry to come from New England, Anne Bradstreet's *The Tenth Muse Lately Sprung Up in America,* which was published in 1650. Bradstreet's poems, written twenty or so years before, before any Taylor poems that can be dated, were nevertheless much closer to the English style in midcentury. Her large, ambitious poems were skillful, learned, and written in the new smooth couplets that were becoming fashionable. They were also pretty conventional. Here are some lines about summer, from the set of poems on the four seasons:

> Now go those frolic swains, the shepherd lads,
> To wash the thick-clothed flocks with pipes full glad.
> In the cool streams they labor with delight
> Rubbing their dirty coats till they looked white:
> Whose fleece when finely spun and deeply dyed
> With robes thereof kings have been dignified.

It was the sound in poetry that people then admired. Now it glazes the eyes, both the rhythm and the diction. Nothing in it is really seen. And, though the knowledge that the New England economy, like the

economy of Bradstreet's native East Anglia, was based on sheep-raising gives the subject some force, the conventional images—compare them to the smell of the barnyard in Taylor—drain it away.

The poems of Bradstreet that we read today are, for the most part, the personal ones that she did not publish in her lifetime—these lines, for example, from a poem addressed to her husband. She was about to give birth to a child, which was, as she knew, a risky business. She uses the couplet again, but listen to the difference:

> How soon, my Dear, death may my steps attend,
> How soon't may be thy lot to lose thy friend.
> We both are ignorant, yet love bids me
> These farewell lines to recommend to thee,
> That when the knot's untied that made us one,
> I may seem thine, who in effect am none.

It's *soon't* that tells us how closely she is listening to her own voice; it's a bit of speech one can still hear among country people in Norfolk and Suffolk. And there is this, from another poem to her husband, which carries the same plainness and earnestness:

> If ever two were one, then surely we.
> If ever man were loved by wife, then thee;

The rest of the poem is conventional, but these lines in Bradstreet with their adamant and Protestant plainness, their attention to speech and the inner movement of feeling, seem almost to leap forward a hundred and forty years; they anticipate both the strictures of Wordsworth in the preface to *Lyrical Ballads* and the sound of his poems.

Taylor, when he arrived in Boston in 1668 at the age of twenty-six, seems to have brought with him the poetic practices of 1633, when both Donne's poems and Herbert's *The Temple* were first published. It's not possible to date his early work with any exactness, but there is evidence that Taylor bound together the first forty meditations and the occasional poems in 1691, which tells us at least that the miscellaneous poems were written before that date. And they are numbered. The sixth of them, "Upon Wedlock and the Death of Children," can be dated to the events that occasioned the poem, the deaths of two of

his children in infancy, the youngest of whom died in 1682. The poem after that, "Upon the Sweeping Flood," is dated by Taylor to August 1683. If this is an indication that the poems are arranged in chronological order by date of composition, it allows us to assume that the first five of these poems were written before 1682, and may have been written in the order in which they occur in the manuscript.

How much before 1682, the year he began the meditations, they were written, it's not, as far as I know, possible to say. I have seen attributions that suggest they were written after 1673 (when Taylor was about thirty) on the grounds that the earliest of his that can be dated, anacrostic verses contained in letters to his first wife when he was courting her, are crude and that the miscellaneous poems, since they represent an advance over this apprentice work, must have been written afterward. The argument doesn't seem very persuasive, since it's perfectly possible to write quite bad poetry after having written some that isn't. So, what we are left to guess is that the first five of the miscellaneous poems were written before he began the meditations and that they represent, possibly in the order that he wrote them, the apprentice work he wished to preserve for himself.

In any case, the first of these poems is a pure imitation of Donne. It's entitled "When Let by Rain." It has a Donne-like stanza, with lines of irregular length and an invented rhyme scheme, Donne's colloquial diction, his abruptness of entry, and his subject, ambivalence about departure. The first stanza looks like this:

Ye flippering Soule,
 Why dost between the Nippers dwell?
Not stay, nor goe. Not yea, nor yet Controle.
 Doth this do well?
 Rise journy'ng when the skies fall weeping Showers.
 Not o're nor under th' clouds and Cloudy Powers.

The development is Taylor. He cannot settle on a metaphor:

Is this th' Effect,
 To leaven thus my Spirits all?
To make my heart a Crabtree Cask direct?
 A Verjuicte Hall?

As Bottle Ale, whose Spirits prisond nurst
When jog'd, the bung with Violence doth burst?

Shall I be made
 A sparkling Wildfire Shop
When my dull Spirits at the Fireball trade
 Do frisk and hop?
 And while the Hammer doth my Anvill pay,
 The fireball matter sparkles ery way.

I will resist the temptation to gloss this, but it's evident that we are already in the territory of his love of the details of the home crafts. He does not do what Donne so often does, marshal the metaphors into a surprising argument. He takes the smithy metaphor through one more stanza, and then, in a sudden and terse ending, drops it:

One sorry fret,
 An anvill Sparke, rose higher
And in thy Temple falling almost set
 The house on fire.
 Such fireballs dropping in the Temple Flame
 Burns up the Building: Lord forbid the same.

What this suggests is that he took from Donne a racy freedom of diction and the use of the conceit, but he was not tempted by, or up to, or persuaded by the ingenuity of Donne's intellectual force.

The next poem, "Upon a Spider Catching a Fly," will remind some readers, in its subject, of Donne's "The Flea," but its style, the short-lined, knotty stanza, is much closer to Herbert. The language is brilliant, playful, and it is a more intensely observed description of the natural world than anything in either Donne or Herbert. It begins by addressing the spider:

Thou sorrow, venom Elfe
 Is this thy play,
To spin a web out of thyselfe
 To Catch a Fly
 For Why?

I saw a pettish wasp
 Fall foul therein,
Whom yet the Whorle pins did not clasp
 Lest he should fling
 His sting.

But as affraid, remote
 Didst stand hereat
And with thy little fingers stroke
 And gently tap
 His back.

and contrasts the spider's treatment of the wasp with his treatment of a fly:

Whereas the silly Fly,
 Caught by its leg
Thou by the throate tookst hastily
 And 'hinde
 Bite Dead.

This is very good writing, and the stanza form has a comic daintiness, or wariness. After it he draws out the theological implications and the moral in an argument that I, and others, have found rather confusing. So far as his development is concerned, what's interesting about the poem is the language—"Thou sorrow, venom Elfe" could hardly be bettered—the humor, and the closeness of observation. It is certainly more disciplined about sticking with the metaphor, but it does not have what goes with this in Herbert, the deftness and clarity of thought. And, in fact, he doesn't quite stick with the metaphor. At the end of the poem, he abandons the insects, assuring the Lord that if He frees humankind from the spider's net of the world,

We'l Nightingale sing like
 When perched on high
In Glories Cage, thy glory, bright,
 And thankfully, for joy.

And ends, one also notices, with an English, not a North American bird.

The next poem, "Upon a Wasp Child with Cold," returns to the subject of insects. It's written in a form—the tetrameter couplet—much more congenial to midcentury writers. He must have been working in it at about the same time Andrew Marvell was, and there are passages in which he deploys it so brilliantly and playfully, one wishes he had explored it a little more. Here, for example, is the description of the wasp dealing with an icy northern wind:

> Doth turn, and stretch her body small,
> Doth Comb her velvet Capitall.
> As if her little brain pan were
> A Volume of Choice precepts cleare.
> As if her satin jacket hot
> Contained Apothecaries Shop
> Of Natures recepts, that prevails
> To remedy all her sad ailes,
> As if her velvet helmet high
> Did turret rationality.

The poem ends, in less distinguished fashion, with a wish to learn from the wasp, a nimble spirit in the world's cold winds.

The fourth of the miscellaneous poems is the one by which Taylor is most widely known. It's "Huswifery," written in the Herbert stanza he was to use in the meditations. It has Taylor's technological thoroughness, and like Bradstreet's lines, it describes a principal feature of the colonial English domestic economy; he looks at what happens to the wool once Bradstreet's swains have sheared the sheep, and turns it into an ingenious lesson in Calvinist theology. Reading it, one feels that it must have been the very poem that a scholar looking for a Puritan metaphysical poet composing homely verses on the colonial frontier might have wished him or her to write. But it is not at all typical of Taylor, mainly because it is—though one might not notice if one didn't know his other work—humorless and static:

> Make me, O Lord, thy Spining Wheele compleate.
> Thy Holy Worde my Distaff make for mee.

Make mine Affections thy Swift Flyers neate
 And make my Soule thy holy Spool to bee.
 My conversation make to be thy Reele
 And reele the yarn theron spun of thy Wheele.

Make me thy Loome then, knit therein this Twine:
 And make thy Holy Spirit, Lord, winde quills:
Then weave the Web thyselfe. The yarn is fine.
 Thine Ordinances make my Fulling Mills.
 Then dy the same in heavenly Colours Choice,
 All pinkt with Varnisht Flowers of Paradise.

Then cloath therewith mine Understanding, Will,
 Affections, Judgement, Conscience, Memory
My Words, and Actions, that their shine may fill
 My wayes with glory and thee glorify.
 Then mine apparell shall display before yee
 That I am Cloathed in Holy robes for glory.

It is his most perfect poem in Herbert's mode, but it is certainly not his liveliest. And it is not where the drama of his writing lay, in that cross between the literalness that's in this poem, the attention to the stuff of the world, and his teeming, endlessly transforming imagination. Nor are there in it the great peaks and abysses of emotion that the meditations suggest were the core of his spiritual experience. It seems a pity, for that reason, that this is the poem by which he is so often represented. It is well enough made, and the working out of the metaphor has its virtue, but it does not get at what is most his own in Taylor's verse. Hopkins's description of a "pied beauty" seems near the mark:

All things counter, original, spare, strange;
Whatever is fickle, freckled (who knows how?)

Though Taylor at his best is hardly spare.

4. His Resonance

It was probably sometime after "Huswifery," and not long after, since he had found his way to Herbert's six-line stanza, that Taylor undertook the meditations. I think the best of them are in the fifty poems or so of the first series, written between 1682, when he was forty years old, and 1692, when he was fifty. Something got released in him in those poems. It was partly no doubt the form that freed him to make his fountaining inventions, but it must also have been that it gave him a way to probe the relation on which he had staked his life. To talk about this requires a brief look at Taylor's theological convictions. I have never understood how practicing Calvinists dealt with the conviction of their absolute helplessness before their God. Or how, having once experienced election, they sustained the experience of it. I think it is no accident that, very early in the meditations—it is the fourth poem in the series— Taylor placed one of three poems that are not based on scriptural citations and do not seem to have been texts chosen for his sermons on the occasion of the Lord's Supper. Each of them has a separate title. This poem is called "The Experience." It seems to be an account of his own conversion experience, which seems to have occurred when he received the sacrament.

Over the course of his life Taylor's theology—he lived to be eighty-seven—grew to be antique. His conservatism apparently tried the patience of his church, and the issue on which he resisted change was just this one of who was eligible to receive the sacrament. The doctrine of his youth was clear. No one was permitted to the Lord's Supper who had not had a conversion experience and who was not therefore absolutely certain of salvation. Taylor's lifelong nemesis and rival was a popular minister in nearby Northampton named Solomon Stoddard who insisted, as Norman Grabo puts it, "that no man could know he was saved with absolute certainty" and concluded that "the only safe course, therefore, was to admit all well-behaved Christians to the sacrament in the hopes that they might thereby secure saving grace." Taylor resisted this view vehemently, and over the course of his life the tide of opinion turned against him. His tenacity, this poem suggests, was rooted in the deepest experience of his life.

It's interesting that this issue, which preoccupied him as a minister, bears so directly on the subject and occasion of the meditations. It

makes a reading of "The Experience" illuminating, because the poem must have been written in Westfield in the early years of his ministry about the moment in his earlier life that confirmed his election and his faith and drove him out of England. It gives us a glimpse into the experience on which his convictions and his sacramental poems were based:

> Oh! that I always breath'd in such an aire,
> As I suckt in, feeding on sweet Content!
> Disht up unto my Soul ev'n in that pray're
> Pour'de out to God over last Sacrament.
> What Beam of Light wrapt up my sight to finde
> Me neerer God than ere came in my minde?
>
> Most strange it was! But yet more strange that shine
> Which filld my Soul then to the brim to spy
> My Nature with thy Nature all Divine
> Together joyn'd in Him that's Thou, and I.
> Flesh of my Flesh, Bone of my Bone. There's run
> Thy Godhead, and my Manhood in thy Son.
>
> Oh! that that Flame which thou didst on me Cast
> Might me Enflame, and Lighten ery where.
> Then Heaven to me would be less at last
> So much of heaven I should have while here.
> Oh! Sweet though Short! Ile not forget the same.
> My neerness, lord, to thee did me Enflame.
>
> I'le Claim my Right: Give place, ye Angells Bright.
> Ye further from the Godhead stande than I.
> My Nature is your Lord; and doth Unite
> Better than Yours unto the Deity.
> Gods Throne is first and mine is next: to you
> Onely the place of Waiting-men is due.
>
> Oh! that my Heart, thy Golden Harp might bee
> Well tun'd by Glorious Grace, that e'ry string
> Screwed to the highest pitch, might unto thee
> All praises wrapt in sweetest Musik bring.

I praise thee, Lord, and better praise would
If what I had, my heart might ever hold.

Not a very strong poem, I think. Taylor does better with some of these
themes elsewhere, for example in meditation 44, in the second series:

You Holy Angells, Morning-Stars, bright Sparks,
 Give place, and lower your top gallants. Shew
Your top-saile Conjues to our slender barkes:
 The highest honour to our nature's due.
 Its neerer Godhead by the Godhead made
 Than yours in you that never from God stray'd.

What's interesting about it though is that the poem is not about
having had the experience once and for all, but about having had it
and longing for it, for the reassurance of the sensation of being at one
with divinity. And also that this longing takes the form of desire for
adequate praise:

Oh! that my Heart, thy Golden Harp might bee
 Well tun'd by Glorious Grace, that ev'ry string
Screwed to the highest pitch, might unto thee
 All Praises wrapt in sweetest Musick bring.

It tells us something about the forty-year labor of the meditations,
and connects his poetic and spiritual practices to a permanent state of
distance and supplication, which he hoped his imagination might—
but must also have believed could not—overcome, at least in this world.
 It's this, I think, that makes him a poet who still resonates with
readers altogether remote from his theology. His euphoria and anguish,
rooted in his faltering belief in the power of his own imagination,
seems in many ways to echo down to the present. It makes me think,
first of all, of the Coleridge of "Dejection: An Ode," suffering from "A
grief without a pang, void, dark, and drear, / A stifled drowsy unim-
passioned grief" and hoping that the sounds of a coming storm

Might now perhaps their wonted impulse give,
Might startle this dull pain and make it move and live.

The terms are different. Though Coleridge addresses his semi-allegorical "Lady" in much the same terms that Taylor addresses his God, Coleridge seems to think, as Taylor, at least officially, could not, that the solution could come from himself:

Ah! from the soul itself must issue forth
a light, a glory, a fair luminous cloud
Enveloping the Earth—

Still one feels, listening to him, that Taylor and Coleridge are engaged in the same conversation. This is clearly not a matter of influence. The connection, I think, is this: at least since Taylor's time, the dilemmas of English Protestant spirituality have visited English poetry with the problem of sustaining an imaginative and inward relationship to whatever the sources of meaning are.

It's not quite the case that if you substitute Nature for God and imagination for grace, Taylor and Coleridge are writing the same poem—you have to squint a little to blur the philosophical niceties—but it is nearly the case. To an unbeliever, of course, to read Taylor's poetry is to watch a man sustain a relationship for all of his adult life with an entirely imaginary being. This would be true of the experience of reading all religious poetry, but there is something special about Taylor's case. The great poems of Donne and Herbert, of Vaughan and Traherne and, two centuries later, of Hopkins have, like Taylor's, a taste of intense spiritual loneliness that is part of what gives them their heft and depth, but all of these poets lived inside communities of belief. There is something about Taylor in the Massachusetts wilderness, ministering to a few dozen families of pioneer farmers, that makes the solitary struggle of his art so affecting and strange. It's one of the reasons why it has come to seem that, when the English metaphysical tradition died with Edward Taylor in the remote fastnesses of New England in 1725, American poetry had already been begun. A hundred and forty years after his death, a little farther up the Connecticut River watershed, Emily Dickinson would be writing lines that seem to take up the same issues:

There's a certain Slant of light,
Winter Afternoons—

That oppresses, like the Heft
Of Cathedral Tunes—

Heavenly Hurt, it gives us—
We can find no scar,
But internal difference
Where the Meanings, are—

And eighty years after that, down river in Hartford, Wallace Stevens, with neither a living God nor the wounding absence of God to refer meaning to, would still be revolving the problem, in a poem called, appropriately enough, "The Poems of Our Climate." In it he is meditating on newly fallen snow and wrestling with the longing for a perfection elsewhere:

Say even that this simplicity
Stripped one of all one's torments, concealed
The evilly compounded, vital I
And made it fresh in a world of white,
A world of clear water, brilliant-edged.
Still one would want more, one would need more,
More than a world of white and snowy scents.

There would still remain the never-resting mind,
So that one would want to escape, come back
To what had been so long composed.
The imperfect is our paradise.
Note that, in this bitterness, delight,
Since the imperfect is so hot in us,
Lies in flawed words and stubborn sounds.

This is how I find myself reading Taylor. Some critics have taken his complaints about the crudeness of his art as confirmation of their judgment of it. I think that misses his point. There is art enough in his poems, and there could never be, for him, art enough in the flawed words and the flawed world. It's that that makes the final poem in the meditations, written when he was eighty-one, so moving. The scripture he is meditating on at the end also comes from the Song of Solomon:

"I am sick of Love." By some last irony, the first stanza is not entirely legible. In the Stanford edition, it reads like this:

Heart sick my Lord heart sick of Love to thee!
* * * * * * * * * * * * * * * pain'd in Love oh see
Its parchments ready to crack, it was so free.
 It so affects true love * * * * * * * * * * * *
As taken * * * * sends my Lords pledge
But seeing its so small, and hence not fledge.

But it is fledged enough, though it looks like the metaphors, after Taylor's fashion, have mixed up a book and a bird.

FURTHER READING

The pioneering critical study is Austin Warren, "Edward Taylor's Poetry: Colonial Baroque," *Kenyon Review* 3 (Summer 1941), pp. 355–71.

Michael Wiggleworth's remarks occur in "The Prayse of Eloquence" (notebook located in the New England Historical and Genealogical Society), cited by Karl Keller, *The Example of Edward Taylor* (Amherst: University of Massachusetts Press), p. 304.

For an account of the origins of the Puritan migration, see David Hackett Fischer, *Albion's Seed: Four British Folkways in America* (Oxford: Oxford University Press, 1989). There is also a study of Leicestershire pronunciation in Taylor's rhymes. See Bernie Eugene Russell, "Dialectical and Phonetic Features of Edward Taylor's Rhymes: A Brief Study Based upon a Computer Concordance of His Poems," 6 vols., thesis, University of Wisconsin, 1973.

In *Albion's Seed* Fischer offers several examples of the sharp differences between East Anglian and Midlands speech. Horses in East Anglia *neighed;* in the Midlands they *whinnied.* East Anglians were *scared,* when folk from the Midlands were *frightened.* Wood that was *rotten* in East Anglia was *dozie* in the Midlands, a word Taylor uses in the phrase "Dozie Beam." He also uses *millipuff* for *fuzzball.* The *OED* gloss of this word is particularly happy. It cites Josselyn, *Voyage to New England,* in 1674: "Fussballs, millipuffs, called by the Fishermen Wolves-farts, are to be found plentifully." See also Craig

Carver, *American Regional Dialects: A Word Geography* (Ann Arbor: University of Michigan Press, 1987).

On the baroque, Heinrich Wölfflin, *Renaissance and Baroque*, trans. Kathrin Simon (Ithaca: Cornell University Press, 1966). The book appeared in German in 1888. See Harold B. Segal, *The Baroque Poem: A Comparative Survey* (New York: Dutton, 1974), pp. 15ff.

For the chronology of Taylor's poems, Thomas Davis, *A Reading of Edward Taylor* (Newark: University of Delaware Press, 1992).

For a general introduction, Norman Grabo, *Edward Taylor,* revised edition (Boston: Twayne, 1988).

2002

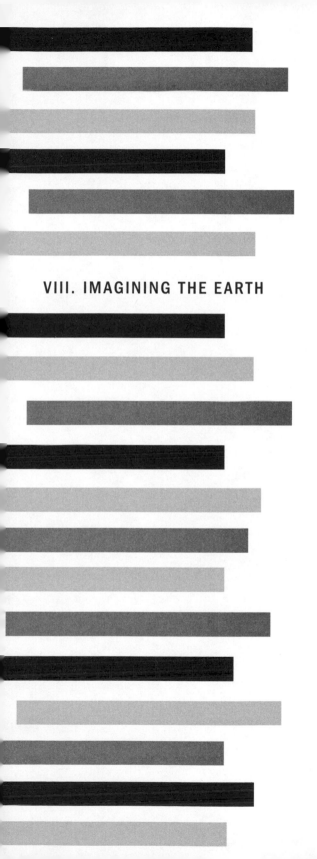

VIII. IMAGINING THE EARTH

cormac mccarthy's trilogy; or, the puritan conscience and the mexican dark

How did a writer like Cormac McCarthy—if there is any writer like Cormac McCarthy—follow up on the immense critical and popular success of his 1992 novel *All the Pretty Horses*, which won both the National Book Award and the National Book Critics Circle Award, and accumulated to itself extraordinary praise? It was called "one of the great American novels," "a genuine miracle in prose," and "a true American original," and Mr. McCarthy got compared to William Faulkner—he has often been compared to Faulkner—Mark Twain, Herman Melville, and Shakespeare. The answer provided by *The Crossing*, the second novel in his projected Border Trilogy, is that he wrote an even better book. *The Crossing* may very well be a miracle in prose and an American original, and it is also a very good novel. It seems likely to sit on the same shelf with other books of its length and intensity, *Beloved* and *As I Lay Dying* and *Pudd'nhead Wilson* and *The Confidence-Man*. It is a book that will put readers in mind of Faulkner, Twain, Melville, and Shakespeare. It will also put them in mind of Ernest Hemingway, Flannery O'Connor, Miguel de Cervantes, Samuel Beckett, Joseph Conrad, the anonymous author of the classic Spanish picaresque *Lazarillo de Tormes*, the great Mexican novelist Juan Rulfo and his *Pedro Paramo*, and for good measure, John Ford, Sam Peckinpah, Sergio Leone, and Sir Thomas Malory. But just barely. It is a tale so riveting, it immerses the reader so entirely in its violent and stunningly beautiful, inconsolable land-scapes that there is hardly time to reflect on its many literary and

cinematic echoes or on the fact that Mr. McCarthy is a writer who can plunder almost any source and make it his own.

Not that *All the Pretty Horses* wasn't a very good book, as miracles in prose go. It is dazzlingly written, a book of high spirits and high adventure, meticulous and vivid. It is a boy's book almost but passed through a sensibility bright with a love of horses and men and bleak landscapes, dark with the consciousness of human fate, and besotted with the high adjectival style of that consciousness as it lifts a coming-of-age narrative to the level of brilliant chiaroscuro meditation. Above all, it is a fairy tale. It has a fairy-tale plot, and one of the sweetnesses of the book is that, near the end, when the hero's fortunes are at lowest ebb, he tells it as a fairy tale to a group of solemnly interested children:

> I once lived at a great hacienda, he told them, but now I have no place to live.
>
> The children's faces studied him with great concern. Puede vivir con nosotros, they said, and he thanked them and he told them that he had a novia who was in another town and that he was riding to her to ask her to be his wife.
>
> Es bonita, su novia? they asked, and he told them that she was very beautiful and that she had blue eyes which they could scarcely believe but he told them also that her father was a rich hacendado while he himself was very poor and they heard this in silence and were greatly cast down by his prospects.

McCarthy has one girl advise the hero that in such cases it is usual to consult a wise godmother, and he tells her that he has offended the godmother, and the children stare into the dirt, and one boy says at last, "Es un problema." It is part of McCarthy's method and his gift that he can signal his literary intentions to his readers in this way without archness. If he seems postmodern in his sense that everything is a quotation of a quotation, he parts company with postmodern practice in thinking not that everything therefore refers ultimately to nothing, but that in human life certain ancient stories get acted out again and again, and that a writer's moral relation to these stories is like nothing so much as a craftsman's relation to his tools, and that nothingness is not to be courted for the pleasure of merely circulating, but built against, sentence by sentence—and here certain Faulknerian adjec-

tives might come into play—if hopelessly, in the knowledge of the doom of all human intention, then indefatigably, in the knowledge of the skills of a trade that has been passed down to one and that will be passed in turn to other hands.

This is a male ethic. It may be *the* American male ethic, but it descends to us from sources as old as the *Odyssey* and the *Aeneid*—those primers of maleness—and it came to the heroes of our popular fiction, cowboys and urban detectives, by way of Joseph Conrad before it got to Hemingway and Faulkner. McCarthy has apparently chosen in his Border Trilogy to examine it yet again. And the form he has chosen is a modern version of the Western. *All the Pretty Horses* is set on the Texas-Mexico border in 1949. It tells the story of a young man who leaves home and crosses the border into Mexico in search of his fate. It is part of the boldness—or obsessiveness—of McCarthy that *The Crossing* tells very nearly the same story. It is set on the New Mexico–Mexico border in the late 1930s and it tells the story of another boy who crosses that border. But fatality has entered *The Crossing*. If the hero of *All the Pretty Horses* heads out like Huck Finn in search of open-ended adventure, Billy Parham, the protagonist of *The Crossing*, has elected, or been elected, to perform a nearly impossible task, or a series of tasks, since part of the originality of *The Crossing* is that it enacts its ancient story not once but three times.

Quest narratives have a goal but not a plot. Any fairy tale soon develops that machinery. The youth wants to marry the daughter of the king. The king opposes this. The good godmother is consulted, helpers appear, and dread tasks are imposed. But in the quest a hero sets out on a journey. He has an end, an obligation solemnly imposed, which he may or may not accomplish, and things turn up along the way. It is a story of accidents and miracles and it takes as its subject the spectacle of human life from the road's point of view. In this way *The Crossing* takes its bearing not from the fairy tale—it is in a way a critique of it—but from some blending between the medieval romance and the early picaresque novel. The picaresque is, by definition, a more ragtag, knockabout, chaotic, and unexpected kind of story. Scholars of the novel used to treat the picaresque tale as a kind of underdeveloped novel because it was episodic. It lacked the grand vision of social wholeness that a plot implied, and its protagonists were shape-shifters who reacted rather than grew. When a character reappears in a novel—like

Raffles in *Middlemarch*—it is because subtle strands of causality bind us to one another. When a character reappears in a picaro's story, it is because the world is full of inexplicable, randomly benign, randomly malicious coincidences. The picaresque made its comeback because it is a view of the world—random, terrifying, full of wonders—in which the story is that one thing happens, and then something else happens. The hero's task—if he has a task—imposes order, a perhaps absurd, privately invested order, on this chaos, and makes it a story about our moral lives, unmeaning malice, unmeaning beauty, the forms of necessity, and the shape of human will. This is the territory that *The Crossing* traverses.

It begins on a small cattle ranch in a New Mexican valley in the last years of the Depression. A wolf has come down out of the Sierra Madre to the south and begun to attack grazing cattle. Father and sons set about trapping the wolf, but it is an emblem of their moment in the history of the West that the last trapper who might know how to go about it is gone. They acquire a key to his cabin, long shut down, and the boys are given entry to the workshop of a cruel, immensely practical, and almost obsolete art: longspring traps for coyote; larger traps for cougar and bear and wolf, iron-teethed, brutal and jagged; springs and chains and stakes greased with lard and packed in wooden boxes, fruit jars and apothecary bottles in which swim the liver and gall and kidneys of animals; elixirs for the purpose of scenting the traps. From this sudden, arcane, unexpected view onto the settling of America, the novel proceeds.

Billy Parham, the protagonist, who has dreamed of wolves, finally stumbles on a method and traps the wolf. He also unexpectedly hogties it, muzzles it, leashes it with a catchrope—all of this heart-stopping to read—and sets off south across the unfenced land to return it to the mountains of Mexico from which it came. And at once we are in the world of romance. If an old man in antique armor on a bone-thin horse followed by a fat would-be squire on a mule was once a strange apparition on the highways of Cervantes's Spain, then a young man on a cow pony dragging behind him a wild and recalcitrant she-wolf through ranches, American and Mexican, where wolves were a remembered tale of ravenous ferocity and terror, may well seem to replay that story, with the same mix of comedy, cruelty, and philosophical wonder. This first section of the book reads, indeed, like a cross between Faulkner's

"The Bear" and *Don Quixote*. It is about a novella's length—it may, as "The Bear" did, come to have a double life as a classic novella and as a section of a novel—and it is written with such force and momentum, the reader is so ransacked emotionally by the end of it, that it seems, one-third of the way into the book, that McCarthy can have nowhere to go.

And what the novel does at this point is, as it were, take a deep breath and repeat itself. Billy Parham, this time accompanied by his brother, makes the crossing into Mexico again. And in the final section of the book, he makes it again. The first crossing is to perform this wildly improbable and Quixotic act of—what? honor, reparation— toward the world of his dream. The second is to reclaim a patrimony. The third is to complete these two tasks in a different form. All three quests seem impossible, and they are undertaken as if he has no choice, and in this they are like fate, like all the things that people have done in their lives that they couldn't not have done, and it is in its meditation on this circumstance that some of the deepest energies of the book reside.

McCarthy, because he is interested in the myth-shape of lives, has always been interested in the young and the old. Or if not the old, then those who have already performed some act so deep in their natures, often horrific, though not always (*ananke*, the Greek tragedies called it), that it forecloses the idea of possibility. "Doomed enterprises," his narrator remarks, "divide lives forever into the then and the now." So *The Crossing* is full of encounters between the young boys, who look so much like the pure arc of possibility, and the old they meet on the road, all of whom seem impelled, as if innocence were one of the vacuums that nature abhors, to tell them their stories, or prophesy, or give them advice.

Some of these episodes are quite long and take the form of those stories-within-the-story that the old romances and the earliest novels were so fond of. Others are quite brief, and they are among the most indelible scenes in the book, partly because, reading them, we are put in the position of the traveler, especially the youthful traveler, for whom the world glimpsed has the quality of revelation. As the young riders traverse poor, rural northern Mexico, in the wake of a bitterly failed revolution, in a landscape of barren and tortuous beauty, what they see on the road becomes an emblem of what the world is. And it is a world

of inexplicable kindness, inexplicable cruelty. The kindness—since this is a book of desperate wanderings—often takes the form of shared food, and it is part of the power of the book that the reader, reduced to something like mendicant vulnerability by its more nerve-wrenching moments, reads these scenes as gratefully as if he were eating.

Some of the moments are pure encounter, two people only looking at each other, or exchanging a few words as they pass by, and they stay etched in the mind like blue-period Picassos, or like the Goyas they were based on. Or, to multiply analogies, like throwaway scenes in Buñuel or Fellini. Indeed, if this book is to be filmed, it is a Sergio Leone Western directed by Fellini or Buñuel that one imagines giving visual equivalents to these portraits of beggars, wanderers, holy fools, the insulted and the injured, and their vatic sayings: an old Mexican trapper dying on a sling bed in a room of half-light and necrotically stale air who tells the young hero that the wolf is a hunter and "a being of great order and that he knows what men don't, that there is no order in the world save that which death put there" and that wolves have to be seen on their own ground because "if you catch it, you lose it. And where it goes there is no coming back from." A half-crazed hermit priest in the precarious remains of an earthquake-damaged church who tells Billy that it is no good looking for things because "things separate from their stories have no meaning" and that a story, on the other hand, "can never be lost from its place in the world because it is that place." A kindly Yaqui drover on a mountain road switching the rump of an ox offers the information that "the ox was an animal close to God as all the world knew and that perhaps the rumination of an ox was the shadow of a greater silence, a deeper thought" and that "in any case the ox knew enough to work so as to keep from being killed and eaten and that was a useful thing to know." The world-ravaged prima donna of a down-and-out commedia dell'arte troop whom Billy later sees naked, bathing enormous pale breasts in a clear stream, tells him that "the road has its own reasons and no two travelers will have the same understanding of them at all" and that "the shape of the road is the road and that every voyage begun upon it will be completed," and a blind man, who lost his eyes as an object lesson in revolutionary retribution and then outlived his despair, tells him that it is his own opinion that "the light of the world was in men's eyes only for the world itself moved in eternal darkness and darkness was its true nature and

true condition and that in this darkness it turned with perfect cohesion in all its parts but that there was naught there to see" and that it was, moreover, "sentient to its core and secret and black beyond imagining."

One of the most fetching and emblematic scenes in the book is a brief encounter at roadside, early on, when Billy Parham is dragging the wolf beside him, and meets an old peasant woman and her thirteen- or- fourteen-year-old, sullen, and probably pregnant companion. Nothing much happens in the scene. The women smoke—"the way poor people eat, which is a form of prayer." They exchange words; the women ask about the wolf, which they take to be a dog—"Es feroz la perra, no?"—and they spar with one another a little, finding themselves suddenly in the theater of a stranger's eyes. It is like stumbling suddenly onto an allegory of youth and age from a medieval pastoral, or like the emblematic figures turned up on a tarot card, and it catches something of McCarthy's sense of the comic. The old woman explains that the young one is married to her son but not by a priest. The girl offers the view that priests are thieves. "Los sacerdotes son ladrones." The old woman rolls her eyes and says that the girl thinks she is a revolutionary and that those who have no memory of the blood shed in the war are always the most ardent for battle, and that during the revolution priests were shot in the villages and that women dipped their handkerchiefs in the blood and blessed themselves, and that the young nowadays care nothing for religion, and that the land was under a curse. The young woman tells him that the old woman is always talking about priests and curses and that she is half-crazy. The old woman says that she knows what she knows. And the young woman says that at least she herself knows who the father of her child is, and the old woman says, ay, ay. Then she remarks that the wolf is pregnant and that she will have to be unmuzzled to lick the pups and that all the world knew that this was necessary. And the young woman regards the wolf and says that she would like to have a watchdog like that to drive off anyone at all that was not wanted. And she makes a gesture, McCarthy writes, "that took in the pines and the wind in the pines." Then the boy says he has to go, and the scene is over, except that Billy Parham looks back and sees that they have not moved, they sit staring at whatever they were staring at when he appeared, and they seem diminished by his departure.

There are more than a dozen of these scenes in the book. They seem

to have no other meaning than the human gesture they describe, and at least half of them have a vividness, a sense of mystery that is the mystery of a thing or person being nothing other than itself—as if the road made all of life a parable—that haunts the mind and hovers over all the rest of the action. Of which there is a great deal. The book teems with it, and with spectacle, and surprise: the life of the towns, the work camps, the haciendas, peasants and miners and cowboys and drovers, Indians and gypsies, lives ruined, thriving, bent under labor, bent to every conceivable shape by circumstance, and the boys traveling through it at the vertical that their wills and their tasks make, tipping their hats, saying "yessir" and "no, sir" and "sí" and "es verdad" and "claro," to all its potential malice, its half-mad philosophers, as the world washes over and around them, and they themselves come to be as much arrested by the gesture of the quest as the old are by their stores of bitter wisdom and the others, in the middle of life, in various stages of the arc between innocence and experience, by whatever impulses have placed them on the road.

McCarthy is a great and inventive storyteller and he writes brilliantly and knowledgeably about animals and landscapes—but finally the power and delight of the book derive from the fact that he seems incapable of writing a boring sentence. Reading him, one is very much in the hands of a stylist. His basic mode in this book—it is a considerable intensification of the manner of *All the Pretty Horses*—is a version of high modernist spareness and declarative force. The style comes from Joyce and Hemingway out of Gertrude Stein. It is a matter of straight-on writing, a veering accumulation of compound sentences, stinginess with commas, and a witching repetition of words:

> He was very cold. He waited. It was very still. He could see by his breath how the wind lay and he watched his breath appear and vanish and appear and vanish constantly before him in the cold and he waited a long time. Then he saw them coming. Loping and twisting. Dancing. Tunneling their noses in the snow. Loping and running and rising by twos in a standing dance and running on again.

Once this style is established, firm, faintly hypnotic, the crispness and sinuousness of the sentences of what would otherwise be quite ordinary description gather to a magic: "The snow in the pass was

halfway down to the horse's belly and the horse trod down the drifts in high elegance and swung its smoking muzzle over the white and crystal reefs and looked out down through the dark mountain woods or cocked its ears at the sudden flight of small winter birds before them." These rhythms pass into even the most workmanlike business of the novel, getting from here to there, moving characters about: "There was still snow in the upper stretches of the road and there were tiretracks in the road and horsetracks and the tracks of deer. When he reached the spring he left the road and crossed through the pasture and dismounted and watered his horse."

And, of course, McCarthy is capable of lifting out of this hypnotic and lapidary directness into high Faulknerian crash-and-burn: "He woke all night with the cold. He'd rise and mend back the fire and she was always watching him. When the flames came up her eyes burned out there like gatelamps to another world. A world burning on the shore of an unknown void. A world construed out of blood and blood's alcahest and blood in its core and in its integument because it was that nothing save blood had power to resonate against that void which threatened hourly to devour it. He wrapped himself in the blanket and watched her. When those eyes and the nation to which they stood witness were gone at last with their dignity back to their origins there would be other fires and other witnesses and other worlds otherwise beheld. But they would not be this one."

A curiosity and signature of the style is the occasional use, faintly mocking, of something like nineteenth-century legal diction. It gives McCarthy's descriptive prose an odd taste of necessity and judgment. The wolf again: "Her eyes did not leave him or cease to burn and as she lowered her head to drink a second pair of eyes came up in the dark water like some other self of wolf that did inhere in the earth or wait in every secret place even to such false waterholes as this that the wolf be always corroborate to herself and never wholly abandoned in the world or any waste thereof." And this, about the jars on the trapper's shelf: "In the jars dark liquids. Dried viscera. Liver, gall, kidneys. The inward parts of the beast who dreams of man and has so dreamt in running dreams a hundred thousand years or more."

This language could easily seem affected and it rarely does, or, as with Faulkner, readers will find themselves yielding to the affectation, and to the barren landscapes it describes, and the carnival of figures

encountered on the road who make a world that is at once unlike any-thing in American fiction and deeply familiar, since it is the site of one of the oldest of stories, the one about having a task to perform in the world and learning what the world is from trying to perform it.

It is, in this way, a book about the artist's task, or any workman's task. This is also the subject of McCarthy's one published play, *The Stonemason*. It concerns several generations of a black family in Louisville in the 1970s, all living under the same roof, and it reads, per-haps, like a version of *A Raisin in the Sun* conceived by Eugene O'Neill. The main character is a college-educated, thirty-two-year-old man, who has, from love of his one-hundred-and-one-year-old grandfather, taken up his trade of freestone masonry. And a good part of the play is concerned with his descriptions of the beauty and saving power of his grandfather's art. It is given an expressionist staging by the device of having Ben Telfair stand at a pulpit and speak to the audience, as if to justify his life, while another actor enacts his part in a story about a family coming undone. It is not a play about race. The main character's name, which seems a pun on "tell fair," suggests that it is as much about the novelist's craft as it is about the mason's: "To make the world. To make it again and again. To make it in the very maelstrom of its undoing." And future critics are likely to read Ben Telfair's relation to his grandfather as a kind of ironic, morally ambiguous allegory of McCarthy's relationship to William Faulkner and to the traditions of the novel.

I can imagine that some African-American readers may feel that McCarthy has displaced his own concerns onto his black characters. The rhythms of Ben Telfair's speech at the pulpit of his life seem to my ear distinctly Irish Catholic, rather than African-American. But it cer-tainly avoids stereotypes, and it tries to think about work in America. The grandfather, perhaps because he has nothing else to call his own, practices his craft as lovingly as if it were a religion. Like the genes of the timber wolf in *The Crossing* (and the art of trapping them), his craft, its lore and its fidelities, are passing away. In one lovely scene, the old man refuses to lay an honorary cornerstone in Louisville because the Old Testament enjoins against building with hewn stone and because he knows it, from the story of the Hebrew people in Egypt, to be the work of slaves. The old man's son, Ben's father, has made a busi-ness of the craft and sent his son to college, and the son has rejected

whatever his education might have given him and taken up the old man's art. And the play is about what this old ethic of work, a male ethic undertaken in piety and desperation, can and cannot sustain.

It is very near to the ethic that leads Billy Parham of *The Crossing* and John Grady Cole of *All the Pretty Horses* to cross over a border from what they know to what they need to know. I can also imagine some readers feeling that McCarthy has displaced the epidemic of violence in American culture onto a half-legendary state of Chihuahua. Displacement has always been a condition of the romance. And the Mexico in McCarthy's novels, if it is half dreamscape, is not unlike the Mexico of Juan Rulfo and Carlos Fuentes and the Mexico of Octavio Paz's *Labyrinth of Solitude*. Perhaps the Western, which was always a sort of American Protestant morality tale, a *Pilgrim's Progress*, made out of simple virtues and simple tests, needs, as the century ends, an older and darker Arcadia in which to be enacted. It would not be the first time that Americans projected their own violence onto other people, and also mystery and the patterns of necessity and fate.

1994

black nature

Camille Dungy's new anthology, *Black Nature: Four Centuries of African American Nature Poetry,* has gotten some early attention based on the premise that there is something unusual about a book of African-American nature poetry. Which is odd, if you think about the history of the American earth. Though I can see some of the reasons why people had that response. The first is the perception that African-American life and literature are predominantly urban. As they are. And for a dramatic and well-known reason. In 1900, 92 percent of all African-Americans lived in the South and most of them lived in the country and did farm labor. In two great migrations between 1910 and 1930 and again between 1940 and 1970, more than nine million African-Americans left the South and moved to the Northeast, the Midwest, and the West. By 1970, 80 percent of African-Americans lived in cities.

This transformation is a more precipitous version of what happened to American society as a whole in the twentieth century. In 1900, 60 percent of all Americans lived in small towns and rural villages and 40 percent lived in cities. By 1990, almost 80 percent of Americans lived in cities. So it would seem that the pattern of movement from a farm economy to an urban and industrial one was an experience shared by black and white Americans. And it was, but with an important nuance. As Southern rural blacks moved into cities, some of the white folks moved partway out. Ezra Pound, Hilda Doolittle, Marianne Moore, T. S. Eliot, Gertrude Stein, and William Carlos Williams, for example, were raised in suburbs; as one of the important patterns of white experience became suburban, representations of black American experience, from as early as the 1920s, became in New York and Chicago and Saint Louis and Kansas City

the paradigmatic expression of the rhythms of urban life in the twentieth century.

It even has a signature note, or several of them: Louis Armstrong's initial trumpet riff in "West End Blues" and Duke Ellington and Billy Strayhorn's rhythms in "Take the A Train," and, because cities are melting pots, places where cultural energies are consumed and transformed, the long glissando wail of the clarinet that begins George Gershwin's 1924 composition *Rhapsody in Blue,* marrying the sound of the shtetl to the sound of the blues by way of introducing a first jazz composition to the upper reaches of musical culture, came to embody the tempo of the modern city.

That's another part of the story and it has been told well by cultural historians. As blacks poured out of the South, immigrants poured out of Italy and Central and Eastern Europe looking for work in the new American industrial economy. They met in the teeming cities and listened to each other and fused musical traditions and produced the sounds of popular music in the twentieth century. Scott Joplin, born in dusty East Texas, not long after Texas became a state, took piano lessons from an immigrant German "professor of music" and syncopated the music he learned and either invented or developed ragtime, and Irving Berlin, whose family fled from the pogroms of Russia to New York, heard it and covered it and recorded "Alexander's Ragtime Band" (hardly ragged at all). Thus urban American music got its start from the chaotic new urban culture that the European-Americans were fleeing. T. S. Eliot, child of Saint Louis, in the poem of the decade, would evoke that music and his relation to it—half mockingly, half enviously—by imagining it going through the mind of a young, desperate, and neurasthenic Londoner: "O O O O that Shakespeherian Rag—/ it's so elegant / so intelligent." And at about the same time, Langston Hughes, having gotten from Kansas City to New York by going around the world, was writing a poem about a blues singer singing "The Weary Blues."

This is Harlem in the 1920s. White people venturing into the new black metropolis to feed off its energy while its poet is expressing that energy through the figure of an old black man singing about the fact that he is bone tired. Somewhere in this mix, somewhere in the music, is something of the then three hundred years of black experience in North America, and it is a story complicated enough to make you wonder how to speak about "black nature."

Well, all this is true. Modern life in America has been predominately urban; black American life—until quite recently—has been overwhelming urban; and the literature of the natural world and the American earth and the literature of environmental advocacy have been for the most part created by European-Americans who have had the access to higher education and to leisure experience of the outdoors as hunters and fishermen and hikers, bird-watchers and botanists and gardeners to make them what we have come to call nature writers. So what is wrong with this picture? Something that a few names might conjure: Sterling Brown, Zora Neale Hurston, Jean Toomer. It is the fact that African-American labor, life in the country and in the earth, has been responsible for giving shape to large portions of the North American continent for the last four hundred years. And it is true there are only glimmerings of it in the written record, and those fairly recent. In this it is not much different from the story of the transformation of the rest of the earth. The written record of the worked land, its life, and its changes over thousands of years is just as patchy in Europe and Africa and Asia. But there is something about the glimmerings that we do have that make the American record especially poignant. They need to be teased out. Toni Morrison has almost made an allegory of that fact in her *Song of Solomon*. And for me, not knowing much about the subject, having it in my head mostly as songs and poems, one of the tools for thinking about it has been environmental history.

Scholars who talk about the making of the North American landscape, especially the landscape of southern North America and of the Caribbean, tend to begin their discussion with sugar. And then to follow it with discussions of tobacco, cotton, and rice. The four crops organized much of the economic and cultural life of the Southern states just as they were transforming the land. They account in many ways for the shape and the culture of the institution of slavery and of Southern life immediately after Emancipation, and so they are a way of organizing an imagination of those three hundred or so years when black labor transformed a large part of the continent and black workers knew, if anyone knew, the evolution of the American earth intimately and on a daily basis.

Sugar is not native to North America. It's indigenous to South Asia. The Arabs took it from India to the East and Spain in the eighth century and Christopher Columbus brought it from Spain to Hispaniola

on his second voyage, where, as he thought it might, it flourished and quickly became a cash crop so valuable it made the settlement of the Americas a desirable proposition and brought the slave trade into being. The first slaves to arrive in the New World from the West African coast arrived in 1505 and they were brought here to work in sugarcane fields.

So there is a reason why one of the first great works of African-American nature writing is called *Cane*. Consider the working of the Atlantic trade in the sixteenth and seventeenth and eighteenth centuries. Ships set sail for the rich towns of West Africa with manufactured goods to sell or trade for slaves, and then sailed to the West Indies to sell or trade the slaves for sugar and molasses and rum, which they brought back to Europe and sold at an enormous profit. Consider this: sugar was such a valuable commodity that the French did not hesitate to trade all of French Canada to the English (the French foreign minister called it "a few acres of snow") for the islands of Guadeloupe, Saint Lucia (whose later principal export was Derek Walcott), and Martinique (which in its turn exported Aimé Césaire to France). The first distillery of rum was built in Barbados in 1627, the first in Boston in 1667. Between 1870 and 1917, according to one economic historian, the most profitable industry in New York City was the refining of sugar. The Jesuits brought sugarcane to Louisiana in 1751. Today sugar contributes $2 billion a year to the Louisiana economy. Growers took cane to the Georgia wilderness, where some years later Jean Toomer had a job in the summer of 1921 at a segregated black school in a city called Sparta. The town got its name, according to the local story, because one of the Scots-Irish settlers said that the Creek people whom they drove from their lands in order to take possession of the place had fought like Spartans. Sparta throve as a center for cotton growing, but when the boll weevil came in 1910 and destroyed the cotton (one of the reasons for the urbanization of African-Americans), Sparta went broke and reverted to sugarcane, which is why Jean Toomer could write one poem that began "Boll-weevil's coming, and the winter is cold," and another that begins "Wind is in the cane. Come along." Well, here is all of it:

Wind is in the cane. Come along.
Cane leaves swaying, rusty with talk,
Scratching choruses above the guinea's squawk,
Wind is in the cane. Come along.

Consider this: in 1898 the United States, by seizing Puerto Rico, Cuba, and the Philippines in the Spanish-American War, acquired control of one half of the world's total sugarcane production. At that time the U.S. was also the world's largest consumer of sugar, after Great Britain. It consumed two million tons of sugar a year and produced only three hundred thousand tons domestically in Texas, Florida, Louisiana, and Georgia. The cost to the United States of its sugar imports was $80 million a year. Reason enough to spend fourteen years from 1899 to 1913 suppressing the Philippine independence movement, which resisted our best efforts to bring them democratic institutions. Wind is in the cane. Come along.

The next story in such a history of black nature would probably be tobacco landscapes. That was the cash crop that settled the middle Atlantic states and the upper South. It was labor intensive and this time it was a native plant and well adapted to the local climate, and once Europeans had acquired a taste for it, and the leaves had become pure gold, a regimen was required to clear enough land and to grow enough crops efficiently on the model of the sugar plantations. The work created a large-scale market in slaves to Maryland and Virginia and the Carolinas and the new settlements beyond the mountains.

It was a model that didn't work very well with tobacco. The plant, as many historians have remarked, wore out the soil, and Europeans discovered that, to grow it successfully, they had to rotate it with other crops, corn, beans, peas, and then leave the fields fallow for a few years. Indentured servants, European and African, cleared land and cultivated tobacco plants all through the seventeenth century. By 1700, according to the ecological historian Sam Hilliard in "Plantations and the Moulding of the Southern Landscape," published in Michael Conzen's *The Making of the American Landscape*, "those entering Virginia were imported as slaves, primarily to serve as laborers on tobacco holdings." The need to keep clearing land spread tobacco and Africans from the James River "to the lowlands on the Potomac and Rappahannock Rivers as well as along Albemarle Sound, which was to become part of the state of North Carolina." By the mid-eighteenth century tobacco had so much become the currency of the Chesapeake Colonies, it was even used to pay fines and taxes. For example, these fines were noted by a historian of Maryland: "persons encouraging Negro meetings were to be fined 1000 pounds of tobacco; owners letting Negroes keep horses

were fined 500 pounds tobacco; if a person wanted to become married, he had to go to the rector of his parish and pay the man so many pounds of tobacco; a man's wealth was estimated in annual pounds of tobacco."

Considering that Africans and African-Americans worked tobacco farms and plantations for almost four hundred years, the record of that relation to the American earth is particularly sparse. If it existed, it would be in the oral tradition, and the written record of the oral tradition does not begin until the middle of the nineteenth century when European-Americans began to notice and record the lyrics of black songs, beginning with Thomas Wentworth Higginson, Emily Dickinson's friend and editor, who wrote an article for *Atlantic Monthly* during the Civil War about the spirituals he found his black troops singing. And there is nothing I'm aware of about work in tobacco fields or tobacco barns in the oral tradition. Probably the best-known language produced by the clearing of the land and the cultivation and marketing of that soothing and fiendishly addictive plant was produced by the sons of Virginia planters who used the income to buy English and European books and to cultivate the leisure in which to write, "We hold these truths to be self-evident, that all men are created equal, that they are endowed by their Creator with certain inalienable rights."

By the time of the Civil War, there were four million slaves in North America. Over half of them were on plantations owned by planters who held twenty or more slaves and these tended to be in the Deep South. Tobacco created plantations in the early eighteenth century but by the time of the Revolution, it was at least equally a cash crop grown alongside subsistence crops for local markets on small-to-medium-sized farms that held no slaves or a slave or two. And this relative isolation of individual African and American-born African slaves, as Ira Berlin has suggested in *Many Thousands Gone,* on small farmsteads led much more quickly to the loss of African cultural habits and practices and to the Christianization of Middle Atlantic African-American culture. Tobacco did not produce work songs in the way that the cotton culture would. What it may have played a role in producing instead were those spirituals that Colonel Higginson recorded. And the spirituals are not a record of the African-American experience of nature, they are a record of a soaring, triumphant, millennial escape from its grip:

Swing low, sweet chariot,
Coming for to carry me home!

I am sure the natural world gave some pleasure to the people who worked the land for those four hundred years. But we will not find in the written record what sunlight looked like to them in the leaves of trees along the Rappahannock River in the spring, or what the sky looked like when tens of thousands of migrating passenger pigeons flew over, or how woods sounded when pileated woodpeckers were as common as wild turkeys, or how the land had been altered by centuries of European agricultural practices. I'm sure that there was an immense practical and aesthetic, biological and pharmaceutical and ecological lore passed down in the oral tradition, from farmer to farmer, naturalist to naturalist, by people who were outdoors every day and observed the world as a respite from backbreaking labor, but it is invisible to us. There may have been an Emersonian nature out there or a Thoreauvian nature, of the kind that those New Englanders learned to see from reading English and German Romantic poetry, but in the tradition of the spirituals, "black nature" is slavery:

Don't care where you bury my body,
My soul is going to shine.

There is, though, at least one poem of the tobacco culture on the record. It comes from Sterling Brown's *Southern Road* (1932). If there is a single book of the tobacco and cotton cultures, *Southern Road* is it. Brown—this needs to be a very short version of a fascinating story— was born in Washington, D.C., where his father, born a slave, was a professor of religion at Howard University. Brown grew up in that Jim Crow city and played ball on its basketball courts with Jean Toomer, the author of *Cane*. It was, for a young African-American at the turn of the century, a privileged life. Brown attended Williams College and got an M.A. in English from Harvard and then went south to learn his roots and serve his people—as a young, educated black man would have said in those days—by teaching first at Virginia Seminary and College in Lynchburg, Virginia, then at Lincoln University in Missouri and Fisk University in Tennessee. And during those years the young man discovered black Southern culture. He heard the blues; he heard

spirituals (which he would have known from Howard) and work songs; he heard the rhythms of several varieties of black speech; he watched crowds of country people come to town, in wagons, on foot, on mules, to hear Ma Rainey sing in a tented campground; he listened to jazz and to the "race records" that came pouring onto the market in the 1920s. And trained at Williams and Harvard in the poetry of the 1880s and 1890s—the poems of Dowson, and Symons and Swinburne—but also having discovered the new poetry of Edwin Robinson and Robert Frost and Thomas Hardy and Carl Sandburg, he began to make a modernist poetry out of the folk poetry he was hearing and the lives he was witnessing. The poems, published in the early years of the Depression, are full of affection for the worlds he discovered, and they focus the folk tradition with wry, bitter clarity. One of them is called "Kentucky Blues." Here are a few stanzas:

I'm Kentucky born,
Kentucky bred,
Gonna brag about Kentucky
Till I'm dead.

Thoroughbred horses,
Hansome, fas'.
I ain't got nothin'
But a dam' jackass . . .

Corn land good,
Tobacco land fine,
Can't raise nothin'
On this hill o' mine.

De red licker's good,
An' it ain't too high,
Gonna brag about Kentucky
Till I die . . .

The story after the story of tobacco would be the story of the collapse of the tobacco market in the Middle Atlantic states about the moment Thomas Jefferson left the presidency. Some historians say

that Jefferson left the White House intending to go home and free his slaves, only to discover that the soils of Virginia were exhausted and that he was in debt. That was the moment of the beginning of the cotton boom in the Mississippi delta, which required a massive infusion of labor. The planters of Virginia weren't growing enough tobacco to pay their way, but what they could grow and market was slaves.

If there is a single epic story of "black nature," it must be the story of cotton. In the late eighteenth century—as Ted Steinberg tells us in *Down to Earth: Nature's Role in American History*—cotton manufacture began to be an important part of the English economy. Most of the cotton came from India, and American planters began to look for a plant they could grow for the British market. They found it in a variety of cotton that grew well in a fairly narrow area of the southern coast, a long-staple cotton from India. There was another species, a short-staple cotton that grew well inland, but the seeds inside the cotton boll proved a problem. It took a field hand a full day to clean a pound of cotton by hand. Then in 1793, as every American schoolchild knows, Eli Whitney invented the cotton gin, which cleaned the bolls easily and efficiently. The result looked like this: in 1790 U.S. planters grew 1.57 million pounds of cotton; in 1840 they grew 673 million pounds. In 1800 cotton exports, valued at $5 million, comprised 7 percent of U.S. exports; in 1860 cotton exports, worth $191 million, constituted 57 percent of U.S. exports. It was in the early years of this boom that Thomas Jefferson and the other high-minded planters of Virginia found that they could only pay their debts to London merchants by selling their slaves south.

Short-staple cotton and the Mexican black- and green-seed cotton that replaced it could be grown all over the South and the eastern half of the Southwest, and it had two requirements: land and labor. And that was how slavery burst its coastal confines. As they exhausted the coastal soils, farmers looked westward for land. Andrew Jackson was their ministering angel. There were, among the Cherokee, Choctaw, Chickasaw, Creek, and Seminole peoples, an estimated 125,000 Native Americans living east of the Mississippi. In the treaties of 1814 and 1824 Jackson got rid of them, making available to planters "three-fourths of Alabama, a third of Tennessee, and a fifth of Georgia and Mississippi," as Steinberg tells us. By 1844 there were at most a few thousand members of the Southern tribes living east of the Mississippi. There were about seventeen million people in the United States and

the territories in 1840. By 1844 a million of them were slaves working on cotton plantations.

It's hard to sort out the stories one might tell here. The "nature" part of the "black nature" story would have to do with soils. Southern soils tended to be acidic. They weren't good for growing grass and so they weren't especially good for raising cattle, and that meant, to a culture that was making money hand over fist and wearing out the soil, manure was a scarce commodity. As Steinberg points out, there was a reason why Millard Fillmore signed the Fugitive Slave Act in 1850 and devoted most of his State of the Union address in that year to the subject of Peruvian guano. Many planters by then had begun to rotate crops to fix nitrogen in their exhausted soil. But the profit system plus monoculture plus slavery did not promote an ethic of land stewardship. The war and its aftermath intensified the trend. Their forests decimated, soil played out, Southerners looked west again for cash to fuel Reconstruction. In the postwar years, writes Steinberg, the South from South Carolina to East Texas was every autumn "a sea of white that drifted off to the horizon."

The "black" part of the story has several strands. The cotton boom began in the post–Revolutionary War period when many Northerners and some Southerners were ready to abolish slavery, so it shut down that possibility and it must also have hardened and shaped the racist ideologies necessary to the justification of the slave system. One can see why a historian might list the cotton gin as one of the causes of the Civil War. Another part of the story is what happened after the war when the slave system was converted to sharecropping. The two crucial developments of that period were railroads—built to transport cotton and to import the beef, corn, wheat, and pork that the headlong planting of cotton kept Southerners from giving land to—and the boll weevil. From a literary point of view, the railroads gave black artists another metaphor of escape from nature, if you thought of nature as unending toil. As the spiritual imagined a soaring vertical escape from bondage, critics have observed, railroads provided the secular tradition with a horizontal one, sometimes celebratory, sometimes intensely wistful and poetic, sometimes quite painful:

Going to Chicago, sorry that I can't take you.
Going to Chicago, sorry that I can't take you
Cause there ain't nothing in Chicago for no damn monkey woman to do.

It's a song—usually sung to sound impudent and jubilant—that projects a century's learned and gendered self-hatred onto what is being left behind. It's also a song of the Great Migration. Between 1904 and 1920 the boll weevil more than decimated cotton production on large plantations and on small farms. In Greene County, Georgia, farmers in 1916 picked 11,854 bales of cotton. In 1922 they picked 333. It was the boll weevil as much as the Ku Klux Klan that initiated the great exodus of blacks to the North that began in about 1910 and that would lead eventually to the perception that black culture was urban.

This is the other part of the story. Between 1780 and, say, 1920, for a period of a hundred and forty years, several million African-Americans, something like five to seven generations, lived out their lives inside that system, either its slave or its sharecropping version, and they lived in such concentrations that they made a culture—an almost entirely oral culture; there were parts of the South where you could get killed if you were caught learning how to read—and one of an amazing richness and depth. Most of what we know of it comes from two sources—transcriptions of the spirituals, ballads, field hollers, work songs, and blues made by literate white and black observers, and recordings made by commercial record companies and by folklorists beginning in about 1920. Most of them—an oral tradition is always a moving target—belong to the period of the sharecropping system. The songs, of course, have become fundamental to what we now think of as American culture, and they are for the most part the story of an immense human and ecological drama, the story of "black nature" and the cotton business.

Sterling Brown went straight to these materials when he was writing his poems of going South in *Southern Road*. "Old King Cotton," one of the poems is called.

Ole King Cotton,
Ole Man Cotton,
Keeps us slavin'
Till we'se dead and rotten

it begins. And the third section of Brown's third book—not published until 1980—is called "The Cotton South." Here's a bit of "Sharecroppers":

With cotton to the doorstep
No place to play;
No time: what with chopping cotton
All the day.

In the broken-down car
They jounce up and down
Pretend to be steering
On the way to town.

It's as far as they'll get
For many a year;
Cotton brought them
And will keep them here.

Two years after the publication of *Southern Road*, having returned to Howard University, he became director of Negro studies for the Federal Writers' Project and instigated as a field project teams to interview, to get the stories of, as many people as possible who grew up in slavery. So it is thanks to Brown and the oral histories that we have other glimpses of cotton culture, like this one from a woman named Mary Reynolds, who was interviewed in 1936: "It was work hard, git beatins and half fed . . . The times I hated most was pickin' cotton when the frost was on the bolls. My hands git sore and crack open and bleed" (Federal Writers' Project, 1936–1938).

Like many Americans, black and white, who did not grow up in Mississippi, I have driven through the delta, spent an afternoon in the Delta Blues Museum in Clarksburg, stood on the foundation of the disused railway station in Tutwiler (pop. 1,368) where legend has it W. C. Handy in 1903 heard a field hand play the first blues chord Handy had ever heard, while the guitar player, supposedly a man named Henry Sloan, sang over and over the originary lyric line of the blues: "I'm going where the Southern cross the Dog." And, like other tourists, I've walked around the corner to Tutwiler's two-block main street and stood in front of the crumbling stucco façade of what was the town mortuary and the place where the ruined body of Emmett Till was prepared to be sent home—by train—to his mother in Chicago. Nature in Tutwiler was dust and blackbirds and a few skinny trees—sycamores, possibly,

almost bare in late October—and tufts of cotton sticking to anything forked enough for it to stick to. People live in Tutwiler. It has an ongoing life. Across the street from the abandoned mortuary is a community center that houses a women's quilting collective begun by nuns from California in the 1980s. To someone passing through, though, the town seems timeless and stilled and feels like a deep ache.

I do not have even that superficial relation to the geography of rice culture, so I am even less in a position to tell its story. What I know of it I know from books and records and one movie, Julie Dash's remarkable *Daughters of the Dust*. Here is the story as I understand it. Beginning in the 1720s colonial planters in South Carolina and along the Georgia coast began to grow rice. There are about twenty species of rice on earth, and only two of them have been domesticated. One of these, according to Ted Steinberg, originated along the Niger River in Mali. It was that strain of rice and the knowledge of how to grow it that was brought from the West Coast of Africa to what would become the Low Country. The first European planters, beginning in 1685, tried to grow the plants inland and discovered from their African slaves that they needed to grow them in the tidal plain. By the 1740s Africans had taught them to use the energy of tidal ebb and flow to flood and drain the fields. Steinberg: "By 1800, the rice banks on a plantation located on a branch of South Carolina's Cooper River extended for some 55 miles and consisted of more than 6.4 million cubic feet of dirt. In other words, slaves using nothing but shovels and hoes hauled approximately the amount of earth it would take to fill the planet's largest pyramid, Egypt's Cheops, *three times*." In 1700 the Carolinas produced 400,000 pounds of rice; by 1720 they were producing 20 million.

Rice was very profitable and it was labor intensive. Africans knew how to grow it and they also had resistance to the mosquito-borne diseases that killed off Europeans who worked in the Low Country wetlands, which meant that by 1705 more than half of the two hundred thousand or so people living in the Carolina colony were black and by the time of the Civil War blacks outnumbered whites in South Carolina two to one. This meant, among other things, that much more of West African culture was preserved intact and evolved in its own way in the rice country than in other parts of the colonies. Some historians, like Judith Carney and Ira Berlin, have suggested that it's useful to think of the rice-growing country of the Carolinas and Georgia as a continua-

tion of the rice coast of Africa, two parts of one culture connected across a sea by the brutal wooden bridge of the slave ship.

One of the powerful survivals of that bridge was language. The Gullah language spoken by Low Country African-Americans is said to be a dialect of the Sierra Leonean language Krio, known to people like me from *Daughters of the Dust* and from recordings of songs from the Georgia Sea Islands, a very rich world and a world apart. Outsiders began to collect Sea Island songs, I've read, when Lydia Parrish, the wife of the painter Maxfield Parrish, began gathering them in the early 1900s. In 1935 Alan Lomax and Zora Neale Hurston visited the islands and recorded songs, and Lydia Parrish published *The Slave Songs of the Georgia Sea Islands* in 1942. It is the first glimpse we have of what was then a two-hundred-and-twenty-year-long story, told by the people who lived it.

I gwine t' beat dis rice,
Gwine to beat 'um so,
Gwine t' beat 'um until the hu'ks come off,
Ah hanh hanh
Ah hanh hanh
Gwine t' cook dis rice when I get through,
Ah hanh hanh
Ah hanh hanh
Gwine t' eat mah belly full
Ah hanh hanh

What must have also survived along with the language and the songs was a living relation to West African religion, to natural magic, and that must have spread, as rice culture spread, into Louisiana and even East Texas. Folklorists may not know what parts of the African diaspora grew African religion in the Southern states, what came from Haiti and what from New Orleans and the Carolinas. It does not show up much in the written record until Zora Neale Hurston looked at it in the 1930s and Ishmael Reed conjured a neo-hoodoo poetics in the 1960s.

American culture knows it, insofar as it does, from the tourist commercialization of the folklore tradition in New Orleans and knows of the rice culture of the Carolinas from George and Ira Gershwin's

Porgy and Bess, which was an adaptation of *Porgy,* a novel by the white Charleston-born writer DuBose Heyward.

But there is a recent book by another South Carolina writer, the poet Nikky Finney, that situates itself in the center of this particular ecosystem. The book is called *Rice.* It begins with an epigraph that quotes a nineteenth-century white writer's memory of a black cook's account of handling rice: "Wash de rice well in *two* waters, if you don't wash 'em, 'e will *clag,* an' put 'em in a pot of well-salted boilin' water." Very sweet. *Clag*—I checked the *OED*—shows up in a play by one of Shakespeare's contemporaries. Rice cultivation, it turns out, was women's work in both Sierra Leone and the Carolinas. And there was an African technique of planting called the heel-toe method. Finney describes it in the book: "To first dig with the heel / drop seed / then cover with the toe." And she makes of it a metaphor for the dance movement of her poems, as she does the process of cultivation. The three sections of the book are "Heel-Toe" (plant), "Winnow," and "Thresh." Some of the poems try to capture the voices of that world and to evoke the ecological and cultural transformations involved in turning the rice fields of two hundred years into golf courses:

> When the crocodile pack he mud on up
> And disappear down
> Cause he old swamp is now the 18th hole

Black nature in the twenty-first century. Finney might be thought of as working in the tradition of Sterling Brown and Zora Neale Hurston, but unlike Brown she was not a Northerner trying to discover her cultural roots. She is a South Carolinian who, having traveled from the place—to California, to the East Coast—had returned to make sense of it. It is interesting that, having published *Rice,* she has also created an anthology of African-American poems about returning to the South, in imagination at least, a kind of reverse migration to rethink or reimagine those four hundred years that Camille Dungy evokes in the subtitle of *Black Nature.*

Most of the poems in Dungy's anthology, by my count about 80 percent of them, were written by poets of the last generation or two. Which is not surprising, as perhaps as it should be. The eighteenth century in America produced two African-American poets, both Northerners

and city folk. The nineteenth century produced a handful. A tradition of African-American poetry really only begins with Reconstruction, principally with Paul Laurence Dunbar, and is followed in the 1920s by the explosion of the Harlem Renaissance, which was really a matter of seven or eight poets, including the brilliant Langston Hughes, who made African-American poetry an urban art, and Brown's crucial *Southern Road* and Jean Toomer's *Cane*. And then the quieter generation of the 1940s, three or four poets, such as Gwendolyn Brooks, who made a myth of black urban Chicago, and Robert Hayden, who imagined the Middle Passage and was formed by Detroit. Margaret Walker belongs to that generation and one of her poems, "Southern Song," expresses very directly what must have been a common African-American yearning toward the pastoral in those years:

> I want to rest unbroken in the fields of southern earth;
> freedom to watch the corn wave silver in the sun and
> mark the splashings of a brook, a pond with ducks
> and frogs and count the clouds.

> I want no mobs to wrench me from my southern rest; no
> forms to take me in the night and burn my shack and
> make for me a nightmare full of oil and flame.

Richard Wright is the most unexpected poet of that generation. After his furious career as a novelist and memoirist, he began in his last years in a village south of Paris to write haiku—poems about the French earth by a black American in a Japanese form.

In the next generation came the eloquent and embattled poets of the civil rights movement and the newly kinetic arts of the postwar years. It's with them that *Black Nature* begins to accumulate many more voices, with them and the perhaps two generations after. So for the most part this is an anthology of African-American poems written in the last fifty years. My impression from a first reading of it is that the relation of these poets, mostly raised in cities and suburbs, to the natural world is not very different from the relation to it of European- or Asian- or Latino-American writers, except for the immensely powerful, largely silent weight of the previous three hundred and fifty years of the African and African-American relation to the American earth.

It's a silence and a story, or set of stories, about people, politics, markets, and the land and its life in which all Americans are implicated, black Americans more intensely and intimately. We are a culture that has treated people and the land like commodities and also one that has defined itself by its wild places, by the beauty and energy of the land, and also defined itself in a literature that has valued the uniqueness of individual responses to the world. The two traditions have not consorted easily.

Which is a way of saying that Camille Dungy has given all of us a gift. Almost the entire history of the earth, as seen from the point of view of the people whose labor transformed it, is unrecorded. The *Shi Jing*, the Chinese *Book of Songs*, is the classic anthology of early Chinese poetry. It is said to have been compiled by order of a Han Dynasty emperor in about 600 B.C., who sent out scholars to record the song lyrics of the people so that he could understand their state of mind. The scholars—they could write—recorded 305 songs. It is one of the phenomenal documents wrested from the silence of the past. The body of African-American songs is another. The new work in this book is remarkably fresh and vigorous and various, and it makes the not-quite-silent past it conjures powerfully present. One of the lyrics of one of the songs that came of that culture goes like this: "Blackbirds sitting on the tree of life: They hear the Jordan roll." I believe they did.

SOME READING

Born in Slavery: Slave Narratives from the Federal Writers' Project, 1936–1938. This online collection is a joint presentation of the Manuscript and Prints and Photographs divisions of the Library of Congress.

LeRoi Jones and Amiri Baraka, *Blues People: Negro Music in White America* (New York: HarperCollins, 1963).

Ira Berlin, *The Making of African America: The Four Great Migrations* (New York: Viking, 2010).

Ira Berlin, *Many Thousands Gone: The First Two Centuries of Slavery in Mainland North America* (Cambridge, MA: Harvard University Press, 1988).

Sterling Brown, *The Collected Poems* (Evanston: Triquarterly Books, 1980).

Sterling Brown, *A Son's Return: Selected Essays*, ed. Mark A. Saunders (Boston: Northeastern University Press, 1996).

Judith Carney, *Black Rice: The African Origin of Rice Cultivation in the Americas* (Cambridge: Harvard University Press, 2001).

Camille Dungy, *Black Nature: Four Centuries of African American Nature Poetry* (Athens, GA: University of Georgia Press, 2009).

Nikky Finney, *Rice* (Toronto: Sister Vision Press, 1995).

Nikky Finney, *The Ringing Ear: Black Poets Lean South* (Athens, GA: University of Georgia Press, 2010).

Sam B. Hilliard, "Plantations and the Moulding of the Southern Landscape," in Michael P. Conzen, ed., *The Making of the American Landscape* (New York: Routledge, 1990).

Lydia Parrish, *The Slave Songs of the Georgia Sea Islands* (Athens, GA: University of Georgia Press, 1992). (A reprint of the 1942 volume.)

Ted Steinberg, *Down to Earth: Nature's Role in American History* (New York and London: Oxford University Press, 2002).

John Work, ed., *American Negro Songs and Spirituals* (New York: Bonanza Books, 1940).

rivers and stories: an introduction

A book of river stories is, of course, an invitation to think about the relation between rivers and stories. It is also an occasion to think about the condition of the world's rivers, which we need urgently to do at this moment in the history of the human relation to the earth.

And a place to begin is with the obvious, with the fact that most of the life on earth depends on fresh water. The mineral earth with its dream shapes of mountain range and valley basin, desert and forest and taiga and prairie and butte and mesa, forged by the heat of the earth's core, scoured by the advance and retreat of glaciers, terminated by coastal cliffs and beaches of sand or shingle, is intricately veined with the flow of it. The story of our relation to it begins, I suppose, with pieces of bone excavated along the Awash River in Ethiopia and a piece of a jaw excavated beside an ancient lake in Kenya. *Ardipithecus ramidus* and *Australopithecus anamensis:* they are about 4.4 million years old. At one point eight million years ago, a welter of hominid species foraged the edges of the same lake. And among them, most likely, were our ancestors. Human life probably developed within easy range of lakes and rivers. Human civilization—at the Tigris and Euphrates, the Ganges, the Yangtze, and the Nile—certainly did.

Human beings must first have used rivers for drinking and bathing and for food, fishing the shallows and hunting the birds and mammals drawn to the banks for water. It was probably fishing and hunting on floating logs that led to boat-making, and boat-making must have increased enormously the mobility of the species. Agriculture developed in the rich deposits of the floodplains. And these sedentary toolmakers were soon harnessing the power of the water with mill wheels and dams. Irrigation, as a technology, is about three thousand years old.

It will tell you something about the stress human beings have put on river systems in the last hundred years of this history if you know that in 1900, 40 million hectares of cropland were under irrigation world-wide. Forty million hectares in three thousand years. By 1993, 248 million hectares were under irrigation.

It's also a fact of the twentieth century that as a mode of travel, for commerce and pleasure, rivers have been largely displaced by high-ways, railways, and air travel. A hundred and fifty years ago the epic stories of engineering had to do with canal building, connecting one river system or one sea with another: Panama and Suez. The locks of the Erie Canal and the extensive lock system of English rivers belong now to a quaint and minor tourism. The stories of the twentieth century have had to do with massive dams, with nationalism and eco-nomic development and the prestige of massive dams. Rivers now sup-ply 20 percent of the world's electrical power, most of it generated by large, ecologically destructive, often culturally destructive, dams. The still-to-be-completed Three Gorges Dam on the Yangtze is only the latest in a series of Faustian bargains technological culture has struck with the rivers of the earth.

Though the names are still magic—Amazon, Congo, Mississippi, Niger, Plate, Volga, Tiber, Seine, Ganges, Mekong, Rhine, Colorado, Marne, Orinoco, Rio Grande—the rivers themselves have almost dis-appeared from consciousness in the modern world. Insofar as they exist in our imaginations, that existence is nostalgic. We have turned our memory of the Mississippi into a Mark Twain theme park at Disneyland. Our railroads followed the contours of the rivers and then our highways followed the contours of the rail lines. Traveling, we move as a river moves, at two removes. Our children don't know where their electricity comes from, they don't know where the water they drink comes from, and in many places on the earth the turgid backwaters of dammed rivers are inflicting on local children an epidemic of the old riverside diseases: dysentery, schistosomiasis, "river blindness." Rivers and the river gods that defined our civilizations have become the sublimated symbols of everything we have done to the planet in the last two hun-dred years. And the rivers themselves have come to function as trace memories of what we have repressed in the name of our technical mas-tery. They are the ecological unconscious.

So, of course, they show up in poetry. "I do not know much about

gods," wrote T. S. Eliot, who grew up along the Mississippi in Saint Louis, "but I think that the river is a strong brown god." "Under various names," wrote Czeslaw Milosz, who grew up in Lithuania along the Neman, "I have praised only you, rivers. You are milk and honey and love and death and dance." I take this to be the first stirrings, even as our civilization did its damming and polluting, of the recognition of what we have lost and need to recover. When human populations were small enough, the cleansing flow of rivers and their fierce floods could create the illusion that our acts did not have consequences, that they vanished downstream. Now that is no longer true, and we are being compelled to reconsider the work of our hands. And, of course, we are too dependent on our own geographical origins to have lost our connection with them entirely.

Traveling in the world, even now, we confront, one way or another, the human history of rivers. Several times in the last few years I've arrived in a foreign city, and gone to sleep in a hotel room, and awakened to look out the window at a river. The first time was in Budapest. The river was the Danube. I woke up just before sunrise, walked out onto a balcony, and in the cold air at first light, looked out across the Pest hills and the first glimmerings of day on the broad, mud-colored water. The smell of it was in the air. I realized that I didn't know much of its geography. I knew that it originated somewhere in the Alps, flowed east across southern Germany—the *Nibelungenleid* consists of Danube river tales—and south from Vienna through Hungary and then southeast again through Serbia, emptying into the Black Sea somewhere south of Odessa. I seemed to recall, vaguely, that the poet Ovid, when he offended Caesar Augustus, had been exiled to a half-wild garrison town at the mouth of the Danube. And I knew that a few years before, a particularly mindless plan to dam the river as it flowed across central Hungary had become so controversial that the government outlawed public discussion of the project by scientists.

The lights were going out on the bridges. I could make out the dim forms of a few barges on the river, and a voice drifted toward me on the wind. There must have existed and perished in five thousand years whole dictionaries of river slang in half a dozen different languages, Magyar, and several German and Slavic dialects, and whatever hybrid Romanian is. There must once have been a Romano-Serb or a Romano-Germanic river pidgin spoken by merchants and boatmen the whole

length of it. And it may have been in Roman times that it acquired its common name, since the Romans were great makers of maps, though it had probably been, long before any legions marched along its banks, a local god in many different cultures, with many different names. I knew of one poem, by the Belgrade poet Vasko Popa, that addresses Father Danube in a sort of Serbian modernist prayer. Belgrade—*belo grad*—means "white city" in Serbian:

O great Lord Danube
the blood of the white town
Is flowing in your veins

If you love it get up a moment
From your bed of love—

Ride on the largest carp
Pierce the leaden clouds
And come visit your heavenly birthplace

Bring gifts to the white town
The fruits and birds and flowers of paradise

The bell towers will bow down to you
And the streets prostrate themselves
O great Lord Danube

I did not bow down. I found myself instead up to my neck in the comedy of consumer travel. I had called room service and ordered coffee the moment I woke. It arrived in a silver pitcher with a cream-colored china cup and a saucer with a fluted rim. I poured the coffee and then thought to check the bill. As near as I could tell, it was going to cost me $30, and this occasioned in me mild panic. The staff spoke English; I considered calling them and telling them there had been a mistake; I didn't require what the menu called a "morning beverage," after all. The problem turned out to be my arithmetic. The coffee was $3—but when I went back out onto the balcony and sipped the coffee, which smelled like wine and unripe berries and dark earth, and watched the Danube turn silver in the dawn. I thought I was drinking a $30 pot of coffee. It was a kind of offering to the river god.

The second time I looked out such a window the river I saw was the Huangpu. I had also come into Shanghai in the dark. This time I woke to a pearl-gray morning hazy with river mist. The river itself was teeming with traffic—barges, sometimes two or three together, linked by thick cables, carrying lumber, sacks of cement, girders, building tiles; tankers low in the water, plowing against the current; tugs; packed ferries; a few sailboats; other ancient and nondescript vessels. In five minutes I counted eighty going and coming. The water was grayish brown, foaming against the embankments, quays, warehouses, and docks. Just below me a crowd of people and bicycles was queuing for one of the ferries. Across the river was the Bund, the old commercial street of the pre–World War II city with its European-style bank and insurance buildings and hotels in the shapes of Greek and Roman temples, old coal-smoke-darkened marble columns and domes. Shanghai, I learned later, is a relatively modern city. In the fourteenth century, the Bund had been a towpath for river barges above a reedy wetlands and a small fishing village. The village became a town in the sixteenth century. By the end of the nineteenth, it might have been the commercial riverfront of any European river city—Lyon or Glasgow or Amsterdam.

The street at that hour was already aswarm with the flow of human traffic and it seemed to mimic the movement on the crowded river. It was as if I were looking out not at another continent but another time. The river was a nineteenth-century river, thick with the traffic that had elsewhere in the world been transferred to trains and air freight, and sixteen-wheel trucks. The Bund—most of the buildings dated from 1880 to 1920—was a living memory of the forms of European piracy that came to be called "the Age of Empire." I half expected to see Joseph Conrad emerge from one of the buildings in his Edwardian beard, carrying a commission to captain a steamer up the Congo. But the scene also looked like a Chinese scroll painting, as if the jagged line of Maoist-era apartment buildings in the distance were mountains, and the river-mists the half-remembered forms of local and dynastic gods, and the river itself an allegory of human life: provision and supply, upriver struggle and downriver flow, and human crowds coming and going in a smudged and dreamy haze.

There was also something unsettling about the scene, and it was not until later in the day, as I was wandering around the city, that it dawned on me what I had seen. Or not seen: I turned abruptly around

and traced my way back to the river, leaned against the embankment, and stared a long time. There were no birds. Not a single gull, no ducks, no herons or egrets. Not a cormorant or a grebe. There were not even sparrows or songbirds in the spindly trees in the riverside park. And there was not a fisherman in sight. The river, for all its human vitality, was dead.

The third river was the Nile. Even at night, from my room at the Semiramis in downtown Cairo, there was no mistaking it, though I couldn't make out that fabulous stream itself. Laughter, some of it good-natured, some of it hilarious, floated up to my window. Brilliant lights all along the riverside seemed to mark bridges and a promenade and open-air cafés. And there was the smell of it, even in the humidity and auto exhaust, green and cool. It was there in the morning, in the unbelievable din of Cairo traffic—it seemed in Cairo that not honking one's horn was the exception rather than the rule—and even in all that noise it looked peaceful: greenish water; a strong, gentle current; reeds; palms; bankside banyans with their broad gleaming leaves; and, as if conjured from a late eighteenth-century watercolor, the red lanteen sails of the feluccas, skimming upriver in a following breeze.

Nilus is probably no older than any other of the discontinued river gods, but he is older in the human imagination, a fact that was demonstrated to me the next day when, quite unexpectedly, I ran into an old friend in the hotel lobby, an American woman living in London. She was in Cairo for one day only. She was about to get into a cab to go have a look at the Ben Ezra synagogue, the oldest in the city, which she needed to be able to describe in a novel she was working on. On an impulse I joined her. The cab driver assiduously honking his horn so that we could only communicate in shouts, we threaded our way through the streets. The previous day had been an Islamic holiday, celebrated by a daylong fast, followed by the butchering of a live animal at sunset, goat or sheep, and a feast—to commemorate, we had been told, the sheep sacrificed by Abraham when the Lord God spared the life of his son Isaac, once Abraham had established his willingness to kill his own son for this deity. It meant that the corners of the Cairo streets were stacked with the still-bloody pelts of skinned animals, in which the flies were conducting their own festival, and that, once we were out of the car, in what is called Old Cairo to distinguish it from the other old Cairo, the Islamic city of the Middle Ages, the cobble-

stones were slick with reddish or tea-colored puddles where the blood had been washed from the streets. We made our way across the street gingerly; wandered down an alley out of the novels of Mahfouz, which smelled of mint tea and apple-wood smoke from tiny cafés; and came to the open courtyard of the synagogue, which was closed.

My friend had to settle for a description of the exterior of the building. A man rose from one of the café tables across the square and approached us, gestured solemnly with two raised fingers for us to follow him, which, somewhat hypnotized, we did. He took us around to the other side of the building, where, in a garden of palms and what looked like antique fuchsias, there was a well, covered with ornate ironwork. "Here," he said, "Moses was found in the bulrushes." We both balked. "Here?" "Oh, yes," he said—within a few days I was to understand that the city was full of these scholars of local legend—"this was the old channel of the river. It flowed straight through here. Moses was a Cairo boy." There was no Cairo in Pharaonic times, but Memphis was only thirty miles upriver, and the river did once flow this way, so who was going to argue the point? Not far from the synagogue is Babylon, a ruin—a wall of brick and rubble—of the Roman fort from which the city of Cairo grew. A renegade band of Persian army deserters had established a settlement there in the sixth century B.C., and their fort, later, in Trajan's time, came to serve as the foundation of the Roman fort. Memphis and the Saqqarah pyramids were just twelve miles south. And if the infant of a Jewish slave had been placed in a basket made from the wicker of river reeds, it may very well have floated downriver to this spot. The probability, at least, would have invited the legend, and it is quite possible that some of the descendants of those Jewish slaves were among the founders of a holy place inside the walls of the abandoned Roman fort that had turned it into an enclave of Jews and Coptic Christians two thousand years ago.

The Aswan High Dam, built in the 1960s by the Nasser regime as a monument to national independence, has had the unintended consequence of eating away the foundations of these old buildings. The dam captured the flow of nutrient-rich silt that created Egyptian civilization so that it was no longer deposited downstream and made farmers dependent on chemical fertilizers. The backed-up waters spread schistosomiasis through the communities of the Upper Nile and allowed the Mediterranean, as it seeped inland against the weakened current,

to wash away almost entirely the Nile delta and its lucrative fishery, and the diversion of water to marginally arable lands forced the city of Cairo to draw down its freshwater aquifers. The result is that the salts underground are rising and eroding the foundations of Cairo's ancient mosques, churches, and some of the pyramids themselves.

Hard to see how this does not spell pure catastrophe, but for now at least the Nile is still alive. The next day I went to Saqqarah. The tombs of Ti and Ptah-hotep are full of images of life along the river—fishermen with their nets and narrow boats above a world of teeming fish, each kind rendered with extraordinary exactness—and there were scenes of bird-catching in the marshes, the birds so exactly rendered that it was easy to pick out species at a glance. One caught my eye because it seemed unfamiliar; it looked like a humpbacked crow. Driving back to town along the river, I thought I saw the same silhouette in the intense green of the river reeds. We stopped the car. "Do you know what that is?" I asked the Cairene friend who was driving. "I think it's called a hooded crow," she said. "They're all over the place, and they're really noisy." I looked again, a black shape humpbacked against the green of the river, the precise outline that the artist's hand had rendered, as if forty-five hundred years had washed by in an instant.

Most of our rivers are still alive, and they are immensely resilient. It now seems possible that human civilization can begin to undo the damage it has done in this last century. Secretary of the Interior Bruce Babbitt, symbolically perhaps, has begun to decommission some American dams. The technology and the understanding of flood dynamics and of the need for water conservation have begun to make the twenty-first-century work of river restoration seem a possibility. A starting place for this work would be to recover an elder imagination of the earth. That is one of the reasons why we need stories about rivers, and why *The Gift of Rivers* has such intense resonance.

Rivers, of course, are *like* stories, and they are like stories that classical strictures on form would approve. They have a beginning, a middle, and an end. In between, they flow. Or would flow, if we let them. It's interesting to consider the fact that, in popular culture, in commercial television, what's happened to rivers has happened to stories. A dam is a commercial interruption in a river. A commercial is a dam impeding the flow of a story: it passes the human imagination through the turbine of a sales pitch to generate consumer lust. So it might be useful to

remember, as you read this book and think about the rivers of the earth and about the task of reclaiming them that lies before us, that what you are reading are narratives without commercial interruptions—which is good for the health of rivers and narrative art.

Note: An account of the Nagymaros Dam campaign in Hungary and of the building of the Aswan High Dam and some of its consequences can be found in Patrick McCully, Silenced Rivers: The Ecology and Politics of Large Dams *(London: Zed Books, 1996).*

2000

an oak grove

Note: In the spring of 2009 I was invited to give a faculty research lecture at the University of California at Berkeley, where I teach literature. The university had been visited for the better part of a year by a sit-in and a series of legal contests over the administration's intention to renovate the football stadium and in the process remove from the hillside above the campus a grove of California live oaks and replace the old grove with a training facility for college athletes. The university won its lawsuits against the city of Berkeley and various environmental groups. Demonstrators, mostly young, camped in the trees for months and were eventually removed. The trees came down. I gave this lecture not long after.

My subject is thinking about nature and thinking about thinking about nature, and my thesis is that we don't do it very well. By "we" I mean citizens at large, poets and scholars in the humanities, whom I represent on this occasion, and perhaps the university community as a community. When I was asked to give this talk, I threw some words at what the endeavor might look like. It is indeed going to take as its subject an oak grove, but, if I could retitle this lecture, I think I might call it "The Egret Fishing Through Its Smeared Reflection."

The line comes from the beginning of my wife Brenda Hillman's long poem *Death Tractates*. In the opening lines of the poem, the speaker, stunned by the sudden death of a beloved friend, seems to be rehearsing to herself a bit numbly the myths we have learned about what happens to us after death—and before birth. The opening goes like this:

> That the soul got to choose. Nothing else
> Got to but the soul

Got to choose.

That it was very clever, stepping

From Lightworld to lightworld

As an egret fishes through its smeared reflections—

That last line seems a metaphor not only for the blurring effect of human desires and projections, but for consciousness itself. "Every creature," the entomologist E. O. Wilson has remarked, "lives in its own sensory world." And this must especially be true of humans, who have had the capacity to articulate this idea, though I have often wondered if it is not something that all mammals know about each other instinctively. Still it must especially be true of human consciousness, which emerged in this world rather late to radically alter it, and to invent ingenious ways in which to study it, and to piece together the story of how human consciousness came to be the instrument through which the world thinks about the world that in the past century has come into the care of humans and their consciousness and unconsciousness entirely.

1.

So I thought a place to start, because it is near at hand, would be the sit-in in the now-vanished oak grove on Gayley Road. I think everyone will recall the general outlines of the controversy. The university administration proposed to remodel, upgrade, and retrofit for earthquake safety the football stadium in the mouth of Strawberry Canyon and to build a student-athlete training facility up against the stadium on Gayley Road where a beautiful old grove of mostly coast live oaks was situated. Coast live oaks are indigenous trees and the common, in fact the representative, tree of the Coast Range.

This was the tree that became the object of contention. The city of Berkeley had an ordinance that forbade cutting down live oak trees, though it was not clear whether the law applied to the university. The administration had considered and rejected alternative locations for their athletic facility. Convenience and the recruitment of coaches and student athletes and the need to preserve space for intramural sports seemed to be the university administration's primary concerns, and

they had filed a detailed and scrupulous environmental impact report on their intentions and the history of the site, including the trees.

There was from the outset a good deal of opposition to the plan, some of it having to do with the idea of revisiting the locating of a stadium on a major earthquake fault. But many people in the community also opposed cutting down the oak grove. The city of Berkeley tested the university's right to take out the trees in court and lost. A group of citizen activists perched on the sturdy limb of a live oak and had their photograph taken looking very cheerful. This group included three older, if not elderly, women, among them a youthful seventy-one-year-old Shirley Dean, environmental activist and former mayor of the city; Betty Olds, an eighty-six-year-old member of the Berkeley city council; and ninety-year-old Sylvia McLaughlin, the legendary environmentalist who in the early 1960s founded Save the Bay, the organization that saved San Francisco Bay from a development plan that would have wiped out its wetlands and reduced its size by half. And a more long-term opposition developed—a community group, which included a few Cal students and recent graduates, pitched camp in the trees while the university litigated various issues surrounding the project. Many of them were inspired by the example of Julia Butterfly Hill, who, from 1997 through 1999, sat for 738 days in the canopy of an old first-growth redwood forest that the Pacific Lumber Company owned and was planning to log. Once the university had won and the last protestors were removed from the trees, a long and somewhat delicate process in a community that remembered both the Free Speech Movement and the People's Park riots, the trees were summarily dispatched, and construction at the site began.

For ten months the protestors sat in the trees and tried to marshal support for their cause. "Native California oak woodlands," their website read, "are a crucial component of our natural environment, supporting higher levels of biodiversity than any other terrestrial ecosystem in California. Over 300 vertebrates and thousands of other plant and insect species depend on California oak woodlands for their survival." As an argument, it seemed promising. The authors on the website were trying to find an ecological basis for their stand. But the newspapers and the demonstrators' posters and the sportscasters who cover Cal football could not resist the symbolism of an archetypal battle. ANCIENT OAK GROVE AT UC BERKELEY WINS COURT INJUNCTION, a headline read in one

environmental newsletter, considerably aging the trees in question and giving the trees themselves a victory over the university.

I could provide many instances of this vision of the conflict as a war between the peace, innocence, antiquity, and natural harmony of the grove and the chain saws and fence of a university hell-bent on financing its athletic programs by delivering ranked teams to the television networks that deliver audiences to advertisers at the expense of all the species supported by an oak woodland ecosystem. On the other side were letters to the *San Francisco Chronicle* about "sports-hating Berkeleyans." One Saturday afternoon, I heard a sportscaster remark with a sigh that it was a tragedy that the mindless hippie kids of Berkeley had no feeling for the traditions of Cal sports that were unfolding so magnificently (I think Cal was ahead at that stage of the football game) on the field on that crisp autumn day.

Aware of my silence on the issue, as the young people sat in the trees and fences went up around the oak grove, and campus police arrived with the unlucky job of policing the fences (which it seemed to me they did with admirable tact), I was also aware of the silence of most of my colleagues. The university public affairs office produced reasoned and informative press releases on many of the issues and made plausible but somewhat peremptory responses to the issues that were touchy. Question: Couldn't the university have chosen another site? Answer: The university took many factors into consideration in arriving at its decision about the location of the facility. Steven Finacom, from the Office of Physical and Environmental Planning, wrote a press release that laid out clearly some of the history of the site as described in the Environmental Impact Report.

One of the reasons for my silence, I know, was that I had had a glance at the EIR and seen that it was quite long and very detailed and that if I was going to understand the issue I had to study the report, which meant walking the land with it in my hand to try to piece together what had happened there, and that I didn't have time to do it. And then, finally, recently, I did. The EIR, prepared by Page and Turnbull, a San Francisco architecture, historic preservation, and urban design firm, is a quite interesting document. First of all, it describes each tree in the grove, specifying the species, age, and health of each tree, and identifying those that were, in the language of preservationists, "specimen trees," vigorous examples of their kind. There were 139 trees in

the grove and 91 were to be removed. Of the 70 mature specimen trees in the grove, 42 were to be removed, 27 were to stay, and one young-ish redwood was to be transplanted. Based on a study of old photo-graphs and of trunk diameters, the team determined that four of the oaks on the hillside were more than eighty years old and so predated the construction of the stadium. Two of them, including the oldest and largest—the tree the demonstrators called "the grandfather oak"—were in the construction zone and were slated to be taken down. The two others would remain.

The rest of the report is a history of the site, beginning with the early history of Berkeley, which it dates from the formal grant of a parcel of land by the king of Spain to Luis Maria Peralta in 1820. The report then proceeds quickly to Misters Hillegass, Shattuck, and Blake. After the treaty of Guadalupe-Hidalgo in 1848, by which the United States took possession of California, and after the California legislature (a brand-new entity) had passed a law in 1852 stating that a squatter could gain possession "of any land not reasonably known to be claimed under any existing title," and then after the legal precedent had been established in the brand-new courts (and in federal courts as well) that all grants of land by the king of Spain were of dubious legality, Hillegass, Shattuck, and Blake so squatted, and claimed thereby most of what would be Berkeley. Then in the report's narrative comes an account of the arrival of the College of California and the hiring of Frederick Law Olmsted in 1864 to lay out the college and the town. Then the University of California, and then by 1873 the completion of a U.S. Coastal topographical survey of the Strawberry Creek region and the donation—according to the Oakland *Daily News*—by a Mr. Nolan "and other liberal nurserymen" of trees and plants for the new campus.

To make a long story short, as people in my family were inclined to say and were genetically incapable of doing, the campus was laid out on Strawberry Creek. Its eastern limit was probably about where Gayley Road is now, and the place where the roadbed is was probably the university's first botanical garden, just below the site of the grove. Piedmont Avenue was developed, according to Olmsted's plan, as an elegant residential neighborhood. On the property where Memorial Stadium now stands, two brothers named Palmer built a pair of hand-some mansions. The place where the grove stood was the spacious front garden and probably contained in the 1890s the four coast live oaks

that predate the stadium (or the Palmers planted them there). At least one of those, the grandfather oak, was probably older than the Palmer mansions. You can still see remnants of the Palmer garden. The very old olive trees are an instance of it, and so is the beautiful old pepper tree that stood next to International House. It is a remnant reminder of the Anglo squatters' Victorian gardener's effort to naturalize them to a Mediterranean climate by planting trees brought to Mexico from Spain, and from Mexico to California in the case of the olives, and from Peru and Mexico to Spain and then back to Mexico and then to California in the case of that noble and graceful old pepper. (I had thought, writing this lecture, that the pepper had survived, but walking here today, I saw that it hadn't. It must have come down just in the last week.)

The next incident of interest in the history of the site is the paving or macadamizing of Piedmont Avenue. By the turn of the century the automobile had arrived in Berkeley, as well as elegant carriages and delivery wagons for elegant houses, and they required paved roads. Piedmont Avenue, destined to become Fraternity Row, was a handsome sort of Gilded Age neighborhood in 1900 that the early residents had lined with English walnut trees, but the project of paving provided a chance to carry out Frederick Olmsted's plan for widening the road and giving it a gracious median strip, and the trees had to go. There were, of course, protests, though the city assured residents that it intended to add new plantings. The EIR quotes the November 12, 1900, edition of the *Berkeley Gazette:* "Added to the handsome attractions of beautiful new trees and gardens of flowers on this avenue is the parking to be provided in the center of the avenue. Old residents of Berkeley will part reluctantly with the old walnut trees that have for so many years given that portion of the city an eastern and rural aspect, but are compensated in the plans for a handsome boulevard in the future."

The grove itself came into being as a by-product of the need for a football stadium that a surge in the popularity of college sports in the 1910s brought into existence. Fund-raising for the stadium began in 1921. The decision to build the stadium on the earthquake fault in Strawberry Canyon was made in January of 1922. Access through the canyon to the ridge above had been part of Frederick Olmsted's initial vision. "In the nineteenth century," the author of the EIR writes, "the hills above the young campus were vegetated in grasslands." But

Olmstead, to whom the dry Mediterranean landscape of the West did not look like much, had noticed the rich diversity of native species in the moist microclimate of Strawberry Canyon and had seen the canyon and the ridge above it as important attractions of the site. The university built paths, benches, and a carriage road to Grizzly Peak, and the canyon was alive—this is the author of the EIR—"with bracken, wild currant, oaks, and bay trees, and wildlife like quail and rabbits." It was here next to the remarkable Phoebe Hearst's Greek Theater that the stadium was built. It was designed, of course, by John Galen Howard, and in March 1923 a San Francisco landscaping firm was chosen to landscape the site. As part of the fund-raising effort the stadium was going to honor students and faculty killed in the First World War. So the stadium became Memorial Stadium, and the grove that the landscape architects planted, drawing on a San Mateo nursery that "produced between two and three thousand plants a year" and imported ornamentals "by carloads from different parts of the world," became the Memorial Oak Grove.

My point, I suppose, is that the actual story, buried in the EIR, is more interesting and useful than the archetypal drama that played in the press and in the minds of many of the participants. And that's not the end of it. The firm of landscape architects the university hired to design the grove was called MacRorie and McLaren. MacRorie handled the business end and McLaren the design. McLaren was Donald McLaren, the only son of John McLaren, the Scottish-born immigrant who laid out Golden Gate Park in San Francisco, became its first superintendent, and in a series of books for gardeners and horticulturists has been said to be the inventor of California gardening. McLaren senior was a close friend and compatriot of two other Scotsmen who played important roles in this phase of California history, the environmentalist and writer John Muir and the painter William Keith. These three Scotsmen in their turn became friends of the architects Bernard Maybeck and John Galen Howard, and among them the five men might be said to have created the sensibility that put together the Arts and Crafts movement in California and the conservation movement and, in doing so, to have made the culture of brown shingle and Beaux Arts Berkeley—the culture that sent a ninety-year-old woman up a hundred-and-fifty-year-old oak tree.

William Keith is not so famous a name as it was from 1900 to 1920,

though I think he is generally regarded as the foremost Northern California landscape painter of his generation. He was also a crucial member of the Hillside Club, the environmentally conscious planning group that included Maybeck and Howard and laid down the guidelines for the domestic architecture, contoured roads, paths, and gardens of the Berkeley hills. The Oakland Museum has a good collection of his paintings, and the Hearst Gallery, at Saint Mary's College in Moraga, where I went to school, has a better one.

I mention this because his most famous painting, called *Berkeley Oaks*, is a portrait of an oak grove. It was a painting John Muir liked so well that Keith gave it to him and in the last years of his life, it hung above Muir's desk in his study at the ranch in Martinez. It occurred to me to wonder what had become of it—this is the research in this research lecture—and I found that, after Muir's death, the Muir family had donated it to the Pacific School of Religion, just at the edge of the Berkeley Campus, where it is still housed this afternoon, hanging on a wall in the receptionist's office.

The painting (readers can view it and several other images from this essay at http://www.harpercollins.com/authors/4281/Robert_Hass/index.aspx) suffuses in a goldish, distinctly Californian light a grove of what looks to my eye like very Scottish oak trees. Perhaps mature groves of *Quercus agrifolia* did have that gnarled look in Keith's time. In any case they look remarkably like the grove of live oaks that Donald McLaren planted as they appear in the photograph of the vanished oaks on the Save the Oaks website. In a color print of it you can see that the photographer was able to bathe the grove in the same golden light Keith saw. They share an Edenic vision that the actual light in northern California sometimes cooperates with on the September afternoons of our Indian Summer.

I wish we knew more about Donald McLaren. There is evidence that he visited the Muir home as a boy and he certainly knew Keith, so it is very likely that he saw the painting. The EIR on the oak grove reports that he wanted to be a baseball player but became a landscape architect at his father's insistence; that he graduated from Berkeley; that his young wife, descended from one of the businessmen-squatter families, died in childbirth when Donald was twenty-seven years old; that their daughter Mattie lived in the lodge at Golden Gate Park with her grandparents. Donald McLaren wrote about landscaping and the

principles of California gardening for professional journals, and was retained by John Galen Howard to landscape Sather Gate, so we probably owe the coast live oaks and incense cedars and redwoods along the south fork of Strawberry Creek to him. He worked with his father on the landscape design of the Panama-Pacific Exposition in 1914 and 1915, and was hired, after doing the Memorial Grove, to design a landscape setting for the new football stadium at Stanford University, to which he gave a much more European and classical treatment, though the floodplain between San Francisco Bay and the Palo Alto foothills where it is located would have been much more likely to have been once an oak grove than the grassy hillside where Memorial Stadium was built.

There is almost always a point in any narrative when the story exceeds the theme. It is the point, I have noticed, when student evaluations in my lecture classes sometimes complain about their instructor's tendency to digression. In 1925, while he was working as the architect for the Transcontinental Highways Exposition in Reno to celebrate the completion of the Truckee-Reno Highway (a moment from which we could mark the end of the story of the Donner Party and the full-hearted opening of California to the automobile), McLaren disappeared. I assume that "disappeared" means that his family and associates didn't know where he was. His body was found a week later. He had checked into a hotel on Mission Street in San Francisco and died by asphyxiation from a gas burner that had been left on. He left no note, so it was unclear whether his death was a suicide or an accident, but the circumstances of his disappearance suggest that it was a suicide.

Here is the digression inside the digression. The poet of San Francisco in those years was a man named George Sterling. He was the first West Coast poet to achieve a national reputation and he is remembered, when he is remembered, because he described San Francisco in one of his poems as "the cool, grey city of love." Here is a bit of the poem:

Tho I die on a distant strand,
And they give me a grave in that land,
Yet carry me back to my own city!
Carry me back to her grace and pity!
For I think I could not rest

Afar from her mighty breast.
She is fairer than others are
Whom they sing the beauty of.
Her heart is a song and a star—
My cool, grey city of love.

The winds of the Future wait
At the iron walls of her Gate,
And the western ocean breaks in thunder,
And the western stars go slowly under,
And her gaze is ever West
In the dream of her young unrest.
Her sea is a voice that calls,
And her star a voice above,
And her wind a voice on her walls—
My cool, grey city of love.

Sterling did not die on a distant strand. He was a friend of Jack London and in Jack London's novel *Martin Eden*, which is the only fictional portrait we have of Berkeley in the first decade of the 1900s, there is a character named Russ Brissenden based on George Sterling. Brissenden is the fin de siècle figure in this naturalist novel and he commits suicide because he is too sensitive to live in the coarse and violent world. The novel was published in 1909. Sterling was honored as the premier poet of California at the Panama-Pacific Exposition in 1915 in a ceremony that took place—I imagine—on a gazebo-like stage amid a surrounding landscape of native Californian plantings designed by Donald McLaren. George Sterling killed himself by taking cyanide in the room where he was living at the Bohemian Club on Taylor Street in November 1926, a year and a half after the death of Donald McLaren. The California historian Kevin Starr said of Sterling's death that with it "the golden age of San Francisco's bohemia had come to its miserable end." Actually the golden age of San Francisco's bohemia was yet to come. But the two deaths do seem to signal the end of the Arts and Crafts era in Northern California, of which the oak grove was both a product and an emblem, and so, when I had finally read the EIR and drove past the demonstrators on Gayley Road, the passionate young activists who were defending the existence of a work of art that was in

all probability based on another work of art and that they thought of as a remnant of primordial forest, I thought about those two men.

And we are not quite through with the story of the live oaks. The campus in the 1900s was full of them, enough so that the university's young assistant professor of botany chose to write a brief monograph on the subject. Willis Jepson was born in 1867 on a ranch near Vacaville in the Sacramento Valley. He graduated from Berkeley in 1889, did advanced study at Cornell and Harvard, and returned to Berkeley, where he received his Ph.D. in 1899. He wrote eleven books, including *A Flora of California* (1909), *The Trees of California* (also 1909), and *A Manual of the Flowering Plants of California* (1925), still much beloved and, I am informed, a groundbreaking work that, by connecting plant distribution to geological history, connecting flora distribution to life zones, providing a separate and extensive treatment of endemic species, and introducing a sophisticated classification of the plant kingdom taking into account the new research in genetics, set a standard by which local and regional botanical manuals were measured for the next fifty years. It made him—I've heard said—the university's first internationally important scientist.

What else? In 1892, at a meeting with John Muir and Warren Olney in a San Francisco law office, he became, over a handshake, one of the founders of the Sierra Club; the university's Jepson Herbarium is named for him, and so is the bible of California botany, *The Jepson Manual: Higher Plants of California,* edited by James Hickman, but the work of two hundred botanists building on the foundation of Jepson's *Flora;* he walked and botanized every county, wetland, coastal strand, and most of the mountain peaks and mountain valleys in the state; he delivered the Faculty Research Lecture in 1934; and, more to my purpose, as a new faculty member he was probably Donald McLaren's botany instructor, and in 1903, he composed a little monograph entitled "The Live Oaks of the University of California Campus."

He begins this essay by remarking that the coast live oak, *Quercus agrifolia,* "is the only native oak found on the lower slopes of the Oakland hills," and he proceeds to catalogue the trees on the campus. There are 686 of them, 290 on the lower campus, which he describes as the area "below the College Avenue bridge," 296 on the upper campus, plus those acquired by the purchase of the Palmer tract, the territory of the stadium and, a hundred and five years later, the contested

grove, which he says, proprietarily, "gave us about a hundred trees large and small which form part of the dense scrub on the south side of Strawberry Canyon opposite the dairy farm." (The existence of that dairy farm is not in the EIR and my research has not located it. But milk cows give us yet another glimpse of the uses to which that grassy upland had been put.) Some of "the finest and largest trees" on the lower campus, Jepson observes, were far past maturity and dying from dry rot, which is caused by a spore that enters through wounds in the bark and eventually reaches the heartwood. The middle-aged trees, also afflicted, could be saved by diligent care before the rot had penetrated too far into the tree's core. Young trees, he notices, naturally propagated by the resident jays and squirrels, will eventually replace them all. And then he has this to say: "If, therefore, the stand of oaks on the lower campus is to be maintained forever, it is necessary that there be systematic planting so that the young trees may gradually succeed those we now have. By such a course the 'Berkeley Oaks' immortalized on the canvasses of Keith, may also be preserved 'in the flesh' forever." In the remainder of the essay he recommends the planting of other native trees in the campus (which was done—consider the beautiful valley oak outside the entrance to Mulford Hall), complains about the depredations of "the genus 'Berkeley Small Boy,'" individuals of which arrived on the campus armed with carving knives, and concludes his small treatise this way: "The greatest natural charm of the grounds is due to the presence of Live Oak trees. The graceful outlines of their low round heads repeat the lines of the hills which back the University estate. What the Elms are to New Haven, the Live Oaks are to Berkeley."

There are a number of interesting and poignant things about the essay. The first is Jepson's desire to give the raw young university a sense of hallowed tradition, of timelessness, through the evocation of Keith's paintings and of the elder, Eastern institution in New Haven. There is other evidence from this period of the effort to use the oaks to give the university a sense of tradition. A campus publication—the one in which Frank Norris, one of the important novelists of the Progressive Era, author of *McTeague* and *The Octopus,* made his literary debut in 1901—is hardbacked, with a handsomely embossed cover that shows a gorgeously fin de siècle image of a grove of blue oaks on a blue hill under a gold sky. The volume is entitled *Under the Berkeley*

Oaks: Stories by the Students of the University of California. This gesture at a respectable pedigree was maybe not altogether successful since Norris, after another year under the oaks, transferred to Harvard for his junior year.

And it is there, for that matter, in Olmsted's siting of the university in 1864—some idea of giving the land to the still-imaginary institution and the institution to the land. And given the importance of these originary gestures, it is interesting to ask, in relation to the conversation that we did not have about the actual history of the grove, why we don't know these stories.

We don't know them, I think, for a number of reasons. One of them is that it is only the story of the origins of a provincial university. Another is that we are not late Stone Age people making our living off the land, so the story of the land is not necessary to our survival. Universities, in fact, have a very odd relation to tradition, especially very good universities, which are driven by excellence, wherever it comes from, and by originality and by innovation. And in that way a university is very like a market economy.

If we lived in a different world, if the university administration were run by a hereditary monarchy and the chancellor were Benjamin Ide Wheeler's great-granddaughter, nobody would have touched those oak trees. But we are not that institution. We are inclined to hire administrators and faculty who did not go to school here, and hire them for talent and talent alone, and from all over the country and the world, so we have not especially bred a public or institutional memory that needed in the first place to know the names of the plants or to find in them any resonant symbolism or to take any particular interest in the intellectual history of the institution. Probably the only person who knew the whole story at the time of the demonstrations was ninety-year-old Sylvia McLaughlin, who climbed the tree on behalf of a whole culture, an era that gave us the Arts and Crafts sensibility of the city and its conservation movements, the Sierra Club, the Redwoods League, and Save the Bay. It was the culture that laid the foundations for the study of the natural history of California, which the new instructors arriving here from the East did not know and which their students who were born and raised here probably didn't know very well either, since most of their parents were likely to have been recent immigrants themselves, so there was no one to teach it to them. The question of the

grove might have been an occasion to have that conversation and it's a pity that we didn't have it.

And, of course, it is not simply a disinterest in tradition on the part of an entrepreneurial and highly mobile administration and faculty that accounts for either our ignorance of the history of the campus or the ease with which the decision to take down the grove was made. That decision was based, I'm sure, on the perception that for the alumni upon whose generosity the campus has come increasingly to depend, athletics are tradition. According to a report on university athletics, issued by a faculty committee, the university's top 138 life donors have given $280 million to sports and $370 million to academics. Since the university had been running a $10-to-$13-million annual deficit for its athletic programs, the argument is not that alumni philanthropy covers the cost of sports, but that it secures their loyalty and interest. In 2010, responding to the faculty recommendations for closing the deficits run by the athletic department, UC's executive director of public relations described sports as "the tie that binds" alumni to the school: "People make their first foray into philanthropy in athletics," the news story in the *San Francisco Chronicle* quoted him as saying, "and it goes from there." Three hundred and seventy million dollars is serious money, increasingly serious as the taxpayers of California have been abandoning the university system that the previous two or three generations had built. That's another conversation that we didn't have.

The second interesting thing about the Jepson essay is the story of the infestation of dry rot. It tells us that many of the older oaks on the campus wouldn't be here were it not for the pruning of diseased limbs and sealing of wounds in the bark a century ago, and since the spores are wind-borne and the breezes from the bay are distinctly westerly, it probably means that many of the old trees in the grove wouldn't have been there to be sat in and then cut down had the botanists and the arborists of the university not seen to their health a hundred years before. The story of dry rot is a way of remembering that the grove was, and the university campus is, a garden. If we are going to think about nature, the distinction between a garden and a wild place would be fundamental to that thinking.

In the humanities these days the starting point for much thinking about nature occurs in the writing of the German critic Theodor Adorno. A very short version of Adorno's view is that "Nature" was a

concept developed by the middle class in the Enlightenment and early Romantic era to sweep away the corrupt, artificial, and unnatural social arrangements of the landed aristocracy and their monarchies, that it was useful in its time as an evocation of frankness and simplicity in manners, freedom and diversity in social arrangements, unstoppable force in social movements, whatever notion of nature was usefully oppositional at a given point in the process of wrenching power from the old order, and that in the later nineteenth and twentieth centuries nature had returned to its previous role as an irrefutable standard by which to justify various forms of racial, gender, and sexual discrimination. In the humanities, therefore, the first thing one says about nature is that it is an idea, socially constructed in the service of someone's ideology, and about wildness and wilderness one says that they are constructions of American westward expansion connected to the ideology of the free market and a masculine conquest of a feminine earth.

This fundamental skepticism is bracing, but it also has its limits. It is not of much use to the scores of living species about to perish from the earth to know that nature is socially constructed. A wildlife biologist's definition of "wildness" is helpful here. I am thinking of an essay by Donald Waller, who observes that what a biologist or restoration ecologist means by "wild" is an organism living in an ecosystem among most of the processes in which it evolved. This definition gives us a practical measure by which to gauge what is at stake in projects of sustainability, preservation, and restoration. You could see that the young people in the trees felt that they were defending something wild and free against all the repressive forces in their society that might be symbolized by a university bureaucracy and by what millions of dollars in advertising money have done to American sports. But the grove was not wild. It was a garden. There might have been very good reasons for preserving it, but they were not the reasons in those young people's hearts or on their posters. And not having that conversation was a missed opportunity.

One of the gifts people who teach can give to students is a sense of complexity, because desire tends to simplify what it sees. We are usually, left to ourselves, egrets fishing through our smeared reflections. Another thing teachers can give them is the gift of seeing what's there. They can give them some of the skills of distinction, discrimination, and description and give them concepts of enormous power to refine

and organize their seeing. Seeing what's there usually requires patient observation and the acquisition of particular skills and disciplines— not that those things guarantee our seeing clearly or freshly. Often in both the arts and the sciences, we see what's there is a flash, but it has taken us hours or years of patient labor to get there and then to name what we have seen.

The ancestor of the live oaks on the hill arrived here ten million years ago. The coast live oak, *Quercus agrifolia,* migrating in and out as the weather changed, has been here for two million years. It is less adaptable than we human beings are, but it understands this weather better. It is exquisitely adapted with its cupped, waxy, dark green leaves and its patient vascular system—one writer about oaks remarked that the lobed deciduous oaks of the East Coast are sprinters and the ever- green oaks of the West are marathoners—to this place with its sum- mer droughts and winter rains and its fogs and drying spring winds. The first people who came here adapted to it better or at least dif- ferently than the later European colonizers. They harvested its acorns and made them their staple food. Ethnobotanists who have studied the matter estimate that the coast live oaks provided every individual per- son in this part of California with about five hundred pounds of food a year, and they did it for twelve thousand years. In their way of think- ing, the trees liked being used. Everything liked being used, if you used it respectfully. We use the trees for beauty. Because we are eaters of the seeds of grasses, we are, as Michael Pollan has observed, the cul- ture through which grasslands came to dominate forests on the planet, and though we are great and talented removers of trees, we like having them around, for various practical uses, but also, I suppose, because they remind us of our origins and because they live longer than we do, which can be reassuring, and because we love their shapes and the way they reach toward light and the way they smell and their shades and the sound of wind in their leaves. And because we are inveterately social beings and build housing so that we can crowd around and hear and see each other, we like them in order to escape our social being for quiet and for reflection. And that is why we make art out of them— make gardens, like the Memorial Grove. And this is another conversa- tion that we did not have.

My friend Stephen Edwards, paleobotanist and director of the Tilden Park Botanical Garden, a man who knows as much as anyone

alive about the flora of California, remarked to me that while the demonstrators were trying to save the oak trees on a campus full of oak trees, the city of Los Angeles was pumping excessive groundwater in violation of a fifty-year-old agreement and drying out alkali meadows and shrinking the range of native grasses in the Owens Valley, a habitat that contains some of the state's rarest endemic wildflowers (including a very beautiful star tulip). And developers in the Livermore Valley were bulldozing a score of endemic plants to put up a mall. What the young people in the grove gave us was their passion to save the earth from human depredation, which must, as poets are always telling us, get some of its urgency from that fact that we can't save ourselves from the predations of time, and they gave us this urgency, a gift that can be both useful and very irritating because, unlike most of us, they aren't already too busy doing what they are doing.

So this was the story of an oak grove. I want to end, very briefly, with a parable about cranes to bring us into the twenty-first century. Cranes are, as a family of animals, between eight and twelve million years old and most of them are threatened or endangered. In Asia there are eight species and seven of them are in trouble. There is, as you know, a demilitarized zone between North and South Korea. It's about 155 miles long and 3 miles wide. It is the last tripwire of the Cold War and the most militarized piece of real estate on earth. And because no human being has entered it for the last fifty years, it has become an immense, accidental game preserve. Two species of Asian cranes— cranes are symbols of longevity and good luck in Asian cultures—have been making a dramatic comeback because they do their winter foraging in the demilitarized zone. Ten million years they have been on the planet, performing their ritual mating dances, guarding and hatching their eggs, and if there is ever peace between the Koreas and the threat of nuclear war is lifted, the DMZ will probably be developed and those two species, *Grus vipio* and *Grus japonensis,* the white-naped and red-crowned cranes, will be that much nearer to being gone from the kinds on earth.

This is the world our students are inheriting. They are going to need a sense of urgency and patience, and a sense of complexity and everything they can learn about the processes of the natural world, if we are going to protect what our science tells us is at the core of life, the richness and diversity of the gene pool. The task may be beyond

us. Wildlife biologists these days often have meetings with titles like "Which Species Can We Save?" or "Which Species Are We Willing to Save?" But we have to act as if we can accomplish it, as if we can preserve that richness and diversity. We have to act as if the soul gets to choose.

2009

acknowledgments

The author and publishers wish to thank the following for permission to reprint copyrighted material:

* Stanford University Press for "Natural Music," "Phenomena," "Credo," "The Beginning of the End," "Rearmament," and "Margrave" from *The Collected Poetry of Robinson Jeffers*, edited by Tim Hunt. Copyright © 1938 by Garth and Donnan Jeffers, renewed 1966; Jeffers Literary Properties.
* Excerpt from *A Bend in the River* by V. S. Naipaul (Vintage Books Edition, 1980). Copyright © 1979 by V. S. Naipaul.
* Excerpts from "Howl" in *Collected Poems 1947–1980* by Allen Ginsberg (Harper and Row, 1984). Copyright © 1984 by Allen Ginsberg.
* Ernesto Cardenal excerpts from "With Walker in Nicaragua" and "Squier in Nicaragua" from *With Walker in Nicaragua and Other Early Poems 1949–1954*, Jonathan Cohen, ed. Copyright © 1984 by Jonathan Cohen. Reprinted by permission of Wesleyan University Press.
* "The Women from Sonjae," "Sleep," "Destruction of Life," "The Wife from Kaesari," "Pyong-ok" from *The Sound of My Waves, Selected Poems by Ko Un*, trans. Brother Anthony of Taize (Cornell East Asia Series No. 68, 1996). Copyright © 1996 by Brother Anthony and Young-Moo Kim.
* "Natural Music," "Rearmament," and excerpts from "Phenemena," "Credo," "The Beginning and the End," "Roan Stallion," "Continent's End," and "Margrave" from *Robinson Jeffers: Selected Poems* (Random House, 1965). Copyright © 1965 by Robinson Jeffers.

* Excerpts from "Three Voices" and "A Warsaw Gathering" from *Without End: New and Selected Poems* by Adam Zagajewski, trans. Clare Cavanagh, Benjamin Ivry and Renata Kaczynski (Farrar, Straus and Giroux, 2003). Copyright © 2003 by the translators. Reprinted by permission of Farrar, Straus and Giroux.

* "Discrete Series" by George Oppen, from *Collected Poems*, copyright © 1934 by The Objectivist Press; "Of Being Numerous" and "Route (part 4)" by George Oppen from *New Collected Poems*, copyright © 1968 by George Oppen; "Who Shall Doubt" by George Oppen from *New Collected Poems*, copyright © 1985, 2002 by Linda Oppen. Reprinted by permission of New Directions Publishing Corp.

* "Canto III" by Ezra Pound from *The Cantos of Ezra Pound*, copyright © 1934 by Ezra Pound, and "Canto XLIX" by Ezra Pound from *The Cantos of Ezra Pound*, copyright © 1937 by Ezra Pound. Reprinted by permission of New Directions Publishing Corp.

* "From the Paris Commune to the Kronstadt Rebellion" by Kenneth Rexroth from *The Collected Shorter Poems*. Copyright © 1940 by New Directions Publishing Corp. Reprinted by permission of New Directions Publishing Corp.

* Excerpts from "Danse Russe," "El Hombre," and "The Pure Products of America" by Peter Dale Scott from *Coming to Jakarta*. Copyright © 1988 by Peter Dale Scott. Reprinted by permission of New Directions Publishing Corp.

* Thanks to the National Archives and Records Administration for the use of Timothy O'Sullivan's "Shoshone Canyon and Falls, Idaho 1873"

* Thanks to the Ansel Adams Trust for the use of "Moon and Half Dome, Yosemite National Park, California 1960" and "Mount Williamson, Sierra Nevada from Manzanar, California 1944." Photographs by Ansel Adams, Collection Center for Creative Photography, The University of Arizona, copyright © 2012 The Ansel Adams Publishing Rights Trust.

* Thanks to Eikoh Hosoe and the Howard Greenberg Gallery for the use of Hosoe's images of Yukio Mishima from *Barakei, Ordeal by Roses*.

* Thanks to Robert Adams and the Fraenkel Gallery for the use of "Highland, New Development, Former Citrus Growing Estate,

1983," "Redlands, Edge of San Timoteo Canyon," "West Edge of Redlands, Interstate 10," "Long Beach, on Signal Hill," "West of Fontana, Abandoned Windbreak," "Redlands, Looking Toward Los Angeles, 1983," and "San Bernardino County, Santa Ana River." Images copyright © 2000 by Robert Adams.

* Thanks to Laura McPhee for the use of "One Car Passing, Valley Road, Sawtooth Valley, Idaho, 2003," "Irrigator's Tarp Directing Water, Fourth of July Creek, Custer County, Idaho," "Mattie With a Plymouth Barred Rock Hen, Laverty Ranch, Custer County, Idaho," "Isaac Babcock, Biologist for the Nez Perce Tribe, Tranquilizing and Radio Coloring Wolves, Fourth of July Creek, Custer County, 2003," and "Rocks from Sawtooth National Forest for Landscaping in Sun Valley, Pettit Lake Road, Blaine County, Idaho."

* Thanks to Robert Buelteman for the use of "Girdwood," "Patricia Leighton/Wake," "Mark Oliver/Mona Lisa," and "Djerassi Ranch."

* Thanks to the publishers and the Trustees of Amherst College for permission to reprint "There's a Certain Slant of Light" from *The Poems of Emily Dickinson*, Thomas H. Johnson, ed. (Cambridge, Mass.: The Belknap Press of Harvard University Press, 1951). Copyright © 1951, 1955, 1979, 1983 by the President and Fellows of Harvard College.